The Year's Work in **Lebowski** Studies

The Big

The Year's Work in

Lebowski

Studies

Edited by

Edward P. Comentale & Aaron Jaffe

Indiana University Press Bloomington & Indianapolis

8503 900 213

JEFFREY LEBOWSKI

This book is a publication of

Indiana University Press
601 North Morton Street
Bloomington, IN 47404-3797 USA

www.iupress.indiana.edu

Telephone orders 800-842-6796
Fax orders 812-855-7931
Orders by e-mail iuporder@indiana.edu

∞ The paper used in this publication
meets the minimum requirements of
the American National Standard for
Information Sciences—Permanence
of Paper for Printed Library
Materials, ANSI Z39.48-1992.

Manufactured in the United
States of America

Library of Congress Cataloging-in-
Publication Data

The year's work in Lebowski studies /
edited by Edward P. Comentale and
Aaron Jaffe.
 p. cm.
 Includes bibliographical references and
index.
 ISBN 978-0-253-35380-1 (cloth : alk.
paper) — ISBN 978-0-253-22136-0 (pbk.
: alk. paper) 1. Big Lebowski (Motion
picture) I. Comentale, Edward P. II. Jaffe,
Aaron.
 PN1997.B444Y43 2009
 791.43'72—dc22

 2009019544

2 3 4 5 14 13 12 11 10

To our own Little Achievers: Elias, Zara, Margaret, and Fern

Tom said to himself that it was not such a hollow world, after all. He had discovered a great law of human action, without knowing it—namely, that in order to make a man or a boy covet a thing, it is only necessary to make the thing difficult to attain. If he had been a great and wise philosopher, like the writer of this book, he would now have comprehended that Work consists of whatever a body is obliged to do, and that Play consists of whatever a body is not obliged to do. And this would help him to understand why constructing artificial flowers or performing on a tread-mill is work, while rolling ten-pins or climbing Mont Blanc is only amusement. There are wealthy gentlemen in England who drive four-horse passenger-coaches twenty or thirty miles on a daily line, in the summer, because the privilege costs them considerable money; but if they were offered wages for the service, that would turn it into work and then they would resign.

MARK TWAIN, *The Adventures of Tom Sawyer*

Contents

Acknowledgments

The authors would like to acknowledge their sincere gratitude and respect for the many friends and colleagues who helped put this collection together. First, we would like to thank those involved in bringing to light the symposium where most of this work was originally presented: Emily Ritter, who knew the dudes; Lebowski Fest organizers Will Russell, Scott Shuffitt, Bill Green, and Ben Peskoe; Julie Kredens and Robin Fisher from Louisville's WFPL; all the kind folks at the Executive Strike and Spare, the Limestone, and the Executive West; for material help, University of Louisville colleagues and staff such as Robin Carroll, Brian Heckel, Jim Hensley, Hung Nguyen, Jennifer Stephens, Tom Byers and the Commonwealth Center, John Hale and Liberal Studies; Bronwyn Williams, Susan Griffin, and Susan Ryan, and the rest of Aaron's Louisville colleagues and students; and Ed's Indiana colleagues and students, especially the kids forced to take L371; and, of course, our special friends and guests William Preston Robertson, Alan Dale, Joe Morgenstern, as well as Steve Davis, Emily Dill, Karen Janke, Todd Comer (and his wandering child), Thomas Gianotti, Marc Ouellete, Stephan Wender, Alisha Wheatley, Karen Hadley, Jane Halliday, Michele Wilbert, Matt Dowell, Stephen Neaderhiser, Jacob Goessling, Bill Kerhwald, Kevin Metcalf, Scott Zurkuhlen, John Vance, Adam Robinson, Lynda Mercer, David Thimme, Chris Hoerter, Matt Wiles, and Elijah Pritchett. Also, we'd like to thank the larger community of dudes

who we've met along the way; your support and continued friendship is greatly appreciated: Cristina Iuli, Daniela Daniele, Rob Richardson, Sean Anderson, Lisa Donald, Chalupa, Liz and Paul at Lebowski Podcast, J. M. Tyree and Ben Walters, Oliver Benjamin (aka The Dudely Llama), Peter Lopilato at *The Ryder*, Jacob Mazer and Victor Lenthe of the Video Saloon. Special thanks to Brian Benedetti, Jeremy Phillips, Josh Cooley, and cover artist Bill Green—for their cool visuals. Many, many thanks to our authors—treasured friends and wits, they got it and they made it better. Also, we had excellent support from Indiana University Press, and we'd like to thank our editor Jane Behnken as well as Katherine Baber, Robert Sloan, Miki Bird, Jane M. Curran, Brian Herrmann, Jamison Cockerham, Chandra Mevis, and, of course, our anonymous readers. Finally, we must thank our families, especially Tatjana and Kimberly, for their patience and support and helpin' to perpetuate the whole durned human comedy.

The Year's Work in **Lebowski** *Studies*

Introduction

Edward P. Comentale & Aaron Jaffe

Far out. Far fucking out.

So what's a Lebowski, you might ask?

This is not the definitive question of the film.

That would probably be *Which Lebowski?* Or, perhaps, *Where's the money, Lebowski?*

We're academics, though. Over-achievers, if you will.

Let's begin with the title of the movie, which, we admit, is a bit of a puzzle. As far as titles go, it is both glaringly idiosyncratic and utterly slack. Through the course of the film, the "big" in *The Big Lebowski* slips back and forth between quality and quantity, spirit and matter. Yes, there's a Lebowski in the film who is big in cash and big in girth, but his decrepit image—bald, bloated, crippled, hot in the face—hardly meets the expectations of the star-burst title sequence. After betraying the family name and his daughter's love (not to mention the little Lebowski Urban Achievers, *and proud we are of all of them*), this Lebowski turns out to be nothing but a big "crybaby," pounding his fists on the floor of a mansion he never owned. The other Lebowski—dead-beat, down-and-out Jeff Lebowski, "the Dude"—reveals "bigness" of a different order. It's not his brains, exactly, but his heart, an expansive tenderness of being, or, at least, a big, sloppy helping of just being there. *Yeah, Walter, I'll be there.* And, with a little Lebowski on the way, bigness surely shifts

Dude-ward. The un-hero finally—cuckoo-like—throws the other egg out of the nest, regains his own eponym and thus a story. Unless, perhaps, we've been fixated on the wrong Lebowskis the whole time, and it's Maude all along who really is Le Grand Lebowski. . . .

Undoubtedly, this titular crisis suggests something about the film itself. The name evokes the awesome as well as the asinine, the tender and the tricky. In all its silly, giddy grandeur, it seems to have kicked itself loose from the earth, beyond any appeal to either high or low. At once chthonic and cartoonish, wise and wise-cracking, the name is just as plausible as an obscure demigod or a subatomic particle, a magic trick, a Cracker Jack novelty, or an Olympic dive. In fact, the Big L could refer to all manner of ridiculously specific things: a bomb; a dildo; a bong; a long con; a cricket bat; a wrestling hold; a half-and-half 'stache; a cowboy hat; a nail-polish color; an antique, bread-box-sized "portable" phone; a trident fetish; an Eve Sedgwick series on *Showtime*. In all its ambiguous plasticity, though, the name abides. Unlike other film titles, which refer plainly to characters (*Barton Fink*), or places (*Fargo*), or specific themes (*Blood Simple*), this one seems to refer to the film itself. It allows the watcher to speak familiarly, touchingly, about the movie. *Have you seen The Big Lebowski? Don't you love The Big Lebowski? The Big Lebowski is awesome, man!*

> What is **The Big Lebowski,** then? Or, if you're into the whole brevity thing, what's a Lebowski? What kind of **thing** is a Lebowski? How does it exist in the world? How does it present itself to human consciousness?

Repeated enough, "Lebowski" starts to designate everything and nothing. Rather than indexing anything specific, it comes instead to sound like the very principle of indexing. It seems to point somewhere,

Edward P. Comentale & Aaron Jaffe

forcefully, broadly, and yet it also tends to slip away from any stable referent. To work as a designation, it must shore itself up, neurotically, stringing together other, more or less useless modifiers. *Which Lebowski? Not just any Lebowski, but a* BIG *one. How big? Really big. Big enough to be* THE *big Lebowski, the only Lebowski of this particular density, weight, height, or what have you.* Perhaps, *The Big Lebowski* is just the only possible name for perhaps the only psychowesternoircheechandchonginvietnambuddy genre pic in existence—as if name and referent were created at once, the way a ferocious beast is named by the native's shriek or the way novelties are named by befuddled executives. *Oh, that? That's a Whatzit! That's a Hula Hoop! That's a Shrinky Dink! That's a Lebowski! You know, for kids!*

What is *The Big Lebowski,* then? Or, if you're into the whole brevity thing, what's a Lebowski? What kind of *thing* is a Lebowski? How does it exist in the world? How does it present itself to human consciousness? If it is, in fact, a thing in its own right—and we guess, given its plastic blister pack, it must be—then it might be categorically linked to other objects of our environment. At first glance, we can reasonably assert that it is not a tool, in the way, say, a hammer or a calculator or a heavy drink may be a tool. In fact, compared to the familiar things on our domestic shelving units, this one seems to lack any obvious purpose, any implicit use or application to aid either the individual or the community. The actual viewing experience produces nothing, accomplishes nothing, changes nothing. In fact, Lebowski-users—the "achievers"—use the film to *avoid* work, and whatever force or energy they might apply in their endeavor is clearly unmatched by any obvious output.

At the same time, though, Lebowski does not meet standard criteria as a commodity. Its initial box-office returns proved disappointing for producers, and, to this day, despite repackaging efforts on the part of its distributors, it remains a losing prospect. We imagine it can be

successfully traded (for, say, a similarly formatted copy of *Office Space* or perhaps *Kingpin*), but its use value seems roughly equivalent to its market value, currently running at 69¢ on eBay. What's more, it defies the basic principles of ownership. Not only does it occasion group viewing and a generally unhygienic sharing of drink cups, but, with clips readily available for mashing on the Internet, any given scene can be physically reproduced on command by even the most casual fan.

Lebowski ... *resembles the joint as an object that is defined by its hollowness, an object that is at once wrapped up and open, that seems to disappear with its use, designed to let in the air that will slowly, deliriously, consume it. In this, it is a runic joint or perhaps a Mobius joint—rolled with single-sided Zig Zag papers by M. C. Escher himself.*

We can't claim with any assurance that *Lebowski* is a work of art. Or even a text, really. Certainly, it looks like a systematic grouping of sign-units. It seems to present itself, more or less, as something to be "read" by the eager filmgoer, and it seems to refer—artfully—to the existence of a recognizable set of humans in real time and space. An incoherent jumble? Not quite. Still, *Lebowski* defies the unities of production, distribution, and use that we associate with texts.

Item: the film was conceived by mutant brothers who communicate largely through "telepathy." Item: its crew consisted of friends and confidantes chosen for their shared "tastes." Item: the film itself is willfully tangential in terms of structure and gleefully schizophrenic in its use of cinematic allusion. Item: the exquisite décor of set and costume does not merely distract from the plot but also determines both action and characterization at decisive moments. Item: it is mostly screened at odd hours before small casual groupings of distracted fans who

compulsively repeat their favorite lines and scenes. Item: it is the focus of multiple dormitory games and accessory diversions, and its footage has been used in literally hundreds of parodies and loving re-creations in digital format. Item: it is at once the center of an annual booze-soaked confab in Louisville, Kentucky, and now at least one book collection of critical academo-scribblers (this one).

No, if *Lebowski* resembles any object in our shared consciousness, it'll not be found in the usual categories. Rather, we take our cue from one of the cunning objects thematized in the film itself. No, not the bowling ball or the severed toe, but the *joint*. Not just any joint, but the sweet relaxing bud enjoyed by the Dude himself, a bud at once gratuitous, trippy, casually illicit, and always gone too soon. *Lebowski* resembles a joint in its multiple senses—(1) joint as the means to altered consciousness, (2) joint as an aide to relaxation and casual sociability, (3) joint as a physical connector, as in joint compound, a means of bringing together disparate sounds and images and meanings in psychotropic array, and (4) joint as a meeting place, as a homeland for shared culture, for casual, if slightly buzzed, citizenship. *Lebowski* also resembles the joint as an object that is defined by its hollowness, an object that is at once wrapped up and open, that seems to disappear with its use, designed to let in the air that will slowly, deliriously, consume it. In this, it is a runic joint or perhaps a Mobius joint—rolled with single-sided Zig Zag papers by M. C. Escher himself. In all its formations—as a connector between people, places, and texts—it both fulfills and empties itself. The Lebowski joint burns like a hipster phoenix. In an instant, it flashes its mythic purpose and ceases to exist, becoming only its own empty openness, dead ash, a doubly dead-beat dead end.

Lebowski suggests connections—laid-back connections between more or less disparate phenomena. It works through the slow-dazed formation of more or less cosmic thingamabobs, stellar mobiles of

fascinating attention, and meaningless junk. Thus, a tumbleweed is a bowling ball is a reel of film that, when projected, shows a Western at the limit of the West, a West that no longer exists except offshore in Korea, Vietnam, and Iraq. Here, a terrier is a Pomeranian is Toto, yapping at the man behind the screen who is a human paraquat, which is a herbicide for killing marijuana and thus an instrument for destroying a good buzz, such as the one the Dude experiences right before he is attacked by a marmot, which is actually a ferret sent by a group of phony nihilists trying to extort money by pretending to have kidnapped a porn refugee missing from, yes, Kansas. The film expands and contracts with these connections, finding ecstasy in the dissolution of the barrier between reality and imagination, reducing everything to sheer connectivity, sheer jointure. Its hazy buzz calls for a mellow reshuffling of the phenomenal field, retroactively transforming the cultural archive as it reduces that archive to ash.

So, what do you with a Lebowski? You smoke it.

And then, the tale wagging Schrödinger's cat, Lebowski smokes you.

Sometimes you smoke Lebowski; sometimes Lebowski smokes you.

In short, *everybody must get stoned*. The film demands to be seen with bleary eyes, and this *Year's Work* is offered in this vein—laid-back, easy-going, comfortably dead-beat, slack. The objects in the film appear at the borders of significance, where everything seems to mean something—or something else—to refer to at least one thing or another. *I've seen that dog before. That's the dog from that old movie. You know, dude, the one with the girl.* Referencing occurs without any sanctioned frame of reference. And, as in altered states, the viewer remains listless, stupefied, and yet bewildered, responsive, open to impossible connections. *You mean Toto, man? Toto's not a pom.* Yes, the experience of the

0.1. Ashes to ashes, Dude.

film—the experience of our work—focuses not on codes, on the cracking of themes and allusions, but on the process of ideation itself, on an imaginative openness that never ceases to fail to focus into form. *Toto's totally a pom, dude.*

Such a state seems to inform the working method of the filmmakers themselves. "You sort of know these people and hear these stories and they all sort of figure together in nebulous ways," as Ethan Coen explains. "It's all sort of really vaporous ideas and then we just start writing at the beginning. And that's how we crystallize the idea" (Robertson 41, 48). The Lebowski process emphasizes openness, fluidity, and a blurring of the line between irrationality and objective fact, between a potential for meaning and the refusal to grant it. Rick Heinrichs, the film's production designer, raises this point:

> I mean, you really don't want to hit it too hard. You have to allow people
> to get it if they want and if not, that's okay, too. If you want, you can
> sort of after-the-fact rationalize it, come up with all kinds of analysis
> that makes it sound like a grand intellectual construction. But what
> it is, essentially, is just a motif. You conceive or stumble onto motifs
> as you go, and you use those to link up the scenes. (Robertson 104)

This is not just your average stoner flick, but a stoned flick. Its very slack-
ness, its lazy, bleary-eyed gaze reveals more than any one of its objects
may contain on its own. In this stoner haze, the material world is turned
inside out. The American scene shakes off its rational frames, dives into
itself like a psychedelic seal, and begins to glow rich and strange with its
own psychic undercurrents. It isn't a question of intelligence but feel-
ings, desire, the unconscious, and what becomes possible again in an
otherwise dead world of dead objects and dead causes. Ethan again: "It's
that it's kind of wrong in a way, but also kind of right in a way. I mean,
even things that don't go together should seem to clash in an interesting
way—like, you know, a Cheech and Chong movie, but with bowling.
You sort of do it by feel and not with reason" (Robertson 45).

 Far out?! Far from it, man. In *Lebowski,* the Coens' work adds up to
a kind of Surrealism of everyday life—it's about inner space, not outer
space, so to speak. Their method follows a long cinematic tradition of
using the screen image to reintroduce a liberating irrationalism into
the rigid forms of expression that distort modern life. Soon after the
invention of film, figures like Luis Buñuel and Man Ray exploited the
motion picture's unique abilities to subvert temporal and spatial frame-
works, and to open up latent meanings beneath or perhaps between
the objects and images of the practical world. They believed the experi-
ence of filmgoing—dark theater, passive spectatorship, psychological
ecstasy—mimicked something like a conscious dreaming, and the spe-
cific qualities of the film text—splicing, montage, the image—tapped

a subterranean realm of desire and fantasy, if not a specifically poetic reality. According to Jacques Brunius,

> The arrangement of screen images in time is absolutely analogous with the arrangement thought or dream can devise. Neither chronological order nor relative values of duration are real. Contrary to the theater, film, like thought, like the dream, chooses some gestures, defers or enlarges them, eliminates others, travels many hours, centuries, kilometers in a few seconds, speeds up, slows down, stops, goes backwards. (Hammond 11)

If Freud's dreams work by condensation, displacement, and a complete disregard for mental and physical categories, then they find a fitting counterpart in the rough editing of both intentionally avant-garde film and unbearably shoddy popular flicks. The "fidelity of the image" meets with the "infidelity of the montage," and thus qualified, in the words of Paul Hammond, "cinema to portray the dream voluntarily since, to put it crudely, the dream is waking reality (i.e., photography) jumbled up (i.e., montage)" (12).

The Coens, like the Surrealists, find grace in ridiculously misplaced objects and shockingly silly images. In *Lebowski,* the viewer must grapple with a severed toe, homework in a baggie, and a suitcase full of whites, not to mention a Vietnam vet and a cowboy in a bowling alley, nihilists ordering pancakes, and an attack marmot on a chain. But each of these objects is given a further kick, some obscene detail—the paint on the toe, the "D" on the homework, the studs in the chain—that heightens the tension between everyday life and its irrational subtexts. The Coens manifest a singularly Surrealist tendency to play with these objects as open images, to allow them to resonate in multiple ways across the surface of the film. Each one traverses a number of registers, moving temporally from scene to scene, spatially from room to room, but also

symbolically, thematically, open to a range of associations, some intentional, some fateful.

Thus, the older Lebowski uncovers a toe in the limo, shouting, "I have no choice but to tell these bums that they should do whatever is necessary to recover their money from you, Jeffrey Lebowski. And with Brandt as my witness, I will tell you this: any further harm visited upon Bunny will be visited ten-fold upon your head. By God, sir, I will not abide another toe." The film soon cuts to the Dude relaxing in his bathtub, the camera focused warily on his ten wriggling toes, intact, but soon to be threatened—ten-fold—by the marmot-wielding nihilists. Given the Dude's relaxed nakedness in the scene, the toes are also ten little penises, threatened with castration by the thugs who will soon appear in his dream, in which, having replaced their crotch-chomping amphibious rodent with a giant pair of scissors (stolen from Maude's painting), they chase the Dude down a bowling alley. So these toes become also, less traumatically, ten pins, about to be knocked down by the ball tossed by Maude in his dream, or perhaps Maude herself, for when she is first shown careening across the ceiling of her art studio loft in a harness, we hear—in a manipulation of sound that would have made the Surrealists proud—the sound of a ball rolling and pins crashing. And, yet, the emerald green of the nail paint leads us back to Kansas, or at least a despoiled vision of Kansas, for this is also the color of money, and Bunny, the girl whose toe line remains surprisingly intact, will apparently suck any cock for $1,000, as she informs the Dude when he blows the paint dry on her right foot and then tips his glasses, Cruise-style (vintage *The Color of Money*), and proclaims, "I'm just gonna go find a cash machine."

These connections—at once objective, fantastic, cinematic, and unsupportable—define the space of the film. The movie grows open on all sides, given over to a game of chance that is both giddily dumb and

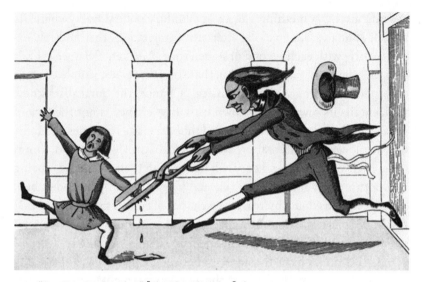

0.2. "Der Daumenlutscher" [The Thumbsucker], from Heinrich Hoffman, *Der Struwwelpeter* (1845).

freakishly fateful. In fact, chance seems to be the only aspect of the film-making process that the Coens are willing to discuss openly, perhaps if only because it excuses them from the haughty logic of authorial author-ity. As William Preston Robertson reveals in his book on the making of *Lebowski,* the Coens used the most basic Surrealist techniques to generate chance within and beyond the formal structure of their film. The process began with a set of unrelated objects (the rug, the toe, the homework in the baggie) and the fraternal challenge of putting them all in the same film. "We get the idea first," explains Ethan, "'Oh, it would be good if a severed toe shows up here.' . . . We want to goose it with a toe. And then you're left with the problem of whose toe it is. . . . that's a way to work, painting yourself into a corner and then having to per-form whatever contortions to get yourself out" (Robertson 49). In this,

the film attains something like an involuntary poetry. Everywhere, its objects split and careen along alternative trajectories that multiply exponentially with each second of screen time. And yet, if chance is built into the very structure of the film, that structure is not simply open or amorphous, never simply nonsensical. Chance, the Surrealists knew well, entails its own logic, its own causality; chance is not the lack of cause, but the openness of cause, and thus correlates openness with coherence, locates disorientation within logic. In the Coens' world, things fall apart by necessity, and they cohere through their openness—being and nothingness roll together. Casually kegeling on the Dude's bed, Maude explains that it increases the chance of conception. "Increases?" the Dude spits out, astounded. "Well, yes," Maude responds, "What did you think this was all about? Fun and games?"

At this point, even the analogy between *Lebowski* and dreaming seems to miss the mark. For even the most surreal night visions are conditioned by the exigencies of an anxious ego, and *Lebowski,* like many cult films, may in fact turn out to be a dream without a dreamer. Or, perhaps, we might say that *Lebowski* is a dream of objects, not just a dream that contains objects, but a dream that objects may have, once freed from their practical, everyday uses or even the symbolic order of psychology. Indeed, the Surrealists privileged filmmaking over dreaming precisely because the technological apparatus freed them beyond the terms established by the dreamscape and allowed objects and images to find strange configurations on their own. Similarly, the Coens cut to dreams not because they reveal anything new or interesting about the dreamer, but because the space of dreams allows the objects of the film to collude in startling ways—the Dude's carpet flies over L.A. with Maude cross-legged on top; Lebowski's tiled floor appears in the bowling alley; giant scissors break loose from a painting and give chase; the

Edward P. Comentale & Aaron Jaffe

Dude becomes the Cable guy, borrows Saddam's shoes, and flies down the bowling alley, etc. Ethan grumbles that the dream sequence is a "cheap, gimmicky, obvious way to depict a character's inner life," but he is captivated by the sequence's possibility of juxtaposing design elements otherwise unconnected to each other: "But it's also a very fun thing to do. Again, it's dovetailing things" (Robertson 50).

The film offers a new poetry of common objects. At its most basic level, it presents the cunning collapse of ideas into things and forces the viewer to remain supple in response to the phenomenal world. Our gaze is opened to a world in which each mundane thing is both drained and saturated with meaning—a world stupid, stubborn, mute, and a world vibrant, charged, and ecstatic. In one direction, objects are charged with a totemic power, a surge at once symbolic and affective, and so, within and beyond the frame of the film, we can never again experience an old rug, a bowling ball, a container of half-and-half in the same way. In the other direction, people become things, taking on hitherto unknown physical properties and thus revealing a new openness to the material world. After the opening credits roll, we see the Dude as bowling ball. He traipses through the apartment gardens, his own case in hand, casually navigating the floral arrangement that, like a ball return, divides the path in two. He enters his apartment, where he is gripped, scruff-wise, by one of the thugs, and bowled,

As may be expected, the beginnings of the **Lebowski** *cult—the narrative origins of any collectivity—are shrouded in mystery, thriving elsewhere in multiple viewings, late-night campus screenings, recitations of catchphrases, drinking games, and theme parties. Somewhere right now, someone's watching* **Lebowski.**

literally, across the wood floor of his apartment and into the bathroom and plunged into a toilet bowl.

A bowling alley is, by and large, a wondrous dream of objects, the most bizarre formation of human culture ever devised. Here, we find brute material in fantastic configuration, and, everywhere, the most inert objects receive obsessive attentiveness. Precision meets inanity, kinesis becomes form. In a feat of staggering communal Dada, we have all somehow agreed that it is fit and proper that a three-holed ball with a standardized circumference of 2.25 feet should be hurled down a lane that measures exactly 60 feet from the foul line to the head pin, which, like the other nine behind it, must be 15 inches tall and about 4.7 inches wide at the "belly." Said hurling is repeated, either individually or in small posse formation, in the same direction twice during each of ten frames, thus producing a score via a formula that is too complex for 92 percent of the world's bowlers. And the bodies that enter this space give themselves over to sublime contortions, at once purposive and spastic, fluid and jerky, in more or less formal uniforms and stylized patterns of hair and posture. The successful throwing of the ball entails a precise generation of chaos, known in the game as "spin": the greater control, the greater spin, the greater chance that the pins will bang wildly into each other, falling at once by a predetermined physics so intense it is barely worth tabulating and an utter randomness that frees us from any need to do so.

The Coens have always been obsessed with controlled chaos. Their work tracks the best-laid plans of marmots and men as they go comically awry, as they come up empty against the stubborn objects of the everyday world, revealing the ways in which precision produces contingency, whereas contingency works with the utmost precision. The roll of a bowling ball reveals the beauty of this logic in miniature, as it careens down the lane, obedient to the letter of each physical law, and

yet inspiring a sense of chance that seems just as implacable, just as intransigent. Controlled chaos, the chaos of control—these terms also describe the Coens' cinematic style, with its detached wide-angle vision and its OCD-like attention to minor imperfections of body and soul. As a space to be filmed, the bowling alley allows them to indulge and explore all of their tics regarding the object world. Here, the camera is drawn to the clean lines of the lanes, the carefully arranged patterns of dots and pins, and the synchronized approach and release of uniformed teammates, and yet the scene is worried by the unexpected sounds and sights of pins crashing, men cursing, dogs yipping.

The Dude, as the non-hero of this world, is a necessarily comic figure. As Henri Bergson famously observed, we laugh at the spectacle of a human behaving like a thing, getting caught up in his own thingliness and the thingliness of his environment. The Coens' comedic formula rests on the belief that an inverse ratio of human effort and material contingency produces the most belly laughs. Again, we're dealing with "best-laid plans," and so we watch the Dude sweating through the construction of a door barrier and then see the door easily opened because he inserted the chair backward, or, more brilliantly, we watch Walter's minutely detailed plan with the ringer go awry, here tripped up by his own girth. Undoubtedly, such humor involves a factor of humility, for when characters seem most free from the burdens of materiality, as when the Dude tries to relax and assert his dignity with a joint and a little Creedence, they are most violently struck by all manner of worldly shrapnel. When the Dude crashes the Gran Torino, say, we are granted neither irony nor even black humor, but a kind of hipster slapstick, a comedy of goofy cool that signals less an existential crisis but a warm humility. Here, the comedy approaches something like an ethos. As comic hero, the Dude is situated against a catastrophic world, but he also brings an incredible uncertainty to that world. His bumbling

adventures open an otherwise sterile terrain to gleeful chaos. The Dude at Ralph's, the Dude stretching in the middle of Star Lanes, the Dude in bed with Maude, the Dude on the cliff with Walter—his very presence, like Chaplin or Boudo or Clousseau, signals encounter, collision, contingency, and eruption, the breakdown of the real, the emergence of the impossible.

Dude, we like your style. But we don't mean your jellies. We like your style for it tells us what it means to have a style. It cuts to the heart of style as event, as ethos, as a means of engaging the world that is at once common and distinct, planned and accidental. Yes, we can read the Dude's robe and roach clip as they express a certain hipster attitude, just as we can reduce Brandt's uppity tie or Bunny's nail polish or the Stranger's moustache to the menial signifiers of more or less obvious stereotypes. The film, though, shifts the issue of style away from code toward phenomenon, toward the very actualization of style, the sloppy physics of style. Style appears here as something both remarkably unconscious and highly precise, lazy and exact. Jumpsuits, hair-weaves, German techno—the objects of style are always both empty and filling. They imply not a content, but a relation, a charged positioning or affective orientation between the self and (the often cheap) things of this world. One key to the film, then, remains the stranger's compliment, "I like your style, Dude," returned in kind by the Dude, "Well, I dig your style, too, man." Here, though, we marvel at the fact that the Dude has a style at all, that the seeming slovenliness of his corporeal bearing attains something like a coherent presence in this world. But we see a similar stylistics at play with the freakishly adorned bodies of Maude, the nihilists, Walter, Smokey, and, yes, even Quintana. This is an irrational community, but it is not an empty community, a fabricated community. These stylized bodies enter a decisively public space and are accepted as citizens within it, humanely, and even, at times, as sources of beauty and

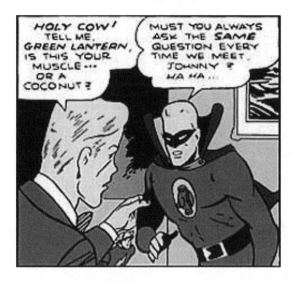

wonder. By and large, if anything holds this film together, it is style. The Coens and their team move by feel, and their work involves a process of solidifying feeling into a range of more or less appealing objects and images. The result is a world that is at once imaginative and observable, uncanny and coherent, but also a world that is open and humane, a world that has proven comforting to more than a few fans, to which we now turn.

If you achieve it, it is no dream.

Big Lebowski fans, so-called "achievers," cling to their movie like sixth-year seniors with only three credits to go. Some evidence for their numbers and dumbfounding tenacity is the appearance of *The Big Lebowski: The Achiever's Edition DVD Gift Set* in late 2005, including a "branded bowling shammy towel," four "collectible coasters," and "photos from

the set taken by the Dude himself, Jeff Bridges." Nothing better announces the arrival of a demographic of consumers—*ahem, a cult*—than big business exploiting their desires—*er, purchasing power*. Much is to be made in this *Year's Work* about anointing *Lebowski* as the great cult film of the age of DVDs and the internets, and it's certainly significant that the Coens—the epitome of the surge in American alternative cinema in the 1980s—found their perpetual youth market cachet not during forlorn midnight screenings, but following a latter-day re-mastering for the dormitory lounge.

All this notwithstanding, it is the word designating the edition itself that catches our attention: *achiever*. By re-appropriating the language of fans, the marketing guys close a circuit of consumption and production. *Achiever,* you see, was the preferred nomenclature, the name that the *Lebowski* fans self-applied. When considering customary lexical suffixes for fan affiliation—the diminishingly synecdochal *head* or the punitively outré *freak*, for example—the self-election of *achiever* is downright heartening. The original appropriation of the term, in fact, occurs in the scene where the Dude first visits Lebowski about compensation for his rug. It is a sublime splinter tweezed from all the old wood in Lebowski's trophy- and plaque-strewn antechamber. In fact, the term appears on all the plaques in the Lebowski mansion: *Variety Clubs International* ACHIEVER OF THE YEAR; *Los Angeles Chamber of Commerce Business Achiever;* even in the *Time* cover-cum-mirror: ARE YOU A LEBOWSKI ACHIEVER? The Dude, though, pauses in front of a photograph depicting the old man in his wheelchair posed with anonymous African American children. "They're the Little Lebowski Urban Achievers," explains the man Friday, Brandt, "inner-city children of promise but without the necessary means for . . . the necessary means for a higher education, so Mr. Lebowski is committed to sending all of

them to college." "Far out," the Dude responds, whip-crack sharp, as ever, "Think he's got room for one more?"

Bums always lose; Dudes just want to achieve. The first demand the Dude puts to his rich namesake—or, his hyper, gesticulating emissary, Brandt—isn't just a plea for a proverbial handout, but a call for a college scholarship—a handout with more complex cultural resonances. And, much to Brandt's surprise, it turns out that, yes indeed, the Dude attended college. Asked, he remembers hazily time split between student activism and other extramural pursuits. Is the largesse of the Little Lebowski Urban Achiever scheme capacious enough for the Dude's, ah, "study habits"—or even more ominously, for the vision of higher education augured by experiences that include occupying administration buildings, breaking into the ROTC, firing up Thai stick, and rolling Ebonite on the maples?

Just what, Sir, do you propose to do with that major? It can be no accident that *achiever* originates in a scene that exposes the Dude's salad days against the withering paternal interrogative represented by Lebowski the elder. Whether the Dude's soliloquy plays as regret or nostalgia, it does have us imagining an audience structure via the communities of achievers who really get him: which is to say, perhaps not necessarily college valedictorians but campus protestors, marijuana users, recreational bowlers, and, above all, sixth-year seniors of the sort who innovate such things as *The Big Lebowski Drinking Game.* As with most of the Dude's back-story, his campus reverie does not so much index obsolescence—the throwback worldview of Timothy Leary's "turn on, tune in, drop out," say—as it unfailingly punctures the received ideas of a world that so deliberately figures the Dude for "a loser, you know, a deadbeat, someone the square community won't give a shit about."

According to the recollection of one of Lebowski Fest's core dudes, the achiever sobriquet started to stick in 2003, on the Lebowski Fest website forum: "People just started using it. I think some of the members went back through the posts to see if they could locate the very first usage, but nothing ever came of it." Another failed research endeavor, yes . . . but, happily, by something like Condorcet's jury theorem, achievers found a good name for themselves and, in the process, fingered one of the crucial topics of their occulted cultural object—the ambivalence of achievement. In the face of his crippled elder's blow-hard hypocrisy, the Dude grins like a postmodern Buddha. His response supports a bona fide point of fan access: the Dude as avatar for a whole Eastern bumper-sticker thing, complete with laid-back, Yoda-like platitudes, visionary suffering, enlightenment, and what have you, all served to strains of Ravi Shankar's sitar. Asked about the Dude's "Zen Wisdom," Jeff Bridges says that he "doesn't think of [him] as a fancy spiritualist": "For me, the Dude has a certain type of wisdom. I like to call it the 'Wisdom of Fingernails': the wisdom that gives you the ability to make your hair and fingernails grow, your heart beat, your bowels move. These are things we know how to do, but we don't necessarily know *how* we know how to do them very well" (B. Green et al. xiii–xiv).

The minor dissonance between the Dude as paternalistic imago and the Dude as dormitory guru surfaces when the Dude's trademark verb—*to abide*—is contrasted with Lebowski's—*to achieve*. *Abide* and *achieve* are both verbs that work with transitive and intransitive syntax. Whereas the meaning of the transitive verb is incomplete without its object, the intransitive verb does not require one. Lebowski senior, for example, uses abide in a transitive way, when he says he won't abide another toe, and the Dude uses it intransitively in his valedictory send-off: he abides, end of story. It doesn't mean the Dude abides everything or indeed anything. Nor is *to abide* his credo; that is, it's not a matter of

principle or belief. It means he abides period—as one sleeps (or grows toenails, perhaps), not as a condition of transaction or instrumentality but as a predicament, a solid state. When Lebowski senior talks of achieving, he tends to use the verb as would a true American, with ambiguous reference and no obvious goal, as if achievement was a matter of character itself, independent of context or object. As he tells the Dude, he achieved anyway, despite adversity, but this achievement turns out to be fraudulent, as Maude reveals to the Dude in their bedroom scene. Yet, the Dude's achievements are, oddly enough, enumerated during that same scene: Port Huron Statement, uncompromised first draft; the Seattle Seven; Roadie for Metallica, Speed of Sound Tour. These kinds of achievements, if nothing else, exhibit the virtue of actually being countable.

Profounder still, the Dude's brand of achieving accesses a tradition of wise laziness and profound slumber that has long comprised a counter-tradition to the American Dream—Rip Van Winkle's slumber as a soporific antidote to Ben Franklin's entrepreneurial wakefulness. Dude Van Winkle surely has one foot in the American dreamscape, but the other rests, along with the satyrs, bunnies, and forest folk of his tale, in an old world fantasia. He recalls, particularly, a certain continental vibe regarding the cunning of stupidity, which, according to Matthijs van Boxsel in *The Encyclopaedia of Stupidity*, stands on "laxity, kitsch and superstition," rather than "melancholy, decadence and the uncanny" (19). Another relative of the Dude is a figure familiar from the Yiddish tradition: the schlemiel. The schlemiel is a man without both shadow and homeland:

> the schlemiel thrives elsewhere—the gap between inner and outer
> reality or between ideal and real worlds.... [His] gullibility is a
> kind of negative capability generative of possible worlds: 'There

were really no lies. Whatever doesn't really happen is dreamed at
night. It happens to one if it doesn't happen to another, tomorrow
if not today, or a century hence if not next year.' (Ezrahi 430)

The Brothers Grimm's tale "The Story of a Boy Who Went Forth to
Learn Fear" tells the connected story of a Gentile schlemiel, the boy
too stupid to know how to shudder, a predicament of Freudian object
relations to be sure, and one that points to at least one scholar's reading
of the slacker as a stand-in for the post-castrated male. The boy's story
is shared by the Dude: it is the tale of all boys too stupid to know when
not to make a joke, but who are ultimately saved from all manner of hor-
rors by their jesting. Causing no end of trouble and embarrassment to
his family, he is forced to leave home and is subjected to various trials,
culminating in a sleepless night spent in a haunted castle, where bones
and skulls rattle past him menacingly. But, for his part, the youth takes
this as an invitation for great fun. In fact, he passes the time bowling,
and the next morning he dutifully receives his prize, the princess's hand.
"Seen clearly," Boxsel writes, "life without hope is hell, but Hell without
fear is a fairground attraction" (80).

In *Lebowski*, the puncturing works on the order of *MAD* magazine's
"Snappy Answers to Stupid Questions" (*It's down there somewhere. Let
me take another look. . . . I'm just gonna find a cash machine. . . . That and a
pair* of *testicles*). Or, what Nicholas Royle, in another context, has called
witsnapping, an idea of wordplay that Royle says comes from "before the
pun" (thinking of Beckett's Murphy who says, "[i]n the beginning was
the pun") (14). For Royle, witsnapping underscores a certain quickness:
a sense that "we can never read [. . .] quick enough, and never speak or
write [. . .] quick enough either" (19). Against all odds, it's the Dude's
quickness above all that bears re-watching. He cracks wise as an anti-
dote to gas-bag grandstanding on the level of language, i.e., words, and

to noxious posture on the level of style, i.e., things. In so many words, the crack means talking back to what Boxsel calls "the ever-startling landscape of stupidity" without flinching, "not by breaking taboos, but by driving home the mystifications involved" (13, 28). In a famous passage from his letters, John Keats writes:

> I had not a dispute but a disquisition with Dilke, on various subjects; several things dovetailed in my mind, & at once it struck me, what quality went to form a Man of Achievement especially in literature & which Shakespeare possessed so enormously—I mean Negative Capability, that is when man is capable of being in uncertainties, Mysteries, doubts without any irritable reaching after fact & reason. (277)

The Dude's negative capability to be in *"uncertainties, Mysteries, doubts without any irritable reaching after fact & reason* about language and style—in short, his "stupidity of intelligence," in Boxsel's phrase—is what makes him a man of achievement. When irritated—by rug-peers, nihilists, his namesake—he's, *pace* Walter, never, never ever un-Dude.

Ever thus from the landscape of stupidity to the fairground. As may be expected, the beginnings of the *Lebowski* cult—the narrative origins of any collectivity—are shrouded in mystery, thriving elsewhere in multiple viewings, late-night campus screenings, recitations of catchphrases, drinking games, and theme parties. Somewhere right now, someone's watching *Lebowski*. Most likely, there's a campus screening being held tonight. The cult and the fest may not be identical, but you'd be forgiven for thinking so. Indeed, the distinction is between *Lebowski* as religion and *Lebowski* as high church. Lebowski Fest is—well, it makes no secret of this—a *Lebowski*-themed Fest. Since 2002, it has been held annually over a weekend in Louisville, Kentucky, and since 2004, the event has been replicated by its creatures in other locations: Las Vegas, New York, Los Angeles, Austin, Seattle, London, Edinburgh,

Despite efforts to festivalize **Lebowski** *in sundry ways, there remain essentially two behaviors central to the cult: catchphrases and dressing up. We'd argue that both have less to do with identification than achievements in citation.*

and, most likely, judging by the industriousness of its organizers, coming soon to a city near you. It all began, in essence, as a one-off, tongue-in-cheek party held by Will Russell and Scott Shuffitt "for their friends" in a local Louisville bowling alley. Pop-cultural dousers, these enterprising hipsters correctly sensed that they had tapped a deep well of fan attachment, press-ganged a graphic designer, Bill Green, and a web-guy, Ben Peskoe, and the rest, as the fella Francis Fukuyama says, is the End of History.

What else is the appeal of the Dude to these achievers if not as Nietzsche's Last Man, who takes no risks and seeks only calm, safety, and unspoiled half-and-half? Decamping from the harsh climates and causes of significance, the Last Man pursues the minor pleasures of the body above all else:

> One still works, for work is a form of entertainment. But one is careful that lest the entertainment be too harrowing. One no longer becomes poor or rich: both require too much exertion. Who still wants to rule? Who obey? Both require too much exertion. (Nietzsche 130)

The entertainments of the Fest include lots of what nihilist and non-nihilist alike would call *making mit de funny stuff.* As the Fest's website explain things, it is

> a bowling event celebrating all things relating to the Coen Brothers 1998 film, *The Big Lebowski.* It can be likened to a Star Trek convention in a very loose sense. The event takes place at a bowling alley

and includes unlimited bowling, costume, trivia, farthest traveled, and bowling contests, prizes, and what-have-you. The friend of the Coen Brothers who inspired the main character played by Jeff Bridges, Jeff "The Dude" Dowd has been known to make an appearance and drink some White Russians. (Lebowskifest.com)

Live music; Lebowski-inspired costume, physical, and trivia contests; carnival games (ringer tossing, marmot flinging); a participatory public screening of the film in the vein of *Rocky Horror Picture Show;* special appearances by participants in the film—Liam is a regular, for example; and, perhaps most importantly, endless bowling and bottomless plastic cups of cheap, White Russians. The natural history of leisure leads from the carnival or funfair to the amusement park to the superlative theme park. Beyond this passage we see a summit built around the dream of total or permanent play. Above the tree line, you'll find Coen Country, Cockaigne, the Big Rock Candy Mountain, Pleasure Island, continuous parades, fireworks every night, and Lebowski Fest's quest for everything *Lebowski* celebrated in the same mildly terrifying totalized way as enshrined in a Death-by-Chocolate dessert course or Dollywood at Defcon 5. Hell without fear, Boxsel says.

Where will it all end? How much longer before mission fatigue and market saturation set in and give us *Lebowski* overkill? Will the Lebowski Fest of the future achieve the scale of, say, the Kentucky Derby? In early spring, a Maude and a Dude and a court of Busby Berkeley Pinettes are selected. This Royal Court in their damn undies attends official Achiever functions across the globe. The festival's first major event, rated one of the top one hundred events in North America, is one of largest fireworks displays in the country, Magic Carpet Ride Over Louisville. Magic Carpet Day, as it's called, begins with the Blue Angels performing their show of military hardware in the skies for hours for

the throngs of achievers crowding the banks of the Ohio River, viewing from inside the city's skyscrapers and from many barques anchored in the river's current. When night falls, Magic Carpet begins and the crowd's long hours of waiting are rewarded. For thirty spectacular minutes the greatest hits of CCR boom in synchronization to rolling waves of fireworks exploding and cascading in the sky like pins in a neon-lit alley and reflected in the ripples in the river below. Events of Fest Day proper vary year to year according to corporate sponsorship, but always include unlimited bowling, numerous carnival-style activities, concerts, costume shows, private backyard White Russian tastings, and lavish tiki trampoline parties attended by entertainment stars, political activists, Jeff Dowd, the actors who played Liam and the check-out girl at Ralph's, and other persons of note. Lighthearted and laugh-inspiring events are also a feature of the festival, such as the Great Coital Bed Races in which local company–sponsored employees in Maude and Dude costumes push beds around a race track, competing for prizes, and the Jesus Jam Toss in which local kiddos of promise gather sponsors door-to-door to compete for scholarship funds. Recognition is given to Louisville's hardworking bowling venue employees with the Saddam-a-Thon. Bowling center employees costumed as the Butcher of Baghdad run an obstacle course carrying stacks of bowling shoes. Servers finishing with the best time win prizes. *If you will it, it is no dream.*

Despite efforts to festivalize *Lebowski* in sundry ways, there remain essentially two behaviors central to the cult: catchphrases and dressing up. We'd argue that both have less to do with identification than achievements in citation. When two achievers meet formally or informally, one way they "talk Lebowski" is by performing a seemingly endless procession of quotations from the film. One hears astounding quanta of quotage at *Lebowski* gatherings, and it would not be an exaggeration to say that the bulk of the text is continuously being recited by

its adherents, re-creating the film in non-sequential quotations, looped in infinitely various, ad hoc, haphazard, and piecemeal permutations. In this vein, Rob Thomas, auteur of the short-lived television series *Veronica Mars,* once revealed an intention to smuggle the entire *Lebowski* script line-by-line onto his show like the auto worker's "Psycho-Billy Cadillac" in Johnny Cash's "One Piece at a Time":

> One day I devised myself a plan
> That should be the envy of most any man
> I'd sneak it out of there in a lunch box in my hand. (Thomas)

In this way, after the final credits roll, *Lebowski* is constantly being dismantled, smuggled into various settings, and rebuilt from the floor up by the achievers. The whole film in, the whole film out—by lunch pail. It's not unusual to overhear achievers regurgitating, with aplomb, any of following lines:

> If you will it, it is no dream.
> You brought a fucking Pomeranian bowling?
> I didn't rent it shoes. I'm not buying it a fucking beer.
> He's not gonna take your fucking turn, Dude.
> Fucking dog has papers, Dude.
> Over the line, Smokey!
> Eight, Dude.
> Mark it zero.
> This is not Nam. This is bowling. There are rules.
> Am I wrong?
> Am I wrong!?
> You're entering a world of pain.
> Look Dude, I don't hold with this.
> HAS THE WHOLE WORLD GONE CRAZY? AM I THE ONLY ONE
> HERE WHO GIVES A SHIT ABOUT THE RULES? MARK IT ZERO!

Walter, they're calling the cops, put the piece away.
You happy, you crazy fuck?
This is a league game, Smokey!

As this inventory suggests, achievers refuse to limit themselves to the Coens' most pithy utterances, but retrieve lines wholesale from multiple viewings as if pulling pieces from a large puzzle box. Extra points are awarded for a particularly apt application of a line, but any ejaculation will do in a pinch. The textual form for this ad hoc theater—its play script, as it were—is written on bumper stickers.

At the Fest, we've seen achievers come costumed as Dudes, Walters, Strangers, Maudes, Jesuses, complimented, to a lesser but always welcomed extent, by the occasional appearance of Treehorns, old man Lebowskis, Busby Berkeley dancers, Bunnys, Donnys, Brandts, Karl Hunguses. Marty, in either his

*Lebowski cultists are too conventional to suffer **for** expression, but lazy enough to suffer **by** it. They are not interested in the pains of meaning, but the pains of mattering*

"jack-in-the-beanstalk" get-up (as one achiever put it) or his courtyard Adidas gear, is a choice rarity. But, where's the Knox Harrington? the Woo? the Pilar? The founding dudes claim that the costumery is critical to the logic of identification that they believe underlies *Lebowski's* appeal. *I'm a Lebowski, You're a Lebowski,* the title of their book, sums it up. Concerning the surfeit of Walter costumes at Lebowski Fests, John Goodman remarks: "Well, yeah, I bet there are a lot of fat guys out there" (B. Green et al. 34).

The most sublime achievements in Lebowski drag, though, have little to do with character identification. The greatest costumes concern the props—the Dude's joint, say—or, perhaps better still, the quotations themselves: a peed-on carpet, a housebroken marmot, bowling pins, Larry's homework, a Folgers can, a pope in the woods, a suit covered with Lincoln Logs and jam packets, some Chinaman who took Lebowski's legs in Korea, a little Lebowski on the way.

The state-of-the-art theory of cult film—such as it is—focuses on camp, costuming, and the carnivalesque. *The Wizard Of Oz, The Rocky Horror Picture Show, Pink Flamingoes*—these films sanction identification by exaggerating the play of identification, opening a space of performed fantasy that is at once remarkably silly and sincere. *Lebowski*-ing is both less giddy and less earnest, a slightly slacker, hipst*er* version of

0.5. Danger Mouse and Cee-Lo, promotional photo for *St. Elsewhere* (2006). Courtesy Cornerstone Promotion.

an otherwise queer *detournment,* claiming little of the latter's political edge. Lebowski fans dress down as they dress up. They over do it as they underdo it. Costumes are at once ridiculous and cheap, too much and too little, attentive to all the wrong details, artlessly artfully artless. And yet, we find a certain critique—or at least productive annoyance—here as well. Lebowski cultists are too conventional to suffer *for* expression, but lazy enough to suffer *by* it. They are not interested in the pains of meaning, but the pains of mattering—a burden of the square community, it can't be helped, but one that cuts to the heart of fan culture as such. For here, it is *ethos* rather than *demos* that is at stake, and the

likes of Dude, Walter, Donnie, and the Jesus become objects of *affection* rather than *significance*. Citation is not merely a form of mimicry, but an expression of affection—an excessive, compulsive mode, for sure, but this excess cuts to the core of all fanaticism. Donny's (alleged) surfing exploits, the Dude's bowling tapes, Walter's Vietnam, Maude's record collection, the nihilists' nihilism: fan culture is essentially tautological, not only because all pop culture is cheap and empty, but because all pop culture is cheap and empty.

Unlike the consumer, who relates to pop culture first in terms of desire and thus acquisition, the fan approaches its object with an "affective sensibility," seeking it out as a means of "investment," as a way of organizing and thus establishing a certain mode of mattering in opposition to other available models (Grossberg 55–57). This model depends upon a theory of affect as a kind of embodied judgment, at once corporeal and ideational, sensory as well as structured, capable of generating and sustaining significant differences. Such affect exceeds the ego on both sides, as it seems to operate on the level of sensation as well as value and judgment. It is open rather than closed, mediatory rather than acquisitive, full rather than empty. It is a pervasive mode or mood rather than a system of presence and absence, frustration and satisfaction. Affect is a form of communication, a way of reading, but it is more open and more immediate—perhaps even dumb, insofar as it lacks a coherent language system. Affect "reads," but not in terms of significance; it is attuned to the mute markers of daily life—fashion, music, taste—but each as a message that even an idiot can read—especially, an idiot.

In another sense, fans are like academics that fare better in PR terms. Like academics, they take their stuff way too seriously for mainstream tastes. Overfed on the hypothetical and the theoretical, fans thrive in an environment where time is wasted on arcane codes about arcane materials, where no one is really expected to produce immediate

or practical results (just theories, annotations, research), and where negligible promise for business almost counts as a virtue. In fact, what amateurs are to professionals, forever putting messy affective relationships before disciplined and disinterested practice, fans are to academics. Walter's preternatural hostility to amateurs (worse than Nazis and nihilists, it seems) manifests a wish to conceal this fact. In this way, fans could be understood as underachieving academics, which may well put them in the running for the laziest consumer group worldwide. A tip-off to the general kinship lies in the *what the fella says* routine of the Stranger. *Which "fella" was that, anyway, Stranger, who said "he ain't never seen no queen in her damn undies?"* It's a citation that obviously won't cut it in peer review. In a sense, the Stranger's role is to underscore the film's combinational critical agenda about the shared American genome of the detective and western genres. But he's also the most important model of fan behavior in a film that repeatedly models excessive, knowingly nerdy styles of fan affiliation, from Walter's preternatural mastery of the oeuvre of iron lung-encased, TV penman Arthur Digby Sellers to the Unitarian record tastes exhibited in Maude's collection.

If the Dude appeals as the "creature who reportedly emerges at the end of history," then the Stranger is the Last Man's critic and fan—in short, the academic. He provides a Marlow to the Dude's Lord Jim, a proxy for the Archimedean predicament of the critic-philosopher at a juncture of historical extremity and semiotic overload (Fukuyama 300). He just points at something innerestin' and gently nods:

> Way out west there was this fella, fella I want to tell you about, fella by the name of Jeff Lebowski. At least, that was the handle his lovin' parents gave him, but he never had much use for it himself. This Lebowski, he called himself the Dude. Now, Dude, that's a name no one would self-apply where I come from. But

then there was a lot about the Dude that didn't make a whole lot
of sense to me. And a lot about where he lived, like-wise. But then
again, maybe that's why I found the place so durned interestin'.

Nothing forced, nothing claimed, little waged and less gained. Just one
fella pointing at another fella. The routine links, however dimly, the
ethical framework provided by the Stranger to the communal ethos
of academia at its most minimal expression. In academic practice, a
similar canon of attribution—citation, quotation, allusion, annota-
tion, footnotes—not only stands us on the shoulder of giants, but also
blazes the chemical trails for the ants to follow. Citation may be a sign
of threadbare communal life, but it depends on shared effort in notori-
ously slow and unpaid brain work, and, more often than not, it points us,
as a community, in innerestin' directions. In this meager way, it remains
an achievement of another sort.

As a comparison, the detective Da Fino—the refugee from the
other genre tradition, noir—obviously misses the point when he tells
the Dude that he digs his *work:* "Playing one side against the other—in
bed with everybody—fabulous stuff, man." Following through on Da
Fino's interpretation confers the Dude with a strong case of *sprezzatura,*
the artful concealment of artifice, and suggests a strong method to the
Dude's weak meanderings, paradigmatically elicited in the tough white-
guy tradition. Yet, Da Fino is so obviously out of his element in his as-
sessment that the Dude, the very subject to bodily abuse, quite literally
beats him back. Imagining an employable Dude not only over-estimates
his competencies but it also seriously offends him: this is what the Dude
minds. And, as little as his fat-cat namesake thinks of his competency,
he too overestimates the Dude. Even as a patsy he fails. The Dude really
just wants his rug back, to go bowling, etc.—achievements of a differ-
ent sort, recognizable by a different sort. The parable of *Lebowski,* then,

leads to two doors: one leads to the achiever; the other, to the Stranger, and, to put the point on it, it's the latter in which we're most interested in the *Year's Work,* namely, the path that leads us to the intellectual as stranger, in Dick Pels's phrase, the critic of an exhausted culture, speaking without much force as a publicist and "privileged nomad" on behalf of the last schlemiel. *Vee do things you only dreamed of, Lebowski.*

Who Ordered the Hi-Fi Pizza?

We hope you'll find this *Year's Work* as conspicuously slack and idiosyncratic as we do. As editors, we're throwing the spotlight on a collection of academic essays that take many of their cues from Lebowski rather than, say, the likes of Brooks or Bloom or Butler. Or, maybe, the essays just sound something like those other critics, but are peppered with a fuck of a lot more profanity. We think you'll share our interest in connections made, theories concocted, arguments waged outside the usual academic cubicles. These essays work ringer-style, throwing Coen-inspired thinking at contemporary culture to see what sort of analyses might develop. In this, we're not pretending to touch the philosopher's stone. We didn't want to touch Walter's whites either. From the start, we've been more interested in work concerned with entertaining possibilities than following predetermined rules, difficulty for its own sake, or, if you will, the rhetoric of challenges met, competitors bested, obstacles overcome.

Here you go, then: twenty-one essays by a group of people who not only take comfort that the Dude's out there, but who also take comfort in cogitating about our world and the place of everything *Lebowski* in it. Some of the contributors are indeed credentialed professors. Some met for an academic symposium of sorts in a Louisville bowling alley as part of an earlier Lebowski Fest—hashing out preliminary versions of

this work, enjoying a beverage or two, and, generally speaking, enjoying themselves. The essays that we—*you know, the editorial we*—have collected in this *Year's Work* cover all of the big issues—noir, bowling, masculinity, the Jesus, war, aggression. But we also asked contributors to track down some of the smaller *Lebowski* items—the iron lung, the White Russian, the Pomeranian, the rug, the tumbleweed. Most of the essays, though, are rambunctious, if not unruly, following their own leads past the boys down at the Crime Lab and across multiple frontiers in genres and styles and histories and theories and issues. In terms of the collection's structure, we decided to tread lightly, arranging the essays into two suggestive clusters—*Ins* and *Outs*. The first section deals with all that went into the film—the bits and pieces of history, politics, tradition, and culture that the film spins and splices into something like its own giddy DNA. The second section takes us out of the film and explores the habits and practices that surround its reception—common cultural practices such as bowling and drinking and coitus, but also more *Lebowski*-specific behaviors and fan cultures. Really, though, each chapter could appear in any either section of the book, and each has multiple connections to the whole. You can read *The Year's Work* cover to cover or leap around from chapter to chapter, even page to page. Use it like the secret menu at the In-N-Out Burger. Inhabit it like the Dude's brain, or his bungalow—explore, rearrange, earmark it in random places and then display it for visitors on the coffee table. Or treat it like the Dude's rug—relax on it, piss on it, roll it up and smoke it, get lost in the patterns, think about tying it all together in its absence.

In one memorable bit in *Eightball,* Dan Clowes's long-running alternative comix miscellany, two strangely garbed dudes, plainly standing at the end of history (a mushroom cloud explodes over skyscrapers in the background) contemplate a Hi-Fi pizza. "In the Future," reads the voice-over, "nothing new will be created. Old ideas will simply be

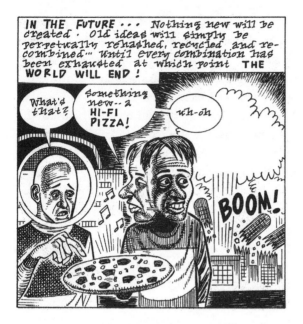

0.6. Dan Clowes on "The Future," *Eightball* (October 4, 1990).

perpetually rehashed, recycled and recombined—until every combination has been exhausted at which point THE WORLD WILL END!"

This joke, in certain terms, comes from a place both beyond modernism—with its insistence on new stuff—and beyond postmodernism—with its discovery of pastiche as the new new stuff. The connection to *Lebowski* and the interpretive predicament it occasions couldn't be more apt. Even if it feels like there's nothing new in it, or that everything in it just recycles something old, what matters here is the additional, almost superfluous feeling that there's nothing new new left and how that—*uh-oh*—stirs the embers of curiosity. After everything's been recycled, rehashed, and recombined, it goes on. Indeed, everything *has* been said before. Yet, more than ever, the conversation concerning what it means—the *what's that?*—is urgently up for grabs. Ours is a rather

forced method of getting at that question by pointing both at the object of our fascination and at the strangely glowing horizon. Like Benjamin's angel of history, or merely the pizza guy pulling out of the driveway, we move forward by looking back at catastrophe. *Sorry we knocked over your flowers, ma'am, but we got more deliveries to make.*

Overall, the contributors to this *Year's Work* follow this model through their openness to the many different things that you can say and do with academic criticism. By and large, as presented here, they model innerestin' patterns, cunning passages between disparate fields and phenomena, and proclaim, overall, not necessarily the truth of academic achievements, but their abiding need and deep pleasures.

So, what is a Lebowski, anyway?

Ins

(Intrinsic Models and Influences)

The Really Big Sleep:
Jeffrey Lebowski as the Second
Coming of Rip Van Winkle

Fred Ashe

At the conclusion of the Coen brothers' 1998 film *The Big Lebowski,* the tale's frame narrator, the Stranger, asserts, "It's good knowin' he's out there, the Dude, takin' her easy for all us sinners." Most manifestly, Jeffrey "the Dude" Lebowski fits into the Jewish folk tradition of the schlemiel—the bumbling, charismatic character *to whom things happen.*[1] Like the classical fool, the schlemiel's "antirational bias," as Ruth R. Wisse has written, "inverts the rational model underlying so much of English humor, substituting for it a messianic or idealist model instead" (51). The Dude's bias is directed foremost against *effort.* Things happen to him because he is not the sort to make things happen, his priority being instead the stylish avoidance of societal expectations—employment, marriage, even hygiene—that might interfere with "takin' her easy." By placing this avoidance in the service of "all us sinners," the Stranger explicitly figures the Dude as messianic. The Dude stands in for viewers who, on some level, would likewise like to forego responsibilities; he redeems our often-soulless bourgeois striving with his compelling, carefree sloth.

Given the American Western flavor of the movie's frame tale, the Dude arguably serves as a *national* savior. Indeed, *The Big Lebowski* grafts the schlemiel template onto a classic American narrative tradition that has always countered the more mainstream rags-to-riches story, or, as the wheelchair-bound tycoon for whom the Dude has been mistaken

A strain of the American psyche has always sought deliverance from duty, and a subset of our fictions have always offered us vicarious identification with appealing characters who find a way to "do nothing with impunity." In this role, Jeffrey "the Dude" Lebowski resurrects Rip Van Winkle.

would have it, the *achiever* story. Eschewing the effort required to obtain riches, a number of American heroes have remained perfectly satisfied with their rags. In this respect, *The Big Lebowski* reprises the classic American monomyth that Leslie Fiedler delineated in his 1960 study *Love and Death in the American Novel:* the perpetual-adolescent male evasion, via masculine companionship and determined leisure, of structured work and marriage and adult responsibility.[2] Fiedler finds an ageless American credo in Huck Finn's valedictory comment, "But I reckon I got to light out for the Territory ahead of the rest, because Aunt Sally she's going to adopt me and sivilize me and I can't stand it" (Clemens 229).

As Fiedler points out, this tradition originates with Rip Van Winkle, slacker hero of Washington Irving's 1819 short story of the same name. Rip is a beloved figure among the women and children in his neighborhood, primarily for the friendly charisma that comes with his "insuperable aversion to all kinds of profitable labour" (450). His dictatorial wife, on the other hand, incarnates stern domestic obligation. In one of Rip's periodic escapes from her into the wilderness that borders his village, he encounters a dreamlike band of Dutchmen playing ninepins and drinking a liquor that puts Rip to sleep for twenty years. His awakening is treated as a rebirth. He returns to a village completely changed by the American Revolution, finds his identity at first doubted by the new generation of townspeople, learns that his wife has died, and is ultimately

accepted and even "reverenced" by the village. Having reached "that happy age when a man can do nothing with impunity," Rip becomes an admired and envied surrogate for those bogged down by real-world responsibilities. The story ends with a reference to the gin that precipitated Rip's sleep: "it is a common wish of all

Both Rip and the Dude must suffer the slings of a Franklinian culture that tries to demand striving and achievement, a demand most forcefully embodied in Dame Van Winkle and the Big Lebowski, respectively.

henpecked husbands in the neighborhood, when life hangs heavy on their hands, that they might have a quieting draught out of Rip Van Winkle's flagon" (459).

A strain of the American psyche has always sought deliverance from duty, and a subset of our fictions have always offered us vicarious identification with appealing characters who find a way to "do nothing with impunity." In this role, Jeffrey "the Dude" Lebowski resurrects Rip Van Winkle. In their comic ineptitude, both serve a critical function, exposing the sickness of a straight society premised on the Puritan work ethic—on the equation of self-realization with material accumulation and public accolade. More to the point, though, they provide simple and abiding wish fulfillment. In doing so, they address an underlying American concern as well, working to relieve our nagging fear that we are inextricably bound up in this system. To identify with the slacker hero is to deny, if only imaginatively, our complicity in the dehumanizing world of consumption and competition.

That world has become only more inhuman over the past two hundred years, and the early-1990s Los Angeles setting of *The Big Lebowski* reflects this in a way that Irving's relatively benign colonial upstate New York tale cannot. The Coens move beyond Irving in the way they tell

their story as well. Both are frame tales, introduced and concluded by colorful narrators who stand outside the action. Irving's narrator playfully overprotests his tale's status as a true story, and in doing so he exposes the frame, gently undercutting our willing suspension of disbelief.[3] *The Big Lebowski,* however, in its celebrated collision of genres and the ultimate incoherence of its plot, completely, comically *shatters* its frame. More than "Rip Van Winkle," then, the Coens' text enacts formally what its hero accomplishes on the level of content. On both levels, *The Big Lebowski* offers us an imaginative redemption from the cultural, structural imperatives that work to constrain us.

In his 2006 book *Doing Nothing: A History of Loafers, Loungers, Slackers, and Bums in America,* Tom Lutz reveals the continuing relevance of "Rip Van Winkle." In a study that treats Irving's story in some detail and traces the idle-hero archetype up through contemporary film—*Slacker, Clerks, Wayne's World, Office Space,* and, briefly, *The Big Lebowski*—Lutz explains, "From the slacker perspective . . . the classic work ethic . . . is a kind of emotional derangement, and loafing is the cure" (25). He points to Benjamin Franklin as the "invent[or] of the work ethic as we know it," and calls Rip Van Winkle "the anti-Franklin" (58, 101). Forty-odd years before Lutz, Leslie Fiedler formulated Rip's influence thus:

> The figure of Rip Van Winkle presides over the birth of the
> American imagination; and it is fitting that our first success-
> ful homegrown legend should memorialize, however playfully,
> the flight of the dreamer from the shrew—into the mountains
> and out of time, away from the drab duties of home and town to-
> ward the good companions and the magic keg of beer. (xx)

With minor adjustments, Fiedler could be talking about the Dude here. In their respective flights from duty and "time," Rip and the Dude share a remarkable number of similarities. In Irving's case, of course, Rip's

primary avenue of escape is extended sleep. Both slacker and proto-schlemiel, Rip does not seek out this sleep; it is visited on him by way of the drink he sneaks from the Dutchmen's mysterious keg of gin. In other hands, such a serious lapse in consciousness might come off as a little dark. The text most often referenced as the Coens' touchstone for *The Big Lebowski* famously uses "the big sleep" as a euphemism for death. When his former boss tells detective Philip Marlowe that maybe noth-ing can spare Marlowe's client from grief "except dying," Marlowe con-curs, "Yeah—the big sleep. That'll cure his grief" (Faulkner, Brackett, and Furthman 86). By contrast, Rip's big sleep is a rest cure. While he is out, Rip's domestic and foreign entanglements—a hyper-restrictive marriage and British colonial rule—neatly resolve themselves. And, un-like the fate envisioned for Marlowe's client, Rip is allowed to wake up and enjoy a grief-free second childhood.

The Coen brothers' treatment of the motif is, like Irving's, tongue in cheek. In his book *The Big Lebowski: The Making of a Coen Brothers Film,* William Preston Robertson quotes Ethan Coen as saying their movie "affects to be noir, but, in fact, it's a happy movie. It's a comedy." It is in this spirit that Ethan responds to a question about his and Joel's writing process: "'Well, you know,' he shrugs. 'We sleep a lot'" (98–99, 47). Although we never see the Dude actually sleeping, we do see him relaxing deeply, for instance, in his candle-lit bathtub and prone on the rug he has lifted from the big Lebowski's mansion. Twice he is rendered unconscious, once from a slapstick blow to the head and the other time, à la Rip Van Winkle, from a comically doctored drink. The Coens use both occasions to introduce extended dream sequences in which the Dude plays out his anxieties over the things that are threatening his freedom—Maude Lebowski's manipulations, castrating nihilists, what have you. Even these anxieties are presented humorously, though, and in the end the Dude survives his surreal ordeal and resumes a carefree

1.1. The Dude pursues his ease.

life at the local lanes. Like Rip's, the Dude's big sleep is temporary and serves mainly to transport him through to the less stressful existence he is accustomed to. As viewers, we are as drawn to the Dude's spots out of time as "the henpecked husbands in the neighborhood" are to "Rip Van Winkle's flagon."

In classic American fashion, the two protagonists pursue their ease geographically as well as temporally. Irving's narrator, Diedrich Knickerbocker (a figure every bit as quirky as the Stranger), situates his action at the foot of the Kaatskills, "away to the west" of the Hudson River. Although Rip resides there in a "village of great antiquity" (449), at the time of the story this represents the edge of the American frontier. As a man happy to "eat white bread or brown, which ever can be got with least thought or trouble" (451), Rip invokes the mythic American

pattern of westward movement away from the domestic power centers of the East, toward dreams of easy money or, in his case, simply ease. Significantly, when Rip wishes to escape the "petticoat government" of Dame Van Winkle's home, he heads further west into the forested Kaatskills.

The Coens' westward theme is more obvious. The Western, as a literary and film genre, is clearly invoked in the movie's first words as the Stranger drawls, "Way out west there was a fella," voiced over the Sons of the Pioneers' version of "Tumbling Tumbleweed" and a shot of a large spherical tumbleweed being blown across desert. The scene shifts as the floating cinematic perspective, in the script's words, "top[s] the rise" to reveal "the smoggy vastness of Los Angeles at twilight," and we follow the tumbleweed through empty, night-time city streets and finally across the beach to the Pacific, the early-morning mountains of the California coast silhouetted in the background. The tumbleweed reaches the shore and then turns right to blow upward along the coast. Though geographically this would be north, the camera pans so as to place the mountains, like Rip's Kaatskills, still to the viewer's left— the west—of the shoreline. In fact, however, the Dude has no further west to go. Los Angeles serves as the terminus for Frederick Jackson Turner's frontier thesis from a century earlier, wherein the closing of the American frontier presages the end of individual autonomy as a primary feature of American life. Whereas Rip can escape into the woods, the Dude remains trapped in the massive electrical L.A. grid that the film's opening sequence lingers on.

Within that grid, though, the Dude is every bit as directionless as Rip Van Winkle, as signaled in the last refrain of the opening song: "Here on the range is where I belong / Tumbling along with the tumbling tumbleweed." It is their mutual indolence that most clearly unites

the two figures as American role models, the Dude reincarnating what Fiedler calls Rip's "scapegrace charm" (333). In Irving's story, Rip is introduced as "one of those happy mortals, of foolish, well-oiled dispositions, who take the world easy" (451). For the Dude, these are words to live by: when he reprimands Walter for drawing a gun on an opponent during league play, pleading "just take it easy," Walter responds, "That's your answer to everything, Dude." Rip, we are told, has "an insuperable aversion to all kinds of profitable labour" (450). The Dude can relate. Though he tells Maude Lebowski his "career's, uh, slowed down a bit lately," he admits to the cops investigating his stolen briefcase that he is unemployed, and we are given no indication throughout the movie that he seeks to alter that status. Irving's Knickerbocker tells us, "if left to himself, [Rip] would have whistled his life away, in perfect contentment; but his wife kept dinning in his ears about his idleness, his carelessness" (451). The Coens' script first introduces the Dude as "a man in whom casualness runs deep," and the Stranger famously "plac[es] him high in the runnin' for laziest [man] worldwide."

As mentioned, in Fiedler's formulation the hero is always a man, always fleeing the responsibilities most directly associated with mature romantic relationships. Yet if Rip and the Dude are not lovers, neither are they fighters. That these particular protagonists' lack of conventional drive equates to a lack of masculine aggression is thrown into relief by the American wars that serve as the backdrop for the two stories. Rip, who "inherited . . . but little of the martial character of his ancestors" (450), sleeps right through the American Revolution. He shifts seamlessly from "loyal subject of" George the Third to citizen in the republic presided over by George Washington (457). Aggression is likewise lacking from the Dude's cosmos. He provokes Walter's derision by proclaiming his pacifism, but he seems unfazed by the Gulf War, a backdrop which all but drops out of the film after an early sequence

depicting a televised George the First aggressively denouncing Iraqi aggression against Kuwait. Despite his professed past of "breaking into the ROTC" and helping pen the uncompromising *original* draft of the Port Huron Statement, the Dude avoids physical confrontations and ignores current events. In this he resembles Rip, of whom we are told, he "was no politician; the changes of states and empires made but little impression on him" (459). The wars in both texts come off as inconsequential and serve primarily to highlight the thematic war between aggressive American striving and passive American slacking. And though the achiever Lebowski insists that the deadbeat Lebowski's "revolution is over" and that "the bums will always lose," it is peaceful idling that prevails in the value systems of these two fictions.

Rip does, the narrative tells us, chafe under one type of government, and that is the domestic despotism of marriage. Women are often the enemy in Fiedler's classic American fiction, and feminist readers such as Judith Fetterly have identified "Rip Van Winkle" as a primary offender. Irving via Knickerbocker does more telling than showing in his characterization of Rip's wife Dame Van Winkle, calling her a "shrew," a "virago," and, twice, "termagant," and making no fewer than seven references to her sharp scolding tongue in the story's first two pages (450–52). Though not "routed" into the woods by a domineering wife, the Dude is equally allergic to domestic partnership, demanding of Jackie Treehorn's rug-pissing thugs at the movie's outset, "Does this place look like I'm fucking married? The toilet seat's up, man!" Walter reminds us that the Dude "do[es]n't have an ex" either. As the Dude's primary partner, Walter brings Knickerbocker's misogyny into the modern era, referring to Bunny Lebowski (whom he has never met) as "that fucking strumpet . . . this fucking whore. . . ." Fiedler claims that American novelists tend to exclude any "full-fledged, mature women" from their fictions, opting "instead [for] monsters of virtue or bitchery,

symbols of the rejection or fear of sexuality" (xix). A film whose two most substantial female characters are Maude and Bunny Lebowski would not seem to challenge that criterion.

Evidence of the Dude's dread of spousal responsibility climaxes just after his only sexual encounter of the film. When Maude explains to him that her yoga-like contortions on the bed are meant to *increase* her chances of conception, the Dude, now standing at the bar, sprays his suggestive-looking White Russian halfway across the room, stammering, "yeah, but, let me explain something about the Dude." He is clearly unwilling to accept the duties of fatherhood at the expense of his preferred pastime of drinking and bowling with his buddies.

It is a pastime directly prefigured in Rip's woodland encounter with the strange Dutchmen. Indeed, perhaps the most amusing connection between Rip Van Winkle and Jeffrey Lebowski is that they are both bowlers. The bowling alley is, of course, a primary setting for *The Big Lebowski,* providing a visual and sonic palette for much of the film's design. (The motif of pins scattering serves a symbolic function as well, as the Dude spends much of the movie in the schlemiel role, passively knocked about by external forces.) The Coens chose bowling as the context for the Dude and Walter's friendship in part, Ethan explains, because "it's a decidedly male sport" (Robertson 44). As a sport, bowling provides this masculine camaraderie while demanding minimal exertion or sobriety, perfect for the American slacker hero. The Dude is serious about league play, however. Rip notices the same thing about the "odd-looking personages playing at nine-pins" to whom he is delivered by a keg-carrying stranger. All male—"they all had beards, of various shapes and colors"—the bowlers "maintained the gravest faces, the most mysterious silence" in their play. And they are just as committed to their drinking. Rip, "naturally a thirsty soul," is made to "wait upon the company" before availing himself of their store of "excellent

Hollands" (Irving 453–54). The Dude's preferred beverage, the White Russian, may conjure the other end of Europe, but is an equally important accoutrement of the laid-back life.

The two stories use identical aural imagery in connection with bowling. As the perplexed Rip assists the stranger in carrying his keg up a mountain gully, he hears "long rolling peals, like distant thunder . . . toward which their rugged path conducted" (453). Again, when the two arrive at the amphitheater of ninepins, the silent scene is broken only by "the noise of the balls, which, whenever they were rolled, echoed along the mountains like rumbling peals of thunder" (454). This is the last sound we hear before Rip slips into his long hibernation. Likewise, the Dude's first dream sequence begins with him lying on the big Lebowski's rug, relaxing beneath his walkman to the sounds of the "VENICE BEACH LEAGUE PLAYOFFS 1987." We hear "a ball rumbling down the lane," and as it clatters against the pins, he opens his eyes to see, looming above him, Maude and her henchmen, one of whom whaps him on the head with a sap. This sends the Dude into surreal flight over Los Angeles, Superman style. Dream logic then places a bowling ball in his hand; the ball "suddenly assume[s] its own weight"; and as he plunges downward, the script says, "we hear a distant rumble, like thunder."

Fittingly, the sound of thunder portends the closest thing to a dark night of the soul faced by either of these comic protagonists. Technically, it is the second dream sequence, launched when the Dude's face slams against Jackie Treehorn's coffee table, which the Stranger introduces with the words "Darkness warshed over the Dude—darker'n a black steer's tookus on a moonless prairie night. There was no bottom." This dream, built like the first around bowling, ends with the Dude in flight from antagonists wielding giant scissors, and is followed upon his waking by the least motivated attacks of the film, by the Malibu police chief ("a real fascist") and an angry cabdriver who turns out to be a

1.2. Rip steps up to the line, from Sam Loyd, *Cyclopedia of 5000 Puzzles, Tricks, and Conundrums* (1914).

staunch defender of the Eagles. The Dude's dark night culminates in his friend Donny's death.

The scissor-bearers from the Dude's dream, of course, are the nihilists who, seeking ransom money for another man's wife, have already threatened to cut off the Dude's johnson. If the Coens are setting these kidnappers' absurdly rendered nihilism in opposition to anything, it would have to be a classic American brand of existentialism. The Dude drifts through life guided by no personal code more tangible than the desire to live free of care. He rejects such traditional markers of American self-hood as family, career, religion, even his given name. The film's

plot is constructed around a mistaken identity—in essence, Bunny Lebowski's kidnappers "got the wrong guy." As Jeffrey "the Dude" Lebowski explains to Jeffrey "the big" Lebowski, "I am not Mr. Lebowski; you're Mr. Lebowski. I'm the Dude. So that's what you call me." In the end the Dude abides as a singular symbol of redemptive sloth. But even the identity summed up in that name is never fixed, as is clear when he expands the list of handles he will respond to: "That, or his Dudeness. Or Duder. Or El Duderino, if you're not into the whole brevity thing." It would be hard to argue that the Dude's essence in any definitive way precedes his existence.

In a post-Camus world, the Coens' choice to name their narrator the Stranger can't help but resonate. Interestingly, 179 years earlier, Washington Irving refers to Rip's keg-bearing companion in the woods as the stranger as well (453). This character, too, instigates an identity crisis. As Rip returns to his village the morning (twenty years hence) after his strange encounter, he is pointed toward the now-grown son who is his namesake and cries, "I'm not myself—I'm somebody else— that's me yonder—no—that's somebody else, got into my shoes—I was myself last night, but I fell asleep on the mountain, . . . and everything's changed, and I'm changed, and I can't tell what's my name, or who I am!" (457). Both Rip and the Dude must suffer the slings of a Franklinian culture that tries to demand striving and achievement, a demand most forcefully embodied in Dame Van Winkle and the big Lebowski, respectively. Both emerge from the trials with their slacker identities intact, to live guided only by their determination to live unguided.

The Strangers in both tales are notable for sartorial anachronism, Irving's in his "quaint, outlandish . . . antique Dutch garb" (453) and the Coens' with the "whole cowboy thing goin'." Neither story strives for realism; neither would trap its hero nor its readers (viewers) within its frame. Despite its playful self-consciousness, though, Irving's tale is

renowned for the Aristotelian purity of its structure, at both story level and sentence level. In the post–World War II vein of postmodern pastiche, by contrast, the Coen brothers toss formal purity out the window. Whereas Irving's stranger remains silent, the Coens' Stranger talks up a dust storm, ostensibly organizing the Lebowski narrative by appearing at the beginning, the middle, and the end. Not surprisingly, though, given the ethos of the Dude's tale, the Stranger can't quite hold things together. In the opening frame, he sets up a sort of sarsaparilla-stoner disjointedness in telling us, "but sometimes there's a man . . . sometimes there's a man . . . well, I lost m'train of thought here . . . but—aw hell, I done innerduced him enough."

> *Surely we are meant to trust that the "little Lebowski on the way" will have inherited his father's heroic laziness every bit as thoroughly as has young Rip. Apparently the revolution is not over after all.*

This lack of narrative discipline reappears at the film's end, when the Stranger attempts to bring closure to the cowboy-western generic structure he instigated with his opening words. He ends with, "westward the wagons, across the sands a time until . . . aw, look at me, I'm ramblin' again." As the script explains, after bidding us adieu, the Stranger's "voice fades" as he "swivels in to the bar" and asks Gary, the bowling alley bartender, "Say friend, ya got any more a that good sarsaparilla?" The Dude may abide; our narrator's last act is to imbibe, to the delightful detriment of narrative closure.

Of course, the Coens' narrative remains open in the structural sense of classical comedy as well, as the Stranger tells us just before his final trailing off, "I happen to know there's a little Lebowski on the way. I guess that's the way the whole durned human comedy keeps perpetuatin' itself, down through the generations." Although Fiedler's thesis

does not necessarily allow for offspring, "Rip Van Winkle" does provide a model for how a man might propagate himself without succumbing long-term to messy marital confinement. After realizing that the likeness he encounters in the village is his son, Rip settles down to a life of happy bachelorhood—Dame having blown a blood vessel during his nap—and he is gratified to see that Rip, Jr., his "son and heir [,] . . . evinced an hereditary disposition" toward idleness (459). Surely we are meant to trust that the "little Lebowski on the way" will have inherited his father's heroic laziness every bit as thoroughly as has young Rip. Apparently the revolution is not over after all.

Yet for all its applicability, the classical comedy template does not adequately contain the narrative of *The Big Lebowski* any more than does the cowboy-western. As almost every commentator on the film has noted, the Coens resist the constraints of literary form by stitching together a variety of genres: the noir detective story (or, as some have identified it, the "bowling noir" film), the Busby Berkeley musical, the Vietnam movie, the pornographic movie, the screwball comedy, the buddy film, and the 1960s romantic quest à la *Easy Rider*. The film's plotline is convoluted enough, with its anti-climactic half-resolution of the money and the kidnapping issues, to constitute a parody of the construct of causal narrative, and many of its characters fit fictional types to the point of absurdity. Visually, too, it is pastiche. Cinematographer Roger Deakins observes, "I'm not sure I ever really had a handle on what Lebowski should look like. . . . It's such a mix, I don't think it has one style" (Robertson 78).

The film's denial of coherence has been deemed postmodern. It is more traditionally American as well. In his seminal 1971 study *City of Words*, Tony Tanner explains the deconstruction of literary form in postwar American fiction as an advance on the classic American escape motif. Underlying the "dream of an unpatterned, unconditioned

life," Tanner finds an "abiding American dread that someone else is patterning your life, that there are all sorts of invisible plots afoot to rob you of your autonomy of thought and action" (15). *The Big Lebowski* sets this dread within the urban maze of Los Angeles, paradigm of the contemporary capitalist city. L.A. entraps Americans not only within the usual imperatives of city life, but also in the aspirations it manufacturers through the film industry—aspirations which invisibly condition how so many of us live our lives. (Significantly, making it to L.A. itself is one of the most powerful American aspirations.)

As, in the Stranger's words, "the man for his time'n place, . . . the Dude, in Los Angeles" materializes through the film industry to embody the antithesis of this sort of aspiration. He abides instead in the service of Tanner's "dream of an unpatterned, unconditioned life." Just as the film that births him resists containment by a single style or genre, the Dude slips the expectations of an emotionally deranged society. In the film's theme song, Bob Dylan bays, "The man in me will hide sometimes, to keep from being seen / But that's just 'cause he doesn't want to turn into some machine." *The Big Lebowski* updates the earliest American story, of (white) men driven continually westward, away from responsibility and from the mechanized and symbolically *feminized* imperatives of social conformity. Rip Van Winkle, the granddaddy of this pattern, retreats into pure wilderness and extended sleep, only to "arrive[e] at that happy age when a man can do nothing with impunity" (459). The Dude, in an era when the western frontier has been long since colonized, finds himself at the mercy of random forces within the malignant grid of Los Angeles. Yet he too manages in the end to hang on to his essentially adolescent-male version of freedom. He too, like Rip, has been doing nothing all along.

Notes

1. Of course, the Coen brothers give the tradition a noir twist, playing on the Philip Marlowe–style detective who "becomes desultory and depressed to such a degree that the mysteries frequently come looking for him, rather than vice versa" (Robertson 42). More recent precursors of the Dude include the picaresque heroes of 1960s fiction, such as Vonnegut's Billy Pilgrim or, more directly, Pynchon's Tyrone Slothrop.

2. In the texts Fiedler analyzes, of course, these are always white men. The racial Other, famously, serves as homosocial companion, meant in his distance from "civilized" (read: Anglo-American) society to enhance the white man's escape into wilderness. *The Big Lebowski* substitutes Walter Sobchak's tendency to violence for this purpose and generally downplays issues of race, or at least smuggles them into the film in an apparently, and probably intentionally, incoherent fashion.

3. In fact, "Rip Van Winkle" is doubly framed, as it appeared in the *Sketch Book* that Irving published under the pseudonym Geoffrey Crayon. Crayon subtitles the tale "A Posthumous Writing of Diedrich Knickerbocker" and introduces it as having been "found among the papers of the late Diedrich Knickerbocker" (448), a fictional historian of New York's Dutch antecedents. Crayon teases Knickerbocker for his lack of literary merit, but insists repeatedly on the story's accuracy and even concludes it with an appended note in which Knickerbocker himself claims to have met Rip Van Winkle and proclaims the story "beyond the possibility of doubt" (460).

2 A Once and Future Dude:
The Big Lebowski as
Medieval Grail-Quest

Andrew Rabin

Although medieval allegory might seem distant from *Lebowski*'s "parlance of the times," references to the Middle Ages—and to the Grail-quest in particular—form a crucial component of the film's narrative world.[1] Like the Old French *Queste del Saint Graal*, Wolfram von Eschenbach's *Parzifal*, or Malory's *Morte Darthur*, *The Big Lebowski* recounts the adventures of three companions seeking to restore a lost fetish-object. This quest leads them through a contemporary wasteland to the castle of a crippled king whose paraplegia marks him as both sexually and politically impotent. Here, the object is found and lost again, and the goal now becomes to restore the king's potency, as well as to recover the original object of the search. On his journey, the principal Grail knight experiences allegorical visions and confronts the temptations of the flesh. He encounters both Jesus (Quintana) and Arthur (Digby Sellers) and receives dubious aid from an "Irish monk" (the "brother Seamus," Da Fino). In perhaps the most obvious Grail allusion, the Dude's second meeting with the "Big" Lebowski takes place in a neo-Gothic great hall with Wagner's *Lohengrin*, an opera based on Wolfram's *Parzifal*, playing in the background. The adventure finally ends with the death of the most innocent of the questers and the return of his two companions, sadder yet wiser men. However, despite such obvious similarities between the medieval and modern narratives, the inhabitants of the Dude's world remain as ignorant of their Arthurian

analogues as they seem to be of the Iraq War beginning around them. In this film, the voice of history is that of "a Stranger." Like the child who wanders in in the middle of a movie, they have, as Walter tells Donny, "no frame of reference."

This essay examines how the medieval Grail-quest functions as an unacknowledged "frame of reference" for the characters and narrative of *Lebowski*. Appropriating the medieval Grail-quest permits the Coens to frame their film as both an allegory of and a commentary on contemporary notions of desire and social escapism. As they will do again in *O Brother Where Art Thou?* (2000), the Coens here depict characters who seek to elude the responsibilities and constraints of modern society. As bowlers, *Lebowski*'s Grail knights seek to master a game which idealizes repetitive, cyclical movement in a confined, constructed, and utterly controllable environment. Bowling offers them an escape into a predictable world isolated from the chaotic nihilism of late twentieth-century culture. Yet *Lebowski*'s ever-present, never-acknowledged medieval context—like the Homeric frame in *O Brother*—highlights the impossibility of the subject ever truly escaping his historical embeddedness. Even as the Dude and his companions appear to have "dropped out" of history, they instead replay a constantly reiterating narrative and historical cycle.

The High History of the Holy What-have-you

The Coens' reimagining of the medieval Grail tradition participates in a history of narrative appropriation originating in the Middle Ages itself. *The Big Lebowski* not only adopts the characters and narrative structure of early Grail romance, but it also imitates those earlier texts by framing the Grail-quest as an attempt to transcend the fallenness of postlapsarian human society. The Grail's origins are the subject of considerable

academic debate, yet most scholars agree that Chrétien de Troyes' in-complete, twelfth-century romance *Perceval* (ca. 1182) provides the earli-est example of literary Grail romance. Although *Perceval* shares many of the features that have come to define the genre—including the journey through the wasteland, the characterization of the knight as holy in-nocent, the crippled Fisher King, and the first undisputed appearance of the Grail itself—Chrétien does not exploit the Grail's potential as a source for Christian allegory that later authors will find so compel-ling. Within forty years, however, the anonymous author of the Old French *Queste del Saint Graal* (ca. 1215–1230) will transform Chrétien's romance into a spiritual allegory involving the whole of Arthur's Round Table and, by extension, all of Christendom. In the *Queste,* Perceval's magical dish has the power to heal the Fisher King's wounds and be-comes a means of resolving the mysteries at the core of Christianity itself. Arthur's knights are told that their quest "is no search for earthly things but a seeking out of the mysteries and hidden sweets of our Lord, and the divine secrets which the most high Master will disclose to that blessed knight whom He has chosen for his servant" (47). This spiritual allegory will be revised in the fifteenth century by Sir Thomas Malory, whose *Morte Darthur* (ca. 1469–1470)—still the most influential Eng-lish redaction of the Arthurian legends—integrates the French reli-gious narrative into a nationalist vision of English imperial ambition. Composed during the Wars of the Roses, Malory's Grail story uses the *Queste*'s eschatological undertones to argue for a reunification of the English aristocracy and a return to the chivalric ideals represented by Arthur and his court. The Grail thus embodies the desire for religious as well as secular transcendence, and the quest offers a means of escap-ing both the fragmentation of postlapsarian Christian history and the corruption of secular society.[2]

For medieval authors, the Grail encoded a notion of desire as both escapist and totalizing. The Grail symbolizes a nexus between our lived-in world of representation and *difference* and another, divine world of stable, absolute signification. To achieve the Grail was to unify these two worlds and restore humanity's fallen, fragmented nature to a state of prelapsarian perfection. In the words of Nascien the Hermit, the knights' guide in the *Queste,* pursuing the Grail will "reveal that which the heart of man could not conceive nor the tongue relate" (*Quest* 47). In *Lebowski* parlance, the Grail is that which ties a room together, a stable source of meaning from which language and history derive their significance. As Lawrence De Looze observes, "the Grail . . . is ineffable and *innarrabilis;* it transcends language and this material world. The telos of the quest is that which terrestrial eyes cannot see, nor human language become: pure signification, immanent and direct, experienced without the intermediary of the signifier" (241).

Yet for all its salvific promise, the medieval Grail-quest is always already doomed to failure. Even Galahad, the most virtuous of the Grail knights, fails to translate the divine vessel into the world of men. At the conclusion of both the *Queste* and Malory's revision, a mysterious hand appears and carries the Grail up to Heaven, "to the end that no man since has ever dared say that he saw the Holy Grail" (*Quest* 284).[3] Instead of the promised reconciliation of human and divine, the Grail-quest and the totalizing signification it represents heralds the end of Arthur's Round Table. As Malory's Arthur predicts, the quest will take from him "the fayryst and the trewyst of

knyghthode that ever was sene togydir in ony realme of the worlde. For whan they departe frome hense, I am sure they all shall never mete more togydir in thys worlde; for they shall dye many in the Queste" (503). The departure of the knights on their quest is the last time the Round Table meets as a whole, and the quest's failure so weakens the court that it becomes vulnerable to Mordred's treachery. As such, even as the Grail offers an escape from the fragmented world of politics, materialism, and representation, it simultaneously marks the impossibility of escape and the perpetual deferral of desire.

A similar Grail symbolism pervades modern film, and not just in the form of the coconut-clapping "k-niggits" of Monty Python. For contemporary filmmakers, grails literal and symbolic offer a spiritual escape from a world of hermeneutic resistance and communicative failure. Terry Gilliam's *The Fisher King* (1991) provides a useful example of what might be described as the "typical" late twentieth-century Grail film. Reimagining the medieval wasteland as modern-day New York, the film transforms Perceval, the Holy Innocent, into "Parry," a homeless former medievalist suffering from schizophrenia, and the Fisher King into Jack Lucas, an ex-disc jockey spiritually "maimed" by the guilt he feels for inadvertently causing the death of Parry's wife. Lucas joins Parry on a quest for mutual healing and redemption, symbolized by the recovery of a "Grail"—a cup which resembles a sacramental chalice but, in reality, is only a child's trophy. In relating the adventures of Jack and Parry, *The Fisher King* relies on a series of thematic conventions common to such other recent Arthurian films as *The Sword in the Stone* (1963), *Monty Python and the Holy Grail* (1975), *Indiana Jones and the Last Crusade* (1989), *First Knight* (1995), and *King Arthur* (2004): an interest in debunking medieval chivalric and religious ideals; the use of anachronism, often for humorous effect; a characterization of the modern world paralleling

that of the medieval wasteland or, alternatively, a characterization of the medieval wasteland in terms reflecting modern social or political disaffection; and an appropriation of the quest narrative as an allegory for the development of heteronormative masculine identities and relationships. Perhaps the most significant commonality, however, is an emphasis on the salvific promise embodied by the Grail. Even when parodied, as by Monty Python, the Grail nonetheless offers a means of escaping the modern(ist) wasteland. The revelation in *The Fisher King* that the Grail is merely a prize from a Christmas pageant simultaneously demythologizes the sacramental chalice of medieval legend and reinforces the notion that achieving the Grail enables a return to a privileged moment of prelapsarian innocence.

Like *The Fisher King* and its analogues, *The Big Lebowski* also draws upon these generic conventions. Structuring *Lebowski* in this way allows the Coens to question the redemptive narrative at the center of Hollywood appropriations of medieval Grail romance. Los Angeles stands in for the medieval wasteland while the Dude and his companions—based on the characters of Chandleresque noir[4]—become debased Grail knights on a quest that is as much about American masculinities in the late twentieth century as it is about recovering a soiled textile. Indeed, the film even extracts comedy from the use of anachronistic medievalisms, such as Maude's Valkyrie armor with bowling-ball-brassiere. Yet for all its similarities,

Los Angeles stands in for the medieval wasteland while the Dude and his companions—based on the characters of Chandleresque noir—become debased Grail knights on a quest that is as much about American masculinities in the late twentieth century as it is about recovering a soiled textile.

The Big Lebowski departs from other Arthurian films in its treatment of the Grail itself: whereas earlier films emphasized solely the Grail's redemptive potential, *Lebowski* recognizes the narrative of failure which also underlies medieval Grail romance.[5] The Dude never does regain his rug—instead, he loses his car, his house is vandalized, and Donny, his friend and teammate, succumbs to a heart condition. If pursuing the Grail offers the chance to escape worldly corruption, the Dude's quest only implicates him more directly in a decaying postlapsarian, post-Vietnam America. *The Fisher King* ends with a resurrected Parry singing, "I like New York in June"; the Dude, in contrast, offers only a resigned "Strikes and gutters, ups and downs." As in the medieval romances, even as the Grail-quest holds out the possibility of healing, escape, or redemption, it heralds also an end to fellowship and a retreat into the very fragmentation the knight hopes to resolve.

Holy Dude, Holy Grail

Central to the Coens' reimagining of medieval Grail romance is a notion of the quest as the expression of a desire to escape the fragmentation, corruption, and alienation so much a part of American society after Vietnam. In particular, it is this desire that shapes the film's three protagonists. In their very different reactions to the historical world outside the alley, they embody three versions of the modern subject reacting to the traumas of the late twentieth century. By incorporating the narrative of failure underlying medieval Grail romance, however, the Coens ask whether an escape is possible even as they interrogate the sorts of fantasies, both social and historical, motivating such a desire.

Perhaps the figure most immersed in such fantasies is Walter, the veteran who remains fixated on Vietnam and preoccupied with a past

fundamentally incomprehensible to him. He punctuates his dialogue with irrelevant, often inappropriate, historical references and locates his attraction to Judaism in an idealized version of Jewish historical progress, characterized as "three thousand years of beautiful tradition from Moses to Sandy Koufax." The hollow triumphalism that frames Walter's summary of Jewish history—one can hardly retain the adjective "beautiful" when confronted with Auschwitz—marks the almost desperate idealism informing his escapist desires. Perhaps more indicative, though, is his reference to Sandy Koufax, whose career ended (along with Walter's narrative of "beautiful tradition") in 1966, the same year that Lyndon Johnson first publicly committed the United States to a long-term military engagement in Vietnam. Announcing his decision in the State of the Union address, Johnson employed language decidedly Walter-ish: "let me be absolutely clear: The days may become months, and the months may become years, but we will stay as long as aggression commands us to battle" (Johnson). The determinative power of aggression in Johnson's speech foreshadows both George Bush's declaration that "this aggression will not stand" at the outset of the first Gulf War and Walter's raging against "unchecked aggression" when urging the Dude to seek recompense for his defiled rug. Filtering his desires through a sanitized, "beautiful" version of Jewish history, Walter's wish to "live in the past" manifests a longing to return to a moment before "aggression command[ed him] to battle," that is, to an idealized innocence prior to the fragmenting of the American psyche resulting from Johnson's intervention in Vietnam.

In contrast to Walter's obsession with the past, Donny appears to have no past at all. He does not share his companions' histories as veteran or activist and seems ignorant of their current activities. As Walter rants incoherently about Lenin, Donny interjects nonsensically,

"I am the Walrus"—theirs is a relationship of mutual incomprehensibility. More importantly, even as Walter remains captive to a history excluded from the bowling alley, Donny remains isolated within the antiseptic world of Brunswick Lanes. Only twice in the film does he leave the alley, and in both cases, his encounter with the outside world places him in imminent physical danger. In the first episode, he remains in the Dude's car as Larry Sellers's enraged neighbor "kills" the vehicle with a crowbar, while in the second, he is accosted by the nihilists and suffers his fatal heart attack. The film emphasizes both Donny's incomprehensibility to Walter and his association with interior spaces in Walter's rambling eulogy. Lacking anything to say about his friend beyond "Donny was a good bowler and a good man," Walter describes Donny in terms unrelated to anything previously established concerning his character or back-story. In Walter's words, Donny "was a man who loved the outdoors, and bowling, and as a surfer he explored the beaches of southern California from La Jolla to Leo Carrillo and up to Pismo. . . . He died, he died as so many young men of his generation before his time. In your wisdom, Lord, you took him, as you took so many bright flowering young men, at Khe San and Lan Doc and Hill 364. These young men gave their lives. So did Donny. Donny who loved bowling." Walter's repeated non sequiturs concerning Donny's love of bowling only highlight the eulogy's inappropriateness: Donny never (to our knowledge) served in Vietnam, and his death can hardly be compared to those who died "face down in the muck," as Walter says elsewhere. Likewise, the film offers no evidence that Donny ever "explored the beaches of southern California": he does not exist outside the bowling alley, and when he finally leaves the lanes, his heart cannot survive his encounter with the nihilism of the outside world. Rather, as the film's innocent (perhaps its only innocent), he becomes a tabula rasa on which Walter can

project his own desire for absolution and redemption. Donny thus provides a foil for Walter's obsessiveness: if the latter remains mired in a history that invades and corrupts his every activity, the former exists at such a remove from the historical world that encountering it proves fatal.

Mediating—both literally and figuratively—between Donny's innocence and Walter's obsessiveness, the Dude serves as a touchstone focusing and clarifying his companions' anxieties and desires. He fulfills this role, not only for Walter and Donny, but for the other inhabitants of the film's world as well: for Maude, he is the means to raising a child without recourse to a male partner; for the "Big" Lebowski, rejecting the Dude allows him to reject a characterization of himself as parasitic "bum" (which characterization later turns out to be accurate); for Da Fino, the Dude models the ideal "private snoop," and for Marty the Landlord, the Dude serves as the ideal audience/critic. Even little Larry Sellers uses the Dude to fulfill his desire for a car. In this sense, the Dude fills the same narrative role occupied by Galahad in the medieval Grail tradition. Entering the narrative at a prophesied moment immediately prior to the Quest's commencement and the only knight qualified to sit in the Siege Perilous, Galahad shares the historical specificity so much a part of the Dude's characterization. Likewise, as "the servaunte of Jesu Cryste and verry knyght . . . [and] a clene virgyne above all knyghtes, as the flour of the lyly in whom virginité is signified; and . . . the rose which ys the flour of all good vertu" (Malory 580). Galahad similarly functions as a projection of societal ideals and desires. Indeed, perhaps the most striking similarity between the two characters—and one which emphasizes their exemplary status—is the parallel drawn between each and Jesus in their respective narratives. Just as Galahad serves as a "type" of Christ according to the generic conventions

of medieval typological allegory, so *Lebowski* repeatedly frames the Dude as a contemporary Jesus. Beyond the obvious similarity of hairstyle, the Dude also twice assumes a cruciform posture and is described sacrificially by the Stranger as "takin' her easy for all us sinners." The Dude is not the film's only Christ figure—Donny also is associated with Jesus, as is "the Jesus" himself, who provides an obvious anti-type. Nonetheless, like Galahad in the Middle Ages, the Dude, as "the man for his time and place," both exemplifies late twentieth-century American identity and acts as the machine through which the component desires of that identity achieve expression and comprehensibility.

The Dude's own desires materialize in the form of the rug he pursues—and never quite regains—throughout the film. The rug's defining quality, we are told, is that it "really tied the room together"—the Dude mentions this, as does Walter and even Lebowski himself. As the film's Grail, the rug marks the fantasies of historical escapism that frame the Dude's world. For the Dude and his companions, the desecration of the rug represents the violation of a unified, organic space isolated from the corrupt post-1960s world of Lebowski-like capitalism. In this space, the "Dude"—an identity liberated from bonds of family or community—can supplant more conventional notions of social identification, as it does when he says to the "Big" Lebowski: "I am not Mr. Lebowski; you're Mr. Lebowski. I'm the Dude. So that's what you call me. That, or his Dudeness. Or Duder. Or El Duderino, if you're not into the whole brevity thing." In seeking to restore the rug, the Dude attempts to restore the integrity of a space in which his identity can be defined by a name unencumbered by social responsibility or connectedness. The Dude, Walter, and Donny reference this idealized space in their descriptions of the rug, which rely principally on images of barriers, enclosures, and penetration: the rug "really

2.1. *The Annunciation.* Jeremy Phillips, painter

tied the room together"; Walter tells the Dude that the real issue underlying the incident is about "drawing a line in the sand . . . across this line you do not, uh. . . ."; the Dude tells Lebowski, "This will not stand, ya know, this will not stand, man," unconsciously echoing the words of George H. W. Bush overheard during the film's opening sequence. Regaining the rug would allow the Dude to "retie" his room together; in other words, to reconstruct the integrated interior space isolated from the exterior historical world.

However, the Dude's rug is hardly an ideal stand-in for the Grail: in contrast to the divine chalice of medieval narrative binding together the temporal and the eternal worlds, the Coens offer a

debased, soiled textile tying together only the eclectic objects collected in the Dude's rundown bungalow. Debasing the Grail in this fashion highlights the impossibility, the always-already corrupted nature, of the Dude's quest. Indeed, the ease with which both Treehorn's and Maude's thugs penetrate—and in Woo's case, figuratively inseminates—the Dude's bungalow indicates the extent to which the fantasy of an isolated, ahistorical space originates more in desire than possibility.

In transforming the Grail from a chalice for Christ's transubstantiated blood to a vessel for Woo's urine, the Coens slyly undermine the grandiose rhetoric of medieval allegory—a debunking of medieval chivalric ideals appropriate in a movie in which Jesus is a pedophile and Arthur is encased in an iron lung. The transformation of Arthur particularly accentuates this combination of futility and chivalric debunking that characterizes the Dude's quest. Just as the medieval Arthur personified a nostalgia for a lost age of fellowship, chivalry, and the ideal exercise of royal authority, so Arthur Digby Sellers, scriptwriter for the television show *Branded,* likewise embodies lost innocence and a model of knightly integrity emptied of value. The lone author depicted in the film, Sellers represents a model of singular narrative authority: as Walter emphasizes, Sellers wrote "the bulk of the series" and thus is "not exactly a lightweight." Given the influence that *Branded* exercised over *Lebowski*'s characters—Walter, in particular—Arthur's authorial authority extends, in a limited sense, beyond his show to the film's protagonists as well. Indeed, Walter's manic cry, "YOU'RE KILLING YOUR FATHER!" might be said to apply as much to himself as to little Larry: it is his post-Vietnam world which most resembles the post-Civil War world depicted in *Branded,* and his own, distinctly unheroic, lifestyle which most fails to resemble that of the show's protagonist, the wrongly condemned

Jason McCord. The comatose state of *Lebowski*'s Arthur/Author thus signifies in a painfully literal fashion the impossibility of reinstituting any sort of narrative coherence through a return to past notions of authority or a chivalric ethos.

Like the conclusion of the medieval Grail narratives, the end of *The Big Lebowski* is deeply ambivalent. Grail romances require their participants—both characters and readers—to become hermeneuticians seeking the theological significance and narrative coherence underlying the tales' disparate and often confusing events: for Perceval and Galahad, achieving the Grail means recognizing the moral *telos* of Christian *historia*. The Dude's quest also is one of interpretation, and in this sense it's significant that he "solves the case" when he finally recognizes the façade erected by his nominal double, Jeffery Lebowski. However, resolving the mystery of Bunny's disappearance does not then impose coherence on the remainder of the narrative. Events, persons, and objects remains as incomprehensible, as much a source of alienation, as ever. Although the Dude restores neither his rug nor the ahistorical insularity it represents, the Stranger nonetheless describes the quest as "a purty good story" and claims that he "take[s] comfort" in its resolution. The disconnection between event and the narrator's perspective highlights the fragmentary, inconclusive nature of the film's ending, a disconnection further emphasized by the Dude's own nonchalance. He "abides," "take[s] it easy" and assimilates the loss of his rug, the death of his friend, and his advance into the semis to a reductive model of moral equivalence: "strikes and gutters, ups and downs." Even as the Dude evokes a fantasy of a harmonious, balanced universe, the incongruence between Donny's death and "rolling into the semis" suggests that such a balance may be little more than an illusion. The Stranger also seems to struggle with Donny's death: after praising the "good story," noting that "things

seem to have worked out pretty good for the Dude and Walter," he admits that he "didn't like seein' Donny go" and thus troubles his own reading of the film. In trying to reconcile Donny's death with the "purty good story" he has just witnessed, the Stranger descends into clichés concerning the "human comedy [that] keeps perpetuatin' itself, down through the generations, westward the wagons, across the sands a time" until he can only confess that "I'm ramblin' again." In the end, history—social, political, and narrative—retains the fragmentation and corruptibility characteristic of a post-Vietnam America in a post-Vietnam world. Without his Grail, the Dude can never finally "tie his room together."

The disconnection between Stranger and Dude at the film's conclusion recalls the Stranger's opening admission that "there was a lot about the Dude that didn't make a whole lot of sense to me. And a lot about where he lived, likewise." This particular confusion hinges on a problem of names: to the Stranger, Los Angeles hardly seems a "City of Angels" and "Dude" is "a name no one would self-apply where I come from." The Stranger here alludes to the fact that the Dude's name originates in the late nineteenth century as an insult directed at those perceived as dandies or aesthetes. The name thus becomes doubly unsuitable, both because of its history as a derogative and as a descriptor of behavior hardly characteristic of the perpetually disheveled Dude. From a historical perspective, the Dude, the quintessential modern, thus becomes someone who does not know his own name. This mutual incomprehensibility between the Stranger—a figure out of American filmic and social history—and the Dude—a "man for his time and place"—exemplifies the extent to which the modern subjects of *The Big Lebowski* have become alienated from the history that provides their frame of reference. By appropriating the Grail-quest narrative, the Coens interrogate modernist fantasies of

historical escapism even as they question whether a self-sustaining, historically distinctive modernism can finally exist. Implicitly, the modern subject's ignorance of his narrative context offers a critique of the historical amnesia so much a part of contemporary discourses of periodization and identity formation. In this sense, acknowledging Jeffrey Lebowski's medieval frame of reference invites us to ask whether he truly is a "man for his time and place," or if we ought to think of him instead as a "once-and-future Dude."

Notes

1. Lebowski's medieval subtext has been passed over by scholars of film and Arthurian literature alike: *The Big Lebowski* has been omitted from every major Arthurian filmography. See, for instance, Harty and Olton.

2. On the medieval history of the Grail legend, see Barber, Frappier (127–55), and Mahoney.

3. For the equivalent passage in Malory, see 586.

4. On Chandler and the demythologizing of Arthurian legend, see Mathis (43–59).

5. On Hollywood's recognition only of the redemptive components of the Grail narrative, see Shichtman (35–48) and Umland (15–17).

3 Dudespeak:

Or, How to Bowl like a Pornstar

Justus Nieland

What condition is the Dude's linguistic condition in? Obviously, it's fucked. But how? We might start with the fact that the Dude's language, more often than not, is not his own, but a stoned mimesis of the phrase making of others. Dudespeak is mimicry, a compulsive borrowing from the stylized tissue of verbiage whose repetitions, loopings, and displacements constitute the film's linguistic world. Examples abound: "This aggression will not stand, man"; "Her life was in our hands, man"; "In the parlance of our times, you know"; "Johnson?"; "You mean, coitus?"; "Beaver? You mean vagina?" All are citations, increasingly absurd sound bites whose discrepant reappearance in other contexts becomes so much linguistic grist for the Coens' comic mill. Even what has come to be the Dude's signature phrase, the linguistic encapsulation of an ethos—"The Dude abides"—is a rescripting of the purported *limits* of Jeffrey "the Big" Lebowski's tolerance, his refusal to "abide another toe." So, while the Dude, "quite possibly the laziest man in Los Angeles County," may be prone to such mimetic locutions, Dudespeak exemplifies the broader expressive world of the film: "sometimes there's a man, well, he's the man for his time and place, he fits right in there . . . and that's the Dude, in Los Angeles."

Like Dudespeak, the comic watchword of the Coens' L.A. is decontextualization, the sundering of persons, words, and things from their grounding "frames of reference," a pun that nicely links the problem of

meaning both to the social space of the bowling alley and to the indexical potential of cinema with its own series of rolling frames. Citationality is both a linguistic and, like, you know . . . um . . . *ontological* condition in the film. Walter insists that Donny is "out of [his] element," but so is the Dude, unlikely noir hero, so is Bunny Lebowski, *neé* Fawn Knutsen, exilic Minnesotan, and so, for that matter, are marmots in bathtubs, pistols and Pomeranians in bowling alleys, severed toes in tissue paper. And so, more profoundly, is Walter, since the compensatory certainty of his rhetorical outbursts is undone by the paranoid transportability of context. Walter cannot think relationally, cannot see the difference between spatio-temporal situations, because all contexts are connectable and, thus, identical: the Persian Gulf War *is* "league play," which *is* Vietnam, which is the violent confrontation with Larry Sellers. And Donny's death *is* the death of those "bright flowering young men" killed "at Khe San, at Lan Doc, at Hill 364." Walter's gambit is to combat the disappearance of context through absurd and violent attempts to ground language in *ethos:* in "rules," in law, in 3,000 years of beautiful, borrowed Judaic tradition, in a "fucking show dog, with fucking papers."

In these loaded terms, the citationality of Dudespeak is, of course, a meta-commentary on the condition of *irony.* For irony poses the interpretive problem of the severing of language from a discernable ethos and entails the notoriously unstable work of stabilizing context, of finding a ground for an utterance for which, to quote the Stranger, quoting Dick Powell's take on Phillip Marlowe, there is "no bottom." The expropriation of language that marks the Dude's linguistic being—his fundamental alienation from language as the putative site of what is most proper to the human—is doubled in the film's much-remarked textual borrowings, its citational logorrhea. Dudespeak exemplifies not just the conditions of expressivity of the film's diegetic world, but of the Coens' own spectacular cinematic idiom. Part of my contention, then, is that

attention to the state of language in *The Big Lebowski* offers a particularly direct way of addressing the extent to which we should, or can, take anything the film says seriously, whether its utterances are backed by any semblance of belief, of Creedence. In raising such questions about the Dude's linguistic alienation, *The Big Lebowski* is particularly invested in three temporal frames. Each frame is, in fact, a linguistic horizon, limning the parameters of political speech through various relationships between language, action, and affect. In what follows, I discuss these linguistic environments through the following shorthand: Chandleresque metaphor; Port Huron Statements; and Pornutopic Logjammin'. Against the first two frames, the joke about 1990s Dudespeak materializes; in the third frame, Dudespeak spills nonsensically into a broader communicative logic: the chatter of the postmodern bowlis. Few films are as eloquent about the language of political passivity.

Metaphor

> DUDE: I—the royal we, you know, the editorial—I dropped off the money, exactly as per—Look. Man, I've got certain information, alright, certain things have come to light, and you know, has it ever occurred to you, that instead of, uh, you know, running around, uh, uh, blaming me, you know, given the nature of all this new shit, you know, it . . . it . . . it . . . this could be, uh . . . uh . . . uh . . . a lot more . . . uh . . . uh . . . uh . . . uh . . . uh . . . uh . . . *complex,* I mean it's not just, it might *not* be just such a simple, uh, you know?
>
> LEBOWSKI: What in God's holy name are you blathering about?

In all its bumbling repetitions, mumbling incoherence, and explosive mismatches between expression and situation, *The Big Lebowski*'s Dudespeak is not just a big "fuck you" to the bravura wit and snappy sangfroid of film noir dialogue—that expressive polish barely

containing the affective unrest at noir's psychic core. Nor are the Dude's lazy words the cognitive-linguistic equivalent of his paunch, both, alas, gone to pot and sloppily ironizing the steely work of hard-boiled diction. The

*In **Lebowski** parlance, the Grail is that which ties a room together, a stable source of meaning from which language and history derive their significance.*

Coens' are connoisseurs of noir. They know their Hammett from their Cain, their Cain from their Chandler, and here they return to the linguistic terrain of the Chandleresque, where language would eschew the instrumentality of mass cultural form—reading for the plot, the payoff, the money shot, THE END—and opt instead for the more refined pleasures of the well-wrought word. As Chandler put it: "My theory was that the readers [of pulp detective fiction] just *thought* they cared about nothing but the action; that really, although they didn't know it, the thing they cared about, and that I cared about, was the creation of emotion through dialogue and description" (Jameson, "Chandler" 122–23). Perhaps naively, Chandler believes that his readers will opt for arty talk over pornography, that, in smut mogul Jackie Treehorn's disingenuous terms, "the brain is the biggest erogenous zone." But then Chandler was always a romantic modernist in the trench coat of a tough. As Fredric Jameson brilliantly argued long ago, Chandlerspeak registers not the outside of instrumentality, but rather the historical pressure put by capitalism upon fictional speech.

We see this first in Chandler's use of "clichés and stereotyped speech patterns that are heated into life by the presence behind them of a certain form of emotion, that which you would feel in your dealings with strangers" (Jameson, "Chandler" 133). Resisting intimacy and expressivity, Chandler's dialogue is a jargon of inauthenticity that doubles an atomized, abstracted, and alienated social world. The summa

of stranger-speech is slang, which is, Jameson claims, "eminently serial in nature: it exists as objectively as a joke, passed from hand to hand, always elsewhere, never fully the property of its user" (134). If slang's seriality bespeaks the abstraction of emotional life and social space, Chandler's exaggerated comparisons whisper utopian perceptual compensation on the level of description. Take, for example, these modern beauties from *The Big Sleep* (1939): General Sternwood summons his flagging "strength as carefully as an out-of-work show-girl uses her last good pair of stockings"; his daughter Vivian bites her lip and worries it "like a puppy at the fringe of a rug"; blood returns to a recently sapped Marlowe "like a prospective tenant looking over a house" (8, 20, 192). Jameson asks that we understand such metaphoric brio as *a way of evaluating objects,* of producing distinctions and distance between objects, a discerning mode "that only becomes possible against the background of a certain recognizable uniformity of objects" (Jameson, "Chandler" 141). Whereas Chandler's dialogue marks the falsification of social unity in verbal commonplaces, Chandler's metaphors are engines of nostalgia for an earlier moment of socio-economic life, when things were simpler and more discernable as *singular* things.

The Big Sleep (1939), Chandler's first novel, offers an especially canny staging of how this typically modernist agon between singularity and seriality, authenticity and abstraction, is encoded in speech. Chandler's Marlowe, unlike Bogart's, is something of a fop, very UnDude, and his sartorial care is matched by an evident pride in his linguistic competency. When General Sternwood asks him to describe himself, he responds: "Sure, but there's very little to tell. I'm thirty-three years old, went to college once and can still speak English if there's any demand for it" (10). Like Chandler, who claimed to have abandoned a dream as a comparative philologist, Marlowe is a connoisseur of the speech of others: he quickly appraises how Sternwood has "learned to

talk the language" of his vanished son-in-law, Rusty Reagan, and reads his mimicry of the bootlegger's cant as a sure sign of paternal affection (10); in the unpretentious candor of Harry Jones's words he discerns "something that was near enough to dignity to make me stare at him" (164); the purr of sociopath Canino's voice is "as false as an usherette's eyelashes and as slippery as a watermelon seed" (174); Vivian Sternwood has a "cool, insolent, ill-tempered drawl" (138), and Marlowe sniffs one of her insults like a turned wine: "There was nothing in that for me, so I let it drift with the current" (18). In this epistemology of the ear, speech is an index of character: of agency and intention, of degrees of sincerity, of moral probity or, more commonly, decay. And Marlowe's linguistic self-possession, buttressed by Chandler's metaphorical excess, is bedeviled by the pressure of lazy, redundant, commodified, or otherwise common speech. Vivian taunts Marlowe with his oc-

Chandler's metaphors and Port Huron statements—both talk a modernist poetic idiom of authenticity, historicity, and passionate conviction that seems hopelessly quaint in the landscape of ironic decontextualization that is the wacky 1990s of **The Big Lebowski.**

casional conversational failures, upbraiding his lapses into vulgarity ("Don't say 'yeah.' It's common.") and his occasional inability to keep up his part of the repartee: "Her lip curled. 'Wittier, please, Marlowe. Much wittier'" (146, 148). Marlowe himself is anxiously aware of this lurking impotence. The talk of two-bit chiseler Joe Brody, he observes, "was the elaborately casual voice of the tough guy in pictures. Pictures have made them all like that" (79). Four years before Chandler began his stint as a Hollywood screenwriter at Paramount, and five years before Marlowe's first cinematic iteration in Edward Dymtryk's *Murder,*

My Sweet (1944), his most singular literary creation anticipates his own demise in the formulas of the culture industry. Does Marlowe's patter mark him as a real wit or already a walking cliché? The novel's tone of overweening melancholy is its own best answer.

Marlowe's fortress of masculine wit is besieged in *The Big Sleep* by two characters of obscene inarticulacy. The first is Carol Lundgren, "the boy killer with the limited vocabulary" (129). Lundgren is the live-in gay lover of Arthur Gywnn Geiger, whose rare bookshop is a front for a pornographic lending library of photographs of "an indescribable filth" (30), and whose home is established as the epicenter of Angelino decadence when Marlowe discovers there a naked Carmen Sternwood, stoned on laudanum and waiting for her close-up. Lundgren gets embroiled in the baroque plot because he shoots and kills Joe Brody, whom he wrongly thinks has killed Geiger. But he functions more broadly in the story as the butt of a running joke because, in response to interrogation by Marlowe and the police, all he ever says is "Go ——— yourself" (97). If language is a characterological tell, Lundgren's "three favorite words" double his obscene sexuality, and with their tickish and unchanging repetition, Chandler draws on familiar period stereotypes between homosexuality, sterility, and hermetic superficiality. More strikingly, he reverses the historical association of "wittiness" with the gay male: Lundgren, "being what he is," is inarticulate, while Marlowe is the masterful wag (110). This is why Marlowe, so good with words and voices, has to be told by Vivian who Proust is: "A French writer, a connoisseur in degenerates. You wouldn't know him" (56). And yet in a novel where Geiger's home, even in the daytime, "had a stealthy nastiness, like a fag party," degeneracy is atmospheric, even mimetic (64). At times, this mimesis is controlled, as in the scene—made famous by Bogart in Hawks's filmed version of the novel—in which Marlowe, pretending to be a connoisseur of rare books, affects a faggy lisp and quickly

discovers that Geiger's shop is a front. At others, as when Marlowe is assaulted by Lundgren, he is brought, by sheer physical proximity, into a compulsive mimesis of the nastiness: "We seemed to hang there in the misty moonlight, two grotesque creatures whose feet scraped on the road and whose breath panted with effort" (101).

Even more perverse, in language and other matters, is Carmen Sternwood, pornographic model, nymphomaniac, and literary anteced-ent to Bunny, *The Big Lebowski's* own "compulsive fornicator." At once animal and child, sadist and victim, Carmen is the privileged figure of a metaphysical nastiness at the rotting core of the novel's moral universe. Like her promissory note, penned in "a sprawling moronic handwriting," her locutions court senselessness and repetition: when she is not coyly fellating her thumb or telling Marlowe "You're cute," she erupts into fits of hysterical giggling or hissing (12). Chandler is obsessed with her nonsense: her scream, which alerts Marlowe to the dark doings inside "the Geiger ménage," "had a sound of half-pleasurable shock, an accent of drunkenness, an overtone of pure idiocy. It was a nasty sound (36, 33). The threat of Carmen's nutty noise is its mimetic contagiousness, and this is most obvious in the novel's most remarkable scene. Marlowe, having nearly succumbed to Vivian's sexual predation, returns to his apartment to find Carmen, naked, in his bed: "The tawny wave of her hair was spread out on the pillow as if by a careful and artificial hand" (154). Chandler, like many of his characters, was a good reader of T. S. Eliot, so it's not surprising that this formulation of sexual terror conjoins *The Love Song of J. Alfred Prufrock's* most outrageous simile ("When the evening is spread out against the sky / Like a patient etherised upon the table") and the desiccated eros of *The Waste Land's* typist, who, after an empty fuck with the young man carbuncular, "smoothes her hair with automatic hand / and puts another record on the gramophone." Mar-lowe shares Eliot's fear of nonsensical noise—automatism, repetition,

and inauthenticity—and, like Eliot, he finds this threat embodied in the feminine voice: Carmen's giggling is a "sound that made [him] think of rats behind the wainscoting in an old house," and her hissing noise [comes] tearing out of her mouth as if she had nothing to do with it" (154, 157). Most strikingly, near to Carmen's nudity, Marlowe's machine of simile stalls: twice in the span of two pages he describes her hissing face as "like a scraped bone" (157–158). Marlowe throws Carmen out, but the stain of her obscenity lingers as a photographic trace: "The imprint of her head was still in the pillow, of her small corrupt body still on the sheets. I put my empty glass down and tore the bed to pieces savagely" (159).

Marlowe's violent fit, itself an iteration of Carmen's epileptic automatism, is an impotent response to a more fundamental violation of privacy in the novel that is troped through Carmen's speech and the discourse of the pornographic more broadly. Chandler makes this quite explicit when Marlowe demands that Carmen dress herself:

> She called me a filthy name.
>
> I didn't mind that. I didn't mind what she called me, what anybody called me. But this was the room I had to live in. It was all I had in the way of a home. It was everything that was mine, that had any association for me, any past, anything that took the place of a family. Not much; a few books, pictures, radio, chessmen, old letters, stuff like that. Nothing. Such as they were they had all my memories. (157–58)

This passage, burlesqued in *The Big Lebowski* with the intrusion of the rug-pissers into the sanctum sanctorum of El Duderino's bungalow, is the very heart of Chandler's modern nostalgia, his longing for a privacy that would secure what is most proper to a singular self: the memory of a past, history and its material props. To preserve this space is to vouchsafe the authenticity that is encoded in Marlowe's metaphoric

manner of speech, and to stave off the threat of uncanny seriality voiced in Carmen's hysterical giggling or Lundgren's dirty mantra. The passage's melancholy stems from Marlowe's awareness that this home is acutely fragile, if not already a Romantic fiction. Once this privacy is violated, he has no frame of reference, only pornography—the obscene conversion of what is most intimate into an abstraction, a public product. The language of *The Big Sleep* is torn between similitic authenticity and serial assimilation, privacy and pornographic abstraction, social intelligibility and a social obscenity that beggars sense and description. Jameson suggests that we read this linguistic tension as a product of the curious location of Chandler's early novels, which both draw on the nearly anachronistic social typologies and organic localisms of the 1930s *and* anticipate the standardization, fragmentation, and abstraction of social space sparked by the post-war economic boom that culminates in the social isolation of the 1950s and 1960s—the very culture of complacency, anomie, and apathy anatomized by that most famous manifesto of the SDS.

Manifesto

> MAUDE: . . . Tell me a little about yourself, Jeffrey.
> DUDE: Well, . . . Not much to tell . . . I uh, I was, uh,
> one of the authors of the Port Huron Statement . . .
> The . . . The original Port Huron Statement.
> MAUDE: Uh huh?
> DUDE: Not the compromised second draft.

Riffing on *The Big Sleep,* this bit of post-coital pillow talk from *The Big Lebowski* supplants Marlowe's self-description as an adroit user of language ("Not much to tell . . . I can still speak English if there's a use for it") with the Dude's own history of political speech. His role as an

author of the 1962 Port Huron Statement (PHS), manifesto of the Students for a Democratic Society (SDS) and founding text of "participatory democracy," earns pride of place in his mini-autobiography. As the Dude reminisces through the list of predicates to follow—from member of the Seattle Seven, to Roadie for Metallica, "Speed of Sound" Tour, to what he does "for recreation": "Oh, the usual. Bowl. Drive around. The occasional acid flashback"—the Coens make an old joke about the decline and fall of 1960s political passions, as His Dudeness moves from committed activism to a paid gig that lets him enjoy to common forms of leisure. At the nostalgic precipice of this narrative of decline, the PHS stands in *The Big Lebowski* as a mode of political speech and subjectivity presumably unavailable in the citational landscape of the film. As political speech, the manifesto is acutely impassioned—hortatory, forceful, *deictic*. Etymologically, the word *manifesto* stems from the Latinate roots *manus* (hand) and *festus* (from *infestus*: dangerous). A hostile hand threatening a radical break with the political past, the manifesto is perhaps *the* exemplary rhetorical genre of modernity—of its contestatory public sphere, of a modern temporality of rupture, and thus of modernist utopianism.[1] Born with the Enlightenment idea of a universal political subject, it has, from the French Revolution onward, served to critique modernity's broken promises, its exclusions to a democratic ideal. At once addressing and organizing heretofore excluded subjects of history through its rhetorical "We," the manifesto works a kind of performative magic: its idealism lies in its desire to bring speech vertiginously close to action, to collapse distinctions between words and deeds by poetically calling into being a world that does not yet exist.

*In the mouths of consummate vulgarians, **fuck** is a word of dazzling polysemy, of stunning referential plasticity.*

The PHS manifesto, as Marianne DeKoven has recently argued, is located on an important historical cusp: that of a massive shift in the structure of political feeling in the 1960s from modern democracy to postmodern populism, from Enlightenment social utopianism to a politics of the self, between the universalizing rhetoric of modernity and the local-particular domain of the political that we've come to associate with postmodernism. The ethos, if you will, of the PHS is

> finding a meaning in life that is *personally authentic;* a quality of mind not compulsively driven by a sense of powerlessness, nor one which unthinkingly adopts status values, nor one which re-presses all threats to its habits, but one which has *full, spontaneous access to present and past experiences,* one which easily unites the fragmented parts of personal history, one which openly faces prob-lems which are troubling and unresolved. (52; my emphasis)

Such democratic activity—such willing participation in the making of history—entails firstly "breaking the crust of apathy and overcoming the inner alienation that remain the defining characteristics of Ameri-can college life" (57).

Apathy, the PHS argues, shields potential historical agents from feeling "the press of complexity on the emptiness of life" and stalls the functioning of a truly democratic publicness. Here, like the deadpan delivery of Chandler's Marlowe, post-war apathy is an affective pose barely concealing an existential fear "of the thought that at any moment things might be thrust out of control" (47). Only by cracking the emo-tional facade of post-war prosperity—what the PHS authors call, with some poetry, the "glaze above deeply-felt anxieties about [Americans'] role in the new world"—and tapping a submerged core of collective af-fect can democracy glimpse futurity: any "truly democratic alternatives to the present" (48). Democratic action and speech, says the PHS, are

the antidote to Chandler's nascent society of alienated strangers. Chandler's metaphors manufacture nostalgia for a simpler past where things were, literally, different; Port Huron statements marshal the jargon of personal authenticity and stake their hopes in a "quality of mind" that can see a different future. Both *The Big Sleep* and the PHS pit the human potential for authentic action and speech against the obscenity of the public sphere. Chandler decries the eclipse of singularity in *people without privacy*, metaphysically deprived of homes in a world of hopelessly feminized, iterative speech. The PHS links the reign of the apathetic individual to "the rise of *democracy without publics*," where the public sector is dominated by military spending and where properly public institutions like the university have become "a place of private people . . . a place of the mass affirmation of the Twist, but mass reluctance toward the controversial public stance" (58). For Chandler, personally authentic speech has become hopelessly demotic, for the authors of the PHS, insufficiently democratic.

Chandler's metaphors and Port Huron statements—both talk a modernist poetic idiom of authenticity, historicity, and passionate conviction that seems hopelessly quaint in the landscape of ironic decontextualization that is the wacky 1990s of *The Big Lebowski*. I've already suggested how the mimetic citationality of Dudespeak one-ups the threat of iterative speech already present in *The Big Sleep* and exaggerates the impersonality of Chandler's serial slang. In doing so, it gestures not to a waning system of social typologies but to a more fundamental disappearance of context in textuality. Like slang, Dudespeak marks the falsification of the intersubjectivity of language—its function as a shared, public horizon of legibility and meaningfulness—in the ever more abstract circulation of recycled utterances that culminate in nonsense, noise, or emphatic declarations of confused reference: The Stranger to the audience: "I won't say a 'hero,' cause what's a hero?"; Dude to Walter:

"What the fuck does anything have to do with Vietnam? What the fuck are you talking about?"; Donny to Walter: "What's a pederast, Walter?"; the Big Lebowski to the Dude: "Hello? Parla Usted Ingles?" and later, "What in God's holy name are you blathering about?!?"; even Larry Seller's social studies teacher has red-penned his ambiguous pronoun referent to ask, "Who is 'he'?"

While Dudespeak's common coin is the mimetic utterance— phrases heard by a character in one context and then spoken by that character in others—it is also marked by *impossible* repetitions. Here, characters recycle fragments of speech from contexts in which they were not physically present as auditors: Walter's admonition "Do you see what happens, Larry?" echoes the blonde carpet-pisser's, "You see what happens, Lebowski?"; the Big Lebowski's angry rejoinder, "My wife is not the issue here!" repeats Walter's insistence that "The Chinaman is not the issue here!"; and Walter's introduction to Lebowski as "the guy who's gonna kick your phony goldbricking ass!" is an unwitting iteration of the "reactionary" Malibu sheriff's warning to the Dude to get "[his] ugly fucking gold bricking ass out of [his] beach community!" The impossible utterance marks the full abstraction of language from the grounding context of an authentic speaker. Not surprisingly, these moments thematically foreground fakery and confusion, and their common denominator is Walter, prey to the pathological mobility of context. In the impossible utterance, the Coens' mannered dialogue achieves maximum theatricality: their characters flaunt their artifice, their textuality, as the stylized tissue of language, reaching across discrepant contexts, speaks them.

My point is not that anything is sayable anywhere in the film, irrespective of context, but to notice what this total sayability—this linguistic plasticity—does to "the political" as, in political theorist Chantal Mouffe's terms, the dimension of antagonism that is constitutive of

human societies. One of the other insistent features of speech in the Coens' 1990s is its parodic linguistic normativity, its evident insistence on, in Walter's terms, the "preferred nomenclature," or in Maude's phrase, "the parlance of our times." The rug-soiling "Chinaman" is, Walter begs of the Dude, an "Asian-American, please." The Big Lebowski is not a "cripple," or "handicapped," but rather, Brandt explains officiously, "disabled. Yes." The word *vagina* itself "makes some men uncomfortable," Maude explains. "They don't like hearing it and find it difficult to say, whereas without batting an eye a man will refer to his "dick' or his 'rod' or his 'Johnson.'" The joke here is at the expense of the PHS, which is generally considered a rallying catalyst for the New Left and, beyond that, the formation of new social movements of postmodern identity politics—feminism, gay rights activism, race-based identity politics, a politics based on age and disability discrimination, etc. The once-radically agonistic polis of democratic claim-making and political futurity has—it seems—petered out into a lame policing of linguistic boundaries, just as the "basic freedom" of free speech—another rallying cry from the Dude's activist past—is only parodically invoked by Walter in the throes of his meltdown in the "family restaurant." The language of political correctness is laughable, not because, as Walter insists, "The Supreme Court has *roundly* rejected prior restraint," but because its insistence on the political limits of the sayable is laughable in the context of no context. For this reason, Quintana's conviction that he and Liam are "gonna fuck up" Walter and the Dude in the league semis can only earn the lame riposte: "Yeah, well, you know, that's just like, uh, your *opinion,* man." In a world in which language drifts bereft of ethos, the Dude can call Woo "the Chinaman" for the same reason that Bush 41 can justify the Gulf War in the name of "collective action," or Jackie Treehorn can claim he deals in "publishing, entertainment," and "political advocacy" rather than "smut." In such deviant predications,

we might say the utopianism of Chandleresque metaphor or the poetic rupture of the manifesto mutates fully into a mode of rhetorical violence, eroding meaningful distinctions between political actors past and present. Such acts of creative naming turn new socio-political agents into old stereotypes, mask neo-imperialism in the language of participatory democracy, and convert victimizers into advocates. In the world of Dudespeak, such speakers are not "wrong," since this judgment would imply an ethical horizon. They're just assholes.

Distinctions between being politically wronged or not, distinctions between aggressor and victim, empowered and powerless—that is, distinctions between political agents as such—these have to be re-taught to the Dude by Walter. His status as a 1990s subject of suspended political agency—bowling and abiding rather than speaking and acting—is most obvious in his acts of poetic self-nomination, those proliferating ways of referring to himself in the third-person: The Dude, "or, uh, His Dudeness, or, uh, Duder, or, uh, you know, El Duderino, if you're not into the whole brevity thing." It is as if the failure of the 1960s dream to unite a local, authentic "I" with a universal "We" of modernity has produced a compensatory circuit of names for a subject of political agency that was never fully realized but now puffs on the roach clip of collective feeling through his various ways of being commonly called, his "jerk off name[s]." We might read the first scene in the bowling alley as a kind of pedagogy in political feeling, with Walter as the teacher. The chilled-out Dude's flagging passions are inflamed by Walter's inexplicable outrage at the "unchecked aggression" of the rug-pee-ers: "there is no reason, there's no *fucking* reason, why his wife should go out and owe money all over town and then they come, and they pee on *your* fucking rug?!? Am I wrong!?!" Tellingly, the Dude borrows not just Walter's *rhetoric,* which, throughout this scene, itself borrows both the Dude's claim that the rug "really tied the room together" and Bush 41's word, "aggression,"

here adjectivally inflated as *"unchecked* aggression," but his rhetorical inflections, his sense of having been *personally* injured: "You know, this is the fucking guy, I could find this fucking Lebowski guy . . . This is the guy who should compensate me for the fucking rug. His wife goes out and owes money all over town and they pee on *my* rug?" "Thaaat's right, Dude," Walter responds, "they peed on *your* fucking rug." Walter's incitements prompt speech imbued with a sense of agential property and propriety that draws firm boundaries around "us's" and "them's," victims and victimizers, that holds persons accountable for not abiding by rules and reason. A Schmittian monster, Walter uses language to carve up an antagonistic political field into WE's and THEY's. In doing so, he offers the Dude a semblance of the contestatory sphere of politics that recalls, as it burlesques, his activist past that will be fully summoned in the next scene. Walter's language gives the Dude affect, purposive orientation, or, to poach the language of the Port Huron Statement, "an agenda": namely, to "find this Lebowski guy" and redress the wrong represented by the soiled rug. So, he poaches the political rhetoric of Bush 41—"Well, I *do* mind, uh, The Dude minds. This will not stand, you know, this aggression will not stand, man. I mean, your wife owes money—" but his conviction stalls as his declaration fails to clarify its agent or its object, or even finish its thought. He is interrupted by the Big Lebowski, who accuses him of confusing responsibility and blame, and then responds, exhaustedly, "Ah, fuck it."

Logjammin'

> MAUDE: It's a male myth about feminists that we hate sex. It
> can be a natural, *zesty* enterprise. However, there are some
> people—it is called satyriasis in men, nymphomania in
> women—who engage in it compulsively and without joy.
> DUDE: Oh, no.

Fuck it, indeed. We might say that the condition of linguistic alien-ation in *The Big Lebowski* boils down to the variety of ways one can say "fuck it." For the Big Lebowski, of course, "Fuck it" is the signature statement of a defeated revolution, as the glaze of post-war apathy is briefly cracked by revolutionary speech before the bums finally lose again and complacency and indifference return. The word *fuck* and its various permutations is the profane heart of the film's expressive world, the warp and woof of the fabric of its demotic speech. This is why, much to the Stranger's chagrin, the Dude "[has] to use so many cuss words." *The Big Lebowski*'s barrage of F-bombs land at the crossroads of the un-sayable and total sayability, in which paucity becomes excess, scarcity plenty, and linguistic poverty a lesson in virtuosity, of how to say more with less. In the mouths of consummate vulgarians, *fuck* is a word of dazzling polysemy, of stunning referential plasticity. It can identify and condemn ("The fucking point is . . ."; "Fucking Quintana. That creep can roll, man!"), and can express wonder or affirmation ("Fuck-ing A!"); it can characterize a seemingly impossible situation ("Nothing is fucked, Dude!"); it can call for referential clarity ("What the fuck are you talking about?"), become form of aggression ("Are you ready to be fucked, man?"), or an unwelcome meddling ("Nobody fucks with the Jesus"). The film's punning insists upon its pornolinguistics, its confla-tion of fucking and the limits of communicability. We see this when the Dude deciphers Jackie Treehorn's hidden message only to find a hastily sketched hard-on where something more meaningful should be. *Log-jammin'* is the name of Bunny's porno, and slang for a communicative impasse, the unworking of logos. The condition of having "lotta ins, lotta outs," for the Dude, names the press of narrative complexity upon his addled brain, but the "in and out" also refers to simpler forms of leisure: tasty burgers and mechanical sex. And, of course, bowling. For saying "fuck it," in this film, is almost always followed by "Let's go bowling."

The sex-bowling metaphor is used most poetically in *The Big Leb-owski*'s pornographic film-within-a film *Gutterballs,* that justly famous homage to the extravagant dance numbers of Busby Berkeley, Warner Brothers' in-house surrealist of the 1930s. An object of pure visual plea-sure stalling whatever is left of the film's shaggy-dog plot, the Dude's fever-dream also provides a hyperbolically self-reflexive commentary on the relationship between spectacle and narrative in the film's inter-texts. Giving the Dude a quick look at *Logjammin'* earlier in the film, Maude remarks disdainfully, "The story is ludicrous." Pornography, the Dude knows, is about fucking, not fixing the cable. Chandler's *The Big Sleep,* remember, has at least one more dead body than killer, and How-ard Hawks's filmed adaptation, more screwball comedy than film noir, famously courted this latent nonsense in Chandler's novel, supplanting its noir morality with a campy hash of disconnected, damned funny *scenes.* And the musical is the Hollywood genre genetically sustained by the oscillation between narrative and spectacle. What Rick Altman calls "the profoundly neoplatonic character of the Hollywood musical," its structural oppositions—and magical crossovers—between the real and the imaginary, the ordinary and the dream, the humdrum and the fantastic, is built on the narrative/spectacle opposition that Berkeley's Depression-era musicals take to a kitschy zenith (86). Plot is rarely so banal (the vicissitudes of "puttin'-on-a-show" during hard times) as in his films, and spectacular interludes are never so sublime.

For film geeks, part of the fascination of Berkeley's work is its arch self-reflexivity, the way his signature traveling, crane, or top-shots draw their own metaphorical equivalences between sinuous camera move-ment and dance, between cinema and sexuality—specifically, the ob-jectified sexuality of women's bodies that Berkeley abstracts into as-tonishing arabesques. Berkeley, then, is something of a pornographer, treating "objects like women," as the Dude says of Jackie, through his

serial reifications of the female form. Indeed, a powerful line of feminist psychoanalytic film theory has developed from a reading of Berkeley's construction of the female image as a frozen spectacle of erotic plenitude staving off the threat of castration. His two signature shots—the traveling crotch-shot between the spread legs of women and the top-shot of female dancers forming "symmetrical abstract floral mandalas... constantly refiguring themselves as intricate petaline vulvas"—confirm Maude's belief that most men find *vagina* difficult to say directly.[2] Both shots are, of course, directly cited in *Gutterballs,* and in a cheeky way, since the nihilists who menace the Dude with castrating scissors in the dream's second portion prove that the Coens, like all film school graduates, have read Laura Mulvey.

Does this sequence amount to more than "jerk-off" reflexivity? The Coens are having fun, but in catering to our visual pleasure, they don't seem particularly interested in, nor do they share, Berkeley's instrumental violence to the female form. Rather, they ask us to leave narrative behind, to enjoy, stupidly, their virtuosity, and so to abide in the Dude's healthy capacity for enjoyment. In doing so, the *Gutterballs* sequence returns us to the utopian dimension of the musical, its suspension of the world of instrumentality, which it links to the place of the bowling alley. As Altman has shown, the musical formally eases passages in and out of its utopia through the "audio dissolve," a technique Berkeley honed to perfection (62–74). The goal is to guide the viewer sonically from life-world to dreamworld, melting from diegetic sound without music to diegetic music to supra-diegetic orchestration—transcendent music. The Coens' sonic bridge functions accordingly: moving from the diegetic sound of the Dude's conversation with Jackie to non-diegetic, subjective, slurred rumblings of the Dude's drugged mind, to the soaring lyricism of Kenny Rogers's aptly psychedelic "Just Dropped In." In this lyrical space, space and time are suspended, and causality is reversed

3.1. A lesson in pleasure.

as *action follows sound.* The sequence's rhythmic editing patterns, like the dancers' gestures, are dictated by the song's trippy lyrics and steady beat. The tune's opening, swelling chant of "Yeah, yeah, oh-yeah," for example, finds a perfect graphic match in the swelling erection of the bowling pin and balls in the credit sequence, and its final "oh-yeah," the Dude's *petit morte,* is punctuated by his strike. The camera tilts up toward the tower of bowling shoes on the lyrics "fell-a eight miles high," and then cuts to the infinite bowling alley that will be the Dude's terminus on the phrase "dead end sign." It also cuts punningly to the first shot of the Dude floating down the lane, and toward his strike, at the end of the line "Eight miles outta Memphis and I got no spare," and the Dude, heretofore face-downward, begins to flip upward to face the open legs of the Brunswick chorines precisely between the "up" and "down" of the line "straight up downtown somewhere." The point is not that the

3.2. Corporeal theater of the common.

directors are clever men, though the Coens are most certainly that, but that, as in Berkeley's extravaganzas, when we reach the climax of *Gutterballs,* we "have entirely abandoned the representational mode. *Everything—even the image—is now subordinated to the music track*" (Altman 71). This pornography is not about doing it or really getting anything done. It is about enjoyment, a lesson in pleasure.

And isn't this same lesson enacted by the Dude in this sequence? Despite Jeff Bridges's lewd pelvic-thrusting as he jives his way down the stairway to bowling heaven, the Dude is not so interested in "banging" Maude, in the parlance of the film, but in teaching her to bowl. No matter that Maude hopes to dispel the myth that feminists, like porn stars, screw without joy. For her sex is an enterprise, an exchange not unlike that pitch Bunny makes to the Dude: "I'll suck your cock for a thousand dollars." (She does hail from Moorhead, after all.) In her

sexual manipulation of the Dude to produce an heir, the film makes clear that Maude fucks like she talks—clinically, and with instrumental precision. As the Dude assumes the position behind Maude, he raises the bowing ball over his head to a seat of tumescent authority, a graphic echo of Quintana's post-strike raised fist. But this phallic verticality quickly gives way to his gentle positioning of Maude's fingers in the holes of the bowling ball, to their rhythmic mutual swinging of the ball back and forth, and finally, to the Dude's yielding horizontality as the ball, now the Dude himself, is set adrift down the lanes. The upshot? Maude, the film's real "Big Lebowski," is all instrumental power with no enjoyment, while the Dude is all enjoyment, full of love but pretty fucked as a political agent. Like Berkeley, whose fantasies of pleasure always revealed their socio-political underside, the Dude's orgasmic strike is framed in *Gutterballs* by Saddam Hussein and the nihilists, the aggression of political demagoguery and the political impotence of non-belief. Between these extremes of political functioning is jouissance—that constellation of passions, fantasies, and identifications that is the affective raw material for building the group identities constitutive of political life.[3] And the home of demobbed political passions in the film, as *Gutterballs'* choreography affirms, is the bowling alley.

The bowling alley is an extension of film's broader, pornolinguistic logic. It is a space of nonsense and pleasure that always threatens to become a musical, stalling action and encroaching on speechlessness, the outside of sense. The rapturous slow motion of the film's opening credit sequence, as it anticipates Quintana's own musical number or the suspended nude bodies at Jackie Treehorn's beach party, celebrates bowling as a space of corporeal gesture, of human action at its most vir-tuosic, refusing to congeal into an instrumental product or end. As the camera tracks lovingly over the labor of the foot deodorizer, spraying a series of anonymous public shoes, readying them for new users; or past

lane by lane of the now-graceful bodies of common folk, casting ball after ball toward the pins; or hovers over a pudgy hand poised at the dryer, preparing for action, the Coens make a spectacle of common life. And here the Coens' implicate their own stylistic capacities in this spectacularity, since their fluid wide-angle camera work is never so fucking virtuosic as when it turns bowling into corporeal theater. The bowling alley, the pornstar's body, the mise-en-scene of *Gutterballs*—all are gestural spaces, all are spaces of the total publicity of spectacular culture, which is to say, of the human's complete alienation from its common being in language.[4] But the Coens refuse a conservative narrative of the bankruptcy of public life in a horizon of stupidity. The pornutopia of Dudespeak peddles neither nostalgia for the past nor the promise of a future, but rather the profane pleasures of abiding the total alienation of the multitude. In such states of suspended agency, where we see most clearly our naked need for enjoyment, we might affirm again our capacity for speech, for action, and for the collective passions of politics. I don't know about you, but I take comfort in that.

Notes

1. For a reading of the manifesto along these lines, see Lyon.
2. See David E. James's superb discussion of Berkeley in *The Most Typical Avant-Garde*, 79.
3. For a reading of the role of affect and jouissance in the structuring of political and popular identities, see Mouffe, as well as Laclau.
4. I'm indebted here to Giorgio Agamben's suggestive musings on the relationship between gesture, spectacular publicness, and pornography: "And how can one touch the porn star's body, since there is not an inch on it that is not public?" See *Means without End*, 123.

4 Metonymic Hats and Metaphoric Tumbleweeds: Noir Literary Aesthetics in **Miller's Crossing** and **The Big Lebowski**

Christopher Raczkowski

In his important study of film noir *More Than Night,* James Naremore argues for a rethinking of noir in terms of discourse, as "an evolving system of arguments and readings that helps to shape commercial and aesthetic ideologies" and, as Naremore goes on to elaborate, political ideologies (11). In other words, noir is less a set of formalized cinematic gestures—visual styles and narrative procedures—than a cultural strategy that resonates across multiple artistic, commercial, and intellectual forms. Thinking noir as Naremore does, as discourse rather than genre, provides an answer for a question that has vexed me for some time about Joel and Ethan Coen's *The Big Lebowski:* can this movie be meaningfully grouped with *Miller's Crossing* (1990) as a noir text? Certainly, both draw inspiration from the well of classic Hollywood noir films; indeed, the movies are frequently referred to as the first two installments of the Coens' "noir trilogy." And, yet, they are jarringly antithetical in look and feel. It is this gap between the noir aesthetics of *Miller's Crossing* and *The Big Lebowski* that interests me the most and animates the analysis that follows. The virtue of Naremore's definition is that it treats relations between noirish texts as dynamic rather than categorical and restrictive; only such a protean and yet tactical conception of noir will do for making sense of the complex relation of *Miller's Crossing* and *The Big Lebowski.* While commentators tend to ignore the aesthetic divide between these movies or reject the proposition that *The Big Lebowski* can

be sensibly grouped with other noir films at all, I argue that the tension is fertile and productive of a noir dialectic evolved by the Coens in the two movies.

This tension appears in its most aggravated form in the films' respective protagonists. In both cases, a character is unwittingly thrust into the role of detective. Although their investigations are finally superfluous, the characterological differences between these accidental detectives result in the wildly different types of investigations that structure each movie. Consequently, *Miller's Crossing* bares the austere stamp of its phlegmatic anti-hero, Tom Regan, while *The Big Lebowski* is marked by the immaculate leisure of its protagonist, an aging hippie-stoner, known as "the 'Dude' . . . or uh, his 'Dudeness,' or uh, 'Duder,' or uh, you know 'el Duderino,' if you're not into the whole brevity thing." The somber look and narrative restraint of *Miller's Crossing* may be hard to reconcile analytically with the comic lavishness and psychotropic excesses of *The Big Lebowski* in terms of a film noir tradition, but such a reconciliation can be affected if we consider the antecedent literary noir tradition. In fact, the Coens have repeatedly suggested that their audience do just that: in interviews and press kits, the Coens discuss the literary noir (or hard-boiled) influence of Dashiell Hammett on *Miller's Crossing* and Raymond Chandler on *The Big Lebowski*. Despite such acknowledgments, few critics have undertaken a thorough study of this literary influence and how it structures the intertextuality of their films, as I do here. By attending to these literary noir antecedents, it becomes apparent that the aesthetic antagonism between *Miller's Crossing* and *The Big Lebowski* is the same antagonism that separates the competing noir aesthetics of Hammett and Chandler: one emphasizes a metonymic figuration of the world, and the other emphasizes a metaphoric figuration.

In structurally parallel opening credit sequences from *Miller's Crossing* and *The Big Lebowski,* the Coens establish visual tropes announcing

the films' allegiances to Hammett and Chandler, respectively. The empty black fedora that focalizes the credit sequence in *Miller's Crossing* establishes the priority of metonymy and the noir aesthetics of Dashiell Hammett. Metonymy, as what Hayden White terms a "reductionist trope," relies upon a relationship of contiguity between objects. As it eschews intrinsic and qualitative relations for the extrinsic relations of proximity, metonymy tends to reduce the whole to one of its parts (35). In the case of the black fedora, the hat refers to Tom through its contiguous relationship with Tom's physical body; it substitutes the container for the contents. It remains an oddly extrinsic figure, not a metaphoric figuration of identity. In the metonymic logic of *Miller's Crossing*, the fedora of the opening sequence refers to Tom but remains symbolically, and physically, empty: it offers no insights, stays with the surface. The metonymy of this central resonating image marks the film's debt to what William Marling has cogently termed the "metonymic aesthetic" of Hammett's noir fiction—its characteristically terse prose and the cold, depthless surfaces of its narration (117).[1]

The tumbling tumbleweed that opens *The Big Lebowski*, on the other hand, introduces the priority of metaphor to that film's aesthetic vision. The tumbleweed's lazy journey from the desert floor down Santa Monica Boulevard and to the beach ends with a quick cut to the Dude's lazy wandering across the shiny linoleum aisles of Ralph's Supermarket. The cut from the image of the tumbleweed to the Dude, with a cowboy crooning in the background—"See them tumbling down. Pledging their love to the ground. Lonely but free I'll be found. Drifting along with the tumbling tumbleweed."—asserts an intrinsic relationship of identity between two extrinsically unrelated things. The Dude is a tumbling tumbleweed. Figuratively speaking, he is "unattached, shiftless, a wanderer," etc. This seems straightforward enough, but then the Coen brothers subject the metaphor—a cliché really, seized from

B-movie westerns—to a series of contextual shocks through shifting generic cues that multiply its possible symbolic figurations. As the tumbleweed passes through modern downtown L.A., it starts to look like a prop from a cowboy movie, and the city appears like a film location set, which, of course, they are. Consequently, the Dude becomes imaginatively identified with the tumbleweed as a quaint cultural anachronism, and any clean discernment between the inside and the outside of the movie is momentarily disrupted. It is possible to extend this line of analysis, but the point is that the genre-mulching of *The Big Lebowski* disrupts, by multiplying, the types of assumptions and attitudes the audience brings to the metaphor's interpretation. Such metaphoric excess, and the extravagant filmic metaphors established through the Dude's drug- and head trauma-induced hallucinations, are markers of *The Big Lebowski*'s allegiance to Chandler's noir aesthetics. The critical discernment is that in Chandler, the metaphoric excess tends to be qualitative—as Garrison Keillor's "Guy Noir" parodies of Chandler make clear—while in the *Big Lebowski,* the excess of metaphors tends toward the quantitative.

The Dude's stuttering, wandering, chaotic dialogue reflects his general bewilderment at the characters and events that surround him. His is precisely not the magisterial subjectivity of Philip Marlowe that uses metaphor to disarm his opponents and to organize an intelligible world with motivated agents.

Formulated in terms of the noir literary aesthetics of Hammett and Chandler, the striking difference between the noir vision of *Miller's Crossing* and *The Big Lebowski* is the difference between a metonymic aesthetic of impenetrable surface and a metaphoric aesthetic of depth and identity. The stake wagered by the Coens on these competing noir

4.1. "An excessive metaphor?" Brian Benedetti, photographer.

Christopher Raczkowski

aesthetics, I argue, is on the possibility of resistance or escape from the reified modern social world that is the sine qua non of almost all forms of noir narrative. Both represent worlds where social institutions are governed by quasi-legal business interests, human lives are measured in exchange values, and possessions are valued in human terms. In the classic Marxist formulation, both *Miller's Crossing* and *The Big Lebowski* reveal worlds where subjects are transformed into objects, and objects are transformed into subjects; or as the Dude explains of the film's ethereal underworld kingpin and adult movie mogul: "Mr. Treehorn, treats objects like women, man."

Metonymic Hats

The art deco office furniture, sharply angled fedoras, and thick blue tobacco haze of *Miller's Crossing* points directly to the classic noir films of the 1940s and the between-the-wars modernism of the film's literary urtexts: Dashiell Hammett's *The Glass Key* and *Red Harvest.* In basic terms of plot, character, and setting, the film's debt to Hammett's hardboiled aesthetics is both direct and directly acknowledged by the Coens in the film's press kit. One of the happiest features of the film's elaborate reconstruction of a stylized noir universe, no doubt, is its scrupulous use of hard-boiled idiom glommed from Hammett's original texts. Gabriel Byrne's signature "What's the rumpus?" for example, is lifted from the pages of *Red Harvest,* while many of the films other hard-boiled lyricisms—"Take the flunky and dangle"—depend on a clipped, agile syntax and diction that evokes a distinctive type of Hammett-ese.

In addition to their skilled rendering of Hammett's verbal idiom on the level of dialogue, however, the Coens also adopt a visual idiom from Hammett's noir aesthetics: an attention to surface and exteriority that eschews any depth of affect or symbolic meaning. Take, for example, the

following characteristic passage from Hammett's early Continental Op story, "The Whosis Kid":

> A curtain whipped loose in the rain.
> Out of the opening came pale fire-streaks. The bitter voice of a small-caliber pistol. Seven times.
> The Whosis Kid's wet hat floated off his head—a slow balloon-like rising.
> There was nothing slow about the Kid's moving. (189)

The Op's first-person narration proceeds along the visible surfaces of a curtain, the propulsion of bullets and bodies, and a slowly rising hat. Little or no subjective contents appear in the passage; no fear, anger, or recognizably human responses are visible from the actors involved or the narrator who observes them. In fact, there are really no human bodies visible at all, just the oddly Kid-less observation of the "Kid's moving." In the grammar of the sentence, it is the "moving" that is attended to, the "Kid" is reduced to the status of a modifier for the prioritized gerund.[2] Ultimately, it is the Kid's hat that focalizes the scene. Its "slow balloon-like rising" cinematically decelerates time and momentarily frames the unoccupied hat as if in still life. And yet, despite its careful elaboration, the hat is not freighted with any symbolic value for the Whosis Kid. As metonymy—the container, again, is substituted for the contents—the hat partially informs the reader of what has happened to the Whosis Kid by referencing his presence (or absence), but it carries little to no symbolic or explanatory significance. The question almost directly asked by the title and rephrased every time the title character is mentioned— "Who is the Whosis Kid?"—remains unanswerable in the story.

I apply such a high degree of interpretive pressure to a passage from an otherwise unremarkable early short story by Dashiell Hammett in order to draw attention to its probably unintentional but inspired

reprisal by the Coens during the credit sequence of *Miller's Crossing*. Following the opening scene in Leo's dark office, the film score is introduced, and head titles are super-imposed over a slow-moving shot of the forest ceiling. The intricate groining of the tall, overarching tree branches against the sky and the swelling musical score give the scene a cathedral-like and portentous feel. Suddenly the score decrescendos, and the shot changes to ground level as a black fedora falls to the forest floor. The film title appears for a moment before a gust of wind picks up the hat and carries it gracefully tumbling in slow motion into the distance until it disappears. Iconically mirroring the "slow, balloon-like rising" of the Whosis Kid's hat, the black fedora from this credit sequence announces the Coens' investments in a metonymic aesthetic associated with Hammett's hard-boiled modernism, although that investment does not become clear until the empty fedora from the opening sequence is methodically emptied of any metaphoric significance.

About midway through the movie, this emptying of an empty hat occurs when Verna, the Coens' femme fatale, wakes up to find Tom Reagan already awake and pensively smoking a cigarette. She asks him, "What're you chewing over?"

> TOM: . . . a dream I had once. I was walking in the woods, don't
> know why . . . The wind came up and blew my hat off. . . .
> VERNA: And you chased it, right? You ran and ran and finally you
> caught up to it and picked it up but it wasn't a hat anymore. It
> had changed into something else—something wonderful.
> TOM: No. It stayed a hat. And no, I didn't chase it . . . noth-
> ing more foolish than a man chasing his hat.

Nearly an hour after its first appearance, the free-floating black fedora of the credit sequence is revealed as an object in Tom's recurrent dream. At last, it seems as if we are about to find out something about the movie's

vexingly impenetrable protagonist. In noir literature and film, which abound in dreams and hallucinatory episodes, such scenes typically offer some furtive glimpse into the protagonist's interiority—the otherwise hard-boiled shell is momentarily cracked in order to get at the yolk of identity and desire, so to speak. Verna, who seems familiar with the genre, makes the interpretive leap that the audience is poised to make when she interrupts Tom to complete his dream narrative. The hat dream, she and we presume, will clear up the stubbornly vexing question of just who Tom Regan is by revealing his desire. The elusive hat, as Verna reads it, symbolizes the "something wonderful" that eludes Tom's grasp—possibly Verna herself. The Coens reinforce such an interpretation in their framing of the scene; its prioritized location in the film and its careful visual treatment all evoke the hat's symbolic depth. The hat, however, remains stubbornly, non-symbolic. "No," Tom abruptly cuts her and us off in our metaphoric reading, "It stayed a hat. And no, I didn't chase it."

Where metaphor operates on the level of the symbolic transference of meaning between two seemingly incongruous entities, metonymy operates "between extralinguistic entities, that is, between objects, and is in no way contingent on the language used to express such a relationship . . . the metonymic pole is thus essentially a referential process, located beyond language, while the metaphoric pole is semantic and consequently intralinguistic" (Issacharoff 419). Like the Whosis Kid's hat, the black fedora refers to, rather than symbolizes, Tom through a relation of contiguity, without transferring qualitative meaning to him. As mute adjuncts, these metonymic hats illustrate the reductionist strategies of Hammett's noir aesthetic as it is adopted by the Coens: containers are referentially substituted for contents without modifying them on the level of meaning.

On a characterological level, Hammett's commitment to a metonymic aesthetic flattens depth and punctures the interiority traditionally identified with liberal humanist conceptions of the self's interiority as stable and self-determining. For the first-person narrator of *Red Harvest*—the anonymous Continental Op that serenely "juggles death and destruction" in Hammett's early fiction—the self is almost all exteriority, surface. In the Op's words, it is the "hard skin all over what's left of my soul," and as the Op makes clear, precious little of this privileged interiority is left (156–57). By Hammett's later fiction, there is nothing of this interiority left: there is no self safely ensconced beneath the surface of social relations. This absence gets registered formally in Hammett's shift away from the unnamed first-person narrator of the Continental Op stories to the icily detached third-person narration of his later work. For the object world of Hammett's fiction, such depthlessness receives its central expression in the eponymous statuette of his third and most influential novel, *The Maltese Falcon* (1930). When the Falcon, the object of desire that motivates all the novel's action, is finally attained, it is found to be worthless. The black lacquer that was believed to conceal precious metals and gems conceals nothing but additional layers of dense, soft, dark lead: dark surface beneath layers of more dark surface. The emptiness behind the mask of subjectivity in Hammett's fiction finds a correlate in what John Walker refers to as the "epistemological emptiness" of the object world in Hammett's noir universe, where surfaces conceal no depth of meaning or significance.

While operative in a visual style that favors a metonymic noir realism, the depthlessness that the Coens seize on from Hammett's also emerges on the level of direct utterance as a kind of thematic refrain from Tom. Investigating the Rug Daniels murder that precipitates the plot,[3] Tom interrogates Verna:

> VERNA: You think I murdered someone? Come
> on, Tom, you know me a little.
> TOM: Nobody knows anybody—not that well.

Later, Tom repeats this statement verbatim to Johnny Caspar, the sociopath and amateur ethicist mob boss at war with Leo for political power:

> CASPAR: ... somehow it don't seem like him. And I know the Dane.
> TOM: Nobody knows anybody—not that well.

Tom's commentary on the depthlessness of identity becomes increasingly urgent in the film as he counters increasingly urgent claims for some stable human interiority from putative heroes and villains alike.

When Tom is first charged by Caspar's flunkies with the task of taking Bernie into the woods at Miller's Crossing and executing him, Bernie's appeals to Tom are a rambling thesis on the intrinsic values that underwrite a humanist conception of identity as a kind of stabilizing interiority:

> Tommy, you can't do this. You don't bump guys. You're not like
> those animals back there ... They can't make us different people
> than we are ... We're not like those animals. You can't do this!
> You're not like those animals. This is not us ... You can't kill me.
> I'm praying to you! Look into your heart! I'm praying to you! Look
> into your heart! ... Look in your heart! ... Look in your ...

When his speech is interrupted by an echoing gun blast and the camera moves to a close-up of Bernie, he seems almost as surprised as we are that he is still alive. Tom appears unmoved by Bernie's desperate appeal to some fundamentally human interiority symbolized by the heart, and yet he lets him live.

Upon the scene's repetition at the film's end, even the apparent authenticity of Bernie's desperation and horror are called into question. Bernie falls again to his knees and clasps his hands, repeating the same words and gestures to Tom that he had first used in the woods—"Look into your heart! Look into your heart!"—only this time, even Bernie cannot summon the appearance of depth his performance simulated earlier in the woods at Miller's Crossing. Tom's response before shooting him—"What heart?"—rejects Bernie's synechdochic heart expressive of humanist interiority (compassion, generosity, mercy, etc.) and replaces it with a metonymic heart: a figure that reduces the heart to its central functioning among other organs of the biological body. In Bernie's case, it is the central organ that is about to stop functioning. At the same time, Tom's "What heart?" points up the fatal shortcoming of Bernie's plea for his life: he cannot really seem to get his heart in this final, curtain-call performance.

The final scene of *Miller's Crossing,* marks the logical extension of these aesthetic strategies. Tom and Leo—Tom's friend who had ruled over the city as a kind of anachronistically Victorian syndicate boss— are reunited at Bernie's funeral, and the two reflect on the accumulated chaos and violence that have resulted in Leo's reconsolidation of political power at the film's end. Following the plot of Hammett's *Red Harvest,* Tom appears to have saved Leo's political regime, unbeknownst to Leo, by publicly breaking allegiance with him and joining forces with Johnny Caspar in order to sabotage the organization of his rival. When Leo strives to re-contain the eruptions of chaos and betrayal that ensue from Tom's actions as a narrative of purposeful action and loyalty— much as the audience has done—Tom's response is glib and as devastating as anything that has happened thus far in the movie:

LEO: It was a smart play, all around. I guess you know I'm grateful.

TOM: No need.

LEO: I guess you picked that fight with me just
to tuck yourself in with Caspar.

TOM: I dunno. Do you always know why you do things, Leo?

LEO: Sure I do [he nods to himself] . . . it was a smart play
. . . As for you and Verna, well, I understand, you're both
young and, well, damnit, Tom, I forgive you!

TOM: I didn't ask for that and I don't want it. . . . Goodbye Leo.

By reading the text of *Miller's Crossing* synechdochically, by integrating its narrative events into "a qualitative relationship among the elements of a totality"—the whole is greater than the sum of the parts in Leo's narrative configuration—Leo strives to effect a comic, unifying order over the chaos and violence that have erupted over the previous two hours of the film. Unlike Bernie, though, Leo takes the synechdochic heart seriously—he calls himself a "big-hearted slob" and abides by gentlemanly codes of romantic conduct with Verna. Indeed, Leo's residual Victorianism is a chief element of his considerable charm and makes Tom's protective behavior toward Leo seem understandable. Tom, however, will no longer suffer Leo's anachronistic humanism or comic emplotments of the modern world. He no longer finds them charming. Tom has come to see Leo's romantic view as a clumsy, if endearing, foible in his personal affairs, and a deadly, expensive blind spot in his political management of the social world. While there may be a qualitative difference between a city ruled by Leo's synechdochic heart or Johnny Caspar's artless pragmatism, the quantifiable difference is nil: the body count remains the same. It is largely a question of whether the police raid the Italian men's clubs or the Irish men's clubs. Restoring Leo to power at the film's end, Tom leaves his friend and the city to the disas-

trous promise of more of the same—an anti-climactic non-resolution that the Coens adopt directly from the noir strategies of Hammett.

Metaphoric Tumbleweeds

While the Coens' adoption of Hammett's noir aesthetics in *Miller's Crossing* is rigorous and extensive, their treatment of Chandler in *The Big Lebowski* is neither.[4] The disorienting mix of film genre—western, musical, sports, detective, porn, buddy movie—seems to discount the possibility of a singular or coherent influence on the film. Even the temporality of the film leads to a disorienting multiplicity: it's a pastiche of events and cultural strategies that overlays the Korean War with the Vietnam War with the First Persian Gulf War and Hippies with Rea-ganite Conservatives, German techno-pop nihilists and third-wave feminists. Watching the movie in 2007, this temporal disorientation gets amplified further as a new George Bush and a new Gulf War eerily haunt the flickering television image of George Bush Sr. announcing to the shoppers at Ralph's that "this aggression against Kuwait will not stand"—a kind of ghost of "Gulf War Yet to Come." And yet, there are still good reasons to think of the film as a strategic, rather than a system-atic, treatment of Chandler's noir fiction. *The Big Lebowski* references Chandler's *The Big Sleep* through its title, obviously, but also through a discreet set of similarities in plot and character: the location in Chan-dler's Los Angeles; the infamously Byzantine blackmail and false-kid-napping plot; the focus on a decaying patriarch plagued by the unruly young women of his family; the attention to drug and pornography sub-cultures; the narrative's ironic structuring of a needless quest, even the detective's seeming substitution for a man he superficially resembles; all these elements indicate the fundamental influence of Chandler on

The Big Lebowski. Still, the movie's most significant engagement is with Chandler's privileged metaphors.

In the *Big Sleep,* Chandler's narrator-detective, Phillip Marlowe, analyzes the bodies and spaces of Los Angeles for the reader through expert metaphor. When in the first chapter, Marlowe first meets the Sternwoods—the Coens' model for the Lebowski family—we get a condensed sample of how Chandler's metaphors work. Vivian Sternwood—reprised as Maude—has "ankles long and slim and with enough melodic line for a tone poem"; Carmen—"Bunny's" forerunner—flashes "sharp little predatory teeth as white as fresh orange pith and as shiny as porcelain" and General Sternwood—the Big Lebowski—has "dry white hair that clings to his scalp like wild flowers fighting for life on a bare rock" and "licked his lips like . . . like an undertaker dry-washing his hand" (5, 17, 14). While there are metonymic elements to these similes, the prevailing effect is decidedly metaphoric and descriptive of some essence of the character in question. In each case, symbolic meaning is transferred from incongruous objects to people. The "tone poem" of Vivian's legs and the impossible "white orange pith" of Carmen's "predatory" teeth give sharp insights into the grace of one and the pathology of the other. The metaphors that accumulate about the General's head relentlessly inform us of his serene tenacity in the face of his mortality and the ruin of his family—qualities which Marlowe evidently admires.

While Hammett's narration metonymically slides along the surface, Chandler continually arrives at depth and interiority with these metaphors—intrinsic qualities, identity, essence. If Hammett's metonymy tends toward dispersal of semantic meaning, Chandler's metaphors plumb psychological depth and reveal truth, so much so that one wonders why Marlowe does not take Carmen directly to the hoosegow upon noticing her teeth. The excessive quantity of Marlowe's tropes—similes, primarily, but also metonymies, synecdoches,

hyperboles—simultaneously carries a surplus meaning that also reveals Marlowe's interiority to the reader in whom he confides. This, of course, marks a profound difference from the icily depthless treatment of identity and subjectivity in Hammett and *Miller's Crossing*. In stark contrast to Hammett, Chandler's metaphors and first-person narration express emotion and reveal affect. Still, the cumulative result in Chandler's novels is that Marlowe is typically positioned as a kind of magisterial subject supposed-to-know, heroically patterning order and justice over a chaotic, fallen world.

The racial and sexual imperatives of Marlowe's metaphoric figurations, its residual Victorianism as well as its paradoxes and constitutive violence are bluntly defined by Chandler in an essay on the hard-boiled novel titled "The Simple Art of Murder":

> down these mean streets a man must go who is not himself mean, who is neither tarnished nor afraid . . . he is the hero, he is everything . . . a complete man and a common man and yet an unusual man . . . a man of honor . . . neither a eunuch nor a satyr . . . he is a lonely man and his pride is that you will treat him as a proud man or be very sorry that you ever saw him. (237)

The dangerous contingency of the modern city and the threatening forms of social, sexual, and racial difference he encounters there are not typically mastered through physical violence, although there is enough of that. In *The Big Sleep*, Marlowe's opponents are left speechless by virtuoso verbal performance, and the mysteriousness of the world—its contingency—is bridged by skilled metaphors that support the detective's reintegration of events and people into rational explanations and solutions of the crime.

Given its singular importance in Chandler's fiction, the most remarkable element of the Coens' adaptation of *The Big Sleep* might be

their replacement of Marlowe's narration with the Stranger's. As narrator, the Stranger's presence in the movie remains an unsolved diegetic mystery; he seems to have wandered in from the same neighboring film set as the tumbleweed. Cast as Sam Elliott—the well-known cowboy/western actor and the voice of the National Cattlemen's Beef Association—the Stranger offers up the most dramatic contrast possible to the urbane sophistication of Marlowe's narrative voice. His befuddled, western drawling, "aw shucks" opening narration concludes with a pause and the admission, "I lost m'train of thought here. But—aw hell, I done innerduced him enough." And he ends the movie with an "Aw look at me, I'm rambling again." This is a narrator who freely admits his inability to rationally organize the events and people that occupy his story. In fact, the Stranger's one attempt at Marlowe-style noir lyricism comically points up the fumbling similarity between Mark Twain's western frontier humor and hard-boiled metaphor. As the Dude blacks out, this time at Jackie Treehorn's Malibu estate, the Stranger intones: "Darkness warshed over the Dude, darker'n a black steer's tookus on a moonless prairie night. There was no bottom."[5] Here, as in Twain's self-ironizing humor, the speaker appears to get so caught up in his own rhetoric that the tropes become comically incapable of drawing attention to anything other than themselves.

Along the same lines, the most remarkable thing about the Dude's reprising of Marlowe as detective hero in *The Big Lebowski* is his almost equally comic ineptitude at language. In his study of language aesthetics in Joel and Ethan Coen's films, Paul Coughlin highlights "the Dude's inability to verbalize anything remotely like a reasonable explanation for his circumstances" (4). Nowhere is this more obvious than when the Dude tries to give his client, the eponymous Big Lebowski, an update on how the case is going about midway through the film. His explanation is a marvel of halting syntactic and grammatical confusion:

I—the royal we, you know, the editorial—I dropped off the money, exactly as per . . . Look man, I've got certain information, all right, certain things have come to light, and, you know, has it ever occurred to you, that instead of, uh, running around, uh, uh, blaming me, given the nature of all this new shit . . . this could be a lot more uh, uh, uh, uh, complex, it might not be just such a simple, uh . . . you know?

The Dude's stuttering, wandering, chaotic dialogue reflects his general bewilderment at the characters and events that surround him. His is precisely not the magisterial subjectivity of Philip Marlowe that uses metaphor to disarm his opponents and to organize an intelligible world with motivated agents. The Dude's witticisms, such as they are, tend to result in either physical assault and further head trauma, or dazed silence. Relative to Marlowe's verbal agility, the Dude can and does get tripped up in the most modest of conversational situations. The Big Lebowski's response to the Dude above, "What in God's holy name are you blathering about?" is frequently ours as well.

Having ruled out a sufficiently masterful speaker to articulate them, the Coens translate Chandler's metaphor into filmic metaphor.[6] The consequences of this shift from verbal to visual metaphor is central to the film's working through of *The Big Sleep*. Marlowe's charismatic populism, phallic rationality, and romantic idealism are all fashioned out of his quick-witted banter and skilled metaphors. In *The Big Lebowski*, these are the failed values associated with what Chandler calls a "man of honor" in the previous passage from "The Simple Art of Murder." It is this suspect concept of honor that drives and ultimately cripples Arthur Digby Sellers, Jeffrey Lebowski, and Walter but has little to do with the Dude.[7] In Chandler's fiction, Marlowe's constitutive loneliness is symptomatic of this residual code of honor. Like Walter's preoccupation with his dead brothers in Vietnam and obsession with the comatose Arthur Digby Sellers—the author of 156 episodes of a 1960s television

4.2. "What in God's holy name are you blathering about?!"

western about violently avenging lost honor, *Branded*—Marlowe repeatedly tries and fails to find communion with other men of honor who are dead like Rusty Reagan or dying like General Sternwood. An aging hippie stoner, the Dude's off-beat charisma is not the stuff of working-class populism, and his investigation of Bunny's kidnapping is anything but an exercise in logic and analysis—he only solves the case after he realizes his "thinking about the case had become very uptight." Read against Chandler's code of honor, the Dude is neither a lonely man nor a proud man, and no one is sorry to see him.

The first strategic effect of the film's redeployment of metaphor from narration and dialogue to image, then, is the interruption of the heroic masculinity that Chandler situates as a form of resistance to a reified noir universe. Through its association with Walter, Arthur Digby Sellers, Jeffrey Lebowski, and the television sound bite from George Bush

Sr., the Coen brothers' obliquely comment on the reactionary violence of Chandler's code of honor and Marlowe's heroism. In each of these characters, this concept of honor and its heroic subjectivity is rendered absurd. The second effect of the redeployment is a reflection of this first on the level of form. Relocated in the visual frame of the movie, the metaphoric excess that the Coens appropriate from Chandler functions quite differently. While embracing the disorienting and lyrical beauty of Chandler's metaphor, its strong connections to the spaces and history of Los Angeles, and its concerns with interiority and depth, the Coens' visual metaphors structure a type of resistance to a reified modern world that abandons Chandler's cumbersome dependence on a residual heroic manhood.

The *Big Lebowski's* visual metaphors—the dreams, hallucinations, non-diegetic inserts like the tumbleweed, and other highly stylized, non-mimetic shots at the bowling alley—accumulate quickly. I count at least six instances where distinct visual metaphors tend to dominate the scene: 1) the first credit sequence with the tumbleweed; 2) the second slow-motion opening credit sequence at the bowling alley with the impossibly sweet 7–10 split conversion; 3) the Dude's first blackout from head trauma and his aerial pursuit of Maude on a flying Persian rug over Los Angeles; 4) the Dude's second blackout at Jackie Treehorn's with the *Gutterballs* Busby Berkeley number; 5) the "castration dream" that ends that hallucination; and 6) the final bowling montage that follows Donny's impromptu funeral service. As this brief survey demonstrates, the film's visual metaphors tend to fall into one of two categories: the oneiric metaphors that belong to the stuff of the Dude's dreams and what I think of the lyric visual metaphors of the bowling alley that cumulatively produce a type of Brunswick Lanes romance.

What's most interesting about the first group is that the Dude's dreams tend to be symbolically thin but aesthetically vivid

representations of the contents of his consciousness. The Dude has his rug (re)stolen by Maude, and after being knocked unconscious, he dreams of chasing her over the night skies of Los Angeles as she flies away on his now magic carpet. The German nihilists threaten to cut the Dude's Johnson off, and he dreams that they chase him with giant scissors. Offering neither proleptic nor psychological insight, these dream narratives are more like the dumb shows of Renaissance Drama than the dream work of Freudian psychoanalysis. One thing we can say about the Dude's castration dream, for example, is that it does not seem to be a castration dream. It has nothing to do with sublimated oedipal anxieties. The German nihilists told the Dude that they are going to cut off his penis, so he dreams about them attempting to cut off his penis. The Dude's dream does not even offer a particularly frightening reference to this castration threat; the Germans that absurdly chase him with giant cardboard scissors run in place and wear embarrassingly tight red spandex body suits that make it appear that they have already been castrated. Collectively, these dream metaphors are visually lush, even beautiful at times, but symbolically and representationally weak; their meaning is oddly underdetermined. They tend to summarize rather bland material in the manner of fantastic exaggeration more than they organize the material of the Dude's unconscious or the plot's Byzantine mystery.

The second significant tendency in *The Big Lebowski's* visual metaphors is isolated to the bowling alley. A filmic strategy typically associated with metonymy, the bowling alley montages in *The Big Lebowski* have little to do with the compression of narrative events, and as they gather force through their extension and repetition in the movie, they take on increasing metaphoric meaning. Together the two primary montages that begin and end the movie provide a visual lyric on working-class culture and community: the abstract starburst neon lights, the molded streamform ball-return machines and highly reflective surfaces

of balls and alleys; the multiply raced and gendered and aged bodies—clothed in unfashionably snug polyester—the cigarettes and Miller High Life, are all lovingly rendered by the Coens in an unexpected and almost transcendent beauty. The Coens' liberal use of slow motion in these montages captures the poise that the physics of bowling requires from a skilled bowler's slightly flabby body—a now forgotten graceful athleticism that must have been part of the sport's original popularity before its debasement. Close-ups of bowlers' faces reveal an intensity of purpose and delight in performance that is then mirrored in long shots of the facial expressions and pumping arms of the other bowlers watching. As the bookends of the film's narrative, these prioritized bowling montages are scenes of purpose, engagement, pleasure, and connection that seem to fly (scandalously) beneath the radar of a larger, official culture.

Here we find an answer to the question that began the investigation of noir aesthetics in this article: what, if any, are the possibilities of resistance or escape from the reified universe of noir? *The Big Lebowski* frames one possible form of resistance through the community—seemingly unalienated and integrated—metaphorized in the bowling montages. There we find a community founded on a combination of the pleasures of skilled performance, ritual, and shared experience. But above all, the cross-cutting between bowlers and audience in these montages make it clear that it is a community founded on the pleasures of what Paul Wolff calls "the reciprocity of awareness between oneself and the others" that characterizes an affective community:

> It is this mutuality of awareness, and not merely familiarity or habit, which makes participation in one's own traditions, however meager they may be, more satisfying than observation of the rituals of others, no matter how elaborate or aesthetically excellent. (186)

The diverse, elective, working-class community evoked in these scenes identifies a quasi-utopian social space within postmodern Los Angeles. It is where the Dude abides and takes it easy for all us sinners outside.

The answer to this same question in *Miller's Crossing* is no. Tom Reagan's ultimate break from Leo and Verna, his final sense of alienation even from himself—"do you always know why you do things, Leo?"—and the city's return to a murderously corrupt oligarchy signal the futility of such a resistance. Both the social world and the agents that fill it remain alienated and locked into the murderous logic of marketplace competition. The metonymic aesthetic the Coens adopt from Hammett is uniquely appropriate to the representation of such a reified social world. Metonym incorporates the logic of reification as it continually reduces individuals to objects or economic functions. Its emphasis upon surface relations and contiguity over depth and identity tends to "thingify" the world. The radical negativity generated by such a metonymic noir aesthetic, however, may well offer a covert resistance to the modern world it seems merely to represent. As Christopher Breu has argued of Dashiell Hammett's *Red Harvest,* its radical negativity "cancels individual identity as much as collective identity," but like Adorno's account of high modernism, "noir holds out the possibility for a utopian resolution of the contradictions of the present in its very refusal to resolve them within the frame of the narrative" (27). Read this way, the profound metonymical negations of *Miller's Crossing* may be read as the elliptical political space into which the *Big Lebowski* puts metaphoric utopian content. This, finally, is the noir dialectic transacted between the two movies. The quite thorough rendering of Hammett's metonymic aesthetic in *Miller's Crossing* results, as it must, in a radical negation of social, political, and psychological meaning. Indeed, the Coens' adoption of Hammett is so methodical—in terms of setting, tone, dialogue, and narrative structure—that many critics, including Naremore, view

it as an ahistorical exercise in noir style, along the lines of Jameson's views of postmodern pastiche. As I see it, though, the emptying work of *Miller's Crossing*—which is central to Hammett's fiction—levels the aesthetic and political ground for the Coens' more experimental adoption of Chandler's noir. The priority of metaphor in *The Big Lebowski* allows for the oblique introduction of some kind of utopian content while seemingly authorizing the film to reflect on the historical contingencies that inform its production: the Gulf War, Reaganomics, the Hollywood culture industry.

Still, the utopian content that emerges from *The Big Lebowski*—the community of affect metaphorized in the bowling montages—is qualified and fundamentally ambiguous. While Hammett's metonymic aesthetic results in a tacitly misogynistic disavowal of affect in *Miller's Crossing, The Big Lebowski* embraces affect warmly and with a big sloppy hug. The Dude is gloriously soft. Where Tom Regan is the epitome of hard-boiled shell in *Miller's Crossing,* the Dude is all yolky interiority.[8] The Dude's desire and affective investments pour out everywhere, and his most important self-fashioning is as a lovable hippie pacifist. Still, the Dude's biggest limitation as a self-professed member of the counterculture—he tells Maude he was a member of the Seattle Seven—may well be his ultimate dependence on affect. With the exception of his inspired solution to the crime, which can only happen when he limbers up his mind with enough White Russians, sex with Maude, and recreational drugs, the Dude's rhetorical confusion is never more pronounced than when he tries to logically persuade someone to his explanations of events.

In Wolff's theorizing of affective community, he asserts a crucial distinction between it and "rational community." In contrast to affective community, rational community is defined as "that reciprocity of consciousness which is achieved and sustained by equals who discourse

together publicly for the specific purpose of social decision and action" (192). The Dude is constitutionally disabled from or disinterested in rational community; such a community could never coordinate the Dude's pacifism with Walter's angry nationalism and Donny's obtuse silence. Such a community, Wolff argues, could be "an element of a possible general good" but by no means does it require it (187). As an affective community, the bowling alley can organize a working-class multiplicity around mutual enthusiasm and enjoyment, but it has no necessary politics or notions of social change. The reciprocity of awareness at the bowling alley is largely non-verbal. In fact, nothing jeopardizes the ties that form that community more than talk between the players. At best then, that community is pre-political and represents a utopian impulse that is nearly as elliptical as that of *Miller's Crossing*—it provides a scandalous critique of official culture through its co-existence with it, but offers no basis for social change, action, reform, or anything. While the Coens' vision of a bowling alley utopia liberated from or resistant to postmodern consumer culture and U.S. imperialism in the Gulf is provocative, aesthetically enticing, and funny, the Coens strategically remind their audience of its significant limitations. In repeated shots of the Dude's apartment, we see a framed poster of Richard Nixon bowling at the White House's famed alleys in the Old Executive Building. Shot in 1969 as a promotional photo appealing to a white working-class "silent majority" that would re-elect him in the landslide 1972 election, the poster offers a brief, oblique, but pointed reminder of how communities organized primarily by affect can be mobilized for virtually any political end.

Notes

1. According to the production notes, the idea for *Miller's Crossing* started with the hat. This shot, the last to be filmed, "was one of the first images we wrote," according to Ethan. "The idea of the hat blowing away in the woods, without really knowing how it was supposed to fit in."

2. Hammett's short sentences and emphasis on verbs—which William Marling points out can and often does run as high as 20 percent of the word count—accounts for the speed and objectivity of a prose where actions take narrative precedence over actors (117).

3. Like the murder of Owen Taylor in the *Big Sleep* or John Archer in the *Maltese Falcon*, Rug's is the largely forgotten corpse that initiates the investigation plot. Interestingly, when Leo wants to read Rug Daniel's stolen hairpiece—the "rug" that metonymically identifies Daniels—as a coded, metaphoric message from the murderers, Tom observes metonymically that it must mean that he was scalped by Indians.

4. In interviews and the production notes, Joel and Ethan Coen routinely point out the film script's debt to Chandler: "loosely based on the narrative structure of a Chandler novel . . ."; "similar to Chandler, the plot is secondary to the other things going on in the piece"; "look at *The Big Sleep* . . . no one seemed to know what the hell was going on." "The Making of *The Big Lebowski*" (interview with Ethan and Joel Coen). *The Big Lebowski*. DVD. Universal Studios, 2003.

5. Along the same lines, when the Dude encounters a private detective named Da Fino (Jon Polito) who introduces himself as a "brother shamus," the Dude's bewildered response indicates his total estrangement from Marlowe's noir idiom: "Brother Seamus? Like an Irish monk?"

6. The Big Lebowski and Maude Lebowski are the film's most verbally adept characters, but the Big Lebowski trades almost exclusively in Horatio Alger–style moralism and Reaganite Republican cliché. Maude, on the other hand, may have some claim as the film's only hard-boiled character, but her troping, as her art, appears to belong to the more restrained, terse, metonymic order.

7. In "'This Aggression Will Not Stand': Myth, War, and Ethics in *The Big Lebowski*," Todd Comer gives extended and illuminating treatment to the function of manhood discourse, nationalism, and violence in the film.

8. Importantly, this is ultimately true of Marlowe as well. Marlowe's affective depth is both valued and ironized. In "Little Sister," for example, an underworld figure named Toad tells Marlowe, "I heard you were hardboiled." Marlowe's response both admits his sappiness and then conceals it with irony: "You heard wrong. I am a sensitive guy. I go all to pieces about nothing."

5 *The Dude and the New Left*

Stacy Thompson

The Coen brothers are not, to my knowledge, communists. Yet they have maintained an interesting relationship with communism, the "Old Left," throughout their work. It runs beneath the surface of their films as a counterpoint, sometimes referenced directly, sometimes obliquely. In the first five minutes of their 1984 film *Blood Simple*, private detective Loren Visser meditates on the differences between the Soviet Union and Texas, musing, in voice over, "Now, in Russia, they got it mapped out so that everyone pulls for everyone else . . . that's the theory, anyway. But what I know about is Texas. An' down here . . . you're on your own." Later he contemplates how much someone will pay him to murder two people and comments wistfully, "In Russia they make only fifty cents a day." A few years later, in *Raising Arizona*, H. I. McDonough, an ex-con and factory worker, thinks about how he and his wife can't have children. He compares his situation with that of an Arizona millionaire's wife who was treated for infertility and gave birth to quintuplets. He comments, "It seems unfair that some should have so many when others have so few." There's a whisper of Marx's "From each according to his abilities to each according to his needs" in this maxim, and, in fact, the film eventually implies, not unlike Brecht's *The Caucasian Chalk Circle*, that the woman who most capably loves a child—who demonstrates that "ability"—deserves to be its parent more than a neglectful birth mother. But while *Blood Simple* invokes communism as a sadly

unimaginable otherness, and *Raising Arizona* thinks of children as the product of socialized labor, and therefore the property of society and not the individual, in *The Big Lebowski* the Coens take a different tack in relation to communism.

In the 1998 film, communism is referenced in more complicated ways than in earlier Coen brothers work. While first attempting to figure out who kidnapped Bunny Lebowski, The Dude half-remembers a line from Lenin that begins "You look for the person who will benefit and . . ."; and the Dude trails off. But when Donny assumes that the Dude is referring to John Lennon, Walter shouts, for our benefit as much as for Donny's, "V. I. Lenin! Vladimir Ilyich Ulyanov!" Later, as Donny rolls his apparently first non-strike ever and leaves one pin standing, an event that somehow foretells his imminent death, Walter waxes nostalgic about the North Vietnamese communist foot soldier, "the man in the black pajamas," who was a "worthy fuckin' adversary," unlike the Iraqi soldiers of the early 1990s and the First Gulf War. Add to these examples the Dude's fondness for White Russians, which share their name with one of the Russian groups that opposed the Bolsheviks after the 1917 Revolution, and the Dude's explicit connections to the New Left—Students for a Democratic Society (SDS), the Port Huron Statement, the Seattle Seven—and what are we to make of how or why the film needs communism and its offshoots as a touchstone? Granted, the film's dabbling in communism might not initially strike the viewer as the film's major concern, and if it's interesting at all it is probably because of its persistence across several films more than its importance to any single Coen brothers picture. Nevertheless, and even though the film points us more directly toward the New Left than the Old, it is ultimately a set of myths about Old Left communism that structures and ultimately explains one of the logics underlying *The Big Lebowski*. But before we consider the Dude as a cipher of vulgar communism—which

I believe he is—I want to consider two other possible readings, the first one more dismissive of his politics, the second one more celebratory.

The Dude as Death of the New Left

To begin, I should note that I'm not using the term *Old Left* in the pejorative sense that it acquired in England, where, in the 1960s and 1970s, it referred to the supposedly retrograde remains of traditional, party-based, labor-oriented, leftist organizations and politics, in short, precisely what the English New Left was supposed to offer an alternative to. Instead, I'm thinking of the Old Left much more broadly as Marxism, socialism, and communism in general, in their pre-New Left forms. In contrast to the Old Left, the New Left, in its U.S. context, like its English counterpart, turned away from labor, economics, and materialist issues as its overarching concerns. The Students for a Democratic Society (SDS) spearheaded the New Left movement in the U.S., and, consequently, the 1962 publication of the Port Huron Statement, the SDS's manifesto—the Dude claims to have helped write an early draft—marks a seminal moment for the New Left. While the Statement itself only mentions Vietnam once, the SDS eventually helped focus the New Left's social activism on opposing the Vietnam War, working for free speech and civil rights, and practicing civil disobedience. Unlike the Old Left, the New Left drew its supporters from college campuses more than from industrialized capitalism's working class, which tended to constitute the rank and file of earlier leftist movements and organizations. For my purposes, the most important differences between the Old and New Left are the latter's turn away from Marxism, especially economic analysis and materialist critique, and its attention to individualized concerns (the individual's sense of alienation with which C.

Wright Mills was concerned, for instance[1]) in place of more socialized or collective concerns, which is to say concerns related to class.

Returning to *The Big Lebowski,* it is tempting to read the Dude as a representative of what the New Left has become by the early 1990s of the film's historical setting or the late 1990s of the film's release. After the implied coitus scene between Maude Lebowski and the Dude, he recounts his biography, such as it is, for Maude, explaining that he "was one of the authors of the *Port Huron Statement* . . . the original *Port Huron Statement,* not the compromised second draft." He then asks Maude, "Ever hear of the Seattle Seven?" and adds, "That was me . . . and, uh . . . six other guys." The film encourages us to fix upon the New Left as having generated the Dude, for which, in addition to these diegetic pointers, there are historical and biographical reasons as well. To begin with, the Seattle Seven included Jeff Dowd, a 1960s radical who called himself "the Dude." But he probably did not have a hand in writing any draft of the Port Huron Statement, the SDS manifesto written primarily by Tom Hayden and published in 1962, because Dowd was twelve years old when the Statement was released. Nevertheless, in the Port Huron Statement's "Introductory Note," the authors write that the Statement "represents the results of several months of writing and discussion among the membership, *a draft paper,* and revision by the Students for a Democratic Society national convention meeting in Port Huron, Michigan, June 11–15, 1962" (emphasis added). So there *was* a first and possibly less compromised draft. But the historical correlations between Dowd and the Dude interest me less than the points where their histories diverge. Specifically, Jeff Dowd, ex-Seattle Seven member, didn't become a washed-up 1960s New Left radical. Instead, he became a film producer and, in the early 1980s, met the Coen brothers and helped find them a distributor for their 1984 film *Blood Simple,* which won the Grand Jury

So there are really only two choices for the Dude within the film's possible world. He can follow the path laid out by received lore about members of radical 1960s groups: they became the yuppies of the 1980s.... Or, and this is the choice that the Coens made, the Dude can embody a second stereotype, the aging liberal, nostalgic for the good old radical days

Prize at Sundance in 1985 and established them as independent filmmakers. So without Dowd's help financing *Blood Simple,* there would have been no Coen brothers as we know them and no Dude.

Jeff Dowd was also one of the early organizers of the Sundance Film Festival, which raises an interesting question: why did the Dude of *The Big Lebowski* have to be unemployed in the early 1990s, when Dowd had "achieved" in the straight world as an independent film producer? Why did the Coens take Dowd's job away from him for the movie? The obvious answer is because *The Big Lebowski*'s Dude embodies a stereotype, just as Walter Sobchak is the archetypal Vietnam Vet, for whom nothing is completely unrelated to his traumatic war experiences; Jeffrey Lebowski (a.k.a. the Big Lebowski) is a roughly drawn caricature of a captain of industry from the early twentieth century; Maude Lebowski parodies the avant-garde feminist artist; the Dude's landlord, Marty, pastiches avant-garde dance; Jackie Treehorn is a Hugh Hefner–style porn magnate; and all nihilists wear black, speak with thick German accents, and announce that they "believe in nothing." So there are really only two choices for the Dude within the film's possible world. He can follow the path laid out by received lore about members of radical 1960s groups: they became the yuppies of the 1980s, in which case the Dude would have become Jeff Dowd, organizer of Sundance and independent producer. Or, and this is the choice that

the Coens made, the Dude can embody a second stereotype, the aging liberal, nostalgic for the good old radical days, not unlike Christopher's Lloyd's pop-eyed Reverend Jim character from the sitcom *Taxi,* who remembers little from his radical past apart from the fact that he spent a year making a macramé couch. In similar fashion, when the Big Lebowski's assistant, Brandt, assumes that the Dude didn't go to college, the Dude answers, "Oh, no, I did, but I spent most of my time occupying various administration buildings . . . smoking a lot of Thai stick . . . breaking into the ROTC . . . and bowling. To tell you the truth Brandt, I don't remember most of it." Bowling is the ringer here, a point to which I return later. More to the point, the Dude was clearly more invested in radical drug use than radical politics, and his contemporary protestations about the compromised Port Huron Statement sound like residual, half-remembered slogans that have long since ceased to mean much to him.

So it is easy enough to read the Dude as the failure of the New Left and its exhausted state in 1991, the moment infamously described as "The End of History" by Francis Fukuyama, when the world economic order had supposedly evolved to its inevitable telos, capitalist liberal democracy. In such a historical moment, the postmodern moment par excellence, archaic political monikers like *left* and *right* cease to signify, and any allegiance to them is risible. But to test this reading dialectically, it is worth inverting its structure and reading the Dude directly against this interpretation, not as the failure but as the triumph of the New Left.

The Dude as Faithful to the Event

What if we, as viewers, along with most of *The Big Lebowski*'s characters, misrecognize the Dude as a loser, a bum, a ringer for authentic politics?

What if the Dude does more than embody a parody of the New Left's ruins and, rather, remains faithful to the New Left and, in particular, to the "event" of the publication of the Port Huron Statement in Alain Badiou's sense of an "event" as an occurrence that punches a hole through its historical moment's established knowledges and reorganizes its "situation" (42–43). The Dude's fidelity to that event, to what Badiou would name the "truth-process" whose possibility emerged with the event (41–42), manifests itself throughout the film as the Dude's refusal to give up on the ideas of the SDS and the Port Huron Statement. The film's most glaring sign that everyone around the Dude misrecognizes his fidelity to an event begins with the first scene after the credits, in which two of Jackie Treehorn's thugs mistake him for the millionaire Jeffrey Lebowski until, realizing their error, they dismiss him as a "fucking loser." In fact, though, the misnomers precede this scene, beginning instead with the Stranger's opening narration, in which he comments authoritatively that the Dude is "a lazy man . . . the Dude was most certainly that. Quite possibly the laziest in all of Los Angeles County, which would place him high in the runnin' for laziest worldwide." But *when* is the Dude lazy? Apart from the bird's-eye shots of him lying on the purloined Lebowski rug listening to, appropriately enough, cassette tapes (a soon to be completely superseded medium, not unlike the SDS and perhaps the Dude himself), we never see the Dude exercising (if this is the correct word) his supposed laziness. We could also ask in what sense he abides (the Stranger assures us that "the Dude abides," a phrase which has become a watchword for *The Big Lebowski* cult members). What if he abides precisely in Badiou's sense that he continues? Badiou's slogan, his maxim for those who remain faithful to an event, is "Keep going!" (79). In other words, what if we read the film as a testimonial to the Dude's commitment to an "impossible wager"—Badiou's term, again—to a non-consensually-arrived-at truth, embodied in the

New Left's origins in the Port Huron Statement. After all, who takes the Statement or the SDS seriously today? Who grasps the Statement's publication, dissemination, and possible enactment as anything more than historically interesting now? It is the Dude who maintains a fidelity to the Statement as an event that shattered and reorganized the situation of his mid- to late-1960s California life.

But where does laziness (as a sign of a failed New Left) fit into the SDS, the Statement, and fidelity? A clue can be found in the fact that the Port Huron Statement can be read as a lazy *Communist Manifesto,* where its laziness is precisely what allows for the Dude's apparent shiftlessness.[2] Where Marx and Engels list the famous Ten Steps Necessary to Move from Capitalism to Socialism and insist upon the "[e]qual liability of all to labour" (490), the Statement lists a series of "root principles" that must be implemented to move from a "dominating complex of corporate, military, and political power" to a "participatory democracy." In relation to labor, the Statement argues that "work should involve incentives worthier than money or survival. It should be educative, not stultifying; creative, not mechanical; self-directed, not manipulated, encouraging independence, a respect for others, a sense of dignity, and a willingness to accept social responsibility." Isn't it possible, then, that in the context of the Statement laziness can be something more than itself? Perhaps the Dude is not lazy but refuses to work at stultifying, non-creative tasks. The Dude takes the Statement at its word and refuses work (or refuses to look for work) that doesn't interest him. Only when the Big Lebowski offers the Dude a sleuthing gig, ironically after recently upbraiding him for laziness, does the Dude, intrigued, accept a job.

In this light, his relations with Marty, nominally his landlord, take on an interesting hue. The Dude's seeming surprise at being reminded that he is in arrears to Marty for rent emerges from the fact that he grasps, perhaps intuitively, that he and Marty operate within a barter economy

rather than a capitalist one. Marty the landowner allows the Dude to live rent-free, and the Dude reciprocates by assembling his friends and providing Marty with an audience for his solo dance opening. Granted, neither Walter, Donny, nor the Dude seem much interested in Marty's "art," but they nevertheless hold up their end of the bargain: they constitute an audience, and although they are uninterested in Marty's current project (interpretive dance?), they hold the potential to be interested in a future one. In this exchange, both the Dude and Marty acknowledge the other's authentic job or work: Marty is not a landlord but a dancer; the Dude is not a deadbeat renter but a patron of the arts. Both embody the Statement's demand that politics "be seen positively, as the art of collectively creating an acceptable pattern of social relations." While the viewer might easily recognize the clichéd signs of creativity (if not the value) in Marty's work/dance, the Dude's parallel creativity is not immediately obvious. But a generous reading might point out that the Dude's life itself is his creation, that he determines its shape to a large extent and embodies the Port Huron Statement's exhortation to find "a meaning in life that is personally authentic."

Another point that undermines the Dude's supposed indolence lies in the film's structural pairing off of his idleness against the Little Lebowski Urban Achievers and, more exactly, against the Big Lebowski as the ultimate Urban Achiever. Maude's eventual revelation that her father is no Achiever, big or little, folds back on the Dude's supposed laziness and tempers it. The Big Lebowski married into his fortune, was briefly allowed to run one of the companies that his wife owned but "wasn't very good at it," according to Maude, and was finally positioned by her as the titular director of a charitable foundation. In short, Lebowski is a ringer; he brought no capital to his marriage and only plays at being a tycoon. What if the Dude similarly plays at being lazy? More to the point, what does laziness mean within the context of the Port Huron

Statement? Wouldn't the realization of its aims render laziness anachronistic? In short, hasn't the Dude found a way to fulfill his means of subsistence without laboring at alienating jobs, preferring instead to enjoy his "authentic" path to meaning, which he tells Maude includes driving around in his car, bowling, and "the occasional acid flashback"? Taking the Statement seriously, or living as if its aims have already been realized, means more leisure and no guilt. Units of time no longer serve as measures of their possible valorization through labor. So the Stranger, an impossible and over-the-top homage to sarsaparilla-sipping singing cowpokes, functions not as an unreliable narrator who begrudges the Dude his leisure and fantasizes over the end of ideology in the early 1990s, hence the end of American imperialism ("westward the wagons," as he expresses it) but as our culture's mythic narrator who ushers out the old capitalist myth of the Big Lebowski and ushers in the new myth of the Dude. In Los Angeles, where the Pacific perforce stopped the North American expansionism—mythologized as the Stranger—the Big Lebowski undergoes a transformation and becomes the Dude, who embodies the individualism explicitly praised in the Statement (which in one register reads as a paean to American liberal democratic individualism). And it is the Stranger who benevolently oversees this metamorphosis of 1950s into 1990s America. Yes, he labels the Dude as lazy but not pejoratively; rather, he grants the Dude his imprimatur and is glad that the Dude is "out there taking it easy for all us sinners." Speaking from within his patently obsolete vernacular, he has yet to find a word other than "lazy" to describe a person who does not labor for others, who does not "achieve" at useless but surplus-value-producing tasks, but his approval of the Dude's situation nonetheless shows through.

So what, if anything, is wrong with the Dude's fealty to a middle way that is neither capitalist liberal democratic nor ardently leftist? My concern lies with the Dude as a cipher of vulgar communism. Finally,

it is not we who misrecognize the Dude as lazy but the Dude who mis-recognizes the Port Huron Statement as an event rather than a compro-mise. He takes its praise of individualism seriously and thereby upholds the New Left's concerns but sacrifices the Old Left's attention to com-munitarian concerns. In short, he should have adhered to the authentic first draft of the Statement—the *Communist Manifesto*—rather than the lazy drafts (first and fi-nal) that became the Statement. One telling difference highlights his mistake. While the Statement concentrates on improving the quality of the labor *experience,* the existential and individual experi-

No rent or mortgage payments compel the Dude to work for a living, so he doesn't. In 1991, he has discovered the impossible situation, a landlord in Los Angeles who lets him live rent-free.

ence of working, the *Communist Manifesto* makes a different demand: "Equal liability of all to labour" (Marx and Engels 490). The brevity of this commentary on labor is not an oversight on the part of Marx and Engels, because, as historical materialists, they assume that the charac-ter of labor cannot be rehabilitated using a top-down, superstructural approach. Rather, the material underpinnings of labor, the social rela-tions within which it occurs, will ultimately determine its quality. In sum, the Port Huron Statement fails to be materialist enough, dictating a series of superstructural changes, including the "feel" of labor (a phe-nomenology of labor), in place of the materialist ones of the *Communist Manifesto:* "Abolition of property in land and application of all rents of land to public purposes"; "Abolition of all right of inheritance"; "Exten-sion of factories and instruments of production owned by the State" (490). The Statement wants to leap peacefully over the revolution that will reshape the mode of production and the exploitative social relations of labor under capitalism to alight upon the better future of enjoyable

work and creativity. The *Communist Manifesto* rejects that option, recognizing that the nature of labor won't change through an act of collective, but idealist, willing.

The Dude as Cipher of Vulgar Communism

It is with the *Communist Manifesto* in mind that I want to present a third possible reading of the Dude, not as a mediation of the first two but simply as another option. There is a hopeful side to this reading, albeit not as positive as the narrative of fidelity to an Event that I have just sketched. To begin to talk about the Dude and the *Communist Manifesto*, though, I need to revisit the issue of labor, to the fact that the Dude has no job within the capitalist economy, while Jeff Dowd, his namesake, does. If we leave behind *The Big Lebowski* as an ultimately unconvincing celebration of laziness—although a laziness that now figures as an avoidance of exploitative social relations—then we return to the Dude who does not work, who pays no rent, who somehow acquires food, clothing, and Kahlua, and whose healthcare is provided for by others (Maude arranges for it). What intrigues me about these characteristics of the Dude's life is that they parallel the characteristics not only of the New Leftist gone bad (see above) but also of a mythic "citizen under communism." In other words, maybe the film encourages us to connect it to the wrong manifesto. In 1998, the year that the film was released, the Port Huron Statement was 36 years old, but 1998 also marked the 150th anniversary of the publication of the *Communist Manifesto*, a document that I think has more to tell us about the film than the SDS's manifesto. This earlier, more famous and infamous manifesto is the pivot around which the film turns. While Walter, the Big Lebowski, Maude, Marty, Jackie Treehorn, and all the other broadly drawn character types spread a postmodern veneer over the surface of the film, assuring us that we

aren't really seeing representations, not even parodic ones, of Vietnam vets, feminist artists, etc., the Dude is different. He goes to the end. Maybe he takes his stereotype (failed New Leftist, failed communist) to its logical conclusion and beyond, and thereby dialectically passes through it and comes out the other side.

The film can then be grasped as asking, rhetorically, "Is the Dude truly what we imagine as the endpoint of leftist politics and utopian thought?"

For this third reading, we must first think of the Dude as traveling along a different trajectory than the film's other walking stereotypes. To do so, we need merely see the Dude as the negative embodiment of all the myths that Marx and Engels' manifesto aims to dispel. The second section of the *Communist Manifesto* is organized as a series of theses and antitheses, where the former are myths about communism or socialism and the latter are their negations. For instance, Marx and Engels write that it is commonly claimed that under communism, "all work will cease, and universal laziness will overtake us" (486). The Dude instantiates this fear; he's unemployed and, in spite of the fact that he's kept hopping throughout the film, would probably prefer lying on his rug listening to old bowling league games to the more arduous task of sleuthing. No rent or mortgage payments compel the Dude to work for a living, so he doesn't. In 1991, he has discovered the impossible situation, a landlord in Los Angeles who lets him live rent-free. Marty does make a half-hearted attempt to remind the Dude that the rent is late, but no one is fooled. The Dude almost completely misses the oblique reference to arrears, and when he finally grasps it, he betrays surprise that it was mentioned at all and barely troubles himself to go through the motions of agreeing to pay. Clearly, no money has passed between these men in years, unless the Dude has borrowed some. So he has

shelter provided for him; he needn't work, and he seems able to keep himself in food and clothing, judging from his waistline and lack of concern about his next meal. The only time we see him buying anything approaching food, he is writing a check for less than a dollar—that for all we know will bounce—to pay for the half and half that goes in his White Russians. Again, isn't this a slightly veiled image of someone who needn't work any longer for his means of subsistence and, consequently, has become fat and lazy? Didn't the U.S. government once drop doctored pictures of Castro, corpulent and happy (the antithesis of the image of the hardworking communist) on Cuban citizens to turn them against their government? The Dude's food, clothing, and shelter are taken care of somehow, perhaps by the state, and it is precisely their satisfaction that frees the Dude to pursue unabashed laziness. It is as if he has found an odd communist space in L.A. that's just large enough for one.

We return to the *Manifesto* and read the next myth: "We Communists have been reproached with the desire of abolishing the right of personally acquiring property as the fruit of a man's own labour" (484). The Dude owns nothing. Granted, he does not work, either, but isn't he the image of the man who will not labor because even if he were to do so, the fruit of his labor would be expropriated from him? He probably owns his bowling ball and his car, although the latter burns up in the course of the film. And unlike the famed aging American cars of Cuba, the Dude isn't even inspired to maintain his jalopy, if not by an embargo then by necessity. Again we are faced with a Cold War propaganda image of communism gone bad, a bad faith version of utopianism designed to force us to choose capitalism as the only legitimate option.

Much more telling, though, is the film's allegiance to—and the Dude's embodiment of—a prevalent anxiety in U.S. culture in relation to any form of utopian thought. The film assumes that, to paraphrase

Marx and Engels's description of this concern, all desire will cease if all persons' minimal means of subsistence can be met within a society. In other words, it is the film's treatment of desire and its objects that highlights its apprehensions about the imagined shortcomings of a vulgar version of communism. For instance, how might we respond to the question, "What does the Dude desire?" He tells Jackie Treehorn, "All the Dude ever wanted was his rug back," and his use of the third person nicely distances the Dude from his own wish. The rug is certainly the first obvious *objet petit a*, the first object that the film situates as something that seems to be a little piece of the Lacanian Real, the "Thing" that, if it could only be acquired, would fill out the gap in the Symbolic Order of representation and satisfy desire.[3] Not surprisingly, then, it is precisely the loss of the rug that initially sets the Dude, and the film, in motion. For this reason, it is striking that the Dude's interest in his lost rug inexplicably vanishes two-thirds of the way through the film. He never retrieves it (or its substitute from the Lebowski mansion, the second rug which he also loses), and the film doesn't reference it again. In a documentary on "The Making of *The Big Lebowski*," Joel Silver, the film's producer, commented on this disappearance after his first reading of the script for *The Big Lebowski*. Ethan Coen remembers Silver suggesting, "The movie should have ended with [the Dude] getting his rug back or some mention of the rug, which would have been a nice resolution." Ethan also mentions that he and Joel probably should have taken Silver's advice but then, at a bit of a loss, admits, "but we never did it."

The next *objet petit a*, the missing toe, functions like the first one. It is an obvious loss, a lack, or a representation of castration, and the Dude's desire, and ours, for a time revolves around compensating for that lack by finding the toe's owner and reuniting her with her toe. The toe, like the rug, serves as a Hitchcockian McGuffin, which functions, as Slavoj Žižek frequently argues, as an *objet petit a*. But two excessively

deliberate shots in the film rid us of this object as well. In the first, the camera cuts from a medium shot of Bunny Lebowski driving a sports car to an extreme close-up, from no one's perspective, of her left foot in open-toed sandals and intact, followed by a slight pan to her right foot, also fully intact. In a parallel scene in a diner, where the nihilists are ordering pancakes, a slow tilt shot reveals that one of the nihilists sacrificed her own toe as a ringer for Bunny's. Again, an *objet petit a* is introduced and in this case doesn't fly away, as the rug does in one of the Dude's dreams, but is dismissed with ham-fisted camera work. The film's subtext is clear: "this is the *objet petit a* you're looking for," or, in other words, "this is not an *objet petit a*," since the force of the *objet* is derived from its desirability and from pursuing it, from *not* arriving at it, because it is not, after all, a piece of the Real but only seems to be. In Lacan's language, it is taken as the *object* of desire but is not, in fact, the *cause* of desire, which is the impossible jouissance that it seems to veil. While even Ethan Coen seems nonplussed about the disappearance of the rug, there can be no mistaking the elimination of the toe as an object worthy of desire. It is just another ringer for a ringer. The desired object does not stand in for the Real as jouissance or plenitude but for its obverse, the repulsive side of the Real, the death drive and desirelessness.

In other words, the film plays fast and loose with its *objets petit a,* because in the Dude's microcosmic communist existence there is no need for them, a point which the film's treatment of the rug and the toe underscores. Here we face off with the film's starkest expression, or exaggeration, of the idea that a communist utopia meets all material needs and, consequently, leaves its subjects desireless. The Dude, with his means of subsistence satisfied, is, as it turns out, more than lazy; he is without desire, which is to say that he is close to death. The Dude's lack of desire also explains the wide berth the film gives his sexuality. The only sex that he can possibly engage in is a purely mechanical act

5.1. Not an *objet petit a* . . . just the whites.

initiated by Maude for procreative reasons. In her first interaction with him, she asks if he is interested in "coitus," the Latin word serving to situate sexuality within the domain of science, much as her following definitions of sexual pathologies do. She also has a doctor screen the Dude before they engage in coitus—which she presumably would have foregone if the Dude had failed his screening—and after intercourse she immediately begins a series of exercises designed to improve her likelihood of conception. The film's editing follows suit, cutting from a low shot of the Dude's robe falling around Maude's ankles to the two of them in bed, the Dude with an arm uncomfortably and momentarily stretched out behind Maude's neck. The editing passes over the Dude and Maude's sex in silence, and we can only imagine their awkward, groaning coitus. We are spared even seeing a kiss or an embrace, because we cannot imagine the Dude, or Maude for that matter, as sexually

desiring. Even the Dude's arm behind Maude's neck seems odd, for both of them, like an assumed attitude or a pro forma acknowledgment of a supposed intimacy. Later, the Dude describes their relationship to Da Fino, the private detective: "She's not my special lady, she's my fucking lady friend. I'm just helping her conceive."

What the abbreviated coitus scene dramatizes, finally, is the suspicion that the libidinal economy of communism (but a vulgar communism, a bad faith utopianism)—its supposed satisfaction of all desires—doesn't correlate with a more genuinely "human" libidinal economy, which presumably would have left the Dude more sexually desiring and Maude less utilitarian about procreation. The point is that capitalism, however, *does* more exactly parallel the human libidinal economy. The scarcity of the means of subsistence under capitalism, their partial prohibition, seems more exactly to parallel the libidinal economy of an individual who has been successfully Oedipalized—in other words, an individual whose desire is born in the shadow of an initial prohibition, that of incest. In short, my fear is that *The Big Lebowski* gives expression to what, in the cultural imagination, and in the Dude as its symptomatic manifestation, we envision communism as, the satisfaction of all desire, not just material but sexual. At the level of the unconscious, we grasp this fulfillment of desire, this desirelessness, for what it is: it can only be correlated with death, with arriving at the Real, with the satisfaction of the original incestuous desire. Isn't this precisely what Maude and the Dude fulfill when they have sex? Maude chooses the Dude for his name, which is literally the Name of the Father, the name of her father, Jeffrey Lebowski. But their incestuous relation is no longer prohibited, because in this vulgar image of communistic plenitude, all prohibition has vanished. But with the loss of prohibition, we also lose desire. And this, finally, is the reason that all of the *objets petit a* vanish over the course of the film. Without a Real characterized by fullness or jouissance to drive

toward, a cause of desire, there can be no imaginary pieces, or objects of desire, to set desire itself in motion.

In the end, I find two options most useful for understanding *The Big Lebowski*, both of which emerge from this third reading that I've proffered. First, the more dismissive reading: in one register, the film acts out the hoariest myths about communism, while expressing a widespread cultural anxiety over utopian projects. Communism, if actually applied and practiced, would lead to a joyless society replete with lazy, propertyless, desireless, incestuous subjects. Second, the more celebratory reading: in another register, something more dialectical is going on here. In this view, the film traverses the cultural fantasy around utopia, a fantasy that supports a capitalist reality in which utopian thinking is fit material only for broad parody and, in its negative form, dystopian fiction. The film can then be grasped as asking, rhetorically, "Is the Dude truly what we imagine as the endpoint of leftist politics and utopian thought? Can't we, instead, recognize in him the ridiculousness of our own apprehensions about a post-capitalist era as well as any attempt to think such an era?" And these questions, hopefully, would bring us to a conclusion: "No, that's not socialism. No, not all utopian thought leads straight to Soviet-style communism." In other words, can we see the Dude as a parody not of communism but of our peculiar anxieties about the Stalinist version of it, as well as our linking of those anxieties to any sort of thinking that attempts to envision a non-capitalist and collectivist future? I should add that this is precisely the kind of thinking that I take to be "utopian" in nature, rather than visions of a perfect-but-impossible world that will banish need and with it desire. The latter is bad faith utopianism exactly, calculated to drive us to the forced choice of capitalism as the only viable system for structuring the social order. It is this brand of cynicism that could be what *The Big Lebowski,* in the Dude, holds up for critique through underscoring its absurdity. Over

against this defeatist, realpolitik option stands what I take to be the necessary type of utopian thought, which is simply the imagining of a non-capitalist and possibly socialist future, which the Dude could be read as pointing toward through his negation of the most hackneyed fictions about communism.

Perhaps this reading grants the film too much credit, though, particularly in light of *The Big Lebowski*'s final handling of its objects of desire—the rug/s, the toe, Maude—which appear on the scene only to disappear, be dismissed, or become mundane—as well as its figuration of death. Donny's passing, for instance, is played for laughs, which is especially telling if we take death as a final outpost of the Real. Death, at least, must *mean* something, even if what it means is only the fact that it veils its own nothingness, even if beyond death there is simply void. In other words, can't death be read as a last-ditch effort to think utopically, where utopian thought is reduced to the bare-bones ability to imagine change? No matter what death is or isn't, shouldn't it at least figure as a sign of difference from life, which is to say difference abstracted or difference in general? Love might also enjoy this kind of valence, for how many so-called postmodern cultural productions resort, after all their irony and dissembling, to love or death to find some kind of last-ditch ground or meaning? Even the most profoundly ironic, supposedly postmodern films repeatedly revert, at last, to love or death, having dismissed all other possible places for meaning. Exemplars of this movement through irony and back to love include *The Matrix, Fight Club, Lost in Translation,* and *The Royal Tenenbaums,* among other examples too numerous to mention, while *The Matrix Reloaded, Adaptation, American Beauty,* and *The Life Aquatic,* again among many others, traffic heavily in cynicism, only to hold up death as the last enclave of significance. Similarly, or perhaps not, *The Big Lebowski* dispatches numerous fields of human experience that have traditionally rubbed shoulders with

profundity, including war (through Walter), politics and love (through the Dude), aesthetics (through Maude), and even pederasty (through John Turturro's character). The pederast is named Jesus, and, if that's not enough to let his pathology play for laughs, he is shown in flashback knocking on his neighbors' doors to alert them of his condition. The flashback ends just before he confesses—or chooses not to, perhaps—his forbidden desire to a character decked out in the most conventional signs of traditional masculinity and working classness, including hirsuteness, a stained and sweaty T-shirt, and an impressive girth. In this film, for the most part denuded of traditional signs of meaning, where half-remembered communist slogans and child molestation are equally humorous, we might expect the film to capitulate, in its dénouement, to one of the twin psychoanalytic drives, love and death, that infuse the final moments of so many ironic postmodern productions with a hint of depth.

How, then, does *The Big Lebowski* approach death? Donny suffers a heart attack in a bowling alley parking lot and dies offscreen. The film cuts directly to the Dude and Walter opting for a Folgers coffee can in which to stow Donny's cremated remains ("cremains," as the "death care industry" labels them). As he sprinkles Donny's ashes into the wind on a bluff overlooking the ocean, Walter comments,

> He was a man who loved the outdoors . . . and bowling, and as a surfer he explored the beaches of Southern California, from La Jolla to Leo Carrillo and . . . up to . . . Pismo. He died . . . he died as so many young men of his generation before his time . . . [like] so many bright flowering young men at Khe San, at Lan Doc and Hill 364. . . . And so, Theodore Donald Kerabatsos, in accordance with what we think your dying wishes might well have been, we commit your final mortal remains to the bosom of the Pacific Ocean, which you loved so well. Good night, sweet prince.

As Walter carries on, it becomes clear that Donny's death is directly related, in Walter's mind, to Walter's experiences in Vietnam, and that Walter didn't really know Donny. The references to surfing seem particularly anomalous, since no one looks less like an outdoorsman or water sports enthusiast than pasty-skinned Donny, and Walter doesn't seem to know exactly where Donny surfed. Walter also falls back on a cliché when deciding where to sprinkle Donny's ashes, since he doesn't know what Donny would have wanted, while the Dude's silence during Walter's impromptu ceremony indicates that he might have known Donny even less than Walter did. In short, Donny's death is played off as a joke, and the punch line comes when Donny's cremains blow back into the Dude's face and stick to his hair and goatee. Having voiced his disgust with Walter's Vietnam obsession, the Dude turns away, Walter says, "Fuck it, man; let's go bowling," and the scene has concluded.

There is nothing coincidental about the film's final shift, here, from death to bowling. The simple cut from the "dust in the wind" scene to the bowling alley communicates, through editing, the film's displacement of death—as a potential place of the Real—onto, or more exactly behind, bowling and, specifically, onto the Dude bowling, the film's most consistent and final *objet petit a.* This final object is the audience's, though, not the Dude's. We never see the Dude bowl. Why not? To read this elision ungenerously, I could argue that in a world in which the signifier is not aimed at the conventional signifieds of presence (and especially those of Marxism and psychoanalysis that I've been emphasizing), it can aim at anything, so why not bowling? What could be more important? Like breakdancing in *Napoleon Dynamite,* bowling could figure as the object that veils the place of the Real and of an impossible jouissance, and, for this reason, we must be forbidden access to it. We must not arrive at the object that promises happiness itself, because, as Lacan remarks, "concerning happiness . . . absolutely nothing

is prepared for it" (13). But an important difference separates *The Big Lebowski* from *Napoleon Dynamite,* and it this difference that saves the former film from a wholly postmodern fate.

In *Napoleon Dynamite,* Napoleon finally breakdances, and the film thereby risks our dismissal of his act as "merely breakdancing" and nothing more, or, conversely, the film hopes to evoke our enjoyment of its displacement of all the old teleological narratives onto breakdancing. In short, *Napoleon Dynamite* offers us a quintessentially postmodern pleasure: if we find its conclusion satisfying, it is because we enjoy its acknowledgment of the loss of all the old tele (plural of telos) that weight down Marxism and psychoanalysis. We no longer strive for freedom from exploitation, cooperative ownership over the means of production, or a profound encounter with the Real. Instead, we revel in the impossibility of such tele and in our freedom from them. We are the non-duped, no longer enslaved to the Stone Age dreams, the ultimately discursive meta-narratives that mask the Real. This is exactly the "pleasure" (if that is the right word for it), that *The Big Lebowski* denies us, and, paradoxically, through this foreclosure upon pleasure, the film preserves it. In sum, the film maintains the structure of the libidinal economy as Freud and Lacan envision it, by recognizing that the final fulfillment of desire during life is forever deferred, that we are initially (in relation to the incest taboo) and ultimately (in relation to the death drive) prohibited from gaining that final jouissance at which we aim. The pleasure is actually in the movement toward the supposed object of desire, not in its attainment. If we were to see the Dude bowl, then bowling would be reduced to itself, bowling as such, which has its place in the Symbolic Order, and desire would be forced to move on. Therefore, instead of giving us the Dude bowling to fill out the empty place in the Symbolic Order, as an object standing in the place of the Real, the

Coens establish a properly psychoanalytic structure for desire through the film's libidinal economy and treatment of this final object. This last *objet petit a* is not disclosed but maintained, and the Real therefore remains foreclosed upon. Granted, the Real isn't hidden behind any of its usual names or objects, but it nevertheless remains offscreen in the film, as a placeholder for something beyond the Symbolic Order, which is to say beyond the film's representational capabilities. This impossible Real is the space that allows *The Big Lebowski* to mediate between Marxism and psychoanalysis, because it is the radically utopian space in which the world as we know it through the Symbolic Order vanishes and the possibility of the socialist world as it could be, but isn't yet, emerges. In other words, the film offers us, in conclusion, an odd but provocative wager and equivalence: if we could only imagine the Dude bowling and all that that would signify, then and only then could we imagine a representation of communism that isn't vulgar, the communism also invoked in the Coen brothers' other films. For now, though, both the Dude rolling and a positive figuration of communism lie just beyond the limits of the film's imaginary, and, consequently, *The Big Lebowski* provokes us to undertake that imagining ourselves.

Notes

1. For a founding definition of the New Left, see C. Wright Mills's "Letter to the New Left."

2. I have Aaron Jaffe to thank for several ideas in this chapter that emerged from his comments on an earlier draft. He proposed thinking of the Port Huron Statement as a lazy *Communist Manifesto,* raised the question of what laziness would signify in relation to the Statement, and noted that the Dude could be read as a cipher of bad faith utopianism.

3. I understand the differences among Jacques Lacan's ideas of the "Real," the "symbolic," the "imaginary," and "reality" as Alan Sheridan describes them. For

Sheridan, "[t]his Lacanian concept of the 'real' is not to be confused with reality, which is perfectly knowable" (x). The Real is "that which is lacking in the symbolic order, the ineliminable residue of all articulation, the foreclosed element, which may be approached but never grasped" (x). I see the *objet petit a* functioning as the object of desire, the object that one takes to be a little piece of the Real and that organizes desire. Knowable social reality, on the other hand, is covered by Lacan's notion of the symbolic order.

The Big Lebowski and Paul de Man: 6
Historicizing Irony and Ironizing Historicism

Joshua Kates

Let me begin by historicizing, not irony, but the Dude, though these two options may turn out to be closer than one suspects. The link between the Dude, the hero of the Coen brothers' 1998 film *The Big Lebowski,* and the era of the 1960s has seemed to many incontestable. I propose, however, not the 1960s themselves, but a certain reception and interpretation of this era in the 1970s as Jeff's actual socio-cultural reference point.

Indeed, at issue in the character and way of life of Jeff—as his homonym, the Big Lebowski, points out—is the fate of the already *failed revolutionary hopes* of the 1960s, as these have been taken up and "processed" by the 1970s. Jeff as we are shown him, in fact, has no living contact with that earlier era. The Dude cannot even be imagined actually doing any of the earlier deeds attributed to him, or to his supposed archetype Jeff "the Dude" Dowd: taking over campus buildings, writing the Port Huron Statement, etc. So, too, from the beginning of *Lebowski,* Lebowski little and big are distinguished along the axis of activity and quiescence, laziness and achievement (suited to the reference of the 1970s), not in terms of politics or political commitment (as would befit the 1960s). Big Lebowski is credited with being an achiever at least five times after the film's opening, and even the doting cowboy narrator calls the Dude the laziest man in L.A. (Of course, by the end of the film, the attribute of achievement having been stripped from the putatively "larger" Lebowski, and Jeff having fathered a still smaller Lebowski, it is not clear

*... at issue in the character and way of life of Jeff—as his homonym, the Big Lebowski, points out—is the fate of the already **failed revolutionary hopes** of the 1960s, as these have been taken up and "processed" by the 1970s.*

who really is the big Lebowski: perhaps the larger-than-life, and about to become large with child, Maude Lebowski?)

The Dude's current way of life, though atavistic or "residual," only appears in the 1970s. His almost wholly inactive, sluggy-slug-like lifestyle embodies a quite recognizable template from that period—from the moment when one knew, let us say, that the revolution, since it was not going to be televised, was not going to occur at all. At that epoch many lived as the Dude does, existing almost entirely for sensual pleasure: getting high—though in Jeff's case, more of this occurs in the screenplay than in the film—listening to music, and having sex (but, as with Jeff, only if it literally falls into his or her lap). Similarly, many possessed, to keep life from utter monotony, as he does, a single otherwise entirely arbitrary hobby or passion: in this case, bowling.

Granting for the moment the identification of the figure of the Dude with the 1970s, how does Paul de Man enter into my discussion? De Man was the leading literary theorist of the 1970s and early 1980s and perhaps its leading literary critic simply. Belgian-born, and having emigrated to the United States right after the Second World War (about which more later), he was the arch-deconstructor among all those working in this field in North America, the preeminent member of the so-called Yale school. Not only his approach, but his style—his unique combination of powerful, often outlandish, even outrageous claims, made in a voice of utmost calm and seriousness—influenced an entire generation of critics, including many of those who broke with him in almost every other respect.

De Man's thought, life, and work come into the present meditation on *The Big Lebowski,* then, in two ways. There is, first, the matter of a shared Zeitgeist. If not de Man himself, his reception, his immense (academic) popularity was a phenomenon of the same 1970s that lives on in Lebowski as portrayed in the film. Indeed, the ascendancy of de Man, I eventually argue, although in part based on a misunderstanding of his actual teachings, was itself a version of the aftermath of the 60s: a 70s response to the largely failed hopes of this era, in a way parallel to the Dude's life and character. De Man, after all, influenced, beyond all others, that generation who came of age with Jeff, and who had themselves often participated in the same sorts of events: campus demonstrations, SDS, and so forth. Yet rather than lying low, bowling, and some day buying that rug, these individuals eventually went to graduate school in English (or French, or comparative literature).

The second issue that supports this unlikely coupling of the often termed "Mandarin," Paul de Man, with the *Big Lebowski,* and indeed perhaps with the entire Coen brothers' oeuvre, is a notion I dub *hyperirony.* De Man himself, as we shall see, treated irony of a unique kind at length, and it was, along with allegory, a defining feature of his own writing practice.

Consequently, I want first to make clear the sort of irony practiced by the Coens, and this leads to my treatment of de Man and a discussion of hyperirony's status in his work. Hyperirony becomes visible in this Coen brothers movie when one presses the theme of nihilism—itself an obvious possibility for characterizing the Dude's current lifestyle, as well as the cultural standpoint that took hold in the wake of the 1960s more generally. The defeat of the ideals that informed the 1960s led to a general loss of conviction, to that devaluation of all values that the term *nihilism* most properly connotes. To grasp hyperirony in regard to this theme, it is also necessary, however, to expand the frame of the

6.1. Pressing the theme of nihilism.

discussion a notch and pose the question not only of the Dude's response to the decade of the 1960s, but that of the Coens themselves: where do they fit in this framework? Do they endorse their hero Lebowski's current stance, his present lifestyle, and his worldview?

The status of nihilism and of the nihilists in *Lebowski* is itself inimitably summed up in Walter's beautiful line near the end: "They're nihilists, Donny—nothing to be afraid of." Of course, Donny himself, as it turns out, *will* have something to be afraid of, but when those confronting the nihilists, in particular the Dude himself, are scrutinized, it turns out that the Dude indeed has nothing to fear, since his own nihilism—his lack, not only of faith, but of any lived relation to a so-

cial structure or political community of any sort, other than that of the league, or "bowling together"—is near absolute.

The Dude's anomie, the nihilism implied by his lifestyle, in fact, is far more nihilistic than anything of which the self-proclaimed nihilists in the film can ever dream. Among other things, the latter have recorded an album, emigrated to the U.S., and are now involved, proactively involved, in some kind of scam to profit from the faux kidnapping of Bunny, including the sacrifice of one of their girlfriend's toes. Indeed, the nihilists' claim in regard to the toe sacrifice, when faced with the likelihood that their scheme will yield no profit, is especially telling: namely, "it's not fair." This remark shows just how shallow is the end of the nihilistic pool in which they swim, as Walter, himself the addressee of this remark, immediately points out. (Walter's own adherence to rules, by the way—including those of Judaism, often considered especially formalistic—is too large a topic to expand on here. Suffice it to say that his embrace of what seems to be principle, as presented by the Coens, is as nihilistic in its *effects* as the Dude's dispensing with all rules, if not more so, something his endorsement of National Socialism—"at least it's an ethos"—further confirms.)

The Dude, then, is a far more consummate, a far more absolute nihilist than the guys in black motorcycle gear who proclaim themselves such. Yet the weakness or shallowness of their position, it should be emphasized, is itself a *structural feature* of any avowed nihilism. Announcing herself or himself as nihilistic, the nihilist proclaims, after all, rather too passionately and too loudly, a belief. She announces, that is, that she *believes* that there is nothing to believe in. And the deep investment in *this belief,* albeit a second-order one, belies its own expressed content, its own statement of lacking beliefs altogether. Nihilism as a stance thus involves what is sometimes called a performative contra-

diction: the very proclamation of nihilism undoes or contests what its statement aims to say.

By explicitly introducing the name and theme of nihilism, and juxtaposing it with the lifestyle of the Dude, the Coens show themselves cognizant of this problematic: they reveal self-avowing nihilism as untenable, joke-worthy, indeed nothing to be afraid of. The Dude's way of life ironizes the callowness of these card-carrying nihilists, highlighting nihilism's silliness as a stance.

The Dude's way of life ironizes the callowness of these card-carrying nihilists, highlighting nihilism's silliness as a stance.

But where, then, do the Coens themselves come down? They finally occupy, I would suggest, the same ironic distance toward Jeff that Jeff has to the nihilists—Jeff's positioning vis-à-vis the nihilists here ultimately working two ways. For, by juxtaposing him with them, the Coens also underscore the still more radical absence of a center that informs Jeff's own existence: his lack of any commitment, any engagement, indeed, any meaningful life effort in any direction. Despite the reading of some of the movie's, and the Dude's, more enthusiastic fans, the Coens can hardly be said to be wholeheartedly endorsing the Dude as we find him; they clearly take an ironic, though perhaps tenderly ironic, distance from their protagonist.

Yet it is equally the case that the Coens also have nothing better to offer in the place of the Dude. The Dude *is* the "hero" of the film, to the extent there is one at all, thereby in part justifying the film's prevailing interpretation. As the plot plays out, Jeff, spurred by events to do his own bit of original thinking, indeed briefly fills the Humphrey Bogartish role of the alienated noir detective. Thus, other than this doubly

negative insight—of the impossibility of inhabiting any self-proclaimed nihilism, and the comical emptiness of the more extreme lived nihilism of the Dude—the Coens' work offers no more definitive perspective. They do not have or present another, better position to which to turn.

What we are left with, then, finally, with reference to the events of the 1960s, as the buried kernel of all this position taking, is nothing other than an unfolding, cascading series of ever more ironic stances: a staircase or escalator of irony leading to an ever more radical, and ever more implicated, emptiness. Each stage establishes a distance from the previous one—the Dude from the nihilists, the Coens from the Dude— even as each also remains dependent on the prior one, thus constructing a totality, itself in motion, from which no one finally gains egress.

Or, as Paul de Man puts it in one of his most famous essays, "The Rhetoric of Temporality," when commenting on Charles Baudelaire's piece "The Comic Absolute": "In the idea of a fall thus conceived, a progression of self-knowledge is certainly implicit: the man who has fallen is certainly wiser than the fool who walks around oblivious to the cracks in the pavement." (This last, the oblivious fool, would be the self-proclaimed nihilists in my example.) Yet de Man continues, commenting on the self who knows the difference between these two stages and must herself or himself have fallen and arisen (the position here finally occupied by the Coens): this self's "ironic language splits the subject into . . . [a] self that exists in a state of inauthenticity and a self that exists only in the form of a language that asserts the knowledge of this inauthenticity. This does not, however, make it an authentic language, for to know inauthenticity is not the same as to be authentic" (214).

De Man, then, captures the Coens' position as embodied in the language or fiction of their film. The Dude serves to mark the "inauthenticity" or incompleteness of any nihilism, including his own—the Coens

having greater knowledge of this than any of their characters. Yet he also embodies the fact that the Coens themselves do not ultimately escape this condition. Even as they distance themselves from both positions, that of the nihilists and the Dude, their "better" knowledge does not entail itself an "authentic" language, or any more positive position, but only a repetition of these earlier stances. They thereby achieve (merely) an irony of irony, hence, a hyperirony—"irony of irony" itself being a phrase used by de Man earlier in this same discussion.

Turning to the work of de Man himself, however (I will eventually make my way back to the Coens, *Lebowski,* and the Dude), it is not this particular reading, or this particular chapter, or even de Man's rightfully famous treatment of irony as such that I want immediately to take up. Having begun to fill in the background (the 1970s faltering appropriation of the 1960s) and the context of the Coens' irony, in a way that makes plain the linkage of the Coens to de Man's own reception, as well as having laid out the irony or hyperirony they both share, I want to turn to that moment when de Man—"irony itself," as Jacques Derrida once called him—was himself rudely intercepted by history. This entails a somewhat detailed look at our current understanding of de Man.

After all, another, still more portentous passage today than the one quoted above is to be found in de Man's oeuvre, a passage that no discussion of de Man at present can afford to neglect. In the last essay in the last book that he published during his lifetime, *Allegories of Reading,* "Confessions: Rousseau," de Man wrote the following, in which he announced what he believed to be the ultimate breakdown of all *excuses* and the untenability of any *confessing:* "It is no longer certain that language, as excuse, exists because of a prior guilt but just as possible that since language as a machine performs anyway, we have to produce guilt (and all its train of psychic consequences) in order to make the excuse

meaningful. Excuses generate the very guilt they exonerate, though always in excess or default" (299).

Now, before unpacking this sentence, typically de Manian in its elegant complexity, the seemingly ominous significance it took on soon after it was written must be recounted. As is well known to some, after his death in 1984, it was discovered that de Man, when a much younger man, at the age of twenty-two or so, had worked for, and indeed published in, a collaborationist newspaper in his native Belgium. Moreover, though this was apparently before the actual advent of the concentration camps, de Man wrote at least one piece with an explicitly anti-Semitic tenor, one with terrifying overtones of the final solution—it posited all Jews placed on a desert island, exiled—although it has also been attested that de Man himself was not personally anti-Semitic even in this era and in fact aided a few Jewish friends. According to the best evidence, de Man's collaboration, as well as this momentary anti-Semitism, was thus a pragmatic position, a way to keep his job—as well as, in his view, a way for Belgium to survive in a Nazi era that he, and his uncle, once prime minister of Belgium, believed was upon them. A bit after this most notorious piece was published, in early 1943, de Man quit his post, when the absolute horror with which he was dealing began to become more widely known, along with the fact that collaborators, even mere collaborating journalists, could be held by the Allied powers as war criminals.

The assertion quoted above from "Confessions: Rousseau," first appearing in print in 1982, from 1987 forward thus became interpreted in light of this history, which had only subsequently become known. And, viewed retroactively, de Man's statement took on the following sense: de Man's claim was a cover, it was asserted, indeed an excuse, for de Man's never having spoken publicly (or privately, for the most part)

about this aspect of his past. The sentence I quoted above indeed seems not only to assert that excuse or confession as a speech-act is impossible, but that it is impossible precisely because excusing or confessing could itself be *the cause* of the guilt underlying it, rather than *the response* to the actual performance of an earlier shameful deed. Given the complexities of language—at least on de Man's analysis of language—the excuse or confession, which is supposed to be some kind of recompense or restitution of an earlier vicious act, might instead be what gives birth to this past and our belief in it in the first place. And de Man, so arguing, was thus indeed taken to be giving himself carte blanche, to be writing in palimpsest the justification or legitimation, not only of his original behavior—his own minor, yet still inglorious, participation in the central historical event of the last century—but also especially to be legitimating his subsequent silence about what he had done: that omission of any confession, explanation, or excuse on his part, which de Man maintained throughout his career.

The sort of literary criticism that de Man actually practiced, as well as its closeness to the Coens, starts to come into view, however, when it is noted that de Man's own *hyperirony* is indeed what is being missed by those who proffer this interpretation, who discover in "Confessions: Rousseau" an excuse written in palimpsest for de Man's never having excused or confessed his own earlier misdeed.

Indeed, de Man's stated position being that excuses of any sort are impossible, those who read his essay as itself an *excuse* may well be engaged, consciously or not, in an extended exercise in missing the point. His position, denying that any piece of speech could function thus—as a reparation or restitution for a shameful action—in fact arguably gives *greater,* not less, weight to the original crime or deed. Excuses would here be being dismissed, or ironized, insofar as they imply that

speech of any sort has the power to retract and absolve a prior (awful) action.

Precisely such ironic, or hyperironic, distance from the *absolving* or purgative work of speech, moreover, comes to the fore in an earlier, equally famous passage in this same essay, where de Man actually discusses Rousseau's *Confessions* (above, he was engaged in a reading of the *Reveries*), and it provides the background for de Man's later remarks. Through an intricate work of interpretation that I have not time to fully review, de Man puts quite a distance between himself and the notion that language provides the ultimate excuse.

For, having first posited that Rousseau's confessing to a variety of crimes might indeed give him pleasure, the narcissistic pleasure of self-exposure, and that these acts thus might even have been committed so as to afford Rousseau the opportunity of guiltily and ashamedly confessing to having done them, de Man next considers another excuse that Rousseau offers for the particular misdeed of slander, or false witness: namely, that he, Rousseau, did not mean any harm, since he did not utter with meaning or intent the name of the woman whom he falsely accused. Rousseau, rather than slander this person, instead made a wholly arbitrary sound, totally unaccompanied by any intention, and thus nobody, certainly not Rousseau himself, was really at fault.

This excuse, which exculpates itself by calling attention to language and its role, is thus essentially the same excuse that de Man's attackers believe him to have promulgated. Yet to me, it seems difficult—though not impossible, since it has been repeatedly done—to overlook the irony in de Man's description of this phase of Rousseau's serial excusing and confessing. Thus de Man writes: Rousseau's "sentence . . . allow[s] for a complete disjunction between Rousseau's desires and interests and the selection of this particular name. Marion just happened to be the first

thing that came to mind; any other name, any other word, any sound or noise could have done just as well. She is a free signifier . . . , metonymically related to the part that she is made to play in the subsequent system of exchange and substitutions" (288).

Notice here de Man's obviously ironic repetition of Rousseau's claim to have uttered a meaningless sound: "any . . . word, . . . sound or noise." And, driving the same point home further, emphasizing still more hyperbolically the supposed emptiness of Rousseau's utterance, de Man continues: "In the spirit of the text, one should resist all temptations *to give any significance whatever* to the sound Marion; for it is only if the act that initiated the entire chain, the utterance of the sound Marion, is truly without any conceivable motive that the total arbitrariness of the action becomes the most effective, the most efficaciously performative [excuse] of all." (my emphasis, 288–89).

De Man's real point at this moment, it thus should be clear, although conveyed hyperironically, is not, as his critics believe, that because we all have language, we all, including de Man, always have an excuse at hand for whatever we do and are uniformly innocent, but rather that *no such thing as innocent or pure or entirely meaningless language actually exists.* De Man is indeed *undermining and distancing himself* from Rousseau's claim that an instance or piece of language can ever be wholly absolved from meaning or consequences. "Madness," a term he himself is about to use, is what it is to think of anyone as actually employing or confronting an intentionless instance of language, a floating or free signifier.[1]

This interpretation gains further credibility, moreover, when the contemporary context in which this essay appeared is recalled, a context indeed flagged by de Man's invocation of a "free signifier." The original title of de Man's essay was "The Purloined Ribbon," and this title and the present discussion, in which the titular ribbon has just

figured, clearly allude to the controversies going on in poststructural-ism at the time, specifically between Derrida and Lacan. Both think-ers were fascinated by the possibilities supposedly unleashed by the pure signifier—the graphic or acoustic image, which, on the basis of an interpretation of Saussure's phonology, they believed best exempli-fied language's autonomous functioning, its arbitrary work apart from any individual, human, or intentional manipulation. De Man, in his reading of Rousseau, by choosing this most fraught of moral situations (an actual slander and its subsequent excuse), was thus clearly *treating ironically* his contemporaries' privileging of language and the linguistic, their belief that linguistics' presentation of a structurally autonomous language has something important to offer concerning ethics, politics, or our own condition. To be sure, de Man is not putting another better or more authentic understanding of language in the place of these; his is indeed an implicated, hyperironic stance, as is the Coens'. Yet he is doubting, not affirming, the ability of this account of language to func-tion in the way its proponents hoped, and he is questioning the ability of language in its pure emptiness to provide any excuse or justification, here of Rousseau's original crime. In "Confessions: Rousseau," de Man, in sum, stakes out a hyperironic distance from the notion of the pure signifier as it was then understood, as well as from Rousseau's apparent belief that recourse to the workings of language could furnish him with any excuse, just as the Coens distanced themselves from that nihilistic worldview that a certain 1970s interpretation of the 1960s embodies.

Accordingly, only the most tendentious of readings could see de Man's treatment of excuses as itself a hidden or retroactive excuse for his having never excused himself for, or having confessed to, collabo-rating when he was twenty-two. Yet further issues, raised by the first passage to which I referred, still remain on the table. De Man, after all, is notorious for privileging, even hyperbolically privileging, the work

of language, granting it a status and power beyond even that assigned to it by Lacan or Derrida, with whose treatments of language his has indeed appeared to many to be akin. Am I suggesting, then, that de Man did not hold such a view? That he did not give a centrality to language similar to, perhaps even greater than, these "rival" theorists? Moreover, part of the privilege de Man is usually thought to give to language takes this as coming at the expense of history. De Man is commonly believed to fold all history into language, and many now retroactively see this as an attempt to flat out *erase* de Man's own past deed: to assert, as in the passage above, that there never was any history in the first place, leaving aside the subsequent matter of confessing to it or excusing it or not. Am I claiming, then, that de Man did not proceed in this fashion, that he did not radically subordinate history to language, as he is now quite ominously seen as having done?

What status do language and history ultimately have in de Man? And what relation, if any, does de Man's construal of these have to the Dude, to the Coens' film, and, more broadly, to that generation similarly marked by the failure of the 1960s and the ironic or perhaps hyperironic response posed by the nihilistic 1970s?

To fashion at least a partial response to these questions, it is necessary, having previously identified them, to distinguish hyperirony as exemplified by the Coen brothers and hyperirony as practiced by de Man—a movement which should also complete my own historicization of (de Manian) irony, as well as ultimately return me to my own ironic habitation of certain styles of historicism (and culture critique), and with that the relation of these to the "postmodern." This last term, often associated with the Coens' work, gives to our current historical period a near absolute status for evaluating the cultural artifacts produced within it, resulting in what might be termed a "temporal identity

politics."[2] And given my own historicizing tendency here, as well as those issues raised by the style of the Coens' film (a matter not yet treated), it will be fitting to conclude by identifying a specific stylistic feature of this film, associated with the postmodern, and offering an interpretation of what it holds for such historicizing, as well as my own employment of the period.[3]

To return to de Man and language, however, the feature differentiating irony or hyperirony in his case over and against the Coens' consists in the fact that irony in de Man's work is inextricably linked to what he calls *allegory*. De Man's practice of irony and allegory *together* renders his treatment of the former distinctive. And grasping how these two are combined lets an answer emerge to the question posed above; it clarifies, in a rough and ready way, the relation of language to history in de Man's thought and the possible effacement of the latter by the former.

Allegory, in de Man, first and foremost describes the way de Man approaches his own subject matter—his working methodology, if one will. As such, it entails that all of de Man's central concepts and themes, including most notably that of language, are never referred to in their own right. De Man instead proceeds through indirect discourse. He addresses his topics by piggybacking on others' claims, by way of allusion to other texts (as we have witnessed, for example, in "Rousseau: Confessions," where he interjects some rather surprising and indeed anachronistic commentary pertaining to the notion of a "free signifier" in the midst of a reading of Rousseau). The most central matters in de Man are always broached in this manner, however: through a recounting that passes through someone else's different recounting—that is always *"allos agoreuei,"* i.e., *allegorically*.

And one, perhaps too startling, way to put what this technique yields, when it comes to language, is that *there really is no such thing as*

language in de Man. For, language as such, *die Sprache selbst,* is indeed only ever taken up by de Man in terms of what others have first made of it—Heidegger, Derrida, Lacan, Nietzsche, Deleuze, etc.

Moreover, given the allegorical status of all his concepts—and here the linkage of allegory back to irony becomes more evident—de Man's standing as a solid member of the poststructuralist community is indeed finally wobbly. De Man doubtless does in some fashion assume the starting points of poststructuralism; most often, however, he does so in order to bring them into question (as already noted in this one instance). Finding himself already implicated in this orientation toward language, his often over-the-top insistence on this theme never constitutes a simple theoretical endorsement of such positions. Rather, de Man plays the gadfly: he teases out and in fact deflates the various *extra-linguistic* pretensions, the salvational, therapeutic, ethical, or political hopes that others' recourses to language inevitably possess. De Man's insistence on language, his astounding hyperbolic attribution to it of all sorts of unexpected achievements, was really far less the communication of a belief that we all knew what language is and what it really does, than it was a deflationary gesture whereby theorists and critics were prevented from ever returning from this storm-tossed sea (upon which the linguistic turn had embarked them) to dry land, indeed to the promised land (of greater freedom or knowledge). De Man thus allegorized—he built sometimes strange interpretive bridges to others' thematizations of language—and, simultaneously, he pushed these thematizations further. He insisted on language all the more, by way of *ironizing* the hopes that accompanied this endeavor, and the self-mastery that these hopes seemed to entail—"I who speak about this signifier somehow escape its play"—even as de Man again himself offered no better, no more definitive standpoint of his own. In this fashion, allegory and irony, allegory and hyperirony, were indeed in de Man finally one.

History, as a consequence of this, doubtless was, then, subordinated to language by de Man; yet this took shape in a far different way and with far different effects than is believed by most people even today—defenders and attackers of de Man alike. For de Man's denial of history, as I have begun to make clear, was always primarily a denial of *literary history,* a denial that these sorts of ruminations—at first Heidegger's, later the poststructuralist canon being assembled around various appropriations and reappropriations of language—could indeed coherently enter history and provide a stable foundation of any kind for a new world, or even a new kind of knowledge.

So, too, on these grounds, de Man was indeed resolutely opposed to all historicism and implacably anti-historicist in his own practice. Allegory and irony, while radically situational, are themselves rigorously anti-historicist models of literary-critical work (as, again, the interjection of the free signifier into a reading of Rousseau witnesses), as well as being anti-theoretical (in the more usual sense of theory as implying the positing of a thesis or principle which one goes on to defend or from which one deduces further reasonable consequences). As practices, they thus finally do entail a kind of skepticism toward history generally. Yet, here, as well, such skepticism begins from literary history (à la Heidegger and poststructuralism) and flows *outward* to history more broadly understood (to our ability to *know,* to discursively take up, historical factuality and thus to grasp and steer it), rather than denying *simpliciter* every historical event and action.

None of this, however, is meant to suggest that de Man himself or his work emerged unscathed from his distancing from history (wholesale or not), or that he carried out his hyperironic and finally hyper-self-ironizing linguistic turn without history, or something like it, taking its own revenge and itself ironizing de Man. This is the last point to be made concerning de Man: history's ironic treatment of him. Such

treatment, history's revenge, let me hasten to add, does *not,* however, consist primarily in the misdeeds of de Man's youth coming to back to haunt him, ultimately sinking his scholarly fortunes, as so many today believe, almost always at second hand. Rather, it takes a more subtle form, which, being recounted, also elucidates what de Man's fate owes to the Dude's and his history.

For the decline of de Man's scholarly reputation, his eventual "fall," to use a favorite de Man word, could only have occurred as it did because history, historical accident, buoyed de Man up in the first place and caused much of his initial popularity. Only because de Man's intellectual *ascendancy* was owed to the rather aleatory workings of (literary) history, could his subsequent decline take place on these grounds as well.

And the Coen brothers' film *The Big Lebowski* indeed gives us the key to the historical setting and mood that facilitated the surprisingly enthusiastic reception of de Man's decidedly esoteric thought. Perhaps the sole viable belief in the wake of the collapse of the aspirations of the 1960s (at least at that moment to that generation), as the Coens' treatment of the Dude attests, was some form of no belief: a belief in nothing, or nihilism. De Man's work, in part accurately, was indeed felt to proffer the most radical, the most high-octane version of such a credo. His stance, after all, really was more ironic than any other (for the reasons I have reviewed); his thought, his positioning, never stabilized or came to rest at a conviction of its own, in a way that indeed held, at that time, an almost inescapable attraction and fascination.

De Man's work owed its original allure to still another aspect of his presumed teaching, however, one also fundamentally linked to this same epoch and its perspective. De Man's writing, misread (for the reasons offered above) as an actual first-order teaching about language, even as it embodied that abyssal loss of faith characteristic of

the post-1960s, seemed to bear, in addition, an emancipatory or revolutionary charge. His theory being understood to assert that any piece of language could indeed mean anything (or nothing), just like Rousseau's sound "Marion," his views appeared to license a new, previously unheard-of freedom: the ability to interpret a text without any prior hermeneutic constraints. Many of de Man's acolytes believed this freedom was to be found in his work: the liberty to read a text in whatever manner its words suggested or moved one to do. Hence, even as his followers, on one level, registered the eclipse of the hopes of the 1960s, they were able to believe that they were enacting the continuation and extension of this decade's emancipatory ideals on another. Like the Dude himself, who clearly still trusts, even in the midst of the life that he presently leads, that he is part of a counterculture, many who took up de Man's thought never abandoned their earlier political commitments, and this supposedly liberatory teaching about language permitted them, at least in part, to continue to uphold this faith.

That de Man's works owed their influence to this setting, the aftermath of the 1960s in the 1970s, is clinched one final time by the fact that when the pushback against de Man came, it came, of course, from this same direction: from a claim to honor still more forthrightly and aggressively that revolutionary inheritance of the 1960s that had animated the initial reception of de Man's thought. The de Manians themselves, having never given up their original political stances, were thus surprised at being so outflanked. More important, however, is the fact that even as the fall of de Man and the submersion of his actual writings gained momentum (to which the revelation of his past shameful behavior gave only the final toppling blow), this supposedly new and freer truth about interpretation that de Man was believed to proffer was taken over and transformed into the prevailing professional belief: the working presupposition of most literary critics.

Indeed, de Man's textual practice, glossed as a hypertextualism, a radical revision and further opening up of New Critical close reading, was appropriated by the still self-avowedly more fervent heirs of the 1960s; therewith, it came to be applied to the now once again fertile fields of history and culture. De Man's current and continuing legacy thus entails a nearly absolute ironizing of de Man on history's part. For this sort of hypertextualist treatment, now channeled back to the domains of history and culture, is held, after all, to accomplish exactly what de Man himself had most insistently denied: to intervene in politics, to change society and the world. Almost an entire generation indeed still retains, albeit tacitly, and largely for political reasons, what they take to be a theory of language and interpretation (centered on the radical freedom of the signifier), initially crafted on the premise of questioning all extant political-historical goals, and they do so, while applying it to material they believe to be primarily historical, political, and social.

In this fashion, then, the Zeitgeist indeed overtook de Man, nearly swallowing him whole—though such a fate, it should be noted, largely confirms his own belief in the total non-guidability, the sheer randomness of (intellectual) history, as well as bringing to fruition his related declaration (originally made about Rousseau) that "he cuts himself off once and forever from all future disciples," something he may well have achieved more successfully than even he hoped.[4] Yet this analysis, depending as it so obviously does on the history surrounding the taking up of de Man's work, on what could well be called a certain "structure of feeling" informing its reception, appears to directly conflict with de Man's own practice. It indeed seems to take a very different tack toward history and interpretation than de Man himself in a way that calls for some discussion.

Accordingly, having struck upon these issues—of periodization, context, history, interpretation, and their various freedoms and

exigencies—let me turn by way of conclusion back to *The Big Lebowski*. It is perhaps not possible, after all, to discuss the Coen brothers—certainly this film, especially its style and more formal features—without taking up the notion of the postmodern (as well as its characteristic predicates, such as pastiche and irony, some of which have already been discussed), which brings all these matters in its wake.

The postmodern, understood as temporal pastiche, indeed seems uniquely to capture the dizzying array of cinematic genres and historical times that pervade the Coens' film. Film noir, the cowboy movie, the late 1960s angry young man film (with its obligatory "Malibu party scene"), to name but three of the most obvious, are kaleidoscopically reconfigured in the Coens' movie, all within the purportedly greater frame of the plot's actual temporal setting (the early 1990s, the first Iraq War). Yet, sealing its quality as pastiche, all the characters, especially the Dude, seem repeatedly to slide out of this frame: none are stuck in a single time, at least not the time of the film (with the exception perhaps of the initial Big Lebowski, the putative achiever, who bears an ineffaceable Reagan-era stamp).

Accordingly, on one rather normative reading of the postmodern, this collage of styles and times and eras would indeed signal the end of all historical grand narratives. The film, moreover, seems to spell out such an end imagistically in the figure of the rolling tumbleweed at the beginning, especially as it finds itself echoed or answered by the other mobile spheres prominent in the movie, the rolling bowling balls. The tumbleweed in the opening credits famously runs out of room as it hits the waters of the Pacific, subsequently being forced to angle up the coast. It thus portrays the cessation of history as linear narrative, above all, perhaps, the cessation of that specifically American narrative of the pioneering west, to which the weed so obviously alludes. Further, as thus impeded, it gives way to, and merges with, the hardened-plastic

balls that playfully, yet repeatedly, transit up and down the lanes, traversing their gutters and alleys again and again, performing evocative repetitions of roll and return. The once vast expanse of the continent (the tumbleweeds rolling across it) has indeed been reduced to the restriction of these lanes, a word which, in an L.A. setting, must also be given its automotive meaning. The tumbleweed, having reached the end of the road of history without its work, its drive, simply ceasing, is thus now taken up, refracted, disseminated in the endless, repetitive, indeed postmodern play of the game of bowling.

This reading depends on the now prevalent and quite familiar notion of the postmodern as a periodizing cultural norm (or dominant). Yet these same visual themes, as presented by the Coens, push toward a somewhat different reading, one that may in part be concealed in the former, yet which, brought out in isolation, spells out a significantly different relation to history as a whole.

After all, when it comes to how these rolling spheres, the bowling balls, are *filmed*, another opposition, presents itself. Perhaps the most beautiful shot in the entirety of *Lebowski* (or perhaps better, given its context, the most *sublime*) opens the scene right after Donny's funeral. In it, a bowling ball, spewed out of the ball machine, unexpectedly surfaces before our eyes and fills the entire screen. This shot—and more generally, all those taken at angles from which an actual bowler would never view her, his, or anyone's roll (close-ups from floor-level, etc.)— finds itself answered in the dream sequence in which the Dude, captured by his roll, is carried by the ball down the lanes, raised about a foot above the plane of the alley and parallel to it. As so positioned, the Dude physically embodies these otherwise unnatural camera angles. He has thus become the substitute, the enfleshed placeholder, of the moving camera that unobtrusively informs so much of the film.

In the case of these shots, however, the excessive narrowness of the frame, the unexpected and unnatural reframing of the movement of the ball, gives pleasure. Yet, in the second instance, when the spectator becomes the spectated, this same narrowing of passage, as attested by the Dude's dream, instead yields a helpless (albeit at times comical) passivity. A hallucinogenic replay of Charlie Chaplin's turn on the assembly line in *Modern Times* (but one notably devoid of all references to labor or other "totalizing" tropes), the Dude's stunt here furnishes the dark, almost fugal counterpoint to those other, visually uncanny shots of various rolls (the rolls themselves already perhaps a metonym for the operation of filming them, as the erstwhile watchword of the very medium of film has long been, of course, "roll 'em").

This coincidence, then, the intersection of (a) the Dude's helplessness and inability in any way to orient himself (his utter loss of a vertical dimension) with (b) the spatial narrowing and fracturing of the filmed rolls (within each diamond shard of which an intense pleasure indeed lies concealed) offers, then, still another version of the postmodern, distancing itself from all periodizing ones. Rather than the postmodern somehow signaling an era, a period connoting the end of all historical thinking (which indeed inevitably becomes again, as in Jameson, a species of such thinking itself), the postmodern, or something like it, would instead be what you are when you no longer know what to think about history at all. Rather than naming a time, and thus fostering an absolute temporal identity (the epoch to end all epochs, the prison house of history), it would name a problem, perhaps an aporia in respect to historical thinking as such.[5] Postmodern would indeed be an intersection of structure and genesis, like (a) and (b) above, belonging to no time— potentially found, for example, in Benjamin's baroque or Longinus' sublime. And this being so, as thus understood, this term could indeed

serve to designate what the Coens', Paul de Man's, and my own way of working all have in common: a pause or gap in the comprehension of history not simply explicable through the working of history itself.

Notes

1. This does not mean that de Man does not also believe that there is a *dimension* of language that indeed functions thus—autonomously, mechanically, non-intentionally and so forth—only that this dimension is never straightforwardly confronted or evinced either in life or even in theory.

2. This is true both in those interpretations in which the postmodern takes the form of an *era* or period bringing to an end our overarching historical orientations (such as J. F. Lyotard's in *The Postmodern Condition*) or those (like Fredric Jameson's) which take this assertion of the disappearance of historicity as itself the key to rediscovering our position in a larger historical narrative.

3. I owe thanks to Edward Comentale for the suggestion that this piece culminate by returning to the Coens' movie, as well as for much other helpful editorial assistance; and thanks to him and Aaron Jaffe for their original organization of the conference, and now this volume, and their inclusion of me in both.

4. *Blindness and Insight* 140.

5. To be fair to J. F. Lyotard, this is often how he does speak of the postmodern. In part due to the early publication date of *The Postmodern Condition,* however, as well as the very coinage "postmodern," which obviously bears a periodizing index, this articulation has a tendency to be overlooked or downplayed.

Lebowski and the Ends of Postmodern American Comedy

Matthew Biberman

What kind of humor is Coen comedy?

The question is difficult in no small measure because comedy itself is difficult to explain. In this essay I offer a reading of *The Big Lebowski* that situates the film in a tradition of Jewish humor animated by social anxieties about nonconformity and collective psychotic behavior. My thesis is that Coen comedy ceaselessly dramatizes such anxieties and presents them as a kind of psychological training ground for surviving the future.

The standard argument about classifying Coen humor argues that it is best categorized as an instance of "postmodern parody" or "postmodern pastiche." Clustering *Lebowski* with such "dark" 1990s comedies as *The Cable Guy* (1996), *The Truman Show* (1998), *Serial Mom* (1993), and *Pulp Fiction* (1993), Christopher Beach, for example, asserts that such films display "a mastery not only of the comic tradition but also of various other film and television genres, any of which are fair game for its *postmodern pastiche*" (205, emphasis mine). Similarly, Peter Körte and Georg Seesslen argue that "Coen films positively encourage us to use words like 'post-modern' or 'manneristic' to describe them" (260). The film is, they write, "a parody of plot twists of so many films noir or contemporary cop movies" (196) and, further, that "Coen country . . . has always been a pastiche," and in this case, they produce a filmic landscape in which "the 1960s and 1970s almost simultaneously return

as parodies of themselves" (200–201). Underscoring this point, R. Barton Palmer has a chapter in his study of the Coens simply called "The Coen Brothers: Postmodern Filmmakers," where we again learn that "The postmodernist's characteristic mode is pastiche, the so-called flat parody famously first identified by Fredric Jameson as one of the most distinguishing features of the aesthetic" (58).

It is perhaps thanks to Jameson's analysis of postmodernism that the attribution *postmodern* calls up *parody* or *pastiche* so readily. The terms are so often invoked together it may be worth pausing for a moment to postulate at least one clear set of definitions for these terms. In his book *Film Parody,* Dan Harries offers a good one: "As a textural system," he writes, "parody simultaneously says one thing while saying another, always acting as an ironic tease" (5). It may be precisely this sense of "ironic tease" that applies in what may be *The Big Lebowski*'s most essential bit of dialogue:

> WALTER: That was a valued rug. . . . Thus was, uh—
> DUDE: Yeah, man, it really tied the room together—
> WALTER: This was a valued, uh . . .
> DONNY: What tied the room together, Dude?
> DUDE: My rug.
> WALTER: Were you listening to the story, Donny?
> DONNY: What?
> WALTER: Were you listening to the Dude's story?
> DONNY: I was bowling—
> WALTER: So you have no frame of reference, Donny. You're like a child
> who wanders in in the middle of a movie and wants to know . . .

In a perfect illustration of the postmodern mode, the scene includes the very critical gloss I wish to make—that, like Donny, the audience has "no frame of reference" in which to contextualize the Coens' comedy.

The fact that an absence is felt happens because we have been conditioned from a tradition of modern irony to expect this kind of humor to work in a way that will send us back to and thus reinforce an implicit framing moral order. Instead, in *The Big Lebowski,* the lack of meaning becomes an instrument capable of fundamentally blurring not just moral order but any order. Ultimately, the audience is left unmoored, uncertain not just of the difference between right and wrong but of other crucial anchoring facts as well. It is this understanding that informs Harries' concluding pronouncement that "parody's postmodern impulse indicates its inability to arrive at any final meaning; reminding us quite overtly that meaning is always fluid and shifting" (133). Modern irony uses comedy in ways that reconcile the sympathetic audience to norms per se while so-called postmodern parody puts comedy into the service of negating such norms, with the end result that *any* act of imposing norms gets called into question.

Many of the unsympathetic responses to *The Big Lebowski* follow in this vein, concluding, with Körte and Seesslen, that the bottom line is that "all the characters are running after pipe dreams, chasing a zero that is just as empty as they are" (196). Behind this comment lies a general disillusionment with postmodern parody itself. Harries, for example, damns parodic effects as "possibly too circular to engender any real positive change" (133). Ultimately, such negative verdicts seem to follow suit, with Fredric Jameson's still influential claim that postmodern pastiche is to be understood as a bad development: what you get is now "a neutral practice of such mimicry . . . devoid of the conviction that alongside the abnormal tongue you have momentarily borrowed, some healthy normality still exists. . . . Pastiche is thus blank parody, a statue with blank eyeballs" (*Postmodernism* 17).

What such judgments miss is precisely the way so-called blank parody comes to function when historically situated in a particular set of

changing comic circumstances. Indeed, Coen comedy may be fruitfully compared to a cognate mode recently examined by Alexei Yurchak in his book *Everything Was Forever, Until It Was No More,* a sociological examination of Soviet culture just prior to the collapse. Prominent in Yurchak's analysis is a kind of humor he calls *stiob,* a form oddly like what the Coens practice in *The Big Lebowski.* In *The Future of Nostalgia,* Svetlana Boym defines it as a "jocular, politically incorrect discourse made of quotations, obscenities and informalities, seemingly free of taboos except on high seriousness" (154). Part of the interest here in the term is the way, after the collapse of Soviet system, *stiob* can *not* be a means of perpetuating the order of the status quo (as is the case in classic reading of modern irony) but as an uncanny means of surviving a future—yet unrealized—mass cultural upheaval. On this note, it is worth considering the deliberate historical uncertainties implied by the setting of the Coens' film at the crack of dawn in an age George H. W. Bush had just then described somewhat ominously as "a new world order." Furthermore, as Stacy Thompson's chapter in this volume usefully discusses, there are a considerable number of obsolescent specters of communism haunting the film to be counted along with a bevy of out-of-date American Cold War signifiers. Be it glib nostalgia for Soviet kitsch or 1960s counterculture Americana, *stiob* describes an exaggerated adherence and over-identification that "bring[s] to light the obscene superego underside" of the obligatory and deadly sober experience of obsolescent signifiers (154).

Like the Coen humor it mirrors, *stiob* seems to challenge norms at a psychological level in ways that reproduce—or, perhaps, desublimate—older patterns of religious identity and its relation to theories of comedy. Following Freud—and, even before him, Hegel—the mythic relation generating humor might be formalized as a dialectical fable where Jewish slavishness contests the spirit of the gentile, the Jew's

master. Though obscured, this is the generic social scenario that underwrites the commonplace that humor in the abstract dissipates anxiety. Comedy is here understood to be a game where the winner is the successful joke teller, who, in effect, "banks" the audience's laughter. In turn, this

Modern irony uses comedy in ways that reconcile the sympathetic audience to norms per se while so-called postmodern parody puts comedy into the service of negating such norms....

transaction is understood in moral terms to be a gloss on power relations. The resulting verdict is biblical: such comedy illustrates how the poor go about exacting just revenge, suggesting that on some metaphysical level, the impoverished will someday reign. Part of the power of this interpretation of humor is that it overtly includes a gloss on the mechanism present in the religious model as proselytizing. Like the Christian (and, tellingly, in this he is different from the Jew), the joke teller must convert others to his code. But it is precisely this logic of yoking comedy with commonsense notions of guilt and superiority that gets decisively reinterpreted in the work of the Coens. They duplicate the logic but then alter it so that the slot once understood as occupied by the Jew is left open with an invitation for the gentile to occupy it. The result in *The Big Lebowski* is a comic film that is now neither Jewish humor, as Freud knew it, nor "postmodern pastiche," as Jameson did, but what I should like to dub "American *stiob*," where, to borrow Yurchak's phrasing, the dominant discourse hollows itself out from within.

In scattergun fashion, *The Big Lebowski* throws out a veritable superabundance of sequences readymade for Freudian interpretation. The Coen universe is, as the critics Renata Salecl and Slavoj Žižek would note, a world always already suffused with that "nostalgic longing for the good old heroic days when patients were naive and ignorant of

psychoanalytic theory" (1). The film's most extended embedded parody, the *Gutterballs* sequence, is the case in point, confirming that the Coens assume that their audience understands everything Freud maintained regarding, for instance, the significance of genital shapes manifest in the suggestive curves of Brunswick balls and pins. To be more specific, in serious modern art, Freudian logic lies buried deep beneath the surface—it is what emerges through deep thought and work as the art's secret truth. The Coens offer a variation on this standard script, a parody of it, by placing this deep truth on the surface. Consider, for example, how the *Gutterballs* sequence ends: the sexual fantasy is capped by an overt, indeed cartoonish, castration joke where Lebowski's pleasant, erotic dream is rerouted into the gutter, a nightmare of what the screenplay describes as "Germans, advancing ominously, wielding oversized shears which they scissor menacingly" (103).

Equally important, this strategy is deeply reminiscent of early Woody Allen, most especially *Everything You Always Wanted to Know about Sex* (1972) and *Sleeper* (1973). Here it helps to remember that Allen is also frequently characterized as a "parodic" filmmaker who, according to Christopher Beach, "is often cited as the paradigmatic example of comic postmodernism" (155). Once pointed out, Allen's influence seems obvious, and yet it is rarely made by critics, despite the fact that not only are the Coens Jewish, but they also clearly operate within the economic niche of independent American filmmakers that Allen helped construct. Instead, the basic interpretation presented for *The Big Lebowski* is that the film is to be read as a parody of *The Big Sleep* and other such noir films. Nor is this wrong. It is just that the Coens' work-over of *The Big Sleep* is done via Woody Allen. It blends Allen's comic send-offs of Freud with his equally pronounced efforts at parodying Hollywood noir films as illustrated by *Play It Again, Sam (1972), Take the Money and Run* (1969) (which like the Coens' *O Brother, Where Art Thou* [2000]

7.1. Readymade for Freudian interpretation.

features a "Virgil" in an "escaped convict" parody), and such later Allen films as *Bullets over Broadway* (1994).

Like these Allen films, *Lebowski*'s humor trades off of the recognition that the essential scene for endless comic dramatization is of the anxious Jew attempting to pass effectively in a gentile world. Consider, for example, how now that Judaism has been introduced, this fact forces us to return to the *Gutterballs* sequence already analyzed in order to ask just why the menacing agents had to be Germans. And, to approach the matter this way is to evoke what is to my mind the film's greatest comic asset—John Goodman's performance as Walter Sobchak. A Polish American, one presumes, Sobchak dominates the movie, creating comedy in the way that everything that happens to him gets routed through the two key elements of his constructed identity: his sense of himself as a Vietnam vet and his sense of himself as an observant Jew.

... **The Big Lebowski** is a comic film that is now neither Jewish humor, as Freud knew it, nor "postmodern pastiche," as Jameson did, but ... "American **stiob**," where, to borrow Yurchak's phrasing, the dominant discourse hollows itself out from within.

A good example comes late in the film when Sobchak and the Dude ceremonially scatter Donny's ashes, and Sobchak's eulogy inevitably leads him to lump Donny into the heroic dead, such men as those who died in Vietnam: "so many bright flowering men, at Khe San and Lan Doc and Hill 364. These young men gave their lives. And so did Donny." The Dude responds characteristically: "What the fuck does Vietnam have to do with anything! What the fuck were you talking about?!" A similar, indeed, related dynamic plays out between Walter and the Dude regarding Walter's adopted religion. It is Walter who, early in the film, proclaims, "Saturday, Donny, is shabbas, the Jewish day of rest. . . . I don't handle money. I don't turn on the oven, and I sure as shit don't fucking roll!" In response, the Dude offers up the following rejoinder to Sobchak about his investment in his Jewish identity: "It's all a part of your sick Cynthia thing. Taking care of her fucking dog. Going to her fucking synagogue. You're living in the fucking past." A comparison of such moments with similar bits in Allen reveals why this critical linkage is so often ignored. Where Allen is always the Jew who creates comedy via the Jew's sense of being an outsider, the Coens invest their Jewish sensibility in characters like Sobchak who—though not Jews—choose to self-identify as Jews, much like the gentile dentist (Tim Whatley) in the well-known episode of *Seinfeld* ("The Yadda Yadda," no. 152) whose conversion remains suspect for Jerry because Jerry believes Whatley "converted to Judaism just for the jokes."

Although this distinction might at first seem trivial, something profound happens when we examine the shift from a comic narrative that rests on the Jew as outsider to an approach where Judaism becomes a generic pose open to all. In the simplest sense, the transformation is one that serves to erase the specificity of Judaism so that while Allen is always tagged as a Jewish filmmaker, the Coens escape such ethnic labels and get classified instead with formal terms (that is, they are postmodern parodists). But I would like to linger on this question of Judaism in order to better understand the significance of this shift. First we must note that this historical development accompanies our posited transformation from the modern to the postmodern, from Freud's deep structures to the superficial psychology constantly circulating on the restlessly parodic surface of *The Big Lebowski* and other such films. The result in the Coens' work is a kind of comedy that is, I think, simply impossible before (or without) Freud, and yet I don't think Freud could have allowed himself to simply make it up. A gentile like Sobchak who converts for the Jewish girl and then remains a Jew after she divorces him? Not in Freud's world. Jews passing for goyim, on the other hand, now that Freud understands—that is the conceit of the cruel and much-remarked-upon joke Freud tells in his famous study *The Joke and Its Relation to the Unconscious* (1905) of the rich Jewess who, in the midst of a painful childbirth, falls back into Yiddish—"oy, oy, oy"—revealing that though she may dress and act like an upper-class cultured gentile, in reality she isn't. You can take the Jew out the ghetto, but never the ghetto out of the Jew. But Sobchak's clinging to Judaism . . . ? This, I submit, is the strange development, one worth closer attention.

Here it helps to review Freud's own theory about jokes. In his joke book, Freud builds a large theoretical edifice that comes to rest rather oddly on a posited distinction between the joke and the comic both in

terms of perceived effect and economy. For Freud, the joke is not comical, but rather it uses the comic as a façade to accomplish something else, namely, a kind of psychical release. Thus, Freud argues, "A comic façade enhances the effect of the joke . . . [by] arresting our attention . . . it also makes the release brought about by the joke easier" (147). The release of laughter then for Freud occasioned by the joke is but the "foreplay" of the release that commences when the listener "gets" the joke. Although notoriously unclear among Freud's critics, the play of getting the joke itself seems rooted in a process of reinforcement by which the joke teller experiences a pleasurable confirmation of his intelligence. This victory involves not so much a release of laughter but a conservation of energy, a deposit of sorts that returns to the unconscious, thereby enabling a more optimized function for the overall psyche of the joke teller. Here, we have perhaps the most important formulation of that commonplace introduced earlier that sees comedy as relieving anxiety derived from situations of social nonconformity.

It is, I think, in order to shore up this thesis that Freud rather oddly excludes what he terms "naïve" or "innocent" jokes, by which he means jokes that simply happen because the joke teller stumbles upon them (as for example, with the malapropism, the classic "Freudian slip" where the speaker, in grasping for one word, says another: Let's skip the buffet and just have the sex, I mean the soup). Instead, Freud invests himself in a claim that locates the platonic joke (so to speak) in the rehearsed joke, the joke that presents itself as sufficiently worked out so as to be performed before and—crucially for Freud—upon an audience. For Freud, "no one is content with making a joke for themselves alone . . . [rather] one is compelled to pass on a joke; the psychical process of joke-formation does not seem to be over when the joke occurs to its author; something is left that tries to complete this unknown process of joke formation by passing the joke on" (138). Here we have hit upon

Freud's other major distinction—that unlike the comic (with its focus on provoking spontaneous laughter at a "chance event"), the joke generates a viral economy precisely because it can be repeated. Of these two claims, the latter dominates Freud's theory, because it enables him to construct a compelling theory for understanding joke work: that is, it enables an individual to experience a feeling of mastery by taking up a different role when repeating the joke to another. Thus to put it in theoretical terms, for Freud, the joke teller gains the mastery at the expense of the listener. This theft then lodges in the listener's unconscious and it is this that drives him to assume the role of joke teller. Thus, he assumes the role of the joke teller, thereby reclaiming the psychic energy he fears lost from when he consented to be the listener.

Such "mature" jokes, which Freud labels "tendentious" (as opposed to "naïve") are illustrated in *The Joke and Its Relation to the Unconscious* above all by one joke involving two Jews at a train station. For Freud, this Yiddish joke functions in a way that is analogous to the Oedipus story: it is the master joke. As Freud tells it, two Jews meet in a railway carriage at a station in Galicia. "Where are you traveling?" asks the one. "To Cracow," comes the answer. "Look what a liar you are!" the other protests. "When you say you're going to Cracow, you want me to believe that you are going to Lemberg. But I know that you're really going to Cracow. So why are you lying?" (110). Throughout his treatise, Freud resorts to paraphrasing jokes in an effort to abstract their sense content in order to isolate the structure he wishes to ascribe as necessary to the ideal joke. Here, he writes, "The second Jew is being upbraided for his lies because he says he is traveling to Cracow—which is in fact his destination" (110). With the content thus removed from consideration Freud then focuses on the pure form of the joke and concludes that such a joke "clearly works by the means of the technique of absurdity"— "coupled with another technique, representation by the opposite" (110).

To be more precise, Freud would appear to have seized on how a statement can at once be true and at another level—that of the spoken utterance—function as a lie or, at least in this case, as an attempted lie. For Freud is also focused on how the second Jew recognizes the deception and divines the truth: that in this case, the words are true, but the voice is presenting them as an untruth such that truth and untruth travel together. As a way to close this discussion, Freud concludes that such jokes must "be allotted a special position" because he sees them as an attack not just on a single person or institution but an attack on knowledge or truth itself (110).

It might, perhaps, be better to focus on how Freud's structure of the joke assumes that ultimately the listener must be able to make sense of the joke to find it funny. In other words, one could resist this joke about Cracow and Lemberg and not "get it." For instance, instead of finding it funny, I could approach it as a problem for philosophy and wonder why I should agree with the presumption that the Jew who says he is going to Cracow is indeed lying. After all, the story, as Freud tells it, just breaks off. What prevents me from concluding that the Jew who is doing the upbraiding is wrong and has launched an insane accusation that ends up making him into the butt of the joke (look at the crazy man!), revealing him to be a ridiculous, perhaps even paranoid soul. Here, I think Freud would say that such a misreading has reduced this joke to a comic moment, and such moments do not say something funny about people so much as they reveal the way that the world is (from a certain point of view) an absurd world the furnishes us with unexpected encounters with insanity. Jokes, for Freud, work differently: they thrust the listener and the teller into the complex economy that comprises lived experience. They force a recognition that life at its very core is—to use a fancy word—inter-subjective, by which I mean every person's sense of self

is constituted as a shifting psychic field of forces that includes the psychic input of other people. At the same time, Freud is not going to leave such play unmediated; he seeks to force a better accommodation for us with what he sees as indispensable—and that is the Oedipal norm that regulates it. Thus he leads us back to the joke, which he sees as fundamentally ironic in the modern sense of the term as I have defined it in this chapter (because it points to the presence of a norm, the ultimate one: the regime of reality). We thus see something the liar hopes we do not see; rather, it is something we hear and then recognize—that he is indeed going to Cracow, and we laugh because we "get it"—we are part, truly a part, of the human chain.

Yet, viewed critically, Freud's insistence that jokes in all their ambiguity require a right way to read them is instead an illustration of his obsession with conflict and with being forced to conform to a world that is often perceived as dominated by aggression and fear of aggression. The joke we are discussing is, after all, about being "upbraided." This thematic is certainly in Freud, and it does cement those psychoanalytic readings that conclude that what we are seeing in Freud's handling of this topic is yet more evidence of the crippling and pervasive effects of the virulent anti-Semitic culture of Victorian Vienna. Thus, Elliot Oring in his reading of this joke concludes, "like the Jew on the train, Freud told the truth; yet his truth was the basis for a deception. . . . he failed to acknowledge that his journey to overtake and surpass his father was fundamentally an effort to escape the identity his father had bequeathed to him [e.g., his Judaism]" (76). John Carey, in his introduction to the recent Penguin edition of the joke book, stresses that "Freud's theory of jokes is itself a kind of joke. Like the Jewish jokes against Jews that he analyzes, it represents a rejoinder . . . that Gentile mockery, when inspected by a great Jewish intellectual, emerges as

merely another economy" (xxvii). Such biographical interpretations allow us to understand how remarkable it is to encounter a character such as Sobchak performing in a movie that is at once unthinkable without Freud and yet seeks to evade Freud at every turn by ceaselessly parodying his interpretations.

And yet, despite the Coens' efforts, is not the master conceit of *The Big Lebowski* precisely Freud's joke: the rich Lebowski tells the Dude that Bunny has been kidnapped in order to play the Dude for the patsy in a scheme to embezzle one million dollars from the family's charitable foundation. The Dude knows (or at least strongly suspects) from the beginning that Bunny has *not* been kidnapped (the equivalent plotline to the train bound for Cracow and not Lemberg), but then in his play with the other characters, Lebowski ends up in a movie that takes on this rejected logic, one in which Bunny might indeed be kidnapped (that is, the movie is going to Lemberg). But then like the joke, the movie resolves when it is revealed that she was not kidnapped after all (that is, the movie is going where the Dude and we thought it was going all along, namely to the bowling alley).

In light of this connection it is tempting to mount a reading whereby *The Big Lebowski* and the resulting cult phenomena are dispatched as nothing more than proof that on this point at least Freud has indeed offered up the last word. But I suggest that such a reading, though illuminating, misses the key component of the film's thinking, and that, I argue, is how *The Big Lebowski* generates its jokes through subjecting this Freudian framework—the X-Y-X joke structure—to an intense deconstructive action with interesting results. To see how, let us return to the Dude's concise analysis of Sobchak's Judaism as nothing but a reflection of his friend's inability to work through his attachment to a former wife. One could say, of course, that the Dude delivers a straightforward

retort that is funny because here the entire Freudian diagnosis is of-
fered up in a postmodern context, that is, manifestly on the surface and
with little bother and certainly no need of an analyst. And that is true,
but that insight stands to the side of what I am attempting to focus on,
which is how the Freudian intervention doesn't simply gloss meaning,
it invents meaning, and in this case, a new kind of comedy that once it
appears seems of a piece with what preceded it. In this case, I think we
can see how change occurs. The bringing to the surface of what was
deep meaning, in the case of *Lebowski,* does not simply result in a kind
of comedy that is postmodern, if by *postmodern* what we mean is art that
cannot, as Harries suggests, enable positive change through its parody.
Rather, I would suggest that the bringing to the surface has to be seen
as a process rooted in time, as a historical process that literally helps
build our shared sense of exterior space, of communal psychic reality,
and that this reality is not only open to change but is always changing.

More explicitly then, I think we can return to my initial proposi-
tion that parody as the Coens practice it need not simply re-enforce
existing norms or deconstruct those norms so as to leave us totally un-
moored. Instead, this clearing action can work in such a way as to create
an enclave into which we can flee and so doing extract ourselves from a
communal set of norms we reject. To be precise then, we can appropri-
ate Freud's distinction between comedy and joke work to other ends.
Comedy, from this vantage point, is funny not because it simply illus-
trates the absurd world we live in it, but because it unconsciously voices
the rational structure that governs our sense of reality. In contrast, joke
work forces us to remember how we need not see things in conventional
ways; it reminds us that meaning gets made by people in their interac-
tions with each other and that therefore our interactions allow us to
act in profound ways that could lead to radical restructuring. To put it

bluntly then, it is the comic that reinforces the status quo and the joke that can be used to alter that situation. Even beyond that, it is possible to imagine how parody might work to project a new set of norms.

To see not only how this might happen, but how it has happened, I would like to cite one brief reading from the study I introduced at the outset of this chapter, Alexei Yurchak's work on *stiob*. Yurchak offers the stage performance of the Russian rock band he managed, AVIA: "In an AVIA performance up to twenty actors in workers' overalls fervently marched in columns, shouted slogans and 'hurray' and built pyramids. In the role of 'young builders of communism' they looked so cheerfully zealous that it all verged on insanity" (253). For Yurchak, this performance explores how "the paradox of late socialism stemmed from the fact that the more the immutable forms of the system's authoritative discourse were reproduced everywhere, the more the system was experiencing a profound internal displacement" (283). The result was that the Soviet people were able to experience the collapse of their system as at once utterly unexpected and totally unsurprising. Thus, the humor of pushing things to the surface can be seen as creating the space both within and without the subject for realignment, for change. In just this way *The Big Lebowski* need not, as I suggested at this paper's outset, be read as a distraction that enables the status quo. It can be read instead as a training ground so that when it showed us Saddam Hussein as a clerk at a bowling alley it enabled us to opt out of the psychotic proposition that he was the architect of the terrorist attacks of 9/11. If it can do that, and I think it did, then we have one key instance of parody's positive ability to institute change.

Thomas B. Byers

The origins of the document reproduced in the following pages is shrouded in mystery. I will only say with certainty that it first came to the attention of the author of this commentary fully formed. Its narrator is, of course, a fictional character, derived from the Stranger (Sam Elliott) in the Coen brothers' *Big Lebowski*. The document makes no secret of the artifice of this act of homage. The brief setup provides a decisive allusion to the almost identical language used to introduce the character in the screenplay: "We are floating up a steep scrubby slope. We hear male voices gently singing 'Tumbling Tumbleweeds' and a deep, affable, Western-accented voice—Sam Elliot's, perhaps."[1] The rest of the document is written in the sort of cowboy lingo that Joel and Ethan Coen employ.

Given that the author of the document seems himself to be agnostic regarding questions of reference, there is no reason for us to posit direct identity between this character and any other, including the character of the Stranger played by Sam Elliott. For purposes of convenience in this commentary, I only note a pronounced similarity between the two characters' voices and refer to the "speaker" of this text as the Other Stranger. His antecedents, like those of the Coens' Stranger, are to be found in the fictional genre of the Western, and particularly in that tradition's Hollywood instantiations. Perhaps the text may provisionally be considered an example of that "blank" parody identified by Fredric

Walter and Donny are descendants of at least two very famous comic pairs: Laurel and Hardy, and Ralph Cramden (Jackie Gleason) and Ed Norton (Art Carney). In all three cases, an irascible and volatile blowhard fat man plays off against a quieter, more passive and, in varying degrees, feminized, thin man.

Jameson in his well-known essay on postmodernism as "The Cultural Logic of Late Capitalism" (*Postmodernism*, 1). Jameson himself figures prominently in the mystery text, for there seems little doubt that he is the "fella from back east in Durham" referred to in the Other Stranger's opening sentence. Jameson's "blank parody" is ungrounded parody whose target is unspecified, or perhaps even non-existent. It is parody without a point, one in which whatever is parodied is appreciated as much as critiqued, and in which the primary end is the parodic performance itself. What we have here largely fits that description, but it may differ in certain interesting ways—ways consonant with the larger phenomenon of postmodernism that is Jameson's subject. The Other Stranger's discourse may be a form of what I would call "disseminated" parody, in which there is no single target, and the satiric and comic effects arise at any given moment from the juxtaposition of two equally appreciated and equally critiqued discourses. Thus, when the Other Stranger "does" a version of academic cultural studies in his Hollywood Western voice, the reader may smile both at the expense of and in appreciation of both discourses.

The burden of the Other Stranger's discourse is finally to raise—but, wisely, not to try to settle—certain basic questions of the referentiality of signs. It seems clear, on the one hand, that we are never in touch with the original—only copies—and that the structure of the world as we know it is the structure of language. On the other hand, I would argue

that even the most radical of postmodernists hold out a secret faith that their claims are not just more rhetorically persuasive, but truer, than their opponents' counter-claims. Here we are back to the Derridean notion that we cannot avoid thinking in the terms of our philosophical tradition, even as we critique it. Ultimately, if we consider carefully the competing lines within that tradition—the lines of philosophy and rhetoric—it seems to me that each of them offers a strong critique of the other that the other cannot fully answer within its own terms. Both are acute in their attacks; neither is fully defensible. Hence, at least for the foreseeable future, both are necessary while neither is sufficient.

But I think the greater significance of the Other Stranger's analysis lies one level down; it has to do with whether and how films and other comparable texts, even those that are clearly on the side of (postmodern) play with the history of their media, of genre, of stock characters, and so on, may nonetheless be seen as non-hermetic. The claim is that they develop as they do in interplay with more overtly political discourses that purport to refer to histories beyond their own. To put it more concretely, the Other Stranger seems to claim that the villains of *Stagecoach, It's a Wonderful Life,* and even the Coen brothers' pomo-*Lebowski* do not refer only to earlier instantiations of their type in popular media, but are rather ways of thinking about non-cinematic subject positions and historical forces.

If this is so, then surely the big Lebowski himself (David Huddleston) is not the only example. What I propose, then, is to try to support the Other Stranger's insight by applying his method of analysis to a few other characters. That method has two stages: first, the investigation of the cinematic antecedents for the film's main characters; second, an analysis of the historical or even generational forces which these commonalities seem to reveal. In one of the ironies into which we are constantly trapped by the film, I find myself beginning with the one

character who has perhaps the most overt relation to a very particular set of historical circumstances: Walter Sobchak (John Goodman) who, in the Other Stranger's commentary, is described as "hotter than a brothel on nickel night for that Viet Nam. Everythin' jus' crowds 'round it." He is, in other words, a comic version of the edgy, traumatized, and obsessed Vietnam vet.

But the Walter character also has another place in film and television history, particularly in his relation to Donny (Steve Buscemi).[2] Walter and Donny are descendants of at least two very famous comic pairs: Laurel and Hardy, and Ralph Cramden (Jackie Gleason) and Ed Norton (Art Carney). In all three cases, an irascible and volatile blowhard fat man plays off against a quieter, more passive and, in varying degrees, feminized, thin man. The question is what such pairings might signify, and what might be at stake in them. Without getting too carried away, I think it is fair to say that the fat man is a comic representation—and containment—of phenomena whose implications are generally far from comic: masculine bullying and violence. Interestingly, too, the threat posed by this phenomenon is progressively closer to the surface in each pair: while Oliver Hardy seems pretty harmless (and in fact rather feminized himself), Ralph Cramden's much more specific threats, particularly to his wife, Alice (Jayne Meadows), are a good deal more ominous—indeed they might well seem truly scary were it not for Alice's constant refusal to take them seriously.

Walter takes masculine volatility and excess up another notch, particularly when he threatens Smokey (Jimmie Dale Gilmore) with a gun in the bowling alley, and also when he rolls out of the car in the scene where Walter and the Dude are going to take the money to Bunny's alleged kidnappers. His misplaced sentimentality about Vietnam when he and the Dude are scattering Donny's ashes is of a piece with his other excesses, and while these excesses are constantly played for laughs, their

representation does have some critical edge, particularly in the ashes scene when the Dude finally loses patience with them while expressing what seems to be far more genuine emotion. Ultimately, I would argue that the portrayal of Walter contributes a great deal to the film's critique of the phallus so perceptively exposed by Dennis Allen and others in this *Year's Work*.

A character with even more specific film antecedents is Maude Lebowski, whose portrayal by Julianne Moore is largely an impersonation of Katharine Hepburn. The particular point of reference is Hepburn's Susan Vance in *Bringing Up Baby* (1938), another rich, eccentric woman who, like Maude (with allowances for the differences between 1938 and 1998 Hollywood in representations of sex), finally has her way with the film's protagonist. Susan Vance is often taken as a sort of proto-feminist character, partly because she is active rather than passive, and her desire drives the narrative far more than does that of the much less assertive male protagonist, David Huxley (Cary Grant). Hepburn and Grant, it should be noted, are the perfect pair for this sort of gender inversion. Hepburn, of all the female Hollywood stars of her period, is perhaps the one who comes across as most intelligent and independent, and as having personal power whose sources are not her sexuality and sexual wiles. Grant, on the other hand, is, as Pauline Kael noted many years ago, a man whose attraction is largely passive—one who is pursued by, rather than the pursuer of, women. He is "willing but not forward ... the male love object" (*When the Lights* 3).

Maude Lebowski is certainly as eccentric as Susan Vance, but she is much more consciously and overtly feminist. Where Vance's proto-feminism is a piece, or a symptom, of her fundamental eccentricity, Maude's eccentricity is much more a function of her fundamental feminism. And, of course, where for Susan hetero-normative romance is the ultimate end, for Maude heterosexuality is simply a means to conception

8.1. "Ok, but let me explain something about the Dude . . ." Cary Grant and Katharine Hepburn in *Bringing Up Baby* (1938).

and deliberately single parenthood. In this light the Stranger's cheerful assertion that "there's a little Lebowski on the way" is far from the typical comic ending's affirmation of "the way the whole durned human comedy keeps perpetuatin' itself." Just as the film undermines the preoccupation with the phallus and with castration, so it undermines the link between normative heterosexuality and reproduction on which patriarchal hegemony commonly sustains itself. For it is completely unclear whether the name of the little Lebowski is the Name of the Father or simply the name of the mother. Thus once again the film's politics,

and its reference outside itself and the history of its own art, emerge from its self-referential play within the history of its own form, rather than being precluded or masked by such play.

This is not to say that the film's primary impulse is political; indeed that can be said of very few Hollywood products. It is rather to say, as the Other Stranger's discourse suggests, that the types or topoi of character that are key building blocks of Hollywood narratives are "shortcuts we use nowadays fer thinkin'." The project of the kind of analysis performed here is to try to decipher just what it is we are thinking *about* when we produce or consume various avatars of these types.

Finally, I propose a few observations as supplement to the Other Stranger's contextualization of "the Dude" in film and cultural history. I would second the claims that as cultural type the Dude represents "the sixties in the nineties," and that he is also a new version of the hard-

Of all the leading men of his time, Bridges is the one who most seems to embody the persistence of the spirit of the 1960s. In this particular sense, he is patently **not** *"the man for his time and place."*

boiled—and even, indirectly, the western—hero. The "harder nut to crack," as the Other Stranger might express it, is exactly how Jeff Bridges fits into all this. If Maude's significance is constituted in part by Julianne Moore's "doing" Katharine Hepburn, what bearing does the casting of Bridges have on the meaning of the Dude? The question seems all the more urgent given that, at least in the hindsight afforded by viewing the completed film, Bridges seems the positively inevitable choice for this role.

A place to start is the *Bringing Up Baby* connection, for Bridges in *Lebowski* is to Julianne Moore as Grant is to Hepburn in the earlier film: he is the pursued. More generally, as an actor Bridges is to his generation

as Grant is to his: the icon of a particular masculine style. This style is self-possessed, relaxed, and—partly because it includes a certain disinterest in the subject's own attractiveness, or acceptance of it as a given—relatively non-aggressive. Both actors seem, as Philip French says of Bridges, free of "protective egotism." In Grant's era, this quality is of a piece with sophistication and glamour. In Bridges' case, it is more a matter of laid-back naturalness. Indeed, Pauline Kael once suggested that he "may be the most natural and least self-conscious screen actor that has ever lived" (*Reeling* 233).

The qualities Kael identifies have made Bridges a critical favorite. Yet he received his only best actor Oscar nomination for a stylized performance in a relatively small movie, John Carpenter's *Starman*. The question that arises is why his particular qualities have not given him greater resonance with the audience or made him a bigger star. If he had become one, it would have happened in the 1980s and 1990s. But he was in fact eclipsed in popularity, box-office pull, and all-around star power by any number of others: consider Mel Gibson, Harrison Ford, Tom Cruise, Tom Hanks, Kevin Costner, Arnold Schwarzenegger, Sylvester Stallone. Part of the reason for this is the type of roles he has played; he has not in general done typical "leading men" in the mainstream action, thriller, and romantic comedy genres. Whether this is a matter of choice or of what has been offered him is an open question; I suspect it is some of each.

But the larger issue, I think, has to do with certain elements of his style that are also part of his generational identification, as noted by the Other Stranger. Of all the leading men of his time, Bridges is the one who most seems to embody the persistence of the spirit of the 1960s. In this particular sense, he is patently *not* "the man for his time and place." For the Hollywood of the 1980s and 1990s was, as many critics have noted, very much in the process of trying to repudiate or at least erase

the 1960s, and particularly the threats to patriarchy posed not only by the rise of second-wave feminism but also by the decade's generational rebellion and alternative lifestyles.[3] For Bridges to have become the legitimate heir to Cary Grant (who himself was completely at home in the grey flannel suits of the 1950s), the transformations of masculine behavioral style that came out of the 1960s would have had to remain much more 1960s-like; the hippie would have to have been much more persistent and much less marginalized by the rise of the yuppie or the bobo than he in fact was. This is why finally it is probably not Bridges but Harrison Ford who wears the mantle of their generation's Cary Grant. Though there are ways in which Bridges's *personal* style seems closer to Grant's, Ford's *cultural* style is much more continuous with the 1950s notion of the star man, and much less inflected by the 1960s—and partly for that reason, Ford is much more the bigger star, much more the kind of Hollywood icon that Grant was.

What makes Bridges less of a star is precisely what makes him perfect for *Lebowski*, whose particular niche of success depends on its outsider, cult status. It also depends on its celebration of a kind of alternative, less driven masculinity that Bridges represents. To the degree that he is the father of anything, it's that he is a kind of older prototype for the slacker, precisely the generation that has taken up the film; in fact, it's the hippie-slacker line that is the film's alternative to the lines of descent of hegemonic masculinity. It's precisely that Bridges/Lebowski doesn't fit—or fits into a line that doesn't fit—that makes him the man for his time and place, so long as we recognize *The Big Lebowski* itself to be the name of that time and place.

Ultimately, then, though one runs the risk of overdoing it, one might suggest that *The Big Lebowski* is itself a shortcut "fer thinkin'" about recent U.S. cultural history, and particularly the way in which the 1960s fit—and do not fit—into that history. This is the thematic that

emerges from a reading of the characters as allegories for particular decades or generations. The other notion that seems to emerge, first from the Other Stranger's remarks and then from my reflections on them, is that film history and cultural history, though perhaps analytically distinguishable, are by this point thoroughly imbricated. We use the former to think the latter, as we use the latter to decode the significance of the former. This is a modern phenomenon in terms of the medium (film) for our thinking, and it may be a postmodern one in terms of the degree to which our thinking takes place in and is saturated by the imagery of media. But there is also perhaps a larger historical continuity here. No doubt each time and place has its representative man or woman. But it is too simple to say that once these were subjects of "real" history and now they are subjects of media. Rather, they are always and everywhere subjects of narrative. I venture, in closing, that what makes a character like the Dude or the Stranger or a narrative like *The Big Lebowski* postmodern is not a change in the fact that we think in terms of narratives and representations, but a change in our awareness of and our thinking about that fact—and hence a change in our relation to the figures who populate, and the forms that figure, our lives.

Another sonorous, affable, Western-accented voice—not Sam Elliott's, but Billy Bob Thornton's, perhaps, if he's available, or Wilfred Brimley's, in a pinch:

> And, then, there's another fella, fella I want to tell you about, fella from back East in Durham.[4] Lotta powerful smart idears, this 'un. Some say he's a pinko, too. But I don't know. Cause what's a pinko, anyway? And, I hear tell he drives a purty fancy car. Now, this here Fred fella said somewheres that one of them shortcuts we use nowadays fer thinkin' is sortin' folks into decades.[5] Sometime ya have to take a shortcut or two,

if ya wanna get anywheres. Trouble is, if ya take too many of 'em, wal, that kinda leads ya nowheres, don't it? Only makin' more of them there simulacra, as some French fella called it. What's stupefyin' is most folks nowadays got their thinkin' all balled up with stuff from the picture shows, and the side-shows, and all them reality shows on their TVs.[6]

Anyhow, seems like in this Lebowski story all the characters stand for differnt decades. Walter Sobchak, frinstance, was hotter than a brothel on nickel night for that Viet Nam. Everythin' jus' crowds 'round it. He jest hollers seventies with all them hangdog vets kickin' up a fuss, and at the same time waitin' fer ol' Ronbo[7] to come along an' tell 'em they were hee-roes all along. In fact, if ya think about it, Walter was kinda like John Rambo all gone to seed an' played fer laughs. Then, there was lil Brandt, followin' his boss around, puttin' on airs, totally believin' that the filthy lucre is be-all 'n' end-all. He was the spittin' image of the eighties. Yuppie-greenhorns. I hate them mother-scratchers. And, let's not forget poor Donny, at sea 'bout near everythin'—politics, women, religion—'ceptin' bowling, maybe. Hair's a little long fer it but I wonder if you thought like I done that he cut it like a fella from the fifties.

That brings us to the Dude. The other fella said he's the man fer his time 'n place. The one who fits right in there, livin' in Los Angeles in the nineties. And, I reckon he still does in his way. But, if ya ask me, the nine-ten-nineties ain't the only decade he was fer. All that there business about the Port Huron Statement and that other stuff he tol' Maude put him right square in the sixties. 'Course, by the nineties, them unbounded energies of that counter-culture brouhaha that Fred goes on and on about purty much petered out.[8] Now, I reckon the Dude ain't the sixties or the nineties neither. He's like the sixties *in* the nineties. He's just kinda livin' day to day in L.A. in the unkempt parts ya best avoid.[9] But part of his bein' the man for the such-n-such is he don't quite fit in, 'cause nobody quite does, no more, 'cause the city and the stereotypes what live there is jest too durned big.

Now, the Dude ain't never changed the world, but he ain't never sold it out, neither. And, ain't it better to be a has-done than a never-did-neither. He may be jest a coffee boiler, but, when sun sets, I take comfort in him there settin' a-spell on Maude's rug. And, when ya put that together with him gettin' all dragged out in a kinda mystery, he's a lot like that there Phillip Marlowe guy. The nineties version of Bogart in *The Big Sleep* from the forties, or Elliott Gould in *The Long Goodbye* from the seventies. But ya see, there it is, isn't it? The Dude ain't nothin' but a stereotype himself and one balled up from the picture shows to boot. And, his kin are from them, too. Now, that may seem as obvious as a heifer in a sheep-herd, but here's the thing; we might think we're thinkin' about the sixties, or the forties, or the seventies, but most likely when we do, we're thinkin' about the picture shows at all them times.

All this puts that fella with his cowboy thing goin' on in a new light, too. Those Coen boys must call him "The Stranger" 'cause it feels like he don't belong in there a'tall. He stands fer the past, not some pertic'lar decades but all the decades 'fore the Dude's. All 'em years when there weren't no cities out west, just fellas like me. He's the gran'pappy of Phillip Marlowe. Phillip Marlowe's the gran'pappy of the Dude. That there's the real deal: he ain't the Stranger 'cause he's from somewheres else; no, he's a L.A. boy (well, ok, a Hollywood boy) just as much as the rest of 'em. He ain't from a differnt place, jest a differnt kinda movie—not the old West, but the old western.

Now, one last fella I oughta mention is the ol' chiseler himself. Lebowski—and here I sure don't mean the Dude. . . . He stands fer that there forties 'n' early fifties Cold War generation; fought in Korea, tells the sixties boy ta get a job, always on 'n' on about hard work 'n' not whinin', but he turns out ta be a big ol' hypocrite, too. An' he really seems like somethin' out of a forties movie. Folks is always talkin' about how *The Big Lebowski*'s like *The Big Sleep*, 'n' a big part of that is how the rich old guy in a wheelchair gets the hero to try to help his fam'ly by fin-

din' a missin' person. Thing is, though, 'cept fer the stuff I jest said, the Big Lebowski ain't really all that much like General Sternwood.

Compared to ol' Lebowski, Sternwood was OK Corral. Naw, ol' Lebowski's really more like a baleful of rich ol' baddies from other old movies, the most obvious bein' that Potter son-of-a buck in *It's a Wonderful Life*. 'Course, Potter's in a wheelchair, too, an' he looks an' talks a lot like ol' Lebowski. And so does that sorry thievin' banker Gatewood, from *Stagecoach*. The three of these four-flushers could be triplets.

They's one more crookit fella ol' Lebowski looks like, and he is— sorry as hell to say—mor'n jest some boogeyman from the side-show. I'm talkin' 'bout Ol' Deadeye Dick Cheney. Now, I can't say fer sure, but him an' ol' Lebowski lookin' alike might be more 'n jest a crazy coincidence[10]—ya gotta remember the first Eye-rack war is in that movie. An' that makes me wonder if all these greedy ol' robber baron bastards skedaddlin' over everybody like hell on wheels can really be made jest of movies? Even if ol' Dick Cheney looks like jest a copy of a copy, mebbe that don't mean they ain't sumpin' behind all these here Gatewoods an' Potters an' Lebowskis an' Dicks. Mebbe when we use 'em ta think with, they's somepin' er other we're thinkin' *about*. Mebbe it's got sumpin' ta do with what ol' Fred Jameson might call history.[11]

Notes

1. The significance of this misspelling is noted by Sam Elliott in B. Green et al.

2. It may well be more than coincidence that Walter shares a last name, albeit in a variant spelling, with two major film studies scholars: Vivian Sobchack and Thomas Sobchack, whose work (particularly the former's) Joel Coen seems very likely to have encountered in his studies at the Institute of Film and TV at NYU.

3. See, for instance, Faludi, *Backlash;* Jeffords, *Remasculinization;* and Byers, "History Re-Membered."

4. The speaker is apparently referring to Fredric Jameson, William A. Lane Professor of Comparative Literature and Romance Studies at Duke University.

5. Although it appears in heavily condensed fashion, the source sentence the author has in mind appears to be: "classification by generations has become as meaningful for us as it was for the Russians of the late nineteenth century, who sorted character types out with reference to specific decades" (Jameson, "Periodizing" 178).

6. Here the Other Stranger seems to be referring somewhat syncretically to Jean Baudrillard's idea of simulacrum, Guy Debord's concept of the society of the spectacle, and what Jameson himself has generally described as the "cultural turn," that "everything has at length become cultural" ("Periodizing" 201), and the "artifacts" of "what used to be called 'culture' proper have become the random experiences of daily life itself" (201).

7. Ronald Reagan. See, for instance, Rogin's *Ronald Reagan*.

8. The Other Stranger is certainly referencing this passage from Jameson: the 1960s represent "a time . . . everything was possible . . . a moment of a universal liberation, a global unbinding of energies" ("Periodizing" 207).

9. In theoretical terms, the Other Stranger may mean the interstices of global capitalism.

10. I.e., the "accidents" of "intertextuality."

11. Translated back to Jameson from the Other Stranger's (in)imitable style, we seem to end with the possibility that we always "retain . . . a final tenuous sense of that exterior or external world of which [the sign] is the replication and the imaginary double" ("Periodizing" 200).

No Literal Connection: Images of Mass Commodification, U.S. Militarism, and the Oil Industry in **The Big Lebowski**

David Martin-Jones

DUDE: Walter, I don't see any connection with Vietnam, man.

WALTER: Well, there isn't a *literal* connection. Dude.

The majority of material written on the films of the Coen brothers has focused on their status as auteurs (Körte and Seesslen; Bergan; Woods; Romney). This trend has ensured that interpretations of their films as products of American national cinema (i.e., as expressions of American ideology, or national identity) are in the minority. It has also meant that, especially in the case of *The Big Lebowski,* political subtexts have been either missed or ignored by film studies academics and film critics. Somewhat typical of the conclusions reached by such an approach is William Preston Robertson's assertion that the film is "nothing less than a pop cultural potpourri" (37). Similarly, Carolyn Russell labels the film—when viewed in relation to the rest of the Coen brothers' oeuvre—"an exercise in overbranding" (166). While these writers come at the film from different viewpoints, they seem united in viewing its myriad popular influences and intertextual references as ultimately meaningless.

This stance is also supported by Ronald Bergan's claim that "There is no compelling reason for *The Big Lebowski* being set . . . at the time of the Gulf War" (198). Yet this seems a particularly misconceived statement, especially considering the political readings that already exist of

other Coen brothers' films that lack the specific references to military events found in *The Big Lebowski*. For instance, Russell interprets their earlier film *Barton Fink* (1991) as an analogy for the rise of fascism and the subsequent Holocaust of WWII. Indeed, her reading is extremely plausible, even though the only references to these events in the film are oblique images that barely stand out from its stylized, early 1940s mise-en-scène (88). If such a case can be made for this film, then why not for *The Big Lebowski*? Although Russell's own argument regarding product overbranding corresponds to contemporary thinking on the use of the auteur's name as a marketing label (Corrigan 1991), another interpretation is also possible.

This essay examines the political subtext of *The Big Lebowski*, which critiques the growth of car culture in twentieth-century America and the nation's resultant involvement in overseas wars for oil. The chapter also explores the various formal and narrative elements which are used to construct the subtext, piecing it together from its often oblique references to the changing face of post-war America, its urban geography, its economy, and its ideology. In particular, it focuses on the way that U.S. foreign policy is determined by Fordism, the automobile, and the need for oil, as it is represented in the film. Thus the film is examined as a work of national cinema that engages with the reasons behind the first Persian Gulf War. With the rapid developments that have taken place in the Persian Gulf since 9/11, this subtext has become much easier to spot than it was previously. This fact, however, does not diminish the importance of understanding its construction.

Exactly how "deliberate" this subtext is must remain a matter of contention. Undoubtedly, the Coen brothers would deny its existence, as they often do when faced with critical interpretations of their work. Indeed, I do not wish to prescribe agency to the Coen brothers. After all, as the debate on auteurism has shown, this would be to uphold the

extremely problematic notion of Enlightenment individualism that film studies has variously tried to shake off since the 1980s (Stoddart 1995). Moreover, as Rajan has shown, such a stance would align this essay with the same "liberal disposition" that is "product and producer" of modernity, and the resultant car culture of "automobility" that accompanies it. However, I do not wish to detract agency entirely from them either. Rather, this chapter operates in the space opened up by the interaction between recent American films and a certain type of spectator that they consciously, but obliquely, target.

As Nöel Carroll has argued, in the 1970s and 1980s post-classical Hollywood films were purposefully produced to maximize profits by targeting both a college-educated, film buff audience and an uninitiated, genre-loving, often adolescent audience. Through allusions to previous films, filmmakers, and genres, additional layers of meaning have been created. Thus, a "two-tiered system of communication" (245) has been established between Hollywood filmmakers and their audience. This particular independent film of the late 1990s could be said to aim at a similarly split demographic, but with a more critical aim in mind than the works of Steven Spielberg, George Lucas, et al. In this case, the film's myriad allusions provide clues to the historical meaning of the film's political subtext. Unable to address the issue of American foreign policy in the direct way that a polemical documentary like *Bowling for Columbine* (2003) or *Fahrenheit 9/11* (2004) does, the Coen brothers have inserted a subversive subtext into their film instead.

On the one hand, it is tempting to argue that the film functions on several levels due to the astuteness of the filmmakers. On the other, however, the interpretation I offer suggests that a certain audience demographic negotiates a political meaning with the text. This assertion is more in line with the change of direction in film studies that emerged with the works of Christine Gledhill, Alexander Doty, etc., away from

auteurism. Much as a queer reading focuses on certain aspects of a film in order to draw out a queer subtext, so too does this reading function in order to (re)construct the film's political subtext.

Initially Clueless

It was around the eleventh or twelfth viewing of *The Big Lebowski* that I realized that something about the opening did not make sense. For some reason, the film pointedly placed this otherwise irrelevant noir story within the context of America's involvement in Kuwait in 1991. It deliberately foregrounded this fact at the beginning of the narrative, in both the voice-over and the appearance of President George H. W. Bush's speaking on a television in a supermarket. However, it then delivered a story which apparently bore no relation whatsoever to the Persian Gulf War. I began to realize that something was bubbling away under the surface of this film that went beyond its appearance as "pop cultural potpourri." This film wasn't just a postmodern take on Raymond Chandler; it also had a subtext that dealt with America's need to control the global supply of oil.

As I have noted, in its opening sequence the film deliberately informs us that this story is set during America's involvement in Kuwait. However, aside from this, the film contains only one or two other, oblique references to the first Persian Gulf War. What should we make of these passing references? At several points during the film, and much to the Dude's exasperation, Walter brings up the subject of Vietnam. In response, the Dude angrily confronts him, saying, "I don't see any connection with Vietnam," and more effusively, "What was that shit about Vietnam? What the fuck does anything have to do with Vietnam? What the fuck are you talking about?" Similarly, having been informed in the opening sequence that this is a film set during the time of the Persian

Gulf War, and bearing in mind also that the Coen brothers themselves have stated, "We've written the story from a modern point of view and set it very precisely in 1991, during the Persian Gulf War . . . which also has a direct effect on the Dude and his friends" (*Time to Bowl* 10), the viewer might be forgiven for asking, "What the fuck does any of this have to do with the Persian Gulf War?" Why bring it up at all—either in the film, or the interview—and why state that its context was used so "precisely," when it seems to have so little relevance to the narrative itself?

From an analysis of the film's opening sequence we can see that the subtext actually examines how the development of America in the twentieth century and, in particular, bourgeois individualism (what we could also term *automobility*) has encouraged a certain lifestyle to flourish. This is a lifestyle that—as both Mark Dery and Steffen Böhm (et al.) point out—relies upon a steady supply of oil for its continuation. For this reason, the film's subtext suggests, America became involved in a war in the Persian Gulf. Moreover, this war was but the continuation of an already established Cold War policy of military intervention in global affairs designed to keep the American market (and, therefore, way of life) stable. In fact, this policy had already led the U.S. into wars in both Korea and Vietnam (Kiernan 232). Thus, there may not be an immediately apparent or *literal* connection between the life of the Dude and the Gulf War, but there is a connection.

The film begins with a shot of a tumbleweed rolling across scrubland. On the soundtrack the Sons of the Pioneers sing Bob Nolan's "Tumbling Tumbleweeds." On the voice-over, Sam Elliott rambles in the style of a reclining, campfire cowboy, telling a story that occurred "Way out West." As the tumbleweed crests the brow of a hill, night falls and the city of Los Angeles appears, sprawling below. A dissolve finds the tumbleweed rolling through the streets of L.A., until it finally

reaches the sea. At this point, we are introduced to the Dude, shopping in a Ralph's Supermarket. Here Sam Elliott says:

> This here story I'm about to unfold took place back in the early 90s, just about the time of our conflict with Saddam and the Iraqis. I only mention it cause sometimes there's a man, I won't say a hero, 'cause what's a hero? But sometimes there's a man, and I'm talking about the Dude here, sometimes there's a man, well, he's the man for his time and place, he fits right in there, and that's the Dude, in Los Angeles.

... the movement from frontier to city depicted in the film's opening is comparable to the historical shift from the image of the gun-toting, masculine individualist of the nineteenth-century frontier to the automobile- driving individualists of the newly emergent twentieth-century America.

Behind the checkout, a small television shows George Bush Sr. commenting on the need for American intervention in the Persian Gulf. "This will not stand, this will not stand, this aggression against Kuwait," he states. This was the bullish, official White House line which led America into war in the Gulf— without consideration of all and any negotiations that could have avoided this seemingly inevitable military conflict—solely in order to establish grounds for an American military presence in the oil-rich area of the Middle East (Bennis and Moushabeck). For Robertson, the opening represents

> an arch statement on America's great Westward Expansion, with Los Angeles being the farthest geographic point in that expansion, not to mention the weirdest and most decadent. And insofar as this is a buddy movie, concerning itself with issues of sex and manhood

> ... the arch statement is really about the chauvinism of Westward
> Expansion, and, indeed, the absurdity of the pioneering American
> masculine mystique itself. But more than that, it's about the past,
> and the irony of a land professing a doctrine of newness and ex-
> pansion that is in reality a vestige of its cowboy past. (44–45)

This reading seems extremely plausible, especially considering the sym-
bolism of "night falling on the range" and the immediate replacement
of this image with one of the city of Los Angeles. However, Robertson's
reading says nothing of the two initial references to the war in the Per-
sian Gulf. To add some extra depth to this interpretation, I first examine
how American expansion and the pioneering masculine mystique are
linked.

Following Eric Mottram's argument in *Blood on the Nash Ambas-
sador*, the movement from frontier to city depicted in the film's opening
is comparable to the historical shift from the image of the gun-toting,
masculine individualist of the nineteenth-century frontier to the auto-
mobile-driving individualist of the newly emergent twentieth-century
America. In his analysis of films like *Bonnie and Clyde* (1967), Mottram
describes how the image of the car came to extend the western ethos
(exemplified in the Billy the Kid myth) by placing the gun on wheels
and making it fully automobile. It is this same myth of individual auton-
omy, supposedly in rebellion against the system, which is deconstructed
in the subtext of *The Big Lebowski*.

With the tumbleweed com-
ing to rest on the beach in Califor-
nia, and the colonizing, westward
expansion literally running out of
land, we are invited to question
just exactly where this expansion

*Walter's blind devotion works
as a loose allegory for the
American military support of
Israel, a cause doggedly pursued
by U.S. foreign policy ...*

moved to next. The answer given in the film, through its depiction of several of the main characters, is Korea, Vietnam, and the Persian Gulf. It is these wars (admittedly, among others) in which the gun-toting masculine individualist found his twentieth-century outlet.

For the film buff viewer, the most prominent intertextual reference in this sequence conclusively points to this reading of the film. Bob Nolan's "Tumbling Tumbleweeds" appears prominently in a very similar sequence in *The Two Jakes* (1990), a film which explicitly critiqued America's need for oil. In this film the distinctive song is heard as detective Jake Gittes (Jack Nicholson) begins to investigate the conspiracy of oil upon which Los Angeles' post-war suburban real estate development was constructed. As he drives through the San Fernando Valley, his car radio plays an advertisement for a new Pontiac car. Gittes changes stations, and "Tumbling Tumbleweeds" comes on. Gittes is heard in voice-over, reflecting on his latest case:

> Time changes things, like the fruit stand that turns into a filling station. But the footprints and signs from the past are everywhere. They've been fighting over this land ever since the first Spanish missionaries showed the Indians the benefits of religion, horses, and a few years of forced labor.

The similarities between the two uses of the same piece of music are apparent. In both instances the frontier-evoking music illustrates how contemporary changes—like the emergence of the filling station under the new Fordist economy—have their roots in America's past, particularly in the colonizing of the land. Far from "pop cultural potpourri," *The Big Lebowski* uses its intertextual references and film buff–directed allusions to invite the viewer to make the connection between the life of the Dude, his car-oriented context, and the legacy of America's past.

From Baron to Barren

Mottram's work on filmic representations of the car is most usefully seen in relation to a much more widely debated issue, that of the role of the motor car in shaping twentieth-century America. Several writers, including Antonio Gramsci, David J. St. Clair, Peter J. Ling, and James Howard Kunstler, have stressed the importance of Fordism in shaping the geographical, ideological, and economic landscape of America. At the heart of the writing of all these theorists is an examination, and at times a strong advocation, of the thesis that the automobile has had a major impact on the emergence of America as a global superpower. While this is a well-known argument, it bears brief rehearsing here.

In 1914, Henry Ford implemented an eight-hour working day for a set wage of $5. His rationalization of production in his custom-designed Detroit assembly plants created a model for mass commodification that would influence first the American and then the global market economy. The economies of scale associated with the division of the production process into a series of unskilled manual tasks enabled the mass production of a single type of product, as typified by the Model T Ford.

The $5 day ensured not only that workers were content to stay at Ford's factories, but also that there was a large workforce who had extra income to spend on commodities like the motor car. Thus Fordism produced not only the product but also the market that would buy it. It created a feedback loop which interminably fed consumerism. Moreover, as this process began to spiral outward, car production also affected the spatial geography of the United States. The Fordist worker now had access to the necessary capital to buy both car and house. These demands from the consumer played a large part in the increasing construction of both highways and commuter suburbs. The increased availability of

these facilities, in turn, fed back into the demand for cars, and as more consumers demanded out-of-town housing, the demand for cars rose, and so on. The national geography thus developed around the automobile, and was shaped by Fordism.

WWII led to the economic dominance of Fordism and to America's global economic strength. America's wartime industries, left undamaged in comparison to its decimated European and Japanese competitors, were relatively unchallenged in the post-war era. For over two decades they enjoyed a period of unbridled production, ensuring economic prosperity for the American consumer. Moreover, as production expanded, so too did the construction of highways and commuter suburbs, along with the new addition of the interstate.

In fact, it was mainly due to the interstate system that America enjoyed such prosperity. First, the economic rationale behind the interstate system was military in origin. While it is still debatable whether America's geographical and ideological development was directly influenced by the changes that took place in National Socialist Germany (St. Clair 149), there were obvious merits to be discerned by the rest of the world in the National Socialists' Autobahn. This was the case both for creating employment during times of depression and also for the swift deployment of the military during wartime (Sachs; Gilroy). This was so evident that when the argument was put forward in post-war America—notably by people with a vested interest in promoting car production—that an interstate system would facilitate the evacuation of urban centers and the implementation of military control in the event of a nuclear war, this Cold War reasoning met with a favorable response.

The interstate system, as Kunstler notes, saved the American economy from sliding into recession in the mid-1950s. It became "simply the largest public-works project in the history of the world" (107) and buoyed up the economy through the 1960s, due to the vast suburban

expansion it enabled. However, neither Kunstler or St. Clair are naïve enough to believe that the political justification given for this expansive program—the supposed "evacuation of cities during a nuclear attack" (Kunstler 107)—was anything other than "window dressing" (St. Clair 154). Such ideas pandered to Cold War paranoia in order to promote the sale of cars for suburban commuters. Whatever the justification, as a consequence of this vast construction work, America continued to grow and prosper during the first two decades of the post-war era. The prosperity it enjoyed was facilitated by an interstate system which, whether indirectly or directly, aligned economic prosperity with an ethos of military mobility. It is here that the ideal of westward expansion, the gun-toting individualist, and the apparent need for automobile freedom for the consumer are most clearly conflated.

The extensive program begun by Ford, however, had one small drawback. Building huge roads and stocking them with cars for suburbanites was fine until you ran out of room. Any threat to the oil supply, moreover, could also have disastrous effects. Los Angeles, then, is perhaps *the* point at which the westward expansion of the interstate necessitated by Fordism literally ran out of room. Whether, as St Clair notes, this is the city that has been most influenced in its development and design by the existence of the car or, as Kunstler argues, the geography of L.A. was decided long before the introduction of the automobile, it remains extremely difficult to get around in L.A. without a set of wheels (St. Clair 128; Kunstler 207–12).

By the early 1970s, the American economy was beginning to feel the strain of these limitations. Admittedly this was not solely due to reasons of internal stress. The previously crippled European and Japanese wartime economies had rebuilt and were competing with American manufacturers for their domestic markets. Indeed, the competition which these economies brought to the global market also required the

transferal of the manufacturing base to developing countries in order to cut the costs of production. The American economy, based on the self-perpetuating production of both commodity and consumer, had finally reached saturation point. With the loss of its domestic manufacturing base, employment gradually leveled off, demand fell, and stagflation set in. Add to this the fact that America was now importing much of its oil, the crisis effect of the Arab oil embargo of 1973, and OPEC's decision to raise oil prices, and it becomes clear how imperative the need to control a steady oil supply had become for the American economy. This had become an extremely serious issue if the way of life supported by the automobile-driven economy was to survive. For this reason, America's intervention in the Persian Gulf nearly twenty years later, and the un-diplomatic manner in which it was pursued, are perhaps no big surprise. In fact, George W. Bush's continuation of this policy under the guise of a perpetual, Orwellian-styled "war on terror" also seems unsurprising, although no less devastating as a result. The question remains, what does all this have to do with *The Big Lebowski*? Just what is the connection?

Characters

The Big Lebowski uses its characters to equate the myth of the gun-toting, automobile individual with post-war U.S. military intervention abroad. The Big Lebowski, we learn early in the film, lost the use of his legs while fighting in Korea. Yet this character is the most vehemently bombastic in defense of his individual business achievements. As his personal assistant Brandt (Philip Seymour Hoffman) takes pains to point out, the Big Lebowski is not *crippled* or *handicapped*, but *disabled*. This specific term suggests that he is defined by his primary loss, that of the ability to remain *automobile*. Made vehicularly automobile once

more through the prosthesis of an electric wheelchair, the now *re-abled* Big Lebowski exists in the film to critique the effect of the masculine myth of the automobile achiever on the American economy.

We first meet the Big Lebowski through the pictures that adorn the walls of his house. As the Dude is talked through them by Brandt, we see the Big Lebowski posing with prominent members of the Reagan administration. These first glimpses, which appear as Brandt informs us of the Big Lebowski's war trauma, suggest that the legacy of U.S. involvement in Korea, and the ethos of the automobile achiever, continued to survive in American politics well into the 1980s. When the Dude meets the Big Lebowski, moreover, he states his belief in himself in terms that mirror his belief in his unchallenged automobility: "I didn't blame anyone for the loss of my legs. Some Chinaman took them from me in Korea, but I went out and achieved anyway." This achievement he further addresses in terms that mirror the capitalist demands of the Fordist economy when he tells the departing Dude that he should "do what your parents did! Get a job, sir!" Finally, his "vanity," as his daughter Maude (Julianne Moore) points out, is apparent in his decision to keep his trophy wife, Bunny, in a full allowance, despite her obvious lack of any feelings for him. Typically, the image he creates, of his phallic, gun-toting mystique, also extends to his masculine prowess.

Shot by Walter's dropped Uzi during the bungled payoff, smashed into a telegraph pole, stolen by a joyrider, crashed into a dumpster, beaten with a crowbar, and finally burned out by nihilists—the car's gradual destruction signals the Dude's downward spiral into pedestrianism, his crushing defeat under the wheels of the infinitely replaceable, automobile economy.

This image, however, is gradually deconstructed by the film. The Big Lebowski is shown to be a fraud whose trophy wife stars in pornographic movies, who has little business acumen of his own, who lives on an allowance from his daughter, and who has been gradually embezzling money from the Little Lebowski Urban Achievers trust fund. He appears as an image of the masculine myth of the frontier achiever, artificially made mobile on a set of automated wheels. This is the reality of the disabled America of the early 1990s, the legacy of Fordism necessitating its constant, martial need to control the global supply of oil.

Walter, the Vietnam veteran, further emphasizes the theme of American military intervention overseas. He also (literally) expresses the excessive rhetoric of the gun-toting individual. While not specifically a war for oil in the same way that the Persian Gulf War was, Vietnam was still a war which, like Korea, enabled the traditional wartime industries (a large proportion of which are automobile oriented) to flourish. A war supposedly to keep Southeast Asia free from the fabled domino effect, it was also a war to secure a greater share of the world market for American capitalism. As Michael Tanzer points out (267), the Mobil and Shell oil companies took full advantage of the war, setting up drilling rigs in Asia. Mobil, in fact, was still drilling off the coast of Vietnam on the last day of the war. Through the use of these bullish characters, the film illustrates David Riesman's contention that WWII "had taught Americans the lesson that wars cure depressions and are, as conducted extraterritorially, less unpleasant . . . a tacit agreement that government can control depression, if need be, by war and preparation for war" (296). Thus, the gun-toting myth that colonized America, we are shown, has become a global force in the latter half of the twentieth century.

Finally, the film brings this critique of U.S. foreign policy up-to-date with the inclusion of the Persian Gulf War and Bush's hawk-like

stance on the need to use excessive military force. The continuation of this policy from Vietnam to the Gulf is foregrounded when Walter, the man who argues that "Pacifism is not something to hide behind," utilizes Bush's aggressive rhetoric of "unchecked aggression." The ideology of the gun-toting frontiersman has so permeated the fabric of American society, however, that Walter uses it to justify seeking recompense for someone peeing on the Dude's rug!

Walter is also used to represent the American support of Israel in the Middle East. This is most evident when he arrives at the bowling alley loudly quoting Theodor Herzl, father of Zionism: "If you will it, it is no dream." Walter's devotion to the Jewish religion continues after the divorce from his wife, Cynthia, even though it was his marriage that necessitated his conversion. Walter's blind devotion works as a loose allegory for the American military support of Israel, a cause doggedly pursued by U.S. foreign policy despite the flagrant disregard of Palestinian rights by the Israeli government. The aggressive individualism of the frontier seen in Walter's unthinking use of the Bush regime's militaristic rhetoric is thus shown to be complicit with America's continued intervention in the Middle East. Running his own security firm enables all-American psycho Walter, an allegorical figure, to make use of the skills he learned in Vietnam. These are shown to be at once ludicrous and extremely dangerous, particularly during the botched payoff deal. Here, he drops the symbolically designated Uzi, which fires off rounds wildly in all directions, indirectly causing the Dude to crash his car.

Dream

It is to the image of Saddam Hussein in the *Gutterballs* dream sequence that I now turn. This is the most crucial image in the creation of the film's iconic subtext. Beginning with the humorously phallic image of

a bowling pin flanked by two bowling balls, it immediately flags up its comment on masculinity. The Dude appears and is handed a pair of bowling shoes by Saddam Hussein from a huge uniform rack of pigeon holes leading up to the moon. This image encapsulates everything that this masculine myth promotes. It portrays the mass commodification of Fordism, seen in the rows upon rows of identical bowling shoes, which is itself based upon the need to control the supply of oil, as seen in the figure of Saddam Hussein handing the Dude his mass-produced shoes. Following the dream logic of this image, the rack of shoes is topped off by an image of the moon, suggesting the ancient parable of the man who attempted to build a tower to the moon. This impossible mission is a suitable analogy for the limits that face Fordist capitalism once it runs out of room to maneuver, in this case due to overproduction and the saturation of the domestic market.

An image containing almost all the same ingredients appears in *Three Kings* (1999). Set during the first Gulf War, *Three Kings* explores exactly the same gung-ho, American capitalist abroad (gun-toting individualist) myth. Toward the middle of the film, Troy Barlow (Mark Wahlberg), a fortune-seeking American GI from Detroit on a mission to steal Kuwaiti gold bullion in order to buy "convertibles in every color," is captured by Iraqi troops. As he is tortured, Captain Said (Said Taghmaoui) informs Troy that his weapons, sabotage, and interrogation training were all provided by U.S. Special Forces during the Iran-Iraq War. The following exchange then takes place.

> SAID: You are here for save Iraqi people?
> TROY: Yes.
> SAID (*Incredulous*): Really?
> TROY: Yeah.
> SAID: A lot of people in trouble in this world my man,
> and you don't fight no fucking war for them.

9.1. The consequences of U.S. foreign policy?

> TROY: You invaded another country, you can't do that.
> SAID: Why not, dude?
> TROY: Because it makes the world crazy, you need to keep it stable.
> SAID: For what, your pick-up truck?
> TROY: No, for stability, stabilize the region.

At this point, Said forces an unlabeled CD into Troy's mouth. As another Iraqi soldier pours crude oil down Troy's throat, Said says, "This is your fucking stability, my main man." In this image, the official U.S. line on keeping the region stable is confronted by a literal rebuttal. Rather like the anonymous, homogeneous bowling shoes in the comparable sequence in *The Big Lebowski,* here the anonymous CD represents the mass-commodified product of Fordism, over which the crude oil of Kuwait pours into the mouth of the American "consumer." It is not the country, its people, or the "region" that is the primary objective of the

American military, but the stabilization of the price and supply of oil needed to sustain the "pick-up truck" lifestyle. The stability that U.S. foreign policy speaks of is that of consumerism. It is based upon the mass production of goods designed by Fordism, which is itself fueled by the oil that the U.S. must now import if it is to stay in the global driving seat. Thus, any threat to this global dominance will meet with military force. Put another way, "This aggression against . . . *American interests which happen to be in Kuwait* . . . will not stand."

To return finally to the image of Saddam Hussein and the bowling shoes, the Busby Berkeley-styled musical sequence that follows is reminiscent of the American cinema of the Depression era. Once again the intertextual reference is far from meaningless. It serves to conflate this image of Fordism, mass commodification, and the need for oil with the historical period of the New Deal. This was a time when the automobile economy was deliberately promoted in order to help push America out of recession, through policies that indirectly increased federal aid to highway construction programs (St. Clair). Considering this was the same process facilitated by the construction of the Autobahn in National Socialist Germany, it now seems a little less random that the German nihilists who fake Bunny's kidnapping are members of the German techno-pop band Autobahn.

Mise-en-Scène

The oil subtext created by the film's depiction of characters and dreams is compounded by its use of the Googie architectural style in its mise-en-scène. This style was deliberately chosen by the Coen brothers to enhance the look of their film (Robertson 102–104), yet initially it is not obvious why. However, if we consider what the Googie style represents, some interesting answers emerge.

The Googie style was named after the Googie coffee shops of Los Angeles. The term came to designate generically many of the coffee shops and diners which were built all over the U.S. during the 1950s and early 1960s. The Googie style is easily recognizable because it developed in order to be eye-catching. Googie diners and coffee shops were built as huge advertisements for the goods they sold and were designed as signs specifically in order to catch the eye of the motorist traveling along America's steadily growing highway network. According to Alan Hess, a typical Googie roadside diner might consist of a huge, space-aged, upwardly angled roof of concrete, beneath which the entire front of the diner would typically be constructed of glass, illuminating its cherry red plastic seating booths and gleaming chrome interior. It was a design that addressed the passing motorist's glance, stating, "pull in and consume here." This automobile-oriented architecture, then, developed to meet the demands of the changing suburban/highway geography of post-war America.

More to the point, the construction of the distinctive shapes of the Googie style developed because of the survival of America's war-time industries and their need for a new outlet in peacetime. The building technologies and techniques that developed as a consequence of the war, especially in the use of concrete and plastics, were thus utilized in the domestic market in the immediate post-war years. Yet again we see the development of the automobile culture expand along with developments in military technology. Military innovations of WWII were also celebrated in the architectural motifs employed in Googie, most noticeably in rocket, jet, and atomic motifs. In fact, the neon starbursts that recur at several points during the film are extremely similar to the atomic symbols that adorned many Googie styled buildings (Hess 130–31). The starbursts were deliberately added to both the interior and exterior of the bowling alley where the Dude and Walter play in order to suggest a

Googie look. They also recur in both dream sequences, evoking further the fears of an era in which vast interstates could be constructed under the pretence of preparation for a nuclear war.

It now seems particularly appropriate that the two diners in which we see the Dude and Walter eating were specifically chosen because they represented the Googie style (*Time to Bowl* 14). Placing the film's characters in settings which evoke the post-war boom time further strengthens the subtext's critique of the consumer culture that the narrative apparently avoids.

Bowling

Finally, this brings us to a major theme of *The Big Lebowski,* leisure and, in particular, bowling. The Fordist eight-hour, $5 day and the desire to consume that it evoked were predicated upon the consumer having both the money and the time for leisure. The consumer lifestyle was based not only upon the automobility of the consumer but also upon leisure time. In fact, when the Dude is asked by Maude what he does for recreation, his response explicitly conflates the two. He states, "The usual . . . bowl, drive around, the occasional acid flashback." The recreational use of drugs aside, "bowling" and "driving around" are felt to be leisurely activities by the Dude. Automobility is thus valued by the consumer in and for itself, not because they believe that it facilitates the work/leisure lifestyle, but because they mistakenly believe it to be its reward.

Unlike Walter, however, the Dude is not a typical Fordist worker. Where Walter represents the frontier cowboy, the Dude, morphing out of the tumbleweed of the opening, represents the frontier drifter. Gridlocked in contemporary L.A., the "Fool" (a meaning implied by the term *dude* in the nineteenth century) has become the waster. He is a product

of the 1960s counter-culture that rebelled against the warlike myth of the gun-toting individual promoted during the Vietnam War. He emerged during the period which witnessed the peak and decline in American economic prosperity, during the late 1960s, and the oil crisis of the early 1970s. The Dude won't work. He is, as the Big Lebowski calls him, "a bum," a drink- and drug-consuming dropout, the antithesis of the ideological aims of "*embourgeoisiement*" (Ling 176) implemented by Fordism. The Dude does not adhere to the throwaway ethos of consumerism, as we see in his treatment, or rather in the film's treatment, of his car.

It became evident in the early years of Fordism that a high turnover of car production necessitated a constant displacement, in the mind of the consumer at least, of the previous model with the image of the latest (Riesman). Since then cars have ceased to be designed or sold for their durability. Rather, cars are marketed as fashionable items in a rapidly changing market. For the Fordist consumer, the replacing of the old with the new is an inevitability. For the Dude, who has opted out of the system, this is simply not an option. Living in a city in which a set of wheels is essential, he is forced to keep on running his dilapidated car, as he simply cannot afford to replace it. His car's gradual destruction throughout the course of the film demonstrates his alienation from the culture in which he lives. Shot by Walter's dropped Uzi during the bungled payoff, smashed into a telegraph pole, stolen by a joyrider, crashed into a dumpster, beaten with a crowbar, and finally burned out by nihilists—the car's gradual destruction signals the Dude's downward spiral into pedestrianism, his crushing defeat under the wheels of the infinitely replaceable, automobile economy.

When the Dude's car is recovered, he retrieves it from a crowded police lot. Here cars stretch out of the frame, quite literally, as far as the eye can see. The Dude naively asks the policeman if they have any "promising leads" as to who stole the car. The cop replies:

Leads? Yeah, sure. I'll just check with the boys down at the
crime lab. We got four more detectives working on the case.
. . . they got us working in shifts! (*Laughs*) Leads! Leads!

Effective policing of car crime is impossible in present day L.A. Nor is it
a main priority, due to the rapid production and turnover of disposable
cars. The vast number of cars that have not been claimed from the police
lot bear testimony to this fact. If we compare this sequence with a prede-
cessor, from Edgar G. Ulmer's *Detour* (1945), then we can see how much
the interim has changed the face of the American landscape. In this
earlier film, Al Roberts (Tom Neal) suggests to femme fatale Vera (Ann
Savage) that he dump the stolen car of the man he has accidentally killed
when they reach L.A. She responds, "Why, you dope! Don't you know a
deserted automobile always rates an investigation?" Although this is not
in any way an accurate historical document, if nothing else these films
show how different the public attitude toward cars has become. Thus
The Big Lebowski's subtext critiques contemporary consumer attitudes
toward the disposable automobile.

In fact, even by completely opting out, the Dude loses. His life of
complete leisure entails only the "luxuries" which the American econ-
omy provides for its workers. What is this type of automated leisure,
after all, than practice for the Fordist workforce? Bowling is a game in
which the consumer racks up points by knocking over a set of pins that
are then automatically righted, enabling him to knock them over again.
This pursuit is the perfect practice for the automated worker of the Ford-
ist assembly plant. The perpetual repetition of a simple, unskilled task
is rewarded by the continual, automated arrival of its duplicate. It is for
this reason that the picture which dominates the Dude's living room,
of President Nixon bowling, is so telling. The president famous for his
continued support of the escalating American war effort in Vietnam is

pictured enjoying the fruits of the leisure that his militarism enabled, at exactly the time at which the Fordist U.S. economy entered into its time of crisis, the early 1970s.

In short, if we are still looking to pinpoint the connection that the film makes between war in the Persian Gulf and the irreverent noir story of the fake kidnapping of Bunny Lebowski, then it is, in fact, all connected. It may not be a *literal* connection—after all, this is not *Bowling for Columbine* or *Fahrenheit 9/11.* As the commercial "success" of each Coen brothers film reflects on their ability to make their next film, it is not wise to rock the establishment's boat too much. However, there is a connection. Every facet of the automobile-orientated American life on the screen is directly a product of an ideologically fueled economic policy that has taken America to global dominance in the post-war world and necessitated its role as global police (read, *military*) force. This is the cause of its interventions in Asia, the Middle East, and, we should perhaps also add, South America. The entire American way of life is based upon the war in the Persian Gulf; that's what anything has to do with Saddam Hussein. The fact that this point is relegated to the film's subtext, and is otherwise completely ignored by the narrative, is perhaps testament to the way in which America itself was able to effectively ignore (or, should we say, prefers to ignore) the real reasons behind the military events in which it was involved.

Conclusion

The subtext that I have pieced together from these images emerges only when they are viewed in isolation from the film's narrative "pop cultural potpourri." It works by referencing previous films that share similar themes and concerns. The second meeting with the Big Lebowski, for instance, while reminiscent of scenes in both *Citizen Kane* (1941) and

The Big Sleep (1946), also proves, as Carolyn Russell points out, "visually evocative" (146) of a similar scene in *The Magnificent Ambersons* (1942). This is perhaps *the* film about how automobiles irrevocably changed the American landscape and the values of its suburbanites. Yet the political content of the subtext requires more than just a knowledge of film history. It also requires a knowledge of American history and ideology.

The question this essay begs is, just how useful is such a subtext? If only the anorak-wearing few like myself will be able to spot it, is there really any point? Mike Wayne—addressing the film as part of a much broader discussion of political cinema in general—has already attempted to answer this question. Briefly noting the film's allegorical reading of America's involvement in the Gulf War, Wayne concludes that the allegory is ultimately not very effective, as it is so "unreadable" (131). He then proceeds to analyze a more effective use of allegory in certain South American cinemas. Undoubtedly, this distinction suits his purpose, the charting of the development of Third Cinema in a post-colonial context (for an introduction to Third Cinema, see Solanas and Gettino; Espinosa; Gabriel; Pines and Willeman).

In this context, *The Big Lebowski* does indeed seem something of a failure. However, when viewed more locally, solely in relation to American cinema, it seems a little less so. After all, American cinema has traditionally shied away from overt engagement with politics (Lindhom and Hall 32) preferring instead to smuggle political messages into its films (Davies and Wells 7). Taking this into consideration, Wayne's work could be said to uphold a somewhat elitist prejudice—that American films are mostly politically disconnected spectacle—on which theories of Third Cinema were initially predicated. The limiting culture industry binary that this stance is in danger of re-creating (i.e., that popular—especially Hollywood—films are "bad," and art/avant-garde cinemas are "good") says nothing of the market orientations or the viewing practices

of the audiences of such popular films (Hollows). As this essay shows, however, if we are to take Carroll's views on the two-tier audience of post-classical Hollywood films into account, then we must realize that there is a certain section of the audience that is able to read the informing allusions of the film's subtext. Indeed, this is a demographic that has been trained to do so since the 1970s and 1980s.

Admittedly, it is up to these viewers to piece together the historical resonances that these filmic allusions create. However, if aiming at this audience is what makes an American film political, then it is indeed a success. Moreover, whether the film's political subtext reached this audience may not necessarily be entirely the responsibility of the film. This is a statement I make despite my own initial difficulties in piecing the clues together. Rather, it is a lack of communication between film and audience that causes its "failure." This is a situation created by industry expectations of profit and readability, and the promotion (or lack of it) of an engaged, critical, national film culture. After all, it is easy to say that all American films should be more overtly political, but who is going to pay for them to be made if there is no audience to consume such films? Like many independent films, then, *The Big Lebowski* addresses a split demographic in order both to capture a market share of the mainstream audience and to address those able to discover a political critique within an otherwise ludicrous, albeit very entertaining, film.

10 "I'll Keep Rolling Along":
Some Notes on Singing Cowboys and
Bowling Alleys in The Big Lebowski

Edward P. Comentale

So what about that tumbleweed-cum-bowling ball that crosses the steep, scrubby slope and crests atop the smoggy panorama of Los Angeles? It flops digitally across the painted desert, carrying us through the rugged terrain of Gene Autry, Roy Rogers, and Jason McCord, leading us up up up, past even the starry sky, to the brighter vista of the Dream Factory itself. When it crests the hill, the tracking camera angle creates a vertiginous gap between the two landscapes, establishing an unsettling connection between the dreamy, if fraught, narratives of national expansion and the dream palaces of Hollywood itself—L.A. as natural extension of the American frontier, L.A. as bizarre alternative universe, a shimmering America beyond America. But the tumbleweed takes the leap, and it is tracked down the eerie, depopulated streets of the big city; it persists, abides (like the film's hero), and makes its way to the shore, where, oddly, it does not fall into the sea, but veers to the side and follows the coastline, rotating sideways, perhaps endlessly, its forward progress now an inane recycling, the ceaseless revolution of a big nothing.

Here, *The Big Lebowski* provides its first surreal pun—tumbleweed as bowling ball as (ultimately) rolling reel of film—and establishes the mythic terrain for the non-mythic action that follows. Before all else, the film is a Western, and, with the voice-over of the Stranger, it gently frames the ensuing tale as a traditional six-shooter, with the Dude

and his posse struggling to establish the moral terms of America as it expands beyond the plains and deserts into the stranger territories of Korea, Vietnam, and Iraq. The Western proves the right genre for the "time 'n' place," and so the film extends its grand allegorical mode into the present, rewriting it as a post-Nixonian battle of the baby boomers, a dusty squabble in the sand over lines both real and imagined. But, again, the tumbleweed is merely a prop, a Hollywood fabrication, and as its westward progress is checked, it loses some of its mythic power. The tumbleweed hits the shore and rotates in place like a reel of film, recycled yet again like so much stock footage that padded out the B-films of yore. Here, *The Big Lebowski* presents the Western as something less and something more than myth, as commercial genre and popular form, but, also, as a significant style. In a film littered with cinematic allusions, the Western appears as the ur-genre of all Hollywood production, before noir, before war epics, before sports flicks and buddy pictures. The film's interest in this mode is nothing if not gestural—as it gestures to the films and styles of the American frontier, it returns to a gestural mode of cinematic experience long discarded by most filmmakers. In this, though, the film attains much of its aesthetic, if not ethical, force, for if cinema has proven capable of responding to modernity, and particularly to the loss of coherent experience that accompanied the closing of the frontier, it responds most significantly through its emphatic use of gesture. This chapter tracks this errant tumbleweed and this cinematic response, moving from American frontier to Hollywood studio to, finally, starlit bowling alley as the last repository of human gesture.

From their first noirish escapade, *Blood Simple* (1984), the Coens have revealed a consistent preoccupation with the cultural and aesthetic productions of the modern period. Again and again, their work turns to American scenes of the 1930s, 1940s, and 1950s, using the art and styles of those decades to theorize the country's social shifts and

gaps, evaluate its enduring icons and trends, and, of course, construct an aesthetic lineage for their own offbeat style. This incessant return has always been slightly skewed, though, away from modern history as such and toward modernity as a project of self-construction, a matter of self-knowledge as well as self-stylization. Many of their films, in fact, focus on Hollywood itself and dramatize the closing of the cultural frontier and the beginning of America's ceaseless project of cinematic self-production and consumption. In this, *The Big Lebowski*'s investment in the Western seems typical, if not inevitable. Here, the Western comes across as unbearably earnest and unbelievably chintzy; at any given moment, it figures as both dire allegory or gratuitous style. On the one hand, the cinematic West, long after the death of the real West, continues to stage the frontier as the scene of intense national struggle and ideological crisis. On the other hand, the big screen shares with the big country a sense of surreal style, exaggerated gesturalism, and, of course, a nearly willful disregard for anything resembling real history.

Before all else, the film is a Western, and, with the voice-over of the Stranger, it gently frames the ensuing tale as a traditional six-shooter, with the Dude and his posse struggling to establish the moral terms of America as it expands beyond the plains and deserts into the stranger territories of Korea, Vietnam, and Iraq.

Thus, beginning with the Stranger's opening monologue, the film presents the Dude as representative of a lost mode of living, a defender of the old easygoing ways against all manner of big city cons. A drifter, a dropout, a man extremely slow to provoke, the Dude nonetheless serves to uphold a moral code in a battle against forces that are awkwardly juxtaposed, but undeniably modern: big business, big government, fluxus feminists,

and German nihilists. Here, particularly, the play of mistaken identity and misapplied guilt—which marks all of the films' Western references: *Tumbling Tumbleweeds, Branded,* and *Rio Bravo*—recalls one of the most significant features of the Western genre, the misapplication of blame and the eventual recuperation of national justice. As Peter Stanfield writes, the B-film status of the series Western designated not simply a difference in quality, but a specific audience niche, mainly rural working-class families, and the standard narrative conventions served to master the torturous shocks of economic modernity at large. Drawing upon Michael Denning's work on popular allegory, Stanfield explains: "Characters in the series Westerns are not naturalistic figures in a fictional equivalent of the world inhabited by its audience but are instead its fantasized substitutes who act out the audience's fears and desires. Through the donning of disguises, characters in series westerns—the outlaw who is in fact a lawman, for example—perform as metaphors for specific social, cultural, and economic struggles" (129; see also Peterson 82–93). Indeed, at first glance, *Lebowski* seems to invite just such an allegorical reading. White-collar fraud, corrupt masculinity, imperial expansion, information age ennui—here, the crises of a specifically boomer generation are enacted by a range of more or less fantastic types and reconciled by a more or less fantastic plot.

But, of course, when William Preston Robertson explained to Ethan Coen that he thought that the film was an "arch statement on America's great Westward Expansion and the absurdity of the pioneering masculine mystique," the latter replied with a wry "Yeah. . . . Yeah. I mean . . . yeah, probably" (45). Ethan's reserve might have derived from the fact that as allegory, life in the cinematic West has always been lived broadly, excessively, and queerly. Camp life is undeniably campy, replete with rhinestones and painted saddles, and a rider is as apt to burst out in song as he is to rustle a steer. Thus, despite its mythic earnestness,

The Big Lebowski presents the Western as pure Hollywood confection, not so much an allegorical aid or even a Depression-era escape, but a fully commercialized, largely stylized, and oddly gestural response to modernity. Indeed, given the pokey digital tumbleweed, the Stranger's affected drawl, and the reference to *Tumbling Tumbleweeds,* the film taps the Western genre for its stylized excess, and it borrows the denaturalized performance style of the past precisely because it is never simply representational. Indeed, this is the never-never land of the West—the big sky as big screen—where rustlers wear sequins, horses chase cars, and a radio is always blaring behind the barn. It is a fantastically messy space, where a range of popular styles and forms—the medicine show, vaudeville, the rodeo, the circus—glide across the screen, held together only by the naturalizing effect of the gritty landscape. In this, the West appears to be no different than Hollywood itself—a timeless, self-contained haze of klieg lights and cellophane, at once fateful and plastic, significant and consumable.

"Tumbling Tumbleweeds," the film's opening song, conjures up this specifically dreamy version of the West. It is a lazy, meandering jaunt of pure style, one that was made famous insofar as it gave the alien landscape of the West a pure, pop sheen for the masses. The Sons of the Pioneers, who first wrote and performed the song, were known for imagining polished ethereal vistas of the range, creating surreal soundscapes and drowsy melodies that, in their romantic grandeur, far surpassed any mortal experience of westward travel (D. Green 34, 69). Here, they sing of an extravagantly painted desert—glorious patterns of sky and sage that dwarf all human drama. The West as surreal dream, a drifting formless openness, capable of tossing up a myriad of shapes and sounds, even the incongruous tumbling pins and rolling balls of the bowling alley:

10.1. "A Mysterious Bag Holds the Secret." Chuck Connors, star of *Branded,* featured here as *The Rifleman.*

I'm a roaming cowboy riding all day long
Tumbleweeds around me sing their lonely song
Nights underneath the prairie moon
I ride along and sing this tune

See them tumbling down
Pledging their love to the ground
Lonely but free I'll be found
Drifting along with the tumbling tumbleweeds

Cares of the past are behind
Nowhere to go but I'll find
Just where the trail will wind
Drifting along with the tumbling tumbleweeds

I know when night has gone
That a new world's born at dawn

I'll keep rolling along
Deep in my heart is a song
Here on the range I belong
Drifting along with the tumbling tumbleweeds

The song also recalls the nation's first singing cowboy, Gene Autry, and the first singing cowboy movie, 1935's *Tumbling Tumbleweeds*. A dude if there ever was one, Autry was famous for hicking-up to sell all manner of cowboy kitsch—guns, spurs, watches, lunchboxes, and boots. From the start, Autry's fame rested on a certain fabricated authenticity, an unholy but profitable union of commercial and folk culture. His singing cowboy's life was not necessarily free but—like his song—cheap, a transposable style that could easily blend with other popular forms: the crime film, the romance, the comedy. Bound neither to past, present, or really any landscape known to humans, Autry was a liminal figure that has now come to represent not moral exceptionalism, but the loose iconicism of Hollywood in general. Indeed, if the cowboy is the master signifier of cheap cinematic Americana, the *singing* cowboy can only be the patron saint of all show business.

I'd like to ride alongside the Singing Cowboy for a moment, if not for his fabulously studded pantsuits, then to at least explore his strange cinematic ethos. Autry's autobiography helps to link the dream of the American frontier with the dreaming of Hollywood and clarifies the strange gestural logic that continues to fascinate film audiences. While

10.2. The patron saint of show business. Gene Autry in *Melody Ranch* (1940).

Autry grew up "scratching a living out of the hardscrabble ground" in western Oklahoma, his early experiences on the ranch were strangely doubled by its cinematic equivalent. He worked as a projectionist in Achille, Oklahoma, where he "got saddle sore" just from watching Tom Mix, William S. Hart, Harry Carey, and the serials (Autry 3). By 1934, as a radio personality, he was established as "The Original Singing Cowboy," and he quickly made his way to Hollywood, where, imitating the broad gestures and laconic speech patterns of his idols, he found a new home on the screen. Autry, as a Depression-era star, drew upon a certain

aw-shucks boyishness and rambling grace as a way of luring fans fallen on hard times. Generally, with his soft voice, shy smile, and quaint, down-home moralism, he provided a good antidote for harsh times, and given his films' casual blend of working-class populism and stylish self-regard, he easily established a sizable audience. Autry's own account of his attraction, in fact, uncannily echoes the Stranger's description of the Dude: "I was just right for those times, those deepening Depression years . . . an average fellow, from a small town, no airs, a friendly smile" (41). Indeed, for nearly four decades, Autry's films managed to maintain a profitable spectacle of Little Dude vindicated against the Big Dude. As a western hero, he projected a passive grace and regional loyalty that, when pushed, worked first through legal channels and only in extreme cases through guns and fists: "My movies offered crimes of cunning, instead of crimes of violence," Autry explains, "Dishonest salesmen and financial pirates were my villains. I ran a kind of one-man Better Business Bureau, out in the wide-open spaces. . . . While my solutions were a little less complex than those offered by FDR, and my methods a bit more direct, I played a kind of New Deal cowboy who never hesitated to tackle many of the same problems: the dust bowl, unemployment, or the harnessing of power. This may have contributed to my popularity with the 1930s audiences" (53).

But Autry's Hollywood experience undoubtedly complicated his sense of his significance and the larger popularity of the Western. For Autry, Hollywood was a frontier of a different sort, an auratic dream world, the cultural otherness which might as well have been purely geographical. As he claims in his biography, "I can no longer recall, if I ever knew, what I expected to find when we reached the end of that road. But Hollywood was already the glamour spot of the world, and I never had been farther west than Albuquerque" (36). Playing the tourist, visiting Grauman's Chinese Theater, taking rooms at the old Hollywood Hotel,

the young Autry claimed, "My first impression of Hollywood was of all that whiteness. The homes. The buildings. The studios. It was like a Russian winter scene" (37). The stars, too, moved with an alien grace, their bodies stylized and gestures precise, even when off screen: "The old stars have a mystique and they clung to it even after everything else was gone. I mean, if they went out the back door to carry out the garbage, they dressed as though they were going to a charity ball. They dressed and lived and fed on that image of glamour. It may have been a make-believe world, but at least they worked at it" (47). Most importantly, the Oklahoma ranch hand found himself contending with competing images of himself and, in the amplification of his own gestures, competing modes of public significance. As both a popular singer in front of the mike and a rough actor in front of the camera, Autry experienced a startling, but decisively modern, sense of his own alienated gestures and their grotesque magnification. At the outset of his recording career, he quickly learned that the slightest vocal tics had to be managed and suppressed—everyday vowels and consonants had to be stretched and twisted for a national audience. With film, this sense of gestural amplification became even more taxing.

As Autry reported from the set of his first film: "I had only one scene to do in Maynard's picture, the barn dance scene, and I was nervous about it. I had worked at fairs, in theaters, in rodeo arenas over much of the South and Midwest. But I had never appeared in front of a camera before, and I knew none of the tricks. In a close-up, you could shake

A drifter, a dropout-out, a man extremely slow to provoke, the Dude nonetheless serves to uphold a moral code in a battle against forces that are awkwardly juxtaposed, but undeniably modern: big business, big government, fluxus feminists, and German nihilists.

your head just a fraction and it would move across a screen thirty feet wide" (37).

Indeed, when Little Autry first encountered Big Autry, his enlarged gestural alter-ego, he wanted to flee in horror: "It was quite a jolt when I saw myself on the screen for the first time. . . . after I saw the first screening . . . I was ready to call it quits. I moved like my parts needed oiling, and I didn't like the way I looked or sounded. I went home that night and snapped at Ina, 'Look, I don't think this picture business is for us'" (38). At the same time, Autry anxiously confronted the drastic biographical contradictions of his new life: his dual role as Depression-era spokesperson and his financial status as big name brand. In fact, his most successful films—*Back in the Saddle, Melody Ranch,* for example—drew upon this tension between a Big Autry and a Little Autry, adopting the tension between the humble character traits upon which his fame rested and his sizeable appeal and the obviously contrasting values of his new lifestyle. In reel after reel, Autry plays himself playing himself or an imposter playing himself, thus contrasting competing identities and competing versions of modern America—big and little, rich and poor, urbane and modest. In terms of this awkwardly gestural body and its exhibition, we might begin to rethink the difference between a Big Lebowski and a Little Lebowski. If the complex allegories of the Western are played out in extreme gestures, then perhaps cinema advances not only competing narratives of contemporary identity but also competing modes of signification. As in Alice's dream of Wonderland or Dorothy's dream of Oz, Hollywood presents a world of gestures that are at once foreboding and uncanny, implacable and unreliable. As a frontier town in its own right, it seems populated by freakish, alienated stars whose bodies are at once obscene, illogical, and captivating.

The Coens' work is deeply, perhaps perversely, invested in the gestural mode that Autry describes. Their films seem willful, petulant even,

in their attempts to revive not only the melodramatic modes of action and characterization that has slowly faded from cinematic experience, but even the jerky histrionics that have long been given up in favor of psychological realism and complex motive. I would wager, though, that their most popular creations are also their most gestural, and that this popularity suggests a continued public interest in the gestic mode. Hi McDunnough rounding up the Arizona quints, Jerry Gunderson spazzing at his car windshield, Ulysses Everett McGill boxing in the Woolworth's—these performances are nothing if not gestural—radically externalized, inhumanly plastic, cartoonish even—and yet they seem to resonate most directly with contemporary audiences.

There are at least two ways of understanding this attraction—one is cultural and the other is critical. Roberta E. Pearson, in her book *Eloquent Gestures,* draws a stark distinction between the histrionic code of early cinematic acting and the code of verisimilitude that slowly replaced it in the 1910s and 1920s. Looking closely at Griffith's Biograph films, Pearson outlines a swift, and seemingly inevitable, transformation of cinematic acting style in which flailing arms and heaving chests gave way to a more subtle play of hands and face. This movement toward corporeal subtlety, she argues, informed equally significant shifts in content: in terms of narrative and character, broad emotion was replaced by complex thought and subtle characterization, while all action was fleshed out by psychological motivation. If anything, the difference between the two codes is a physical one, but differences in size, scale, and texture were affectively aligned with certain class preferences. With the histrionic code, each gesture was magnified, intensified, and accelerated, performed broadly on the physical body for the common body. The verisimilitude code, by contrast, works in miniature, in segments, on the face and its small features, to establish the individuality of the character and the existential isolation of the moment. Thus, historically,

the shift outlined by Pearson corresponds to an explicit shift in the composition of the cinema audience. While the excessive bodies of the earlier period reflected the public exchanges of lower-class audiences, the later emphasis on realism and the expressive verisimilitude of the face reflected the presumed multiplicity and alienated complexity of increasingly bourgeois audiences (127, 144). Peter Stanfield, too, in his "strange" history of the singing cowboy, locates the mass appeal of serial films, such as the Western, in their promotion of action and spectacle over narrative coherence and in their tendency toward an emphatic "exhibition of performance" rather than a seamless psychological realism (41). "Their focus was on acts of performance," he writes, "horse chases, fistfights, courtship, slapstick comedy, and, what was most important in singing westerns, the music. Rather than understand performance as an act of illusion where the trick is to convince viewers that they are not watching actors, the series western celebrated performance as an act of value in and of itself" (100). For Stanfield, the longevity of the Western resides in its recognizable use of gesturalism over and against the innuendo, characterization, and psychological motivations of the middle-class drama. Cowboys like Autry, like the Stranger, like the Dude, play an excessively stylized version of themselves on the screen, and this "highly distinctive reflexivity in the representation" responds to the "fears and desires" of a specific class (102, 129).

Given my earlier remarks about the Coens' interest in modernism, it is worth suggesting that their gesturalism figures as an attempt to revive the earlier mode of cinematic negotiation. Indeed, I'd love to revise our contemporary image of the Coen brothers as brainy postmodern aesthetes by situating their work within a long cinematic tradition of popular gesturalism. I'd gladly wager that their ability to capture an audience's attention depends on their presentation of bodies ataxic, dystonic, or generally spastic. In this, they seem to tap what Miriam

Hansen calls "vernacular modernism," a loosely connected collection of popular forms that seem to "register, respond to, and reflect upon processes of modernization and the experience of modernity." Specifically, Hansen explores the ways in which the films of the modern period seemed to explore a "universal language of mimetic behavior . . . an imaginative reflexive horizon for people trying to live a life in the war zones of modernization" (60). Similarly, Justus Nieland, in *Feeling Modern: The Eccentricities of Public Life,* attempts to redefine the modern public sphere from the bottom up, in terms of its dependence upon public displays of mimesis and affectivity. In his formulation, gestures are the genetic building blocks of modern public identity—they are neither simply expressive nor crassly commercial; rather, in their visibility and transposability, they become the means of cultural negotiation as well as cultural dissonance.

Importantly, though, the histrionic mode is also always self-referential, focusing attention on the body as means of performance. Whether on the melodramatic stage or in early cinema, the gesture refers to staged realities, and significance resides in the emphatic "exhibition of performance," in the virtuosity and stylization of the body on display. Thus, formally, the Coens' belated interest in gesturalism is marked by its hyper-citationalism and also, undeniably, by its self-conscious sense of excess and its incredible negativity. In this, their work seems hardly available to the logic of vernacular modernism and, in fact, seems to resist the mass incorporation that defines popular culture in the twentieth century. In fact, in *The Big Lebowski,* as throughout their work, the gestic body appears frantic, hostile, or hopeless, and its appearance often signifies nothing other than its own nihilistic persistence.

Here, then, I offer my critical reading of their return to gesture. Specifically, I'm recalled to Giorgio Agamben's claim, "By the end of the nineteenth century, the Western bourgeoisie had definitely lost its

gestures" ("Notes" 49). For Agamben, early twentieth-century aesthetics, particularly the obscene histrionics of stage and screen, reveal a bourgeois obsession with a significant failure of communication. The bodily riots of early cinema exemplify the death throes of the bourgeois public culture, a last-ditch effort to record, scientifically, the expressive language of gesture as it slipped through their fingers. In this, film traces a magic circle around gestures that no longer perform their social function, each image a reified moment of a once vital engagement, yearning for release back into the socius ("Notes" 56). Here, we find something of the negativity for which the Coens' most difficult work is marked. In *Miller's Crossing* and *Barton Fink*—any moment, really, featuring John Turturro—gesture is born of frustration and obsessively repeated. Their characters are at once excessively talky and aggressively physical—gestures emerge in the breakdown of communication, in the

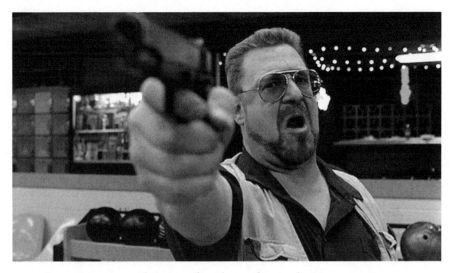

10.3 and **10.4.** Extreme manifestations of a widespread gestural crisis.

face of writer's block, both literal and cosmic, and so they inevitably
grow monstrous, extreme, oppressive. *The Big Lebowski* is no exception,
for the script serves first and foremost as an analysis of language prob-
lems. Characters bicker over linguistic distinctions such as *Chinaman*
and *Asian American*; *johnson, dick,* and *rod*; *special lady* and *lady friend.*
They malappropriate and misappropriate everything from marmots to
Pomeranians; the Dude holds up the wrong hand to show he's not wear-
ing a wedding ring, and, of course, Walter smashes the wrong car. If
anything, the film is a comedy of misapplied and misread gestures, sug-
gesting a grand cultural malaise of which the Coens' own filmmaking
is a supreme expression. At moments of extreme linguistic frustration,
the characters spazz without restraint, and some, like Walter and the Big
Lebowski, gesture with an obscene excessiveness typical of early silent
film. Conversely, some characters lack all gestures, thus suggesting a

different kind of communicative dysfunction—like Smokey, they are either burned-out, uncommunicative, and inconsequential, or, like Larry Sellers, they refuse to gesture at all.

This gestural emphasis sheds a certain light on some of the seemingly extraneous moments of the film. Marty's performance at Crane Jackson's Fountain Street Theater reveals perhaps the desperate gesturalism that underlies much modern art, especially bad modern art. The image of Arthur Digby Sellers in his iron lung, artificially preserved by the film, comments on the reified gestures of not just the Western, but genre film in general. In fact, it is primarily because the Coens proceed from the gestural (rather than from, say, thematics) that their work opens up to a range of other texts and performances. Dynamic but disassociated, each gesture is also always a gesture toward some other work, contains something of the formal presence of prior gestures and their context. Immediate, but generalizable, the cinematic gesture communicates beyond its own moment to a whole host of other moments, and thus to a much greater system of gestural practice. Indeed, following Agamben, we can read the film, and the Coens' entire canon, as a catalogue or repository of lost gestures both big and small. It is an archive of gesticulation, an exhibition of the already exhibited, that ranges from the quaint (Brandt adjusting his collar) to the obscene (Quintana licking the ball), that swells to include specific cinematic constructions (such as Toto trailing behind Dorothy in *The Wizard of Oz*) to entire styles and genres (noir, the Western). Even speech in the film works mostly as gesture. It is a film full of stylized catchphrases, and each is merely a forceful performance of speaking—"Fuck it. Let's go bowling." "What makes a man, Mr. Lebowski?" "The Dude abides." In fact, most popular cinematic catchphrases gain their force precisely for being uttered outside the communicative loop. They typically appear at the end of an exchange, at the terminal point or breakdown of communal

exchange and usually entail an excess of expressive intent: "Hasta la vista, baby." "Show me the money!" "They're baaaack!" "Here's Johnny!" "It's okay with me."

I'd like to argue, though, that as archived gesture, the Coens' cinema confounds conventional understanding of gesture and its historical significance. For the Coens, gesture is never simply reactionary or ironic, neither fully expressive nor merely citational. It does not romantically precede spoken language, as in a modernist fantasy of pure signification; neither, though, does it signal a simple aesthetic detachment, as mere citation, as empty sign. Rather, following Agamben, if cinema is the "homeland of gesture," it reveals gesture as something willingly "endured and supported." Simply put, gesture abides in the frames of our cinematic tradition. It now exists outside the orbit of mundane communication, and in its release from any specific social use, it now reveals the human body as the exhibition of mediality in the very process of making itself a means ("Notes" 57–58). In film, as film, gesture appears as nothing more (or less) than "the endurance and the exhibition of the media character of corporal movements" and thus reveals humans in their pure mediality, their "being-in-a-medium" (58). Moreover, film— as a jumbled collection of more or less reified images—calls for a liberation of moving gesture. Film, as the frontier of image, as ramshackle outpost of crumbling linguistic order—teeters on the brink of moving gesture. This is not a temporal logic, but a spatial one, or rather a liminal one, for the screen at the end of the frontier reveals, or perhaps allows, history as gesture.

Thus, in *Lebowski,* while many gestures arise out of communicative failure, they also—following Agamben—expose communicability in its purist form. Importantly, in *The Big Lebowski,* manic gesturalism competes with a certain wordless grace. Bodies are put on display, exhibited in their mediality, and, at these moments, they communicate

nothing but their own communicability. Here, of course, the Dude becomes our prime focus of attention—as dropout, as bum, his body attains its own gestural richness, at once psychedelic and ridiculous, sublime and stupid. In an early scene, he stretches exquisitely in the bowling alley as Walter and Donny bicker before him. Without content, beyond concept itself, his form becomes a mystery of its own expression—consumed in itself, it "paints itself with its own luminous shades" (Agamben, "Kommerell" 80). Later, we see him in his apartment, silent on his new rug, working through his own tipsy tai chi dance, exhibited in his environment as a series of purposeless shifts and stances, bearing forth without end. With the Dude, as with the film itself, gesture becomes dance once more—not as art, but as the exhibition of body as medium, "[oscillating] forever between reality and virtuality, life and art, the singular and the generic" (80). For the Coens, each cinematic gesture is a promise, a suspension or crystallization, waiting, like the statues in Lebowski's great room, for a world in which they once again make sense (Agamben, "Notes," 56).

Or, perhaps, like bowlers. More than anything else, the Hollywood Star Lanes is the scene of anxious public breakdown, as bowlers frantically mime the gestural logic of a public sphere that no longer exists. Indeed, in its depiction of PBA sociability and its failures, the film seems to echo the central argument of Robert Putnam's *Bowling Alone: The Collapse and Revival of American Community*. Putnam's rather conservative line, which is adopted wholesale by the bowling documentary *A League of Ordinary Gentlemen* (2004), bemoans the demise of league bowling as representative of a larger decline in the nation's social capital and suggests that bowling alone is only one manifestation of a larger generational decadence that eschews civic virtue for passive spectatorship and ironic detachment. As suggested above, *The Big Lebowski* hews to a similarly generational line, and while it does not share Putnam's

general fear that well-balanced civic-minded boomers have been replaced by alienated suicidal dropouts (257–65), it does present a similar view of the more or less dysfunctional forms of public engagement in late twentieth-century America. In *Lebowski*, the bowling alley is presented as an essentially flawed site of collective engagement, one that everywhere exposes the cracks in its civic structure ("Over the line!") and its general dissociation from the nation at large. Moreover, while bowlers congregate in teams and leagues, they inevitably bowl competitively and aggressively, and, despite Putnam's fantasy, they always bowl alone. As a form of civic participation, or even democratic organization, bowling is typically American in its contentious format and strangely alienated in its stark isolation of the bowler up against the line, turning away from his teammates in order to face down the pins alone. More generally, the film confirms Putnam's analysis in its gestural logic. The communal surety of the older generations is expressed by a certain gestural reserve, while the social incomprehensibility of the younger generations results in either manic gesturalism, as with Brandt, or a complete gestural breakdown, as with the mute and nearly comatose Larry Sellers.

In **Lebowski,** *the bowling alley is presented as an essentially flawed site of collective engagement, one that everywhere exposes the cracks in its civic structure ("Over the line!") and its general dissociation from the nation at large.*

At the same time, though, the film finds a certain value in the gestural drama that occurs at the line. From its bracing opening credits to its last, wistful frame, the camera lingers over the bodies at the line—some are bloated and jiggly, some are graceful and fey, some are mechanical, and some are utterly sublime. Importantly, though, the

moment at the line is the moment of gesture revealed—the exaggerated squint, the fist pump, the gut wiggle, the crotch chop, the ankle shimmy. In other words, bowling is ridiculously expressive—it is both ballistics and ballet, a brute manipulation of boulders and sticks, but also a heightened, if utterly gratuitous, form of dance. But the gestures that occur after the roll are the most interesting. Simply put, a bowler cannot avoid gesturing after the ball is thrown, and yet that gesture seems to serve no purpose whatsoever. These little moments—immediately lost to the tumult of time—are both compulsive and useless, instinctive and gratuitous. I dare you to test it out. Go to the alley and throw a ball—throw it scientifically, throw it ironically, throw it amorously—no matter how you do it, you will be gripped by gesture as the ball moves down the lane. Or just watch other bowlers—they do not merely follow through on the arc of the throw; no, they fall to their knees, they pat their chests, they play air guitar. Some of this phenomenon can be explained away by sympathetic magic—the bowler contorts his body in order to will the direction of the ball. And yet, at the same time, it is an awkwardly spectatorial, strangely public phenomenon. For one stark moment, the bowler stands alone, without purpose, apart from his team—the bowler is on display, and he must make his body mean; he must find significance for the utterly nonsensical position in which he finds himself. In this, bowling has always been about public being and our ridiculous attempts to claim it. As a sport, it is all too social, and it expresses what it means to be alone in public, a citizen without a state. Thus, if the film does present bowling as a metaphor for the fate of the American public sphere, it does so as a site of public dysfunction. The alley is presented as a decadent republic: it mimics publicness, but without much respect or even awareness of what publicness means; there are citizens, and at least the pretense to rules, but no adequate sense of their purpose or even consistent application. And yet, at the same time, for

10.5. A quiet gesture before the line.

the same reasons, this is an oddly liberated public—at once extra-legal and perhaps illiterate, but thus more incredibly suggestive in its gestural cavortings. It is, perhaps, a new frontier—lawless, anxious, and desperate—that never fails to suggest the possibility of some significance, the inspiration of otherwise indistinct, and perhaps even grotesque, bodies groping for communal meaning.

I must confess, I like to watch *The Big Lebowski* as a silent film. Despite its rich four-letter dialogue and dialectical babble, it also seems to work without sound. I don't need Walter's eulogy to appreciate the ashes flying in the Dude's face. I don't need Quintana's threats to know him as a lascivious beast. While watching, I'm drawn to Bunny lifting her foot, Maude stroking the Dude's jaw, Jackie Treehorn stalking elegantly across the sand. Brandt is a physical marvel of awkward toadiness, and the image of the Corvette owner heaving in his T-shirt is the stuff of

dreams. But perhaps I don't need to remind you that *The Big Lebowski* has its silent moments. No one ever speaks when a bowler starts to roll. The opening credit sequence is a mute ballet before the line, as a variety of bowlers approach, release, and then jig and reel freely. Later, in one of the most beautiful moments in the film, Donny releases his ball and does a tiny dance. It is in this rare moment, after the release, beyond cause or effect, when the body becomes pure gesture, dancing at the line, that the film speaks most beautifully. In this, in this very silence, I think *The Big Lebowski* offers a unique kind of modern experience. Here, gesticulating gracefully on the last frontier, the film loses its voice and makes us feel something more than alienation, something other than violence.

As William Preston Robertson suggests, the Coens' work on the set is defined by a nearly freakish sense of control and a complete inability to communicate their most basic ideas. The brothers, he explains, are not "gabby types," and, on set, they maintain a frustratingly midwestern "economy of speech and resistance to overt displays of emotion." When they open their mouths, they give voice only to a manic "word jazz of monosyllables and demisentences . . . halting advances into non-sequitur and abrupt retreats into coma" (20, 33). Somehow, though, as filmmakers, they manage to "think out loud," using an "odd telepathy" of free-roaming ideas and images and moods—"it's a weird feedback thing," claims Ethan. "It doesn't have to do with vision. . . . That makes it sound like a personal thing. It's a very *im*personal" (57, 74, 68). The common point is perhaps the material—the props, the locale, the cast's bodies—and the Coens and their crew manage to transform this material into something like a group gesture, a community of style. As Ethan explains, "So it's like a taste thing: you gravitate toward people who have similar styles and tastes. . . . What's important is they get it. They're very sensitive. They can feel their way through it, kind of like we can, you

know what I mean? (70, 69). Despite their awkward muteness—which is perhaps the muteness of their era—the Coens have been able to speak with a legion of designers and actors and fans who silently share and silently value their eccentric gestural logic. In this, each film is a gesture in itself and thus perhaps provides something like a "speechless dwelling" for a new kind of community.

Outs

(Eccentric Activities and Behaviors)

Allan Smithee

In the spring of 1998, moviegoers had the chance to purchase a ticket to a magic carpet ride called *The Big Lebowski,* a strange new Coen brothers project that may never have gotten off the ground had it not been for the assured wizardry of its creators and its colorful cast of likable actors. In the end, it sank like a bowling ball after just a few short weeks, having racked up a paltry domestic gross of $17,451,873, a largely unsympathetic reaction from critics and indifference from a mass audience that seemed interested only in keeping the good ship *Titanic* afloat at the local multiplex (boxofficemojo.com). At that point, *Lebowski* might very well have settled into its designated slot in the home video graveyard, fondly remembered, perhaps, by the same clutch of diehard Coen brothers fans who continue to defend disappointments like *The Hudsucker Proxy.* What happened instead was a massive revival, one that has by now easily transcended the esoteric confines of the "cult movie" and settled into a strata of public awareness somewhere just this side of the American pantheon of immortal favorites like *Star Wars, The Wizard of Oz,* and *The Blues Brothers.* Of course, the belated adoration of *Lebowski* is not unique in and of itself, for there are plenty of other recent comedies such as *Half-Baked* or *Office Space* that have also turned into breakout hits only after their release on home video, thanks in no small part to that peculiarly imitative ritual whereby people recite memorable dialogue or recount favorite scenes. Though such vernacular mimicry

has also contributed heavily to the *Lebowski* phenomenon, I want to begin my discussion by suggesting that what truly distinguishes *The Big Lebowski* as a film—what compels us to watch it repeatedly, what makes it a phenomenon worthy of study, and what swells its continually growing ranks of admirers—is its almost unrivalled capacity to act as an occasion for the collecting of culture.

As an *omnium gatherum* that throws open its doors wide to a bewildering miscellany of genres, *Lebowski* would initially seem resistant to easy classification; yet the film does not so much challenge genre pigeonholing as provide it with a challenge, as one is left to puzzle out to what degree it ought to be considered a buddy picture, an art film, a MacGuffin caper, a stoner comedy, a Chandlerian neo-noir, a Western, a requiem for the 1960s, an ode to bowling, or a satirical tour of Los Angeles. As a trouncing of stable genre categories the Coen brothers' freakishly exogamous cultural collection extends a middle finger to the way that American movies have come to be conceived and marketed as instantly recognizable "properties" in order to create a favorable buzz well before opening day—a practice known as *pre-selling* in the film industry. This imperative to maximize generic legibility works to ensure the highest possible audience attendance during the all-important opening weekend, when profit potential is either realized or dashed in a matter of days. It is in accordance with this economic logic of "time-space compression" (to use David Harvey's shorthand description of postmodernity) that the usage of pastiche in commercially released movies almost always adheres to one particular genre (or at the most, a readily identifiable grouping of recombinant genres) while staying well within the limits of some principle of referentiality or unified stylistic code that has been established by past usages.

At this point, I need to make it clear that my understanding of the cultural collection encompasses not only the metaphorical sense in

which postmodern narratives like *Lebowski* function as a repository for the odds and ends of cultures high and low, but also the material practice of accumulating and arranging artifacts, both for the sake of aesthetics and the mere fact of possession. In fact, the *Lebowski* narrative turns out to be an extended meditation upon the way that the metaphorical category of "collecting-as-narrative" inevitably folds back into the latter materialist category of collecting, which in turn derives much of its coherence from its own easy assimilation to narrativity. In regard to the "narrative-as-collection" metaphor, I mean something quite distinct from *pastiche*, that signature technique of postmodernism that names the way that the disruptive modernist method of juxtaposing fragments has long since become modulated into a pure play of differences facilitated by the various signifying

… one is left to puzzle out to what degree it ought to be considered a buddy picture, an art film, a MacGuffin caper, a stoner comedy, a Chandlerian neo-noir, a Western, a requiem for the 1960s, an ode to bowling, or a satirical tour of Los Angeles.

systems, models, codes, virtualities, and simulations. Although *Lebowski* certainly does hold up as a tour-de-force of postmodern pastiche, with many of its scenes thrown together with elements plucked from the capacious grab bag of popular culture, what really "ties the whole narrative together," as it were, and what lends it a certain pathos and thematic heft is its underlying nostalgia for wholeness and lost origins, a nostalgia for a past that is not so much accessed through memory as mediated through the objects of the material world. *The Big Lebowski* therefore instantiates the cultural collection as a strategy for generating postmodern narrative even as it alludes to the wider significance of collecting culture as an expression of desire for that elusive object that

might precede the precession of simulacra and subtend the surface level of the mere play of differences.

As distinct from the narrow spectrum of referentiality allocated to most films, the unusually broad sampling of cultural references in *The Big Lebowski* does more than simply *reflect* the inevitability of what Jameson calls "depthlessness," the postmodern replacement of historically astute depth perception with flat images that are only capable of simulating "pseudohistorical pastness." Instead, the expansive Lebowskian cornucopia of pastiche invites us to *reflect upon* the poverty of intertextuality that afflicts most other cinematic narratives, a state of affairs that Jameson calls "a deliberate, built-in feature of the aesthetic effect . . . in which the history of aesthetic styles displaces 'real' history" (*Postmodernism*, 20). While it might very well be the case that the postmodern condition conditions us to descry the master narrative of History only obliquely, through the evanescent traces of simulacra in the "nostalgia film," it must also be added that such repeated indulgence in the facile play of surfaces and its correspondingly routine enlistment of desires has only given rise to a far more intense strain of nostalgia; that is, the desire for contact with "the thing itself" in its original form, what Derrida in *Archive Fever* refers to as "the archontic impulse." Without the reassuring material presence of the solid referent, the presumed correspondence of literary narrative and worldly event gives way to a free-floating representational field of hyper-reality and simulacra. While the practice of collecting culture has, if anything, been positively stimulated by the advent of postmodernism, its significance has become drastically altered: whereas artistic modernism indulged in its collecting urge as a kind of tactical response to the universalizing, paternalistic and systematic tendencies of the archive, the postmodern collection turns out to be right in sync with the dominant sensibility of its age: playful, localized and quite open to the mandate of "openness" set forth

in its various theoretical guises of hybridity, multiplicity, multicultural-ism, et cetera. But it is precisely this attenuated relationship of the col-lection to the archive and all things archival, an irresolution that may be characterized as both the unfinished project of modernity and its unfulfilled desire, that marks the postmodern narrative generally and *The Big Lebowski* in particular, with the inexorable trace of the missing origin—a theoretically untenable nostalgia that might be characterized (somewhat paradoxically) as nostalgia for the shameless nostalgic ten-dencies of modernism. Or as Jean Baudrillard has remarked about our own age of "the pure simulacrum": "When the real is no longer what it was, nostalgia assumes its full meaning. There is a plethora of myths of origin and signs of reality ... [and] panic-stricken production of the real and of the referential, parallel to and greater than the panic of material production" (*Simulacra* 6–7).

Baudrillard's parallel "panics of production" do not really remain parallel, however; rather, they converge within the products of post-modern culture themselves, where some kind of archival "mythology of origins" usually gets grafted on to the more contingent valuation of the object as an item of exchange within the capitalist marketplace. The rel-evant example here, of course, is none other than *The Big Lebowski* and its unqualified resurgence, which received something like official recog-nition last year with the "Achiever's Edition Limited Edition Gift Set," a deluxe bowling-themed box that contains an "all-new collector's edition DVD," "8 exclusive photocards, taken by Jeff Bridges on the set," "4 char-acter coasters," and, of course, the "collectible bowling towel." Even af-ter taking into account the recent strategy of the entertainment industry of wringing extra value from their vaults and differentiating their own products from bootlegs by coming out with "special editions" and boxed sets replete with bonus materials, booklets, and special features, the fact that this particular (and particularly expensive) collector's edition of

a onetime box office flop debuted at number sixteen in the top twenty DVD sales charts gives us some indication of the degree to which the recrudescence of *Lebowski* has been implicated in the wider practice of cultural collecting.

And if further proof of a special connection to the artifactual realm is needed, we have only to take notice of the massive proliferation of unauthorized Lebowskiana, including bumper stickers, shot glasses, poker chip holders, fridge magnets, T-shirts and other clothing, and the kind of oddball ephemera that invariably winds up on eBay, such as a set of bowling pins individually painted with acrylics to resemble each character from the film, or a replica of the *Time* "Man of the Year" mirror prop that adorns the wall of the elder Lebowski's study. In fact, the successful marketing of the deluxe "Achiever's Edition" and the heavy demand for fannish memorabilia are in some sense expressions of the desire to take part in the postmodern drollery of the film itself, insofar as both the *Lebowski* narrative and its real-world complement of gimcracks and gewgaws represent a collective piss-take on manufactured nostalgia whereby the ersatz inspires an ironic condescension that all too readily folds into a sincere delight at the elaborateness of the deception and its capacity to distract us from the absence of revelatory authenticity that fairly characterizes "the postmodern condition."

That *The Big Lebowski* is in large part concerned with the surrealistic momentum of the archaic artifact and the related tendency to attribute identity to things is announced right away in an opening sequence of shots that tracks alongside an impossibly intrepid tumbleweed rolling up over a hill toward the glittering lights of L.A., past an expressway, a taco stand, a deserted boulevard, and finally up to the shore of the Pacific Ocean, all by way of unconsciously recapitulating the westward drift of frontier settlement. The absurdity of the peripatetic tumbleweed here is compounded by the unavoidable inference that this shot sequence does

not result from any "artistic vision" per se, but has rather simply been inserted as a visual analogue for the 1935 song "Tumbling Tumbleweeds," itself an ode to the West recorded well before postmodernism but long after the frontier had been considered "closed." In reversing the usual hierarchy of the visible and the audible by building upon a soundtrack that motivates the action instead of merely accompanying it, the Coen brothers have also clearly signaled that at various moments in *Lebowski* their music collection will take center stage, a style of filmmaking that owes less to the aesthetics of Griffith or Eisenstein than to the urge to spin records for friends at an all-night pot party.

Besides providing the Coens with an occasion for the collecting of culture, *Lebowski* also provides them with an excuse to bring together some of their favorite actors, and here again the activity of collecting and its resonances with past association cannot be meaningfully separated from the creative process. The Stranger, whose achingly superfluous narration bookends the film, was quite transparently a device for including the grizzled persona of Sam Elliott, and although Walter Sobchak had his beginnings as a kind of composite of the Coens' friend Pete Exline, his buddy Walter and director John Milius (a collector of a different sort, who once offered to bring the Coens home to inspect his firearms), the character was ultimately inspired by the outsized persona of John Goodman. Though "The Dude" was not initially written for Jeff Bridges, it soon became obvious that the role was the perfect showcase for the kind of dazed conspiratorial victimization that Bridges had embodied in 1970s thrillers like *Winter Kills* and *Cutter's Way*, and so the Coens bent over backward to accommodate the actor's schedule, even to the extent of pushing back their own shoot by several months. The Coens' determination to put together just the right ensemble for the film amounts to a reversal of the usual order of casting only after a script has been completed, so that in *Lebowski* the casting process

instead enjoys a full freedom of motion along the axes of combination and selection, a freedom more typically reserved for the "pure" literary expression of scriptwriting. Finally, lest the analogy between the nostalgia that accrues to the cultural collection and the casting of actors in *Lebowski* seem overly strained, we should take note of the stated dissatisfaction of Ethan Coen with the casting of the dancers in the *Gutterballs* production number, which had been overtly modeled on the Busby Berkeley dance sequences of the 1930s: "In Berkeley movies, the dancers are always dough-faced . . . kind of puffy, kind of pudgy. But . . . in California, good luck. All health, fitness, beauty. They just don't have LA dancers who look like that" (Robertson 180).

Even more significant to the genesis of *Lebowski* than the collecting of songs and actors is the Coens' compulsion to compile an ever-expanding treasury of the memorable lines of dialogue and anecdotes that they encounter in everyday life. Indeed, the entire idea of the film can supposedly be traced back to the stray remark of Pete Exline, a friend who expressed his satisfaction at the way that a shabby rug displayed within his modest apartment "really ties the room together." It seems perfectly in keeping with the Coens' ironic, but obsessively attentive, fidelity to origins that this inaugural non sequitur has not ended up as merely the basis for one of the many bizarre incidents that occur throughout the film, but rather has been preserved intact as the initial catalyst that sets the whole meandering, shaggy dog plot into motion (Robertson 172). Something about the spectacle of a slovenly friend assessing his own half-assed interior design by invoking the desiderata of completion and plenitude—the antiquated watchwords of classicist aesthetics—must have tickled the Coens, and yet they have also provided a crucial twist to Pete Exline's remark by transforming his confident boast into the Dude's lamentation for a beloved object despoiled and hence forever lost, a nostalgic plaint that manifestly reverberates

throughout *Lebowski* as an expression of the desire for the original in its original condition, a desire that can never quite be extricated from "the postmodern condition."

In keeping with the continually recursive drift of the *Lebowski* narrative toward objects and their origins, I want to propose that the "virtual realities" encapsulated by the electronic media of postmodernism have not yielded a cultural situation of disembodied, boundary-shirking "flows" or the consumption of information for its own sake so much as they have induced a growing consciousness of lack that has resulted in an unprecedented mobilization of the most exotic and esoteric items of the material world. When Walter tells the Dude at the diner counter (itself a quintessential scene of American nostalgia) that the toe sent to the elder Lebowski that supposedly came from Bunny is probably not the genuine article, and adds that he can get a human toe by three o'clock—"there are ways, believe me, you don't want to know"—the contemporary viewer cannot help but wonder how many human toes might be up for auction at this very moment on eBay. Certainly much of what constitutes Internet traffic and the searches performed thereof amounts to the business of locating objects, and the eBay phenomenon and its single-handed booming of the collector's market presents just one striking example of this overall trend. Likewise, within a *Lebowski* milieu standing on the brink of an electronic "wave of the future," as Jackie Treehorn puts it when he tells the Dude about the upcoming advances in virtual reality that are going to revolutionize adult entertainment, there remains a pervasive if not to say perverse attachment to the visceral ("Yeah, well, I still jerk off manually," responds the Dude), an anxious apprehension that the "stuff that dreams are made of" that Sam Spade summarily describes in *The Maltese Falcon* is indeed stuff. In *Lebowski*, the most important thing about the toe is not who it belongs to, but that it is indeed an actual human toe, and we are therefore gratified

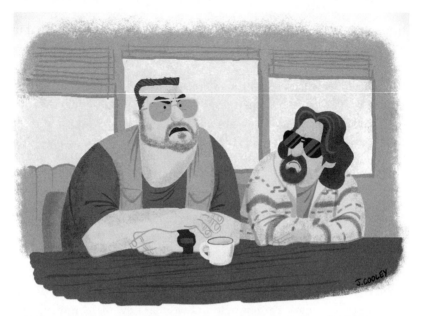

"You want a toe? I can get you a toe", said Walter.
"Hell, I can get you a toe by 3 p.m. this afternoon,
with nail polish."

11.1. Logistical support from Walter, the collector, from the proposed
Golden Book of *The Big Lebowski*. Josh Cooley, illustrator.

by an otherwise gratuitous scene where the nihilists order pancakes,
and we are treated to a close-up that reveals Aimee Mann's mutilated
foot inside her cowboy boot.

Although I have cited moments in *The Big Lebowski* that demon-
strate how the all-consuming fool's errand of desire that Derrida calls
mal d'archive—the desire to inhabit the moment of the origin—per-
sists in our increasingly virtual electronic age, my definitive example
occurs not within the *Lebowski* narrative, but with the insidious lure

of the *Lebowski* collectable. That, anyway, is my theoretical justification for having taken part in an Internet fact-finding mission prompted solely by the dodgy but persistent rumor that the porn video *Logjammin'* that appears briefly in *Lebowski* was actually based upon an extant adult movie of the same name starring one "Asia Carrera." Like all good urban legends, the Tale of the Ur-Logjam does have a kernel of

… the most important thing about the toe is not who it belongs to, but that it is indeed an actual human toe, and we are therefore gratified by an otherwise gratuitous scene where the nihilists order pancakes, and … a close-up … reveals Aimee Mann's mutilated foot inside her cowboy boot.

truth to it; namely, that a porn star named Asia Carrera does indeed appear in the *Logjammin'* video as Bunny's neighbor Sherri, the woman who inexplicably "just came over to use the shower" and is seen sauntering out of the bathroom just as cable TV repairman Karl Hungus arrives. As all attempts to locate an actual movie called *Logjammin'* on DVD or videocassette proved futile, the next logical place to check was the filmography that Ms. Carrera has posted on her own web site. After perusing the "L" section of her stunningly prolific "A to Z" of film appearances and detecting no sign of the elusive artifact, I decided to cast my net wider, and lo and behold, there in the "B" section (appearing slightly out of sequence between *The Bitch* and *Bite the Big Apple*) I discovered a most illuminating entry next to *The Big Lebowski,* courtesy of Ms. Carrera herself: "I play the pornstar in 'Logjammin'' who asks to use the shower. ('Logjammin'' is NOT a real movie!)" (www.asiacarrera.com). One can only infer from the exasperated tone here ("NOT" in all caps; the concluding exclamation point) that Ms. Carrera has been inundated with emails from *Lebowski* fanatics eager to confirm

the veracity of the Tale of the Ur-Logjam; alas, in this instance it seems that the archival desire of the collector has over-extended its reach.

While my trip to www.asiacarrera.com has unfortunately rendered moot any hope of possessing an actual film called *Logjammin'* (along with the associated pleasure of displaying it prominently on the home media shelf as a guaranteed conversation piece), it seems that in Ms. Carrera's case *Lebowski*'s inexact imitation of art has been offset by a bizarre instance of life imitating *Lebowski*. For in an "Asia's Bulletin" blog entry dated 06/14/06, the now retired pornstar relates the tragic news that her husband Donny has just been killed in a car crash, a situation that has left her devastated both emotionally and financially: "When I looked at the prices for urns and keepsake jewelry for the loved one's ashes, I fliped (*sic*) out at the prices. Did you ever see 'The Big Lebowski', where they want to bury their buddy Donny (!) but everything is just so expensive they wind up putting his ashes in a Folgers coffee can and tossing them off a cliff. I was pretty close to doing that myself." In the end, this indignity does not come to pass, and she decides to go with a wooden green and brown box with pineapples carved into it, "to remind us both of the happy times we shared in Hawaii." Even after peeling back a few of the multiple layers of strangeness that envelop this passage (the omission of the fact that she herself had a bit part in *Lebowski;* the recurrence of the name "Donny" in a funeral home scene that recalls the one in the movie; the choice of the Hawaiian box as a reminder of happy times for "us both"—meaning a reminder both to the aggrieved and her dead husband as well), what makes the most lasting impression here is the way that Ms. Carrera's grieving process takes the shape of an actual shape, through a compensatory objectification that goes beyond the figurative objectification of the body that we associate with pornography (though that objectification is not all figurative, as the cautionary remarks made

elsewhere in "Asia's Bulletin" about the pain of breast augmentation attest) in order to effectuate the literal transformation of person into thing, or in this case, Ms. Carrera's husband Donny into household tchotchke. In this instance, the archival nostalgia that attaches to the collectable object achieves something like maximum symbolic condensation, with the memory of the father kept alive not through any two dimensional photographic image, but through immediate contact with the ceremonial receptacle that contains "the thing itself." When Ms. Carrera urges her daughter to give her daddy a goodnight kiss, she opts to kiss the box that holds him instead of the photograph that represents him, "like she knew he was in there, and she was glad he was home too. . . . I'm glad Donny's home. I missed him. Welcome home, Donny I love you."

While this example of Ms. Carrera's ritualistic anchoring of grief within the externalized "hypomnesis of memory" (here, the Hawaiian-themed urn) at the site of the "arkheion" (that is, the place of "consignation" and "domiciliation") helps us to realize the persistence of the Derridean archive even within the postmodern context of popular culture and the Internet, it might at first seem somewhat tangential to our understanding of *The Big Lebowski*. And yet here we have only to remind ourselves that the reason Maude shows the Dude her copy of *Logjammin'* in the first place is to expose the depravity of her father's opportunistic "trophy wife" (in the parlance of our times), thereby also honoring the memory of her deceased mother, an absent matriarch whose family fortune is the real source of wealth for the House of Lebowski. Further, let us recall that it is Maude's sentimental attachment to her mother's rug that first initiates her encounter with the Dude—the very same rug that was first a gift from daughter to mother, then an heirloom from mother to daughter, and has now finally been expropriated by the Dude from her father's estate. Maude's dedication to restoring the matrilineal

line can be assessed by the lengths that she goes to secure the two vital materials that will guarantee both continuity with the past and the possibility of a future: her mother's rug and the Dude's Y chromosomes, the last of which she extracts in a frankly businesslike assignation in the Dude's apartment. The purposeful coinciding of these two objects in the filmic narrative presents us with a portrait in miniature of the ironic tension that subsists between the nostalgia of belonging and the harsh fact of alienability, as Maude's quite modernist attribution of nostalgic significance to her mother's otherwise unremarkable rug still holds strong even within a regime of simulation in which the very archival stuff of human biology (i.e., the Dude's DNA) proves all too reducible to the terms of a code capable of being accessed or withheld.

If Maude has designated the Dude a paternal patsy whose desirability is a function of his status as the perfect non-entity, as someone who will merely donate archival materials to her without attempting to curate them through the raising of the child, then her plan to elide the question of paternity seems perfectly consistent with her m.o. as a postmodern artist who understands the body to be a cultural artifact of pure potentiality or "becoming." Or as Terry Eagleton puts it, in postmodernism "what is special about the human body . . . is just its capacity to transform itself in the process of transforming the material bodies around it" (72). When the Dude first sets foot in her loft studio, she literally swoops down upon him as a likely prospect, fitted in a harness attached to wires and operated by attendants in order to create a piece of pseudo-fluxus art that purposefully conflates somatic movement with artistic representation. But even as Maude's work celebrates the creative power of the body it also betrays an awareness of its materiality and consequent susceptibility to metonymic exchange, as evinced by the mutilated sculptures on display all around the studio, including limbs hanging from the ceiling, a torso with a head stuck inside a hollowed out

solar plexus, and a black-and-white print that depicts a pair of hands taking the measurements of an anonymous underwear-clad female form. Besides housing this decorative display of body parts, her studio also contains a formidable collection of popular culture, notably the stack of VHS tapes that includes the pornographic *Logjammin'* and a row of vinyl LPs, one of which is the 1965 Herb Alpert record *Whipped Cream and Other Delights* with its famous cover depicting a naked woman covered in whipped cream. In Maude's private collection, the fragmentation of the human being remains consistent not just throughout her own avant-garde work and the flotsam of mass culture, but with her relationships as well: when the Dude later drops by the loft, he must compete for Maude's attention, and he struggles in vain to get a word in between a phone call from an Italian-speaking woman named Sandra and the giggling British man who sits nearby idly flipping through magazines, a video artist named Knox Harrington, who evidently belongs to Maude's exclusive coterie of artistic types.

Maude's propensity to collect things that appear to be parts of people and people who are in some part collectible things ought not, however, to be interpreted as some kind of aberration, for her depiction of the body as a site of both transformative possibility and alienated exchange proves quite compatible with the activities of the film's pair of "obscene undead fathers" Jackie Treehorn and the elder Lebowski, men whose competing attempts to extract cash value from the "trophy wife" Bunny not only set the plot into motion but establish the lengths to which they will go to collect their due. In spite of the clashing affinities for respectability and sleaze that mark them on the surface, both the elder Lebowski and Treehorn have much in common, as they are both only shown (with one brief exception) hunkering down in their respective mansions, where they do not so much preside over their lairs as entomb themselves in nostalgia.

For the elder Lebowski, the continuing legacy of the Reagan era has afforded a historical vantage from which might be derived a comforting homily, namely that the 1960s are gone for good, that "the bums lost," and that the nineteenth-century work ethic that made America great has been restored. To that end, the elder Lebowski's study-cum-archive is dedicated to achieving the solidification of "achievement" through the display of tangible objects that refer back to the precise moment at which official recognition has been ceremonially conferred, objects such as the key to the city of Pasadena, a commendation of business achievement given by the L.A. Chamber of Commerce, a *Time* "Man of the Year" cover, and a photo that documents a reception with Nancy Reagan, whose primacy as "the first lady of the nation" is unctuously underscored by the fawning Brandt. But no item in the elder Lebowski's narcissistic "walk of fame" attests to his worth as a person as much as the Little Lebowski Urban Achievers, that collection of little people whose struggles have all been patronizingly consolidated under the patronymic *Lebowski* in honor of the archon who has, it turns out, not worked a day in his life, except in the sense that he has made it his life's work to construct a monument to the American work ethic.

If the elder Lebowski operates according to the triumphalist nostalgia of an old-fashioned materialism that antedates modernism, then Jackie Treehorn is very much a child of the atomic age whose regressive desires have compelled him to surround himself with the kitsch of the 1960s and 1970s, including low-to-the-ground furniture, late night luaus on the beach, and a stereo that plays vintage selections of "lounge exotica" such as the jazzy Mancini composition "Lujon" and the obscure selection "Piacere Sequence" by Teo Usuelli, a track that can be found on the *Beat at Cinecittà* CD, a compilation that bills itself as "a sensual homage to the most raunchy, erotic filmmusic from the vaults of Italian 60s and 70s cinema." In keeping with his predilection for bygone days,

it seems that Treehorn has only reluctantly acceded to the post-1980s business model of adult entertainment, an accelerated mode of film production that does not allow for the finer artistic touches that might be capable of conveying the real "feeling" that he confesses to missing in his meeting with the Dude. When Treehorn excuses himself from this meeting momentarily, the Dude resolves to try a bit of sleuthing by shading over the top page on a tablet of paper on which Treehorn has just scribbled, an attempt at archival recovery that yields not a message, but a primitive doodle depicting a man with an erect penis. Whereas the elder Lebowski's collection has been arranged to portray the familiar narrative of the self-made man who has pulled himself up by his own bootstraps, the Dude's recovery of Treehorn's repressed phallic engraving suggests an empire predicated upon the pulling of something else, not of course vis-à-vis actual physical contact, but through the simulation of stimulation, a sleight of hand (as it were) accomplished by tapping into the limitless capacity for fantasy contained within what Treehorn himself calls "the biggest erogenous zone"—the human mind that archives "the Freudian impressions" of the unconscious. It is precisely Treehorn's compulsion to pine after the sentimental objectifications of his youth that prompts the Dude to later blurt out a strangely appropriate malapropism to the Malibu Chief of Police: "he treats objects like women, man."

Although the rival patriarchs of *Lebowski* make a show of their power by collecting people for the sake of pornography on the one hand (Treehorn Productions' stable of porn stars) and public relations on the other (the Little Lebowski Urban Achievers), it must be acknowledged that such exploitation ultimately comes across as far more pathetic than menacing, as both men appear to have succumbed to a state of paralysis (Treehorn emotionally, Lebowski physically) that is very much exacerbated by the archontic impulse of nostalgia. In fact, their attempt to

"brand" themselves by subsuming others under their own patronymics has only contributed to a creeping reification whereby they have essentially become both keepers and prisoners of their own image, sedentary collectors for whom collecting and recollecting have become mutually reinforcing ends unto themselves. Here the Coen brothers have gone Baudrillard one better, as they have realized cinematically what the former has theorized in the essay "The System of Collecting," that "the object emerges . . . as the ideal mirror" and partakes of "a mechanism whereby the image of the self is extended to the very limits of the collection . . . for it is invariably *oneself* that one collects" (12). According to Baudrillard, the ultimate goal of the collection is the suspension of mortality through the simulation of a kind of stasis or "living death": "The man who collects things may already be dead, yet he manages literally to outlive himself through his collection, which, originating within this life, recapitulates him indefinitely beyond the point of death by absorbing death itself into the series and the cycle" (17–18).

It is Walter's own death drive and, along with it, his inability to forget the "buddies who died face down in the muck" that brings him to the archive, which Derrida identifies as the site of an "archiviolithic" violence that "always works, and a priori, against itself" (*Archive* 12). Yet, while Walter's lonely jeremiad as a devoted servant of archival integrity shows no signs of abatement, and his determination to remember the American lives sacrificed in Vietnam is unflagging, he is never quite able to lay to rest the suspicion that the conflict lacked a clear sense of purpose. It is Walter's pent-up frustration with a suspended historicity and its potential nullification of the significance of Vietnam that compels him to take out his rage on what he presumes to be Larry Seller's brand new Corvette, a proximate object that is less a car than a simulacrum of a car, with its shiny, reflective chassis perfectly encapsulating the meaningless reflective surfaces of postmodernism.

At the same time, the Coens present the Dude's desire to be at one with his flying rug, or else his desire to be at one with his bowling ball, which has grown to giant proportions in an enchanted bowling alley and in one instance gathers him up into a finger hole as it rolls down the lane, climaxing in a spectacular point-of-view shot that tumbles toward a full set of pins. If the Dude has here been privy to a vision that crystallizes his Zen approach to bowling by assimilating him into the bowling ball and thereby letting him actually "become the ball," then the *Logjammin'* dream sequence takes it one step further by letting him glide effortlessly down the bowling lane between the legs of a troupe of dancers, a moment of sexual arousal that is equal parts scopophilic pleasure and satisfaction at having attained the dynamism of the object in motion. These imaginary moments in which the Dude merges with the consummate fetish object of his bowling ball are very much in keeping with what Lacan calls the desire for "the partial object," a fantasy of achieved wholeness that is cut short by the incursion of scissor-wielding nihilists and their explicit castration threat. So, whereas for Walter the collectable object always defers to the public archive (his ex-wife's Pomeranian requires special care precisely because it is "a show dog with papers"), for the Dude objects are so many free-floating signifiers of experiential opportunity, lures for the gaze that gets caught up in the flowing patterns of the oriental rug or the gliding trajectories of the bowling ball.

Thus, while the Dude's insistence that he personally authored the original first draft of the Port Huron Statement recalls Walter's much more obsessive vigil over his own historical role in the 1960s, the Dude's retrospective groping for the forever-misplaced founding document derives not from any rationalized desire to set the record straight, but rather from an impulse to "take back" the liberationist agenda of the counterculture by assigning it to himself. By claiming to have originated the language of the "authentic" but unlocatable document, the

Dude might be said to embody the letter of the law, and yet in doing so he ironically proves himself to be very much in keeping with the spirit of the "second draft," for as Marianne DeKoven points out in *Utopia Limited: The Sixties and the Emergence of the Postmodern*, the Port Huron Statement was first and foremost a manifesto that validated the subjectivity of the individual: "PHS is at once a text in the tradition of utopian socialist modernity and also a text moving away from this Enlightenment narrative toward a politics of the local and particular, as well as a politics of the self that prepared the ground for, and was the immediate precursor of, postmodern politics of the subject" (126). In a sense, the Dude's fantasies of uninhibited bodily motility and free association and his refusal to cast off the hippie lifestyle are in fact the signs of a struggle that has become localized in the extreme—in this case, localized to the somewhat insular existence of the Dude himself. With decisive passing of the historical moment of an explicitly utopian community, the Dude has settled instead into the implicitly utopian comradeship of league bowling. And though Tom Hayden and the other Port Huron idealists might have thought league bowling a pretty poor substitute for the participatory democracy that they hoped would overcome the "loneliness, estrangement [and] isolation" of postwar human relationships, on the other hand it is precisely the inclusive neutrality of the bowling league that provides former war protestor and war participant with the common ground that enables their friendship.

... the Dude and Walter are both very much stuck on (if not "stuck in") the past ...

Although the Dude and Walter are both very much stuck on (if not "stuck in") the past, and their relationship often seems to be predicated upon talking *at* each other instead of talking *to* each other, overall it's fair to say that their friendship coalesces around "the running debate

between Utopia and Eden" that Ihab Hassan identifies as the American dialectic of Innocence and Experience, a debate "between the active will moving ever forward in time and space, unburdened by the memory of guilt, and the reflective or passional conscience moving toward the past in hope of knowledge or atonement" (36–37). Ultimately, the topos of the bowling alley proves to be a flexible space, one that is at once Edenic and Utopian, allowing Walter to hearken back to a time when the rules made sense and were thus habitually obeyed and the Dude to dream of a time when the rules will become irrelevant and thus ignored altogether. More so than any other recognizably postmodern American comedy, *The Big Lebowski* might be deemed a profoundly funny film, in the sense that it is only as comic types that the Dude and Walter are able to categorically apotheosize Innocence and Experience, respectively—categories that are themselves roughly homologous to the French tradition of liberation and the German tradition of systematic knowledge, which have by now become thoroughly "delegitimated," according to theorist Jean-Francois Lyotard. If the Dude and Walter are coded as inept and anachronistic, it is only because they so consistently uphold the positions of what Lyotard calls "the hero of liberty" and "the hero of knowledge," dual protagonists of a master narrative long since abandoned. And yet the continued co-dependency of these categories, a codependency that also corresponds to that of the open-endedness of the collection and the finality of the archive, is not merely the occasion for ironic distanciation, but for an overall acknowledgment of the ongoing necessity of human solidarity. If the narrative and the phenomenon of *The Big Lebowski* can finally be said to "achieve" anything, it is a renewal of solidarity based upon the pursuit of the elusive object—a decidedly pragmatic outcome for the ongoing postmodern predicament of nostalgia.

12 Holding Out Hope for the Creedence: Music and the Search for the Real Thing in **The Big Lebowski**

Diane Pecknold

Midway through *The Big Lebowski,* a hapless Dude—having substituted Walter's phony "ringer" (a bag full of underwear) for Lebowski's briefcase full of money in delivering ransom to a group of apparent kidnappers—contacts the police to report that his car, with the briefcase and his Creedence Clearwater Revival tapes inside, has been stolen. When he wanly asks whether the police often recover such stolen cars, one of the cops replies, "Sometimes. Wouldn't hold out much hope for the tape deck, though." "Or the Creedence," adds a second cop derisively, suspiciously twiddling the Dude's bowling-pin-shaped one-hitter between his fingers.

The scene aptly summarizes the pervasive flux between ersatz and authentic that underpins the narrative of the film. The real briefcase, of course, turns out to have been a fake itself. The lost Bunny turns out not to have been lost to the kidnappers at all, and in fact not even to be named Bunny Lebowski, but Fawn Knutsen. And maybe she has been lost after all, since her parents are looking for her. The accumulation of real objects that turn out to be fake, and fake ones that turn out to be real, though never in the way we are led to expect, is the central device of the film's noir plot. Appropriately, it is within this dizzying array of inauthentic objects of yearning that "the Creedence" is introduced, not just as the music we have heard playing in the car during the ransom payoff, but as a recurring point of identification for the Dude.

We might well ask what hope the Dude, and the Coen brothers, holds out for the Creedence and the other music in *The Big Lebowski*. Film music has commonly been understood as a uniquely effective technique for allowing audiences to identify emotionally and intuitively with the characters, places, historical moments, and moods of a film's narrative. This is particularly true when the soundtrack is a compiled score that uses popular music to mobilize social narratives that exist first outside of the frame of the film, capitalizing on the codified meanings already established through the genre organization of music industry marketing. According to Simon Frith, genre definitions provide a way of predicting "what people with tastes for music *like this* want from it," a process that involves both defining what kind of people share a given musical taste and what consensus aesthetic and social values they find expressed in it (76). Thus, unlike a single song, which might invoke individual nostalgia related to a particular moment or memory, genre is an ongoing, fundamentally social narrative, one that necessarily involves a search for authenticity and social location. In deciding what counts as "really jazz or punk or disco," the listener must weigh what's new against "a notion of the real thing," listening to the music "for clues to something else, to what makes the genre at issue valuable as a genre in the first place." Genre thus anticipates and fulfills already established desires, confirms a sense of authenticity, and reliably and indefinitely reproduces affective identification with both the music and other similar listeners. In this way, for Frith, genre narratives offer their audiences a connection "to an implied community, to an implied romance, to an implied [social, historical, and personal] plot" (89–91).

Popular music soundtracks activate the longing for authenticity and social location that underpins genre organization. Seminal pop song compilation scores like *American Graffiti, Easy Rider,* and *The Big Chill,* for example, all capitalize on "the linking of [rock] music with nostalgia

and . . . generational solidarity" by mobilizing the historical and personal narratives associated with the rise of rock (as opposed to rock 'n' roll) in the late 1960s (Shumway 36).[1] In these films, the narrative implied by rock's history as a genre—its association with a particular time, place, and generation—authenticates the identities of the characters and arouses the audience's emotional identification with them.[2] On the surface, the *Big Lebowski* soundtrack was conceived in similar terms. *Lebowski* was the Coen brothers' first pop song soundtrack, and the decision to use popular music rather than a traditional score, according to Carter Burwell, the film's music director and a frequent Coen brothers collaborator, grew out of the desire to construct the Dude's own sense of time and space through music. "They knew they would have to use a lot of recognizable songs to capture that feeling of the Dude, this guy who's kind of trapped in the seventies, 'trapped' is not the right word, but in any case is living in his own time and space, and that time and space is certainly not the early nineties, which is when the action takes place," Burwell told an interviewer (Morgan 69–70).

The nostalgic possibilities of the rock soundtrack would seem to be ideal for a movie about the Dude, whose life is defined by the very historical moment when it first became a culturally sensible practice to use popular music soundtracks to evoke generational nostalgia and solidarity. But the Coens expressly avoid using the pop score in this way. The *Lebowski* soundtrack is not rock-based, nor even genre-based. Rather than triggering the processes of identification that pop music in film and genre organization in popular music are supposed to covertly initiate, the music in *Lebowski* openly calls our attention to those processes. Instead of marking out a generational identification or mobilizing affective associations with a particular historical moment, the music in *The Big Lebowski* repeatedly gestures to being out of place, out of time, and disconnected from coherent social and historical narratives, even while

seeking to revive such narratives. Far from merely capitalizing on it, the film instead lays bare the romantic, questing impulse that makes the pop music soundtrack so effective.

In *The Big Lebowski*, the processes of memory, authentication,

. . . the music . . . repeatedly gestures to being out of place, out of time, and disconnected from coherent social and historical narratives, even while seeking to revive such narratives.

and identification that are assumed to inhere in the social functions of both film music and popular music genre narratives break down in a truly spectacular way, evidenced especially clearly in the role of "the Creedence." The *Lebowski* soundtrack and the representations of music in the film's narrative consistently frustrate musical identification between the audience and the characters and between the characters on-screen. In *Lebowski,* music always fails to communicate a coherent sense of social identity, memory, or even nostalgia. At the same time, though, the soundtrack continually refers to and reaffirms the Dude's (and our own) investment in those very functions. Like the better-known pop compilation soundtrack that accompanied *O Brother, Where Art Thou?* music in *The Big Lebowski* both "marks the validity of the desire" for authenticity and identification and "shows how far we are from being able to satisfy that desire" (M. Harries B14–15).[3]

Most of the artists whose music appears on the soundtrack are, as one reviewer put it, more "genuine oddballs and geeks" than the "stars pretending to be 'characters'" in the movie (Moerer). They are almost universally artists who have strikingly transgressed genre boundaries and conventions of stable, continuous selfhood. Included, for instance, are the Monks, four American soldiers stationed in Germany who began as a basic pop and British invasion quartet, but who, after shaving their hair into monastic tonsures and donning all black, became one

of the most direct forerunners of punk rock. We also hear the voice of Yma Sumac, "a Peruvian housewife who reinvented herself as an Inca princess" (Moerer). In these and other instances, the soundtrack foregrounds incomplete and incoherent social narratives, and the inability or unwillingness of individuals to conform to the times and spaces that should define an authentic sense of self.

Indeed, tracks in which artists fail to adhere to their own genre boundaries are some of the most notable in the film and were written into the script as part of the characterization of the Dude. When the Dude listens to Bob Dylan, he chooses not the politicized folk that, to Dylan's dismay, made him the putative voice of his generation, but settles instead on "The Man in Me." The song is an uncharacteristically sweet romantic ballad that begins with a self-consciously inane refrain of ooh-ooh's and la-la-la's and was featured on *New Morning,* a 1970 album that marked Dylan's return to his own material after what many critics viewed as the outrageous departure of *Self-Portrait.* Together, these two albums have been interpreted as Dylan's effort to distance himself from the social and generic narrative the media had foisted upon him. If *Self-Portrait* figured as a variety of self-parody (one critic noted the irony in Dylan "call[ing] his album *Self-Portrait* and then fill[ing] it with corny versions of other people's hits"), *New Morning,* though not especially well received, was understood as a re-creation of the "real" Dylan, a project necessarily haunted by the popular expectation that he would radically re-invent himself again in the future.[4] Its prominence in one of the film's two "musical" dream sequences suggests a congruence between the song's conflicted narratives of selfhood and the Dude's own post facto performance of a long-gone, and somewhat suspect, identity.

The song that so thoroughly defines the film's second dream sequence, "Just Stopped in (To See What Condition My Condition Was

In)," is a similar concatenation of parody and authenticity. Written by Mickey Newburg and recorded by Kenny Rogers and the First Edition, the song was intended partially as satire of the psychedelic rock counterculture, but it was nonetheless embraced by that audience as an authentic statement of experience and aesthetic. The song itself is an apt enough expression of the ways irony and identification can co-exist within a given musical moment, but its role in this regard is enhanced by Rogers's historical presence, at a point when the singer was midway through his transformation from the folk revivalism of the New Christie Minstrels to the country pop of *The Gambler*. Indeed, Rogers's career reiterates not only the frustrated generational belonging that characterizes the Dude, but also the film's critical approach to the fantasies of national identity embodied in the Western. It's probably no coincidence that both the Dude and the narrator in Rogers's most famous song, "The Gambler," work out their quests in dialogue with a mysterious western stranger.

The songs and artists most prominently associated with the Dude tend to confuse the ersatz and the authentic so thoroughly that the very notion that they might be distinct becomes untenable. This is particularly apparent in the case of the Dude's ultimate musical proxy: the Creedence. Creedence Clearwater Revival was one of the most popular bands of the late 1960s and early 1970s, and their role as a mark of the Dude's past is therefore chronologically sensible. In part, the Coens' decision to characterize the Dude through Creedence rather than a more obvious symbol of hippiedom was simply an effort to avoid reducing him to a caricature. As William Preston Robertson points out, discussions among the filmmakers "were always framed with 'We don't want to hit this too hard.' No lava lamps . . . No Day-Glo posters . . . No Grateful Dead music on the soundtrack" (95). But Creedence also recapitulates the Dude's personal quest for the real in a particularly

effective way. As the first heralds of "roots rock," Creedence broke with psychedelia in favor of stripped-down rock songs that incorporated elements of blues and country music in a traditional four-man framework of guitars, bass, and drums. Rather than indulging in the experimentation and exoticism of their contemporaries, Creedence played straightforward rock that returned to the genre's origins. Yet, as many critics pointed out at the time, the band's efforts to connect to the (equally fabricated) signs of authenticity and history embodied in southern vernacular music were at least incongruous if not outright artificial. They were themselves from Northern California and had never even visited the South, whose mythic past they elaborated in songs like "Born on the Bayou" and "Proud Mary" and in their down-home visual personae. Indeed, the band's very name—which invokes credibility or authoritative weight (*credence*) alongside the notion of imitating an authentic source (*revival*)—hints at a self-aware construction of a counterfeit past.[5] In the biography of Creedence, as in the plot of *Lebowski,* the ringer and the real are so thoroughly conflated that only the earnest quest for something like authenticity remains unimpeached.

In spite of its failures as a vehicle for establishing an authentic self with a clear connection to larger social narratives, music matters intensely to the Dude. He plays it nearly continually in his apartment, in his car, and on his Walkman. At first glance his taste is somewhat eclectic, encompassing folk, pop, experimental, and traditional jazz. Upon further inspection, though, nearly all of the music the Dude listens to is united by an obsession with romantic longing. From Dylan's "The Man in Me" to Elvis Costello's "My Mood Swings," Captain Beefheart's "Her Eyes Are Blue a Million Miles," and Nina Simone's cover of Duke Ellington's "I Got It Bad and That Ain't Good," the Dude surrounds himself not with the culturally and socially politicized music with which his favorite artists (and the hippie counterculture he theoretically represents)

are most commonly associated, but with their expressions of desire for elusive or mysterious love. Listening with the Dude, we hear his (and perhaps our) sense of longing privileged over the object of affection, the quest itself ratified though the goal is unattainable.

While the Dude's attachment to his music is clearly meant to be humorously endearing, the Coens excruciatingly detail the ways it leads him down false paths

> ... *music matters intensely to the Dude.*

and into disaster. Here again the Creedence serves as a metaphor for the uselessness of the Dude's quest. Though the band is mentioned often by the film's characters, we hear Creedence only twice on the soundtrack, in each case while the Dude is driving his ill-fated car. In both cases, the song ends in a moment of vehicular slapstick, as the Dude crashes his car with a trunk-flapping bounce. As the car becomes more and more crumpled, it becomes apparent that the Creedence always leads to calamity; it is always a dead-end in the Dude's determined search for the real thing. Indeed, after his car is nearly totaled by the aggrieved owner of the Corvette that Walter has attacked, the Dude apparently decides it can't take much more and switches to Santana.

The Coens' use of "Lookin' Out My Back Door" also elaborates on the pitfalls of using music to stake out claims of identity and authenticity. For if music offers even casual listeners "a part in some social narrative," its operations of identity and authenticity necessarily imply exclusion as well as inclusion (Frith 90). As Jeff Smith has pointed out, "Lookin' Out My Back Door" is first heard as the Dude takes down his pants for the prostate exam that Maude has ordered for him as part of her surreptitious sperm-donor screening. The film thereby "recontextualizes the meanings of the original lyric" by substituting the "scatological implications of the term 'back door'" for the original pastoral

back door overlooking a psychedelicized yard (422–23). As the song continues into the next scene, a similar and perhaps more telling recontextualization occurs. Fogerty's whimsical lyric and the song's sunny shuffle beat are pervaded by a sense of satisfied self-containment, as the narrator happily locks himself into his house to escape the pressures of the external world, but can still enjoy all of the imagined wonders that lie outside through the window. In its context in *Lebowski,* though, these pleasures of seclusion evaporate.

At first, the Dude essentially assumes the position of the song's narrator, banging on the roof in time to the music and enjoying a joint in the seclusion of his car (perhaps the only secluded place in late twentieth-century L.A.). But when the Dude looks out his back door, or the back window of the car in his rearview mirror, the innocent nostalgia instantiated by CCR's roots revival turns sour. As he anxiously checks and rechecks the rearview mirror, the Dude realizes that he is being followed, appropriately enough by a VW bug, and the sense of safety and certainty of place that pervades the original song, and the overall aesthetic of CCR, is suddenly replaced by its more sinister complement: paranoia. By again reconfiguring the meaning of the original lyric, the Coens remind us that the nostalgic register of both the traditional pop soundtrack and the generational solidarity it stands in for is based as often on fear, insularity, and rejection as on a sense of belonging and community.

If the Dude is characterized by his relentless but mostly futile chase after the real goods—whether an authentic sense of self and place or the money in the briefcase—Maude serves as his antithesis. She is a hard-nosed realist, whose no-nonsense thinking ultimately provides the Dude with the key to unraveling the skein of deception and masquerade involved in the Bunny ransom plot. So it's no surprise that Maude's record collection reveals a total disregard for the "implied romance"

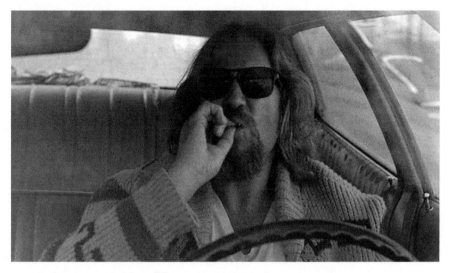

12.1. And, so, generational confidence turns to personal aranoia.

attached to music's genre narratives. Maude simply takes what she likes with no loyalty to a particular style. As she directs the Dude to rifle through her record collection for her copy of the nihilists' late-1970s album, she demonstrates, with a dismissive wave of the hand and a distracted description of the band as "ugh . . . technopop," that she finds the very notion of genre, and no doubt its sense of infinitely delayed fulfillment of desire, to be somewhat distasteful.

Her rejection of the idea of musical authenticity becomes even more apparent as her choice of records is revealed. The Dude flips through four records on his way to Autobahn's *Nagelbett*. In the front of the bin, we see the cover of *Stereotomy,* the Alan Parsons Project's lumbering prog-rock reflection on the human condition as an inevitable process of accommodation to social pressures. Behind this is a copy of *At Home with the Barry Sisters.* Like many of the Dude's own favorites, the Barry

12.2 and **12.3.** "Ugh . . . technopop." Autobahn's *Nagelbett* and its original, Kraftwerk's *Die Mensch Maschine* (1978).

Sisters are an odd mixture of cultural identities, described by one observer as "the United States' leading exponents of Yiddish Swing" (Hip Wax). The next record that flips into view is *Blue River* by Eric Andersen, a Greenwich Village folkie in the classic revival mode, whose sound is dominated not by Parsons's synthesizers or the Barry Sisters' orchestral arrangements but by spare acoustic guitar. Finally, as the Dude picks up the Autobahn album, we catch behind it a glimpse of the renowned cover of *Whipped Cream and Other Delights* by Herb Alpert and the Tijuana Brass, a band composed of three Italian Americans, two Jewish Americans, and one Anglo American playing a Muzak approximation of a Latino brass band. The collection spans a riotous range of identities, genres, instrumentations, and historical moments and a similarly broad expanse of artistic positions on the notion of personal and musical

authenticity, from a pessimistic acknowledgment of futility (Parsons) to unrepentant and unreflective re-enactment (Andersen) to joyful and self-aware disregard (Barry Sisters, Alpert). Clearly, the difference between these positions is completely irrelevant to Maude. She has no use for the romantic quest for identity or social location; she just gets what she wants in the most expeditious way possible.

Music also fills out the identities and emotions of *Lebowski*'s other characters. The Jesus is characterized through a Latinized version of the hated Eagles, the Big Lebowski by his portentous and pretentious classical music, Bunny by the vivacious, shimmying "Mucha Muchacha," and Jackie Treehorn by his cheesy musical exotica. But these identity-establishing functions, which the film implicitly authorizes for the audience, are scrupulously denied to the characters in the movie. Though it

is always sourced within the narrative, the music in *Lebowski* is almost never expressly played by one character for another as a way of establishing or communicating personal identity. In this, *Lebowski's* use of pop music is quite distinct from that in the films of Quentin Tarantino, to whose idiosyncratic soundtracks the Coens' are often compared. Tarantino, as Ken Garner has pointed out, frequently foregrounds the process of characters selecting and playing music in "a performative act of display of identity" that allows one character to know another as a person "with a particular identity and past" (190). In *The Big Lebowski,* by contrast, the possibility of performing identity or establishing a particular past through music is always thwarted. The one notable instance in which one character consciously plays music for another ends, like the appearances of Creedence, in disaster. The Dude, in a taxi on the way home from Malibu Beach, suddenly becomes aware that the cab driver is playing the Eagles' "Peaceful Easy Feeling." When he asks the driver to change the music because he hates the fucking Eagles, the driver simply yells, "Fuck you man! You don't like my fucking music, get your own fucking cab!" The Dude continues to protest, and the cab driver throws him out on the street.

In this scene, the "performative act of display of identity" is complicated and undermined in a number of ways. First, the cab driver is a middle-aged black man in a brimless leather hat that is vaguely reminiscent of black nationalist style. His embrace of the Eagles as "my music" sets up a comic dissonance between his own identity and the white target audience of classic rock. The kinds of social locations that characters usually demarcate for themselves by playing music rely, as mentioned, on mobilizing "the cultural associations which have already been codified and packaged by the music industry," in large part through genre definitions. But here the social locations don't fit the marketing package. If anyone should be an Eagles fan, it's the Dude, who presumably rejects

them on the basis of a distinction more esoteric than mere genre: the Eagles can be interpreted as a watering down of the roots sympathies of Creedence, as the commercially eviscerated denouement of the culture of the counterculture. Whatever his reasoning, the possibility of reaching some form of mutual understanding of particular identities and pasts is entirely upended. The scene becomes an explicit rejection of nostalgic mood created through music, a diegetic recognition of listeners' refusal to adhere to the social narratives implied by genre boundaries, and a graphic demonstration of the failure of music to establish shared memory or community.

A similar failure of identity and memory is insinuated earlier in the movie, when Maude comes to reclaim her rug. As the scene opens, we see the Dude listening to his Walkman with his eyes closed, apparently transported by the mood of the music. A cassette case lies on the floor nearby, bearing the hand-lettered label "Venice Beach League Playoffs, 1987." At first, this appears to be a mix tape the Dude has made for a particularly memorable occasion. For a moment, we can imagine at least a past instance in which popular music has functioned in the Dude's life as it is conventionally understood to function in popular film, as a way of establishing mood, memory, and specific senses of place, history, and shared experience. But, of course, this tape does nothing of the sort. Rather than being a collection of shared music associated with a particular experience, it is an actual taping of the cracks and rumbles of the bowling event itself. Once again, music is antithetical to memory and here is replaced in that function by the ambient noise of the bowling tournament—the actual soundtrack of the Dude's life.

But even as they acknowledge that it can only be in vain, the Coen brothers, like the members of Creedence Clearwater Revival, nonetheless ratify the search for a personal connection to a mythical authenticity. The soundtrack's eclectic mix of songs emphasizes camp and the

excessive, and therefore constructed, performance of identity, but the music's structural position in relation to the narrative and soundscape of the film aims particularly at creating a feeling of authenticity. All of the music in *Lebowski* is source music, sound that appears to originate naturally from within the frame of the film, where it is heard by the characters as well as the audience. Burwell and the Coens adopted this approach so that there would not be anything recognizable as an artificially imposed score "that would pull you out of 'Dudeville'" (Morgan 70). One fan attested to the success of this strategy, writing, "One thing I dug about the big lebowski was the music and how they used it. Not phoney like in other movies. You know music where there would not really be any. All of the music in the big lebowski was sorta real. It would really be there like in the bowling alley or the dude's pad or ride."[6] Though the music continually calls into question the very idea of authenticity, its structural position encourages us nonetheless to indulge, along with the Dude, the fantasy that we can find what's real and represent it through music.[7]

The Coens' choice of tracks and their representations of music in the narrative of *The Big Lebowski* are nothing if not ironically distant, but, in part through assiduously sourcing the music throughout, the movie also issues a warm invitation to viewers to indulge their desire for authenticity. So it's fitting, though certainly unintentional, that the official "original motion picture soundtrack" for the film recapitulates the narratives of incompletion and absence embodied in the film's plot and music. Featuring just over half of the tracks from the film, and conspicuously excluding, probably for copyright licensing reasons, both Creedence Clearwater Revival and the Eagles, the official soundtrack offers the same kind of partial, inadequate reminder of authentic experience that *Lebowski* seems to argue is the fate of all attempts to get at the real thing.

And, like the film itself, fan responses to the soundtrack express the limitations of music as a way of organizing memory and shared experience, while nonetheless engaging in the quest to recreate an authentic source. A number of fans applaud the eclecticism and obscurity of the songs in the movie and on the official soundtrack, embracing the genre inconsistencies as a reflection of the Coens' jibes at musical authenticity and seriousness, even if the underlying narratives of self-invention and re-invention associated with individual tracks are not immediately apparent to them. In a testament to how effectively the Creedence serves as a metaphor for the Dude himself, its absence on the soundtrack was often greeted with howls of indignation. "CCR defines this flick. Where in hell is 'Lookin' Out My Backdoor?' Just thinking of The Dude pounding on his roof of his car, with joint and beer in hand has me rolling! And it's because of the Creedence!" wrote one Amazon reviewer. "I just wonder who mixed this CD. The dude was better off losing the briefcase and getting the Creedence tapes back," groused another, while yet another suggested that the absence of both Creedence and the Eagles negated each other, "like matter and anti-matter." One reviewer even adopted the position of the Dude in puzzling through the lacuna: "While this soundtrack is GOOD, the Creedence just isn't here, MAN!!! I mean, there's just no ... uh, you know ... the Creedence just isn't um ... around the um ... well, the music is on, Man, but the Creedence just isn't here! ... I mean, man ... when you make a soundtrack to this film and play two of Creedence Clearwater's songs during crucial times in the film ... you kinda expect to pick up a record, a cylindrical object with the Credence, man!" To some degree, the soundtrack makes everyone the Dude, searching for the missing pieces, working to return to the real thing, which seems unaccountably to have come apart.[8]

"... you kinda expect to pick up a record, a cylindrical object with the Credence, man!"

The faults of the official soundtrack aside, fans seem to have found music itself to be inadequate to the task of recreating or communicating the mood of the film. The gaps in the official soundtrack prompted the construction and circulation of multiple fan-made versions, both on burned CDs and as playlists on iTunes. These collections are notable both for their obsessive completism and for their reliance on non-musical sound elements from the film. Typical fan-made versions include incidental cues written by Carter Burwell and bits of dialogue interspersed with the featured pop songs and jazz and classical pieces. Ironically, one of the most commonly demanded and included elements is the sound of the Venice Beach League Playoffs, followed closely by the whale songs the Dude listens to in his bathtub and the original theme song to *Branded*, which is never actually heard in the movie, but only drunkenly sung by the Dude after his meeting with Jackie Treehorn. In all three instances, the soundtracks mimic the film in consistently finding music alone to be a hollow representation of shared experience.

In the penultimate scene of *The Big Lebowski*, the Dude finally expresses in all seriousness his frustration with the simultaneous longing for and rejection of authenticity that characterize the film's score and its narrative. Disgusted with Walter's insertion of Vietnam into his eulogy for Donny, the Dude bursts out, "Goddamn it, Walter, you fuckin' asshole, everything's a travesty with you!" The Dude's choice of words reminds us that the constructions of historical memory, social narrative, and personal identity—like the genre stories of popular song and film music—are indeed shams, charades, and mockeries. But as the melancholy strains of Townes Van Zandt's cover version of the Rolling Stones' "Dead Flowers" strike up, we are reminded again of the redeeming value

of shameless imitation and derivative re-invention. Although it continually references the impossibility of constructing or communicating an authentic identity, or of forging a meaningful connection to others or a shared past, the film nonetheless ratifies our desire for that elusive confidence in our sense of self and social place. It encourages us to hold out hope for the Creedence, even if, unlike the Dude—who does ultimately get his tapes back, though not his rug or his money—we can never quite lay our hands on it.

Notes

1. For general statements on the functions of film music, see Gorbman; Kassabian; and Lapedis.

2. For a discussion of the pop soundtrack's shift from a contemporary to a nostalgic register, see Kermode's "Twisting the Knife."

3. See also Chadwell, 2–9.

4. See Gold, "Life and Life Only" and Murray, "Local Jew Boy Makes Good." Gold argues that *Self-Portrait* figured as a "radical re-invention" of Dylan's identity, while in his review of *New Morning,* Murray offers the very carefully qualified assertion that "Dylan speaks to us here in what sounds closer to his true voice than anything we have heard since *John Wesley Harding*" and notes that "[a]ll Bob's previous faces and voices have superimposed and fused together" on the album.

5. See Doggett, 102–5. It should be noted that the band's reasons for choosing the name had nothing at all to do with this reading of it, and that they occasionally enjoyed fooling gullible journalists into taking the name in this sense, as when their press agent told a reporter for *Time* that the name referred to "their belief in themselves, and something deep, true and pure." The fact that the band recognized and sometimes satirized this distance between surface and truth, though, reinforces their status as an uncomfortable, if self-aware, mixture of the longing for and rejection of authenticity. See "What's in a Name?"

6. Jazzman, post to "DVD, Soundtrack, Posters, etc." forum, *The Dude's House,* http://www.thedudeshouse.com/forum/f_index3.php?id=49743 (accessed September 15, 2006; no longer available).

7. Martin Harries, "Coen Brothers' New Film," 14. Note, however, that even the authenticating practice of sourcing the film's music at one point becomes a way

to emphasize the hollowness of music as a sign of identity. Near the end of the film, the nihilists arrive to threaten the Dude in the parking lot with a hilariously out-of-place boom box in hand, which conveniently plays a tense, dark segment of score (presumably meant to be their own band, Autobahn) that serves the traditional film music function of heightening suspense during the attack and Donny's death scene. Here, the Coens again point self-consciously to the artificiality of music's function in prompting emotional connections with the action and characters of the film.

8. Bryan Dodd, J. A. Toska, M. Shiflett, and Matthew Perri, reader reviews of *The Big Lebowski: Original Motion Picture Soundtrack,* Gramercy Pictures, Amazon Books and Music, http://www.amazon.com (accessed February 10, 2007).

"Fuck It, Let's Go Bowling": **13** The Cultural Connotations of Bowling in **The Big Lebowski**

Bradley D. Clissold

Bowling Noir, Again?

In *The Big Lebowski: The Making of a Coen Brothers Film,* William Preston Robertson reads bowling in *The Big Lebowski* not only as an important social activity and a serious lifestyle commitment, but also as a highly stylized aesthetic and part of an allusive tradition in classic film noirs. The back cover copy for Robertson's book describes *Lebowski* as "classic Coen *noir,*" "a razor-sharp comedy-thriller of mistaken identity, gangsters, bowling, kidnapping, and money gone astray." This synoptic blurb identifies the film's stylized participation in the cinematic traditions of film noir and provides a list of generically recognizable noir motifs as proof of this participation: "mistaken identity," "gangsters," "kidnapping," and "money gone astray." This list, however, also includes "bowling" as one of the film's governing motifs. Buried, as it is in the middle of this list, "bowling" becomes at once the odd term out in this list of conventional noir thematics and the syntactic centering term around which these other more identifiably noir descriptors ironically pivot. More to the point, this list of filmic motifs directly follows the labeling of *Lebowski* as a "comedy-thriller" and, in effect, serves rhetorically as evidence of such generic hybridity: the distinctively noir subjects support its generic designation as a "thriller," and, by (cultural) default, the filmic motif of "bowling" (in 1997) marks its status as "comedy."

Robertson's tongue-in-cheek analysis of "bowling noir," as he calls it, depends on a commonly held cultural view of bowling as an outdated, blue-collar/lower-middle-class leisure activity, centered around now bankrupt idealizations of the nuclear family and conservative family values. He sardonically concludes: "Film noir; bowling noir. Even the coolest of genres may be burdened with an idiot son" (101). Picking up on the ironic contrast between league bowling and the life-and-death seriousness of noir themes exploited in *Lebowski*—a contrast that supplies much of the film's black humor—Robertson ironically rereads classic film noirs that include scenes of bowling as if they were intentional generic precursors to the Coen brothers' film. In the self-consciously bloated hyperbole of conventional noir narrative voice-over, Robertson glosses:

> Bowling is a bright beacon of chuckleheaded salvation burning in the dark existential American night, which noir characters can either follow to safety or spurn to wander forever lost. It is a symbol of goodness, wholesomeness, and tract housing—insipid, yes, even nightmarish in its own peculiar way, but rejected at one's own peril. (97)[1]

Critically speaking, the genre-determining connections between bowling and film noir he identifies appear artfully tenuous, little more than ironically observed trivia—at best, interesting sociological footnotes. However, Robertson's intended ironic juxtaposition, like that found in *Lebowski* itself, is more critically insightful than he knows and doubly ironic because, at various times over the course of its historical evolution, bowling was considered an illegal activity in the same vein as "mistaken identity," "gangsters," "kidnapping," and "money gone astray."

Of course, to Robertson's list of films could be added *Pushover* (1954)—another Fred MacMurray film in which the now typecast

"bowling noir" actor plays a corrupt police officer who makes at least one (fateful) telephone call from a bowling alley.[2] Similarly, Roger Corman's *The Saint Valentine's Day Massacre* (1967) includes the historically accurate scene where Clint Ritchie's character (Jack "Machine Gun" McGurn) gets gunned down in a bowling alley. In the end, what all of these pop-cultural sightings (citings) of bowling in film noir serve to confirm is bowling's ubiquity as a cultural signifier even within one of the most visually stylized and thematically fixed film genres. Bowling appears as mise-en-scène background in film noir because it was a highly recognizable "popular" social activity during the peak mid-twentieth-century noir years, which is not to say that bowling's presence in these films does not also evoke a host of cultural assumptions about "good, clean fun," back when bowling centers and emporiums first appeared in the 1940s and before they became part of the "seedy" 1970s.

While bowling and film noir indeed seem to be strangely ironic bedfellows, their shared historical use of "alley" space links the two not only in *terms* of locale, but also in *terms* of the socio-economic conditions of "alley" life. One of the foundational settings for classic film noir is the darkened alley—tucked in just off rain-slicked busy streets and at the bottom of fire escapes (before and after rooftop chases). The alleyway is where noir bars and speakeasies dispose of their unwanted trash—human and otherwise—and where shady characters meet to do illegal business, to bet, to fight, and to sneak backstage. Alleys also provide the spatial means through which to make elusive quick exits or explosive surprise entrances. In traditional film noir, alleys support the dark activities of the urban underbelly of society, and at one time, bowling was one of those dark activities practiced in the alleyways behind saloons. In a doubly ironic twist of historical signification, bowling—before it became synonymous with wholesome family values in the twentieth century—was associated in the early part of the nineteenth century

with gambling and criminal activity. In fact, *bowling alleys* referred to the hidden alleyways (and saloon basements) where illegal games of bowling were bet on and played long before the term referenced contemporary indoor multi-lane establishments.

Unbeknownst to Robertson, then, bowling was noir before film was. In the early nineteenth century, bowling was so intimately connected to "gambling and racketeering" that New York, Connecticut, and Massachusetts outlawed it (Bosker and Lenček-Bosker 19). In 1841, when Connecticut made illegal all "ninepin lanes," bowlers simply added a tenth pin to evade legal prosecution (19). Bowling was also banned back in 1366, during King Edward III's reign, because it was too much of a distraction for the English monarchy's training troops (16). This dark, threatening side of bowling persists, as Joel Coen discovered (quite ironically) when he talked to the "Old Guy in the Pro Shop" at Hollywood Lanes (on Santa Monica Boulevard): "You wouldn't believe the things that go on in bowling. . . . Bribery. Extortion. *Murder*. . . . No one . . . has done the real story of bowling!" (Robertson 140). And as Robertson notes, the Coens up the ante for bowling's menacing associations by casting Jesus Quintana ("the Dude and Walter's arch bowling nemesis") as a convicted pederast (140).

In other words, bowling—besides still being a popular sport and recreational activity for professional and amateur bowlers alike—functions both as a complex signifier rich with ironically alternative connotations and as a stable and known frame of reference for practitioners of postmodern culture. In *The Big Lebowski*, for instance, bowling provides an ordered, escapist sanctuary from the complexities of the postmodern condition (however defined). On two occasions of heightened exasperation—one just after the bungled ransom drop-off, and the other just after scattering Donny's ashes to the wind—Walter says

to the Dude, "Fuck it, let's go bowling." For these men, bowling is a cultural constant, a rule-governed universe of institutionalized practice that resists change and can therefore reground them—it's always there and always just a ball and a set of pins. However, the comfort and retreat Walter and the Dude find in bowling is never reducible to just a ball and a set of pins, for the word and the activity it describes is charged by a multiplicity of conscious and unconscious cultural connotations. Surely, Walter's characterization of Donny as a "bowler" during his "eulogy on the mount" articulates something more than just that Donny was "one who bowl[ed]." Walter begins his oration, "Donny was a good bowler," and, as an afterthought, adds, "and a good man"; Walter then claims that Donny "was a man who loved bowling," and later refers to him as "Donny who loved bowling." But what does it mean to be a "good bowler," over and above being a "good man," and what kind of a person loves "bowling" so much that it gets repeated twice in a eulogy which is less than a minute and a half long and dominated by digressive rants about Vietnam casualties?

For the Dude and Walter, calling someone a *bowler* signifies more than the word's most generic denotation. The mere mention of bowling in the film becomes a statement of associative provocation as suggestive second-order meanings compete in the foreground against a permanent backdrop of ball, lane, and pins. Bowling functions as a highly contested signifier in *Lebowski,* and the film strategically plays off of, ironically exploits, and unavoidably renegotiates many of the governing cultural connotations of bowling. Consequently, this chapter functions as a first step in redressing bowling's troubled status in academia: in spite of its continued popularity and pervasive iconographic use in popular culture, bowling remains a critically under-theorized cultural practice, as well as an under-appreciated, renewable resource for postmodern cultural

production and reception. In *Lebowski,* bowling is the metaphorical rug that ties the film together; bowling, especially ironic bowling (bowling with an awareness of its ironic sensibilities), functions in the film in several ways: 1) as a stabilizing plot device (the teleological movement of the bowling league playoffs toward the championship); 2) as a stylized retro-aesthetic; 3) as a masculinized, regulated, and working-class setting (a recognizable backdrop for the "outing" and development of idiosyncratic characters); and 4) as a connotatively overdetermined signifier. The choice of bowling as the Dude's preferred social activity sets in motion an ironic associative logic in the film that reveals how irony has always driven bowling's complex cultural significations.

Bowling Alone in a Crowd

According to statistics offered by Mark Miller of the American Bowling Congress, 220 million Americans have bowled at least once in their lives—a staggering number when the U.S. Census Bureau estimates that the current population of America is just under 300 million. In fact, the almost universal appeal of bowling has made it the second highest participation sport in the world. Because of this mass popularity, bowling now also functions as an iconographically recognizable cultural frame of reference even for those who have never attempted the game. As a result, ideas about or figurative representations of bowling continue to serve as powerful rhetorical tools that build community and reinforce communal cultural understandings. In its present state of statistical decline, for instance, league bowling provides Harvard professor Robert Putnam with a metaphorical vehicle through which to understand the crisis in community and civil activism he currently perceives as the state of contemporary America. Bowling may no longer be

practiced according to regularly scheduled league matches in the same way that it once was, but as *...220 million Americans have bowled at least once in their lives...* Putnam's example reveals, the positive connotations associated with league bowling remain entrenched and active in subsequent contemporary allusions to bowling.

In *Bowling Alone: The Collapse and Revival of American Community* (2000), Putnam argues that the decline of participation in bowling leagues is symptomatic of the social disengagement that pervades all aspects of American society. "Bowling alone" stands in for this lack of community-based engagement; more Americans are bowling than ever before, but they are no longer doing it in regular, organized, social formations. According to Putnam's statistics, since 1980 there has been a 40 percent drop in the number of Americans who bowl in organized bowling leagues (110). Putnam recognizes the mass-marketed image of bowling as a family-based activity and argues that its participatory decline implies an accompanying loss of social capital—that is, "the social and economic resources embodied in social networks" (19). Social capital is the "good will, fellowship, sympathy, and social intercourse among . . . individuals and families that make up a social unit," and it serves both the individual and the collective by fostering norms of *generalized* reciprocity: "Some of the benefit from an investment in social capital goes to bystanders, while some of the benefit redounds to the immediate interest of the person making the investment" (19–20).[3] Putnam's metaphor of "bowling alone" becomes shorthand for this negative shift in organized social interaction. It signals a change in "patterns of trust and altruism in America—philanthropy, volunteering, honesty, reciprocity" (27), but one that is ultimately reversible. League bowling as an antidote to the apparent social crisis in the American public sphere?[4]

Putnam closes his opening chapter ("Thinking about Social Change in America") with an optimistic example of social capital at work within an existing bowling league:

> Before October 29, 1997, John Lambert and Andy Boschma knew each other only through their local bowling league at the Ypsi-Arbor Lanes in Ypsilanti, Michigan. Lambert, a sixty-four-year-old retired employee of the University of Michigan hospital, had been on a kidney transplant waiting list for three years when Boschma, a thirty-three-year-old accountant, learned casually of Lambert's need and unexpectedly approached him to offer to donate one of his own kidneys.

According to Putnam, "in addition to their differences in profession and generation, Boschma is white and Lambert is African American. That they bowled together made all the difference" (28). Putnam uses this example to highlight how league bowling creates community through "social interaction" and "civic conversations," something that "solo bowlers [closed informal groups] forgo" (113).[5] According to this logic, league bowling provides an organized social formation, and bowling alleys provide centripetally organized social spaces in which interaction can occur between individuals who would not otherwise meet over the course of their daily lives:

> To build bridging social capital requires that we transcend our social and political and professional identities to connect with people unlike ourselves. This is why team sports provide good venues for social-capital creation. . . . bowling together . . . does not require shared ideology or shared social or ethnic provenance. (411)

If the current state of American community can be measured and understood in terms of league bowling, then Putnam's argument also

confirms the presence of a shared social capital at work in the use of bowling as a cultural signifier capable of standing in metonymically for a decline in community values. The underlying shared ideology of his argument that league bowling provides participants with beneficial social capital—"networks and norms of reciprocity" (315)—ironically depends on the constructed clean-cut facade of bowling that twentieth-century bowling alley operators successfully marketed: bowling as a healthy and wholesome family recreation. Vestiges of this family-oriented environment still exist in modern bowling alleys like Executive Lanes (in Louisville) where a framed and mounted sign—in authoritative uppercase (faded) red ink on a yellow background—conveys the alley's governing ethos:

WE ARE PROUD TO OPERATE A FAMILY RECREATION CENTER.
Vulgar or Obscene Language, Articles and/or Apparel Will Not Be Tolerated.
Intentional Lofting of Ball and/or Other Equipment Damage Is Not Allowed.
Your Cooperation Is Appreciated.

Indeed, in the immediate post-war decades (1940–1960), bowling alleys became synonymous with clean-living, (nuclear) family values. Bowling alley proprietors aggressively advocated bowling's open accessibility and strongly linked it to healthy and morally upstanding lifestyles. For example, the 1955 promotional short *Let's Go Bowling* endorses the bowling alley as a "carefully supervised . . . wholesome family environment," and bowling as "a healthful recreation that the whole family can take part in and enjoy together, all year round." Putting aside for the moment the Cold War containment implications of bowling alleys as "carefully supervised" social spaces, the film begins with an onscreen marketing mission statement that, by the mid-1950s, had already become a fait accompli: "The Members of the Bowling

Proprietors Association of America aim to promote the high standards of cleanliness and conduct, and all-round excellence of environment, that have helped to make bowling America's foremost *family* sport." The upbeat narrative voice-over invites viewers to come out and join the 20 million regular bowlers across America: "If so many millions of folks of every possible description can and do bowl and get so much out of it, it's a cinch you can learn to bowl and enjoy it too." As documentary bowling images of anonymous bowlers—of various body types, male and female (but all conspicuously white)—appear, the voice-over exudes, "Just look at the amazing variety among bowlers. Every size, age, kind, breed, and class—from all walks of life. Every type imaginable." Accompanying this appeal to the apparent social accessibility and "openness" of bowling alleys is a guarantee that bowling is not a game that depends on physical strength. Instead, learned form and practiced timing are stressed as the keys to successful bowling.

In one of the film's most blatantly self-interested statements, the documentary spokesperson for the BPAA assures viewers that "[a]nybody can master the fundamentals of the game and with consistent practice become competent at it." The film then follows a young (hetero-white) couple (bowling novitiates) as they are led wide-eyed and bashfully into a bowling alley by another couple (hetero-white). The more experienced couple tries to teach the two beginners in a confusing and obviously improper manner until two professional bowlers (Ned Day and Marion Ladewig—both white) arrive and instruct the two couples on proper bowling etiquette and form: from how to select appropriate balls and the proper way to pick them up to foul line penalties and the cautionary caveat, "Don't lose your temper." Within a couple of bowling/film frames, all six bowlers are bowling crescendo strikes and picking up their spares when they miss. The bowling alley becomes a morally transformative site for the two young bowling couples; they

have graduated from being "alibi artists"—in the words of the narrator—into confident, successful bowlers, who bowl for enjoyment, use proper bowling technique, and follow proper bowling alley etiquette.

In contrast, Hollywood Star Lanes in *Lebowski* is a decidedly no PG-13 bowling alley. Patrons liberally curse, smoke, and drink alcohol. They bring animals to league games, threaten each other with sodomized bodily harm, and pull handguns on their opponents. One of the regular league bowlers is a known convicted pedophile. In the parking lot of the bowling alley, patrons' cars get stolen and torched, and a gang of nihilists physically assaults exiting bowlers. Late twentieth-century representations of bowling culture, like *Lebowski,* not only depend on bowling's squeaky clean, "Golden Age" image for ironic contrast, but they also contribute to the ongoing cultural evolution of bowling and its growing arsenal of ironic connotative possibilities. On a final note of cultural irony, as the social capital—derived from serious (league) bowling—declines, the symbolic capital of ironic bowling—that depends on serious (league) bowling for contrast—increases.

Serious versus Ironic Bowling—Bowling Hits the Mattresses

Sometime around the late 1970s, a seismic shift in the cultural semiotics of bowling occurred: bowling became conspicuously ironic. The actual moment of this cultural transition is impossible to locate, but its presence is strongly evidenced in the 1979 straight-to-video release of *Dreamer*—a *Rocky*-styled film about a bowler who overcomes adversity and through hard work and sacrifice becomes a championship bowler—and the 1982 debut of NBC's *Late Night with David Letterman*—a show where the host habitually removed bowling balls from

their conventional contexts and used them for everything but bowling: dropping them off buildings, driving steamrollers over them, and blowing them up with explosives. In fact, over the years, Letterman has featured "Stupid Pet Tricks" with bowling hamsters and pot-bellied pigs, not to mention bowling-themed features of regular installments like "Stupid Human Tricks" (the Human Bowling Ball) and "Will It Float?" (incidentally, both bowling tenpins and eight-pound bowling balls float). His November 18, 2003, list of the "Top Ten Things You Don't Want to Hear in a Bowling Alley" are all ironic statements that either challenge bowling's wholesome seriousness, exploit its associative metaphorics, or recapitulate its rich historical connotations:

10. "I was wearing those shoes earlier—hope you like athlete's foot."
9. "Someone tried to flush a pin down the toilet."
8. "I'm guessing your sex life is one big gutter ball."
7. "Whoever owns a red Honda Civic, I just threw a bowling ball through your windshield."
6. "Wanna go back to my place and try a seven-ten split?"'
5. "This is roughly the weight of a severed human head."
4. "I lost my virginity on lane 5."
3. "Somebody lose a thumb?"
2. "A bowling alley? Nice going, Romeo."
1. "You know, you strike me as the type of guy who polishes his ball every night."

This self-conscious ironizing of bowling—of its iconography, of its fashions, of its associative stereotypes, of its conventions, practices, and locales, of its institutional and ideological identity—marks a critical division in bowling sensibilities and practice between ironically serious bowling and seriously ironic bowling.

To bowl with irony is to bowl with a self-conscious awareness of bowling's overdetermined and often competing cultural connotations

so that the very act of bowling self-reflexively enacts, parodies, and performs, often in an exaggerated manner, bowling's multiple significations. To bowl with irony is to celebrate bowling's connotative possibilities as liberating and flexible, rather than viewing them as signs of semantic instability. In the end, the difference between bowling seriously and bowling with irony is not just a self-conscious awareness of difference, but a difference in readable practice. Today, wearing bowling shoes and monogrammed bowling shirts, for everything, *including bowling,* is part of the self-conscious recirculation and ironic re-commodification of vintage fashion that is symptomatic of cultural postmodernism. Then again, perhaps understanding bowling with irony is as easy as one online reviewer recently quipped: "Bowling's so unhip, it's hip."

Current magazines like *Bowling This Month, Bowling Digest,* and *Bowling Journal Online*—with their comically hyperbolic taglines: "The Best Bowling Magazine In Print and Online," "the only magazine in North America to devote so many pages to bowling instruction," and "if you're serious about bowling and you want to improve your scoring, you need the most up-to-date technical information available on subjects ranging from advanced technique through lane play to balls and ball motion"—attest to the seriousness of bowling for large segments of the population who still regularly league bowl and want to keep abreast of new techniques and equipment improvements. The sheer number of Internet hits in a search for Bowling Associations, coupled with the large number of instructional bowling DVDs currently on the market designed to improve one's game, confirms the presence of large bowling populations who do not intentionally bowl

> *To bowl with irony is to celebrate bowling's connotative possibilities as liberating and flexible, rather than viewing them as signs of semantic instability.*

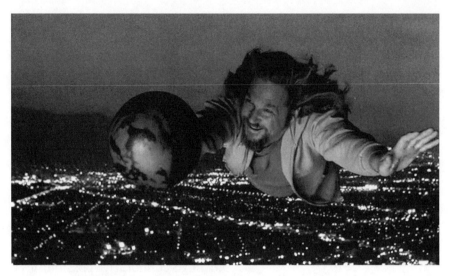

13.1. The Dude about to bowl with irony.

with irony. Instead, bowling as a serious game of athletic competition, decorum, and skills—with its various leagues and championships, both amateur and professional—continues to function like a jazz standard playing in the background of contemporary society and culture. In the foreground, performing with and against this backdrop of serious bowling, are creative postmodern improvisations of bowling's mobile connotative (often ironic) semiotics. Such is the relational field of cultural production for representations of and allusions to bowling like those found in *Lebowski*. This is not to say that bowling should be conceived as some cultural master narrative; indeed, this chapter argues just the opposite. Bowling is a culturally pervasive frame of reference, recognized and recognizable in its metonyms and iconographic details even by those who have never bowled a frame, exploitable yet governing: a flexible, yet connotatively overdetermined, signifier.

Perhaps it is a sign of postmodern sensibilities that Simmons Bedding Company decided in 2006 to resurrect its now famous 1995 TV commercial about a bowling ball mattress test. In that commercial, a scientist—complete with official clipboard and requisite white lab coat—drops a bowling ball onto a traditional mattress, knocking over the bowling pins set up on the other end. The scientist repeats the experiment (such highly sophisticated scientific experimentation depends on repeatability), but this time the bowling ball is dropped onto a Beautyrest Pocketed Coil Mattress, and none of the standing pins even moves. Effective because of its illustrative simplicity, the bowling ball commercial still lingers in the minds of consumers almost ten years after it stopped airing (incidentally, it aired for three consecutive years).

According to the research conducted by Simmons, 56 percent of consumers polled remembered the bowling ball commercial even if they couldn't remember the name of the mattress or the company that produced the commercials. In fact, because of the commercial, the mattress became popularly known as "the bowling ball mattress" with customers. This ironically defamiliarizing union of bowling, scientific inquiry, and mattress technology was effective because it tapped into bowling's universal recognizability, and the ironic use of the bowling ball provided a mnemonic durability for the company's mattresses that most advertisers can only dream of. The new retro-commercials trace the eighty-year development of Pocketed Coil Mattresses with a representative scientist figure from each of the last eight decades performing the same bowling ball test (the test for the current decade will *even* feature a female scientist). Simmons seeks to capitalize on its own longevity with these "era" representations, but the other thing that remains iconically constant in all of these historically stylized commercials— besides the mattress and the scientist's clipboard—is the black bowling ball and the white set of tenpins.

Arguably, the postmodern origins of ironic bowling emerge televisually with the beginning of TV on Allen Funt's *Candid Camera,* where bowling alleys regularly figured as hidden-camera gag settings. From trick bowling balls and tenpin balls without finger holes to warped alley boards and pins that explode upon contact, Funt's proto-reality TV program poked fun at the wholesome seriousness of American bowling culture.[6] Ironic bowling—as well as derivative cultural production—was also poignantly thematized in 1963 on *The Dick Van Dyke Show* in the episode "When a Bowling Pin Talks, Listen"—about a seemingly "original" talking-bowling-pin skit Rob proposes for *The Alan Brady Show.* The idea for the skit, however, comes from his son Ritchie Petrie, who has seen it, ironically enough, on TV, where it has been a recurring gag for the past three years on the children's program *The Uncle Spunky Show.* Today the Internet is filled with amateur video clips of trick-shot bowling and bowling-alley bloopers—representations of seriously ironic bowling—alongside footage of ironically serious bowling. For instance, the video clip of hall-of-fame bowler Mark Roth's 1980 7–10 split conversion—the first ever recorded on live television in the nineteen-year history of ABC's *Pro Bowling Tour*—is currently on (ironic) public display at numerous YouTube-style Internet sites. It would seem that even one of the most dramatic bowling events in TV history is only capable of producing ironic bowling heroes.

Bowling for Heroes, Bowling as Religion

Recent attempts to repopularize and rethink bowling with strobed and fluorescent black lighting and loud techno-pop playing in the background is a promotional strategy only possible once bowling becomes retrofitted with irony. Adding to the status-anxiety of serious bowling, rock 'n' bowl or glow bowling attempts to bring bowling to an MTV

generation. Part of bowling's problem, though, is that it has never been able to produce household-name superstars. Ask someone to name the most famous bowler, and see what immediately comes to mind. Chances are that unless that individual is a very serious bowler, he or she will either name a fictional character strongly linked to bowling in the cultural imagination (Fred Flintstone, Archie Bunker, etc.) or offer Richard Nixon, remembering the well-known iconographic image of Nixon bowling in the White House. Now ask someone to name a famous baseball player, a famous basketball player, even a famous hockey player, and compare the results.

The 2004 bowling documentary *A League of Ordinary Gentleman,* for example, not only bombed at the box office ($20,000 gross), but it also failed to create celebrity superstars of professional bowlers, as was initially intended. The film's title parodies the title of the Victorian superhero film, *The League of Extraordinary Gentlemen,* which came out a year earlier (starring Sean Connery), but the professional bowlers profiled in *A League of Ordinary Gentleman* are anything but heroic. They are, as the film's title suggests, just "ordinary guys" who happen to earn their living bowling, albeit with extraordinary bowling skills. At best they are idiosyncratic niche superstars in the world of ironically serious bowling. This cinematic attempt to revitalize and promote serious bowling was ironically flawed from conception. By showcasing these bowlers as superstars in the film and in the world of serious bowling, *A League of Ordinary Gentleman* contributes to the very status-anxiety about bowling that it sets out to overcome; bowling, just like bowlers, can't be ordinary and extraordinary at the same time—not without irony entering the equation.[7] The professional bowlers who made cameo appearances in the 1996 bowling spoof *Kingpin* were certainly able, through gestures of self-reflexive playfulness, to look ironically at their chosen careers. Under normal circumstances they don't bowl with

irony because bowling with irony doesn't win championships or the prize money needed to pay bills. That these professional bowlers were paid for their cameos proves that they are perfectly capable of ironizing their profession without necessarily detracting from the seriousness of that profession: a deft survival strategy adapted to a postmodern cultural landscape of ever-changing and retro-fitted trends. Paid or not, these men effectively used the symbolic capital of their celebrity in the world of ironically serious bowling to divide audience reception in the world of seriously ironic bowling: you either recognized them as championship-caliber bowlers or you did not.

When the Stranger introduces the Dude at the beginning of *Lebowski,* he establishes the Dude as an unheroic, but representative, individual of the times: "Sometimes there's a man . . . I won't say a hero, 'cause what's a hero? . . . but sometimes there's a man . . . and I'm talkin' about the Dude here . . . sometimes there's a man . . . well, he's the man for his time and place. He fits right in there . . . and that's the Dude in Los Angeles." The Dude, an out-of-work league bowler, who drinks White Russians and smokes pot—is the very opposite of the conventional hero. His list of things he can remember about college includes "occupying various administration buildings, smoking a lot of Thai stick, breaking into the ROTC, and bowling"—all of which coincidentally, with the exception of bowling, are illegal student activities. He is a postmodern anti-hero who, because of his idiosyncrasies—bowling included—fits right into the ironic culture of Los Angeles. In the film's first dream sequence, the Dude appears flying over Los Angeles à la Superman. However, just as he becomes noticeably comfortable in the Man of Steel's iconographic flying pose, a bowling ball appears at the end of his outstretched right hand. Immediately after establishing the Dude as a bowling superhero, the filmmakers symbolically undercut the

image. The bowling ball's sudden appearance and metaphorical weight pull the Dude down out of the sky. The ball simultaneously triggers the Dude's transformative shift from overseeing flying superhero to shrunken vulnerable miniature and consequently confirms that popular culture is no place for bowling heroes. In *Lebowski,* the fantasy of a bowling superhero is nothing more than an ironic image temporarily dreamed up in the wish-fulfilling unconscious. The film reaffirms that heroism and bowling are culturally incompatible except in the most ironic circumstances.[8]

Similarly, the Dude, Donny, Walter, and Quintana, all bowl seriously, yet their stylized characterizations of bowlers ironically foreground the potential kitsch quotient in bowling.[9] Walter pulls a gun during league play to force adherence to proper bowling etiquette and its institutionalized rules of fair play; the Dude listens to audio cassettes of the 1987 Venice Beach playoffs to mentally prepare for the semi-finals; and, seemingly on the verge of terminating his friendship with Walter ("Fuck you, and leave me the fuck alone"), the Dude reassures him at the end of their telephone conversation, "Yeah, I'll be at practice." Bowling supersedes all. It is a foregone conclusion for Walter and the Dude that the imminently scheduled ransom money drop-off *will not* interrupt league play, and even though Walter claims that his Judaism does not allow him to bowl on Shabbos, he finds the emergency circumstances needed to allow him to roll on Saturday.

For some, bowling is as powerful as established religion, and bowling alleys, like churches, offer accessible relief and sanctuary to those— especially from the working and middle classes—who have lost their way in a postmodern world. When the Coen brothers first introduce the religiously monikered Jesus (Quintana), he is shot in balletic slow-motion, and his acts of bowling become microscopically ritualized.

The Dude, Donny, and Walter cannot help but be mesmerized by the aestheticized spectacle; however, the entire shot sequence is fraught with contrapuntal irony. This reverential act of bowling gets quickly undercut as the Jesus sexually tongues his ball before throwing it, and Walter reveals his pederasty: "Spent six months in Chino for exposing himself to an eight-year-old." The camera then zooms in on the word "Jesus" embroidered into his tight-fitting, purple "all-in-one Dacron-polyester stretch bowling" suit that prominently displays his crotch bulge (Robertson 134). As a result, there is a strong tension in this film between bowling and religious worship (not to mention aberrant sexuality). What's more, the Dude is distinctively Christ-like with his long hair, beard, and sandals: "Suffer the little bowlers to come unto me." The Stranger even reinforces this iconographic connection at the end of the film: "The Dude abides. I don't know about you, but I take comfort in that. It's good knowin' he's out there, the Dude, takin' her easy for all us sinners."

The relationship between bowling and religion, like the one between bowling and heroism, is uncomfortable because it seemingly yokes together the profane and the sacred. Ironically, however, the historical origins of bowling also date back to a religious game of Germanic descent (*Kegelspiel*) where parishioners bowled stones at standing kegels (a type of club) that represented heathens. If bowlers knocked down the kegel (heathen), they were considered free of sin. If not, they were required to perform an act of penance. Theological reformer Martin Luther (1483–1546) apparently loved bowling so much that he built a personal "rink" (or lane) for his family (Bosker and Lenček-Bosker 16). Moreover, if bowling seems so antithetical to Judeo-Christian faith, why has the metaphor "the angels must be bowling"—used to describe distant thunderclaps—remained so stubbornly in the parlance of our time?

13.2. "Suffer the little bowlers to come unto me." St. John's, Newfoundland, Canada. Bradley D. Clissold, photographer.

Bowling's Ironies: (Re)Framing the Argument

While it may be tempting to locate the shift to ironic bowling sometime in the late 1960s or early 1970s and to read the signs of such a shift in declining league bowling rates, or in the outdated décor of run-down suburban bowling alleys, this chapter argues instead that bowling has always been endowed with ironic tensions. It is paradoxically a team sport that highlights individual bowling performance. In doing so, bowling's structure of play stages the ironic tensions between assertions of individuality and the maintenance of community that are the ideological cornerstones of American civilized society. Accordingly, bowling alleys function both as democratic spaces for idiosyncratic performances of

identity and as highly regulated institutional places that determine the decorum limits of such bowling performances (no shoes, no lane). Even the conflicted historical origins of bowling, both as an illegal vice and as a metaphorical religious activity (used to establish levels of penance), suggest that its constitutive signifiers were already ironically inflected long before bowling's mass popularization in the twentieth century.

The two eroticized bowling-themed dream sequences in *Lebowski* explicitly draw further ironic attention to the psycho-sexual meta-phorics always-already invested in a game consisting of tubular-shaped gutters and ball returns, alleys, lanes, and phallic white pins that fly when struck by spinning black balls, designed with three orifices for finger penetration. Indeed, bowling is a highly sexualized activity, in part, by virtue of its suggestive iconography, but also, in part, because it is tacitly voyeuristic and exhibitionistic—providing a performance space (latently sexualized) against which to stage spectacles of individual style and negotiate identity politics under the expected gaze of teammates and competitors. As such, bowling is not a sport for self-conscious individuals. During a bowler's delivery, the body is repeatedly put on ironic public display—awkwardly bent over and stretched into unflattering positions—even if you're bowling correctly, you're putting *it* out there. There is also an ironically dissociative logic at work in post-release gestures (sweeping hand movements and leaning body weight), the unconscious habits of bowlers who try to will the direction of the bowling ball after it leaves their hands. All of this is to say that bowling has always been an ironically endowed activity; when serious bowling's twentieth-century popularity waned in the mid-1960s, subsequent post-modern representations simply reactivated (often unconsciously) these ironic possibilities and connotations to reinvest bowling as a cultural practice and signifier.

In the final scene from *Lebowski,* the Stranger asks the Dude how things have been going, and the Dude's response metaphorically maps a bowling vocabulary onto his recently balanced state of personal affairs: "Ah you know, strikes and gutters, ups and downs." Unconsciously, the Dude translates the bowling metaphorics of his reply into the less colorful, spatial metaphorics of "ups and downs." This default act of explaining his bowling metaphorics simultaneously betrays the Dude's internalized status-anxiety about bowling, as well as just how unnecessary such explanation is. Returning to the film's first bowling scene, Walter verbally spanks Donny for not paying attention to the Dude's entire story about his urine-stained rug: "Were you listening to the Dude's story?" he repeats twice. Donny replies, matter-of-factly, "I was bowling." "So you have no frame of reference here, Donny. You're like a child who wanders into the middle of a movie and wants to know—" but before Walter can finish his meta-filmic simile about interruption, the Dude interrupts Walter, and the simile remains ironically incomplete. Walter's refrain, "Donny, you're out of your element here," however, proves shortsighted. Donny's act of bowling a *frame,* while removing him physically from hearing the details of the Dude's story, actually provides him with a cognitively flexible, yet structured, interpretive *frame* of reference (bowling) to understand almost any story. The representations of bowling in *Lebowski* function, therefore, as more than just a highly ironic backdrop to the idiosyncratic events and characters in the film. Instead, the film's various references to and scenes about bowling activate and draw upon a complex cultural rhetoric of bowling connotations. These moments are both textured by a multiplicity of appropriations (ironic and serious) of bowling across popular culture, and always already overdetermined by bowling's own complicated historical narratives about its origins and shifting associative practices.

Notes

1. Robertson's "A Short History of Bowling Noir" effectively draws attention to the presence of bowling in multiple film noirs: "In a moral sense, the bowling noir universe is divided into those who 'are bowlers' and those who 'aren't bowlers'" (98). In *Criss Cross* (1949), Burt Lancaster responds to his love interest's father's after-dinner question, "You wanna go bowling?" with "I'm no bowler, Pop!" (quoted in Robertson 98). In doing so, Lancaster's character establishes himself as morally suspect, which he is. A bowling alley provides the redemptive setting for Ida Lupino's character in *Road House* (1948), Paul Muni sacrilegiously guns down Boris Karloff in a bowling alley in *Scarface* (1932), and Robert Mitchum's stalking of Gregory Peck's family in *Cape Fear* (1962) is made all the more disturbing because it occurs in a bowling alley: "You have to know him to feel the threat. He stopped me this afternoon after court, and he showed up again this evening at the *bowling* center!" (quoted in Robertson 101).

2. John Goodman's recurring acting roles as a bowler mark him similarly as a typecast bowling actor. On the TV series *Roseanne* (1988–97), Goodman's character Dan Connor was a regular league bowler; in *The Flintstones* (1994), he played Fred Flintstone—a stone-age regular league bowler; in *The Big Lebowski* (1997), he plays another serious league bowler (Walter Sobchak); and, in *King Ralph* (1991), he plays a Vegas-lounge-singer-turned-King-of-England who proves his commitment to bowling when his only response, after being shown his new residence (Buckingham Palace) and asked if there is anything missing, is "How about a bowling alley?" Soon thereafter, a single-lane bowling alley appears in his royal bedroom. In 2001, Goodman also made a guest appearance on the TV series *Ed*, in the episode "Loyalties" (season 1, episode 15), where he plays Big Rudy, former owner of the town's bowling alley (Stuckybowl).

3. Putnam argues that the Golden Rule (Do unto others as you would have them do unto you) is a well-known articulation of *generalized* reciprocity: "I'll do this for you without expecting anything specific back from you, in the confident expectation that someone else will do something for me down the road" (21).

4. Admittedly, league bowling may not be as trendy as joining a health club (even now with bowling's ironic retro-fitted sensibility and its high-tech reincarnation as black-light "cosmic bowling"), but Putnam defends bowling's indexicality of social disengagement with rhetorically persuasive statistics. First, during the Second World War and in the two decades after, increases in social cohesion, national unity, and patriotism characterized dominant American Cold War ideologies. Increases in league bowling were part of a widespread "extraordinary burst of civic activity": "Virtually every major association whose membership history we examined—from the PTA,

the League of Women Voters, and the American Society of Mechanical Engineers to the Lions Club, the American Dental Association, and the Boy Scouts—sharply expanded its "market share" between the mid-1940s and the mid-1960s. As we observed, there were similar [sustained] postwar spurts in other community activities from league bowling and card playing to churchgoing and United Way giving" (268). Second, Putnam argues that bowling remains "the most popular competitive sport in America. Bowlers outnumber joggers, golfers, or softball players more than two to one, soccer players (including kids) by more than three to one, and tennis players or skiers by four to one" (111). To put these impressive recreational comparisons into perspective, in terms of their larger social implications, Putnam notes that "according to the American Bowling Congress, ninety-one million Americans bowled at some point during 1996, *more than 25 percent more than voted in the 1998 congressional elections*" (112–13).

5. For Putnam, league bowling is a type of productive social networking, something threatened in more modernized bowling alleys where screens above the lanes encourage bowlers waiting for their turns to watch television (sporting events, news programs, music videos), rather than talk to each other (245). The loud music (any style) played during black-light glow bowling and even during special non-league times (under normal lighting) similarly promotes superficial interpersonal socialization (111). Lisa Chadderdon claims that much of bowling's increased popularity (domestic and now overseas as well) is the result of bowling's transformative "technotainment" facelift into "Rock 'N' Bowl"—or as AMF product manager Ron Wood says, "We're creating a new experience for bowlers of all ages and abilities. . . . We're breaking the mold, leveraging technology and expertise to breathe new life into a stagnant industry" (Chadderdon).

6. For a reading of *Candid Camera* as a foundational program in the history of reality TV, see my essay "*Candid Camera* and the Origins of Reality TV." I argue that *Candid Camera*'s hidden-camera humor trades on two Cold War fears that remain mainstays of American society: surveillance-anxiety and simulation-anxiety.

7. Bowling heroes are not easy to sell to the public, nor is bowling—however modified—a particularly adventurous or heroic activity, as the video game makers of AMF's *Xtreme Bowling* found out in 2006 when gamer reviews rejected it outright: "Despite what you may assume, this game does not contain rocket ships, rabid gorillas, or ketchup covered ice cream. About the only thing extreme in this one is the stunningly boring, simplistic gameplay. . . . [and the] several different [types] of lane oil that affect ball spin" (Onyett).

8. In the superhero film parody *Mystery Men* (1999), one of the ironic superheroes is the Bowler. Actually, she is the daughter of the Bowler, and she takes out

criminals by bowling a personalized bowling ball that encases her dead father's skull. Her fellow wannabe (ironic) crime fighters include Mr. Furious (weapon is anger), Spleen (weapon is flatulent gas), the Shoveller (weapon is shovel), the Blue Rajah (weapon is thrown cutlery), and Invisible Boy (weapon is invisibility that only works when people don't look at him). The incompatibility of heroes and bowling, besides staging bowling's cultural status anxiety, also becomes a symbolically optimistic gesture of postmodern democratization.

9. In spite of bowling's thematic predominance in the film, and the recurring use of Hollywood Star Lanes as a setting and contextualizing frame of reference, Donny is ironically the only one of the three bowling teammates who bowls onscreen. When the Dude or Walter bowl, they do so offscreen; they are either shot in preparation or post delivery, but never during the act of bowling. In a film about (ironically) serious bowling, the fact that almost no league bowling occurs onscreen suggests that bowling's role in the film is predominantly connotative: figuratively offscreen.

Lebowsklcons: The Rug, The Iron Lung, **14** The Tiki Bar, and Busby Berkeley

Dennis Hall & Susan Grove Hall

The Big Lebowski is full of the kinds of images that are popularly called *icons*. The film not only places these in our view, but also shows them in dimensions and relationships that are new to us. What are these *icons*? The term is now used so commonly, especially for celebrities, that it might seem without meaning. In several years of studying icons in popular culture, though, we have found the term difficult to define because it has deep and pervasive influences beyond our usual perceptions. In preparing *American Icons: An Encyclopedia of the People, Places, and Things That Have Shaped Our Culture,* we identified several common features of icons.

An icon often generates strong responses; people identify with it, or against it; and the differences often reflect generational differences. Marilyn Monroe, for instance, carries meanings distinctly different for people who are in their teens and twenties than for people in their sixties and older. An icon stands for a group of related things and values. John Wayne, for example, images the cowboy and traditional masculinity, among many other associations, including conservative politics. An icon commonly has roots in historical sources, as various as folk culture, science, and commerce, often changing over time and reflecting present events or forces. The log cabin, for example, has endured as an influential American icon, with meanings and associations evolving from our colonial past through the present.

Moreover, icons are malleable, reshaping and adapting. The railroads and trains, for instance, have shifted from carrying associations of high technology and modernization to conveying ideas of nostalgia and a retreat from high technology. Icons also tend to be culturally fluid, often showing the breakdown of former distinctions between popular culture and art or historic American culture. Icons like *Whistler's Mother* and the patchwork quilt are both revered as high art and widely accepted as popular art; they resonate in both wide and narrow audiences. Icons can be employed in a variety of ways, adding meaning and complicating the contexts in which they appear and helping to shape the responses of "readers" of cultural texts of all kinds.

Based on our shared understanding, we explored the iconic images in *The Big Lebowski* in our separate ways; what follows are our individual reflections. Somewhat to our surprise, they came to some agreement. Our different perspectives revealed complementary views of the film and its audience—ourselves.

The Rug *Dennis Hall*

The Big Lebowski is a flood of metonymic, often iconic, figures. For but one of many examples, that semi-precious area rug—and its transformation into a Persian carpet—points to an important feature of all cult films, an element that is, if not a sufficient or necessary condition of cult classics, at the very least a common characteristic.

Movies exhibit a dynamic tension between narration and figuration. Their general order subsists through this elemental strife—with the joint forces of narrative and figurative desire commonly drawn up in a more or less careful balance, wherein the movie's figures propel the movie's narrative and the movie's narrative stimulates an interest in its figures. In cult movies, however, figuration overwhelms narration. A

cult movie's work is done primarily in terms of figures tied to a nominal narrative frame. Its narrative is commonly subordinate to its dialogue, to its soundtrack, and to its visual images. Thus, in *Lebowski,* despite the sense of an ending that the Stranger invokes with his twinklin'-eyed observation that "a little Lebowski is on the way," the Dude's rug remains in play, multiplying disparate associations throughout the movie. That rug and its replacement Persian carpet are more emphatically signs of the social and cultural differences at the movie's core than drivers of its plot. The figures of people, places, and things in *The Big Lebowski* amount to a rush of allusion and cultural looting that produces the delicious high that is the pleasure of this film text and the source of its— dare one say—cultitude.

In other words, the dominant figurative device in *The Big Lebowski,* as in all cult films, is metonymy rather than metaphor or metaphor's extensions into symbol and allegory, which tend to fix meaning. The cult movie to one degree or another disperses meanings—generates a nexus of associations out of which viewers create their own readings and meanings. Movie cults, perforce, are big tents, admitting a wide variety of responders and responses without any modernist or new critical sense of exclusivity. Indeed, flux drives cult movies. Metaphor, symbol, and allegory are materials more commonly brought squarely, if not always clearly, to meet a narrative's ends. In cult films, however, metonymy often becomes an end in itself, or at least has rendered the narrative incidental. Metonyms are the strongest tools in the cult film's figurative idiom. Cult films "stand for" a wide variety of potential as well as actual associations far more than they are "like" anything.

Nearly every place, thing, and person in *The Big Lebowski* is either charged with associations or so constructed that cult viewers are licensed to infuse them with associations. The opening images and the Stranger's monologue on "Los Angeleees" set us up to invest every

place in the film with meaning, from the Dude's apartment in Venice to the interior of the bowling alley and its parking lot, to the Lebowski mansion, to the diners and coffee shops, to the Seller's valley house, to Jackie Treehorn's house on the beach in Malibu, to Maude's studio, to the streets and highways that connect them. That the Dude lives in Venice, for but one example, places him at that time (it has since been gentrified) on the outskirts of respectability, where we would expect him to live, just as living in the beach community of Malibu, much inhabited by movie stars, confers a degree of unearned respectability upon pornography, the moist underbelly of the motion picture business, and upon Jackie Treehorn, whose beach party is attended by many of his "stars." The Lebowski mansion scenes were shot at Greystone in Beverly Hills—that is, a mansion belonging to the Doheny family of the Teapot Dome scandal—a venue sufficiently opulent and tainted to fit the pretensions and fraud of the Big Lebowski. While these associations may not be operative when one first sees the film, they become part of its common lore among cult film devotees.

So too, this seemingly cluttered filmscape is filled with resonant things: the Dude's bathroom fixtures and bathrobe and sunglasses and rugs and car, the carefully selected costumes the actors wear, the check the Dude writes at Ralph's, the pistol Walter flashes in the lanes, the *Time* magazine cover mirror, the bowling ball that brings the Dude crashing back to earth in the first dream sequence, the frequently smoked pot, the cricket bat, the marmot, the Corvette, the iron lung, the scissors pictured on Maude's wall and later wielded by the nihilists in the Dude's dream, and Maude's painting harness are a few among the many, many things that fill the visual space in this movie. These things either carry meaningful associations or invite the devotee to invest them with meaning. None are allowed to remain incidental.

As mentioned, among the many iconic figures at work in *The Big Lebowski* that illustrate this metonymic function is the rug. In the first bowling alley scene, in his conversation with Walter and Donny, the Dude focuses on the insult to his rug—a sign of his unique domestic order—rather than the assault on his person. The trio repeatedly remark that the thug *peed*—not *pissed*—on the rug, a preference for a relatively child-like and decorous diction, that underscores the many verbal as well as substantive inconsistencies that propel the movie: "Thaaat's right Dude; they pee on your fucking rug." The assault on his person, the first of very many in the movie, is not the subject for compensation; rather, the rug—"something of value," as Walter repeats three times—is an object, although more defiled than destroyed, for which the Dude, at Walter's urging, seeks compensation, the pursuit of which nominally drives the movie's plot. As the intricacies of conspiracy overwhelm him when passing out at Jackie Treehorn's house, he mutters, "All the Dude ever wanted . . . was his rug back . . . not greedy . . . it really."

While the rug triggers associations constructed within the movie, it also imports into the movie an inventory of associations from outside which may or may not come into play in the repeated viewing that is the central rite of the movie cult. The area rug that "ties the room together," for example, is an empty cliché found on eBay and in decorating columns rather than in the discourse of serious interior design. Oriental rugs, of course, particularly Persian carpets like the one the Dude takes from the Big Lebowski's mansion, are signs of wealth and often of a refined and informed aesthetic consciousness. The magic of carpets extends from Solomon's carpet of green silk to Aladdin's flying carpet in *The Arabian Nights,* to the rug-soaring plumbers of Super Mario Brothers, along with tens (possibly hundreds) of other electronic and video games based upon the same conceit. *The Arabian Nights* also

characterizes hash as an aphrodisiac. Sex-lexis.com reports "riding the magic carpet" is an expression for drug use, and William Novak in *High Culture* reports as common the observation of a middle-aged woman that "Sometimes when I am very turned on to the person I'm with, I've had the sense of riding on a magic carpet.... I don't feel anything under me; the visual image is that of soaring on a magic carpet.... It's strictly a stoned experience. I don't ride on carpets unless I'm stoned." Nor does the Dude.

*The magic of carpets extends from Solomon's carpet of green silk to Aladdin's flying carpet in **The Arabian Nights,** to the rug-soaring plumbers of Super Mario Brothers ...*

Carpets—as distinct from mere rugs—are, of course, rich in linguistic associations. While the Dude visits the mansion intent on challenging the Big Lebowski, he winds up on the defensive, finds himself classically "called upon the carpet," in the sense of being rebuked or closely questioned by a person in authority. While the association is something of a scholarly stretch, in Henry James's "The Figure in the Carpet," for but one literary example, Hugh Vereker's claim that the meaning he has written into his books, the thing the critics are to find, is like a complex figure in a Persian carpet, but it, like the Big Lebowski's million dollars or this movie's narrative point, may well not exist at all. The association of Persian carpets with the pursuit of something that may not be there is more common and current than one might think. Seymour Hersh writing in the *New Yorker*, quotes Giandomenico Picco:

> "If you engage a super power, you feel like you are a superpower," Picco told me. "And now the haggling in the Persian bazaar begins. We are negotiating over a carpet"—the suspected weapons program—"that

we're not sure exists, and that we don't want to exist. And if at the end there never was a carpet, it'll be the negotiation of the century." (49)

And Maude's painting technique is an intriguing variation of that of Jackson Pollock, which might suggest Persian rugs as it did to Richard Lacayo in describing Pollock's opening: "For months he has flung lashing tangles of color onto canvases laid across the floor—literally slapdash, yet as intricately woven as a Persian rug, his pictures pointed the way to the future—or would if anyone noticed." Moreover, Maude is keen to get that particular Persian carpet back because of its associations for her with her own mother. Sex-lexis.com reports that a carpet-muncher is one who performs cunnilingus, while WomynsWare.com offers for sale silicon sex toys called Magic Carpets, in both plain and electric configurations, suggesting practices easily associated with Maude's self-proclaimed vaginal art. And, of course "rug-rats" are cartoon characters as well as a more general term for small children, like that "little Lebowski" the Stranger reports is on its way. A good many other associations are available to those attuned to the ways of the world, but the point is that multiple associations are in wide circulation that to one degree or another are evoked by the movie or may be imported into a reading of it. The rug is but one of the many people, places, things, and sounds made available for this movie's viewers to put into play. (Sounds, particularly those characteristic of the bowling alley and of the musical soundtrack, play an important metonymic role in this movie and contribute to its status as a cult film; a colleague, Jack Ashworth, has coined the term *earcon*, for aural icon. See "Banjo" in Hall and Hall.)

The movie also constructs associations for its objects. The rug is a reflection of the Dude's desire for compensation, as much a psychological as a material need. With his lie to Brandt, "The old man told me to take any rug in the house," the Dude magically transforms a marker

of his simple domesticity into a sign of wealth and sophistication—a device that allows him to participate, after his fashion, in the life of his social and economic betters, as well as to have something between him and the floor, a venue upon which he spends so much time (indeed, the Dude may hold the record for voluntary and involuntary floor time in a major motion picture). In this, the Persian rug does not tie his room together; rather, it marks differences. Indeed, the brilliant red center of the Persian rug is the launching pad for the Dude's magic carpet flight—à la superman—over L.A., allowing him to perceive but not reconcile or even to understand vast differences.

Donny is a key, perhaps the key, to understanding cult movies and their metonymic logic. Walter accurately describes Donny as "like a child who wanders in in the middle of a movie and wants to know. . . ." Donny is us—as we watch the movie for the first or second or even the third time with little or no idea what is going on. We have no frame of reference. We swim in the figurative soup that finally drowns Donny just as it obscures our sense of what is going on, our sense of narrative order. Then we buy the DVD to indulge in repeated viewing, which is the central ritual of a cult film, and out of that ritual we tease metonymic associations or, perhaps, continually reconstruct them. In the online words of Infofreak from Perth, Australia, an observation that 55 out of the 64 IMDb (Internet Movie Database) respondents found useful, "My favorite Coen brothers movie changes over the years as I watch and rewatch."

The Iron Lung *Susan Grove Hall*

The iron lung has such an obvious practical use in *The Big Lebowski* that to ponder a further rationale for it risks fallacy or paranoia. It encases a father at once noble and praiseworthy, but utterly detached from the

present day and its living room farce, and thus it provides a compelling dramatic foil for the ridiculously frustrated Walter Sobchak. But it should be pointed out that an iron lung in a film from 1998 is not quite the anachronism it seems. It looks especially antique because it demonstrates its function with a large black bellows heaving up and down beneath it. Most tank respirators shown in historic photographs have attached cylinders or boxes enclosing pumps, but the visible bellows was a feature of the Drinker-Collins model used for polio patients in the 1950s ("Iron Lung"). These body chambers made paralyzed polio victims breathe as their chests expanded into the negative air pressure created by vacuum pumps. These were later replaced for most respiratory problems by oxygen-supplying ventilators, but in 1998 a few iron lungs were still used by polio survivors. An Oscar-winning 1996 documentary titled *Breathing Lessons: The Life and Work of Mark O'Brien* provides some context for the image of Sellers and his family. Produced by Jessica Yu, the documentary profiled a journalist and poet of Berkeley, California, who had survived childhood polio but suffered a relapse in his forties that made him spend most of his time inside the iron lung. This film updated images prevalent during the polio epidemics of the 1940s and 1950s of valiant patients smiling while encased, from neck down, in fearsome metal cylinders. The recurrence of polio's damaging effects was common enough that by 1990 it had become termed *post-polio syndrome*, or PPS. Well-known people who had recovered but been re-afflicted, like the folk singer Joni Mitchell, led to wide public awareness of PPS. The popular writer of the script and novel for Stanley Kubrick's *2001: A Space Odyssey*, Arthur C. Clarke, was seen and photographed using a wheelchair after 1988 due to PPS (Hecht 71, 73).

Giving credibility to the iron lung, though, emphasizes the incoherence of the characters and actions of Walter and the Dude in the scene. Walter's threats of a "world of pain" and destruction of the Corvette

erupt without the declamatory politics that drive his other rages. The Dude, interrupting Walter's demands of "Is this your homework, Larry?" to bring up the pertinent car and money, and later watching Walter smash the Corvette in bafflement, obviously does not share any plan Walter may have concocted to intimidate Larry. Among his exasperated interruptions of Walter, he directs anger at Larry only briefly, calling him a brat, before he suddenly blurts the dire threat, "We're going to cut off your johnson, Larry!" The remark is out of keeping with the Dude's role in the situation and opposed to the laid-back temperament and conduct otherwise so consistent throughout the film: simply put, it is not his "style."

The iron lung scene brings a point of confusion about the characters and disruption in the apparent plot. Janet Maslin, in reviewing the film, mistakes the Dude's acquiescence in Walter's interrogation for a befuddled notion that Larry is

"Is this your homework, Larry?" Bunny's kidnapper; so his subsequent adventures seem irrelevant: "Since the Dude is dim enough to decide, at one point, that a blank-faced schoolboy is the mastermind behind the kidnapping, this plot need not be taken too seriously." The ending fails to pursue or finish a plot, Alex Ross observes; instead, the film, like the Coens' previous ones, imposes "an artificial resolution on a sequence of brilliant character studies" with a "farcically arbitrary" climax, when Donny suddenly dies of a heart attack during the parking lot fight. For many, indeed, the sequence of events lacks meaningful interrelation in terms of consequence or motivation. However, in terms of visual allusions and transformations, the actions, things, and characters interlace in patterns that unfold a psychological subtext.

The weaving of images into a dreamlike narrative, with the "lung" at its center, begins with the tumbleweed bouncing from the range to

the overlook of nighttime Los Angeles, through its streets, and to its shore. Already several elements have appeared that connect the iron lung encounter to the overall scheme of the film. The Western, the mode in which the Stranger's commentary sets a beginning, middle, and end to the story, will be realized in its inspirational origins as the *Branded* series attributed to Arthur Digby Sellers. The actual NBC series starring Chuck Connors—whose theme song Walter repeats in "All but one man died there at Bitter Creek."—dates to 1965–1966 and so illustrates the formative period of his and the Dude's manhood, carrying the heroic ideal of a generation that fought in and protested against the Vietnam War. The Dude, having been introduced by the Stranger as the man for his time, represents his generation, as successor to that of the Stranger, author Sellers, and the Big Lebowski, soldier of the Korean War. The iron lung images the plague of their generation as the wheelchair does its war wounds. The alienation of the Dude, however, along with Walter, from ties of generational or family respect pervades their visit to the Sellers, as it later provokes Walter to floor the crippled war veteran. Among the parallels in a generation younger than, possibly successive to, the Dude and Walter, the author's son endures verbal assault, while Donny—the Dude's guileless son-like follower—has to escape from the neighbor's avenging attack on the Dude's car, in a forecasting of his heart attack when Walter and the Dude fight the nihilists.

The metal cylinder encasing Sellers, set up on wheels, is a more threatening carriage of debility than the wheelchair. It resembles a casket, sounds like gasps of suffocation, and represents helpless, sexless existence. In various guises, the metal container plots the story to its ending in the coffee can of Donny's ashes that besmirch the Dude. Another "can," in a punning transformation such as Freud traced in dreams, threatens the Dude in the encounter that begins his adventure, when the thug forces his head into the toilet. His assault by submersion

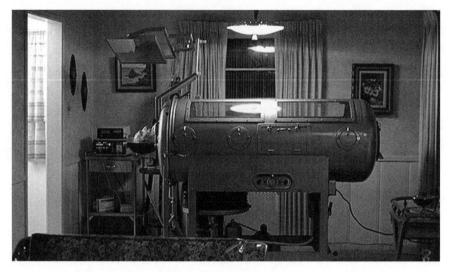

14.1. "Oh, no, no. He has health problems."

in this body receptacle prefigures the fate of the elder author. Another ominous attack featuring a container occurs when the Dude lolls in his bathtub listening to the "Song of the Whale," and the nihilists throw the marmot in, with the threat to cut off his johnson. These entrapments increase the menace of the tank respirator when it looms before, and above, the Dude in the living room, and when it wheezes. Perhaps the domestic and intimate enclosures with their watery noises also threaten a womblike imprisonment. Later, Maude's post-coital contortion meant to capture the Dude's sperm caricatures her danger to his freedom as a constricting receptacle.

The Dude's ventures abroad in Los Angeles depend upon his own wheeled container; his missions are fraught with perils of collisions and attacks on his car. The automobile is as prominent in the film as the hero's steed in a cowboy Western, but it carries more vulnerability and

damage than empowering freedom. The Dude's automotive alter ego crashes into a bridge and later a dumpster. In parallel to his mishaps, it is abducted and subjected to toilet indecency. It suffers the retribution for Walter's destruction of the Corvette outside the Sellers' house and attests to the Dude's abashment while serving out the promised trip through the hamburger drive-in. Finally set afire outside the bowling alley by the nihilists, it is a surrogate for the Dude and a double of Donny in his concomitant death and cremation.

The iron lung supplies a central, signifying image of perils that beset the Dude's pursuit of the freedom that is his "style." Dangers to his necessarily haphazard course of non-engagement emerge in random encounters, at once absurd and ominous, connected together and to unacknowledged fear like a nightmare's metamorphoses.

The Tiki Bar *Susan Grove Hall*

As the camera introduces the Dude's apartment, its expanse of smoke-dyed wallpaper, with its faded balloon and stencil patterns, attests to a persistent indifference to decor continued from several decades of prior tenants. No clear view of the peed-upon rug evinces its alleged transformational power. Only when the Dude concocts the first of his numerous White Russians do we see the personal appointments that create his valued home sanctuary: beneath a large photograph of President Richard M. Nixon bowling stands a bamboo-sided tiki bar. This altar for the Dude's favored potions offers more of importance than simply rites for imbibing alcohol. The tiki bar carries a longstanding, still-burgeoning imagery for the viewer that imbues and links scenery throughout the film with the Dude's role in enacting the culture of his era.

The beach where the tumbleweed rolls at the outset, the half-and-half the Dude then buys at Ralph's market, the bare-breasted woman

tossed on the blanket at Jackie Treehorn's estate, and the Pacific Ocean vista at the end coalesce in a tradition of liberation in which exotic cocktails are served in some semblance of Polynesian hospitality. The Dude's bamboo bar relates him to those venerable hosts of escapist resorts such as Don the Beachcomber and Trader Vic, and also to their myriad imitators who light tiki torches in their suburban backyards across the Midwest.

As fashion, the trappings of the tiki bar have waxed and waned, and veered in status, up to collected artifacts, down to the neon sign's pink palm tree on Jimmy Buffett's Cheeseburger in Paradise chain restaurants, and the balloon hats and plastic leis on his "Parrothead" fans. Recently, in 2007, the "bamboo aesthetic" in lounge furnishing resumed its classic appeal in the opening of a new Trader Vic's Las Vegas at Planet Hollywood Resort and Casino, heralded by 100 six-feet-tall grinning tiki heads along the Strip (Beirne). The decor's currency for high-end marketing extends from a resurgence in taste for tiki bars that occurred in the late 1990s (Curtis 45)—when the Coens placed one in *The Big Lewowski*.

... the trappings of the tiki bar have waxed and waned, and veered in status ...

A romantic history attaches to the Dude at his bar, the creative legacy of a former South Seas vagabond who in 1934 opened a tiny tavern with a bamboo bar off Hollywood Boulevard, which he named Don the Beachcomber and decorated with beach scavengings. Due to his charm and novel rum concoctions, Ernest Raymond Beaumont Gantt's tropical watering hole gained so many fans, including Charlie Chaplin, that he changed his own name to Donn Beach. In 1937, his growing business inspired another entrepreneur to reinvent his place and persona. Victor Jules Bergeron had started the Hinky Dinks taproom and luncheonette in

Oakland, California, in 1934; it had gained success because it provided "sort of a club" for people who needed an escape from drab homes and lives. Hoping to expand, Bergeron adopted his model from Hollywood's Donn Beach. Where Bergeron had previously entertained his customers with cheap food and beer, an amateur hour, card tricks, and jokes involving his wooden leg, he put together multiple liqueurs with fanciful names, palm tree surrounds, and a tale of a shark attack, reinventing himself as the colorful host Trader Vic (Trader Vic 36–37).

Coincidentally, Polynesian scenery and culture became widely popular in 1937, when Bing Crosby starred in Paramount's *Waikiki Wedding,* a musical comedy about the charms of Hawaii; and then World War II broadcast the state's allurements through the experiences, films, and tales of service people. Both Don the Beachcomber and Trader Vic's flourished into chain restaurants. Bergeron's donations of liquor during the war brought "Trader Vic's Officers Clubs" to islands across the South Pacific (Trader Vic 52). Subsequently, James Michener's *Tales of the South Pacific,* the Rodgers and Hammerstein musical based on it, and Thor Heyerdahl's 1947 account of his voyage on his raft, *Kon-Tiki,* undertaken to prove the Incas had settled Polynesia, heightened the appeal of mysteries and adventures implied by proximity to the tikis. The glamour of the tiki bar was spelled out to Main Street America in a *Saturday Evening Post* article detailing the success of Donn Beach and his ex-wife and business partner, illustrated with photos of Joan Crawford and other stars drinking and dining, of Donn surrounded by swimsuit-clad women at his parties in Hawaii, and of pineapples with drinking straws (Martin). Ultimately, though, the fashion for tiki exotica, which continued to swell into the 1970s, ultimately spoiled its fresh appeal when even cheap apartment buildings and Laundromats took on tiki totems, and the many torch-lit restaurants with hula girls serving liquors in ceramic skull and fruit mugs aged out of style, along with their

clientele, a generation accused of imperialism for sending youth across the Pacific to a war in Southeast Asia. The tikis' glamour, like President Nixon's vaunted earnestness, was rendered fake and risible.

Still, the spell of the tiki bar, under this legacy, draws upon the image of a strong man with a past as a sea wanderer, cultural explorer, and entrepreneur, who is a bon vivant, ladies' man, and host of a congenial, leisured community, inviting bared bosoms. The Dude in his rebellious history, his confident self-sufficiency, and his friendships has these attributes, in a latter-day, somewhat dampened version. In his lazy hedonism, the Dude is more true to the countercultural impulse of the original tiki bar trend than he is a successful purveyor of sexual license such as a Jackie Treehorn. The Dude is in tune with fantasy, not explicit pornography. That the picture of Nixon bowling is the altarpiece on the Dude's tiki bar represents the Dude's role as a reconciling host for the past in the present, reclaiming the honest sport in Nixon's, and his contemporaries', striving energy, shrugging off all else. Likewise, the Dude's own style recenters the iconic function of the tiki bar. His offhand style, and decor, acknowledge the balance of parody and nostalgia in the tiki revival of his current time and place (Curtis). He's neither serious nor sentimental about his bamboo, whale songs, and flame-lit bathtub lagoon. He maintains a space for fantasy, much in keeping with the barroom lounges promoting Polynesian pop fantasy that brightened American modern culture. And the Dude's places, in locale and in the film, remind us of the central role of Hollywood in creating and hosting the fantastic dreams that seem to be our own.

Busby Berkeley *Dennis Hall*

Also contributing to this metonymic play is the *Big Lebowski*'s surreal quality—a suspension of conscious reasoning while maintaining the

visual discipline of realist film that has become a hallmark of Coen brothers' movies. The reality of this movie resides, however, in the repeated experience of viewing it, of "re-reading" it, an experience that floats, if you will, above the sharply realized surface of its visual images, inviting subconscious associations, even feelings. The most explicit manifestations of this quality are the two dream sequences.

The first dream is initiated by a blow delivered to the Dude while he is lying on his newly acquired rug, possibly stoned, by one of Maude's henchmen who is assisting her in the recovery of her Persian carpet. This occasion is Maude's first sight of "Jeffrey," and presumably it initiates her interest in him as zesty sperm donor. His dream begins with a night-time, Superman flight high above the City of Angels. The city at night is clear, and the view of it detailed; it is realistic in every respect apart from his flying and two appearances of a female figure, presumably Maude, sitting upright on a flying carpet, taking a ride worthy of Aladdin. This trip is part of the whole movie's homage to L.A., but it also reflects the tension between the real and surreal at work throughout the movie. The weight of a bowling ball which suddenly appears in the Dude's hand—one of only two balls he really lays hands on in the movie—reasserts the laws of physics in a fashion worthy of a Warner Bros. cartoon, to bring him crashing down to earth, but not to reality. Rather, the surreal is extended as the Dude is transformed into a bowling ball and assumes the ball's point of view as it rolls down a lane, crashing into the pins. This technical feat in filmmaking, finally, seems an entirely acceptable occurrence in the "logic" this sequence has created and never loses sight of—this tension between the real and the surreal. The Dude's return to what passes for reality remains tempered by this surreality.

The second dream sequence is considerably more elaborate and just as sharply realized. Induced by the Mickey Finn that Jackie Treehorn

The weight of a bowling ball which suddenly appears in the Dude's hand ... reasserts the laws of physics in a fashion worthy of a Warner Bros. cartoon, to bring him crashing down to earth, but not to reality.

puts in the Dude's Caucasian, this dream is bracketed by a violent return to consciousness at the hands of the Malibu police chief. The sequence opens with old-time Hollywood movie titles: "Jackie Treehorn Presents ... The Dude ... Maude Lebowski ... in ... Gutterballs." What follows is an homage to Busby Berkeley, the generally acknowledged father of Hollywood surrealism. The Dude appears dancing, as a diminutive figure against a gigantic black and white background, to Kenny Rogers singing "Just Stopped In (To See What Condition My Condition Is In)." The images here are drawn in a hyper-realistic style to represent an entirely fantastic sequence. They have the visual "feel" and the military precision of a Busby Berkeley classic, of either *Dreams* or *Whoopee* or *42nd Street* or any of the many other 1930s Berkeley productions. They include a shot of Sadam before a bowling shoe rack extending into the heavens and a shot of the Dude dancing down an elaborate black-and-white staircase that is a visual quotation of the floor in the Lebowski mansion. The dream sequences are filled with visual quotations of the nominally "real" parts of the movie, further compromising the distinction between the real and surreal. This sequence also includes some of the images most revered by Lebowski cultists: the Dude in the cable repairman's white uniform (the same one Karl Hungus wears in *Logjammin'*), Maude dressed as a Valkyrie, Saddam of the bowling shoes, and the chorines in Brunswick-cum-Valkyrie costume.

The bevy of chorines marches into the scene, marked by a Berkeley trademark overhead shot designed to show their formation and to display their elaborate, Berkeleyesque headdresses. Jackie Treehorn, as

did Busby Berkeley, treats women as sex objects, as things. The chorines march down a bowling lane and straddle it to form a tunnel, another Berkeley move. The Dude appears, in a role reversal perhaps only possible in a dream, to teach Maude how to bowl, crouching behind her, his hand on the ball, guiding her as she delivers a ball down the alley. At the ball's release, the Dude is once again transformed—this time into a human representation of a bowling ball, making his way between the legs of the chorines, flipping over to look up their skirts with a grin on his face matched only by that of William Powell in many similar circumstances in Berkeley films. When his head strikes and scatters the pins, the Dude does not immediately return to consciousness. Rather, the dream provides a gradual transition into (guilty) consciousness, as he begins to run in darkness from the nihilists wearing bright red costumes, wielding giant scissors like those pictured on the wall of Maude's studio. Finally, the Dude escapes his dream into the relative security of Malibu police custody—a full return to consciousness again tempered by the tension between the real and the surreal.

These two dream sequences, particularly for the repeat viewer, underscore the surreal quality of the entire movie. *The Big Lebowski* in many respects enjoys the quality of an animated film, filled with artificial landscapes, props provided by Acme, Inc., and characters larger than life and twice as durable. In the early days of animation—before Mickey, as Donald Grafton puts it—drawn films sought to imitate live action films and characters, perhaps most notably Otto Messmer's Felix the Cat, a dude modeled upon Charlie Chaplin in his movement, adventures, and attitude. Early animation made possible an exploration of surprise, of unexpected juxtapositions, of the illogic not only of dreams, but of ordinary life. "Although the creators of the first animated films," Grafton concludes, "were not surrealists or even cognizant of that movement, they inadvertently made films that demonstrated a

disregard for everyday existence, normal logic, and causality, and a propensity for dream-like action which André Breton and his followers admired" (348). This propensity is manifest in the hard-edge worlds of Messmer and Berkeley, and, later, even of Tex Avery and Chuck Jones, rather than the soft fantasylands of Walt Disney. The Coen brothers, for their part, invert early animation's move, employing the devices of hyperreality to create a dream-like action which André Breton and his followers would have admired.

Craig N. Owens

Palm trees finger the sky, and there's enough sunshine to lay
some off on Pittsburgh. But that's all on top. L.A., truth to
tell, is not much different than a pretty girl with the clap.

Coleman and Zippel, *City of Angels*

Thanks to James Bond's filmic popularity, the two rival mixologies of
the vodka Martini are well known: the shaken and the stirred. Indeed,
one might easily imagine a Levi-Straussian work of cultural anthropol-
ogy, along the lines of *The Raw and the Cooked,* exploring how these two
mixing methods have come to encapsulate whole attitudes toward life,
love, and libations. The mixological niceties of the White Russian, by
contrast, remain relatively unremarked upon, even among libationists
familiar with the Dude. For, while it's conceivable that the Martini is to
James Bond what the White Russian—or to use the preferred dudism,
the *Caucasian*—is to the fortuitously eponymous protagonist of the
Coen brothers film *The Big Lebowski,* it is not so clear what impact his
Belarusian leanings have had on his favorite collation's cultural place,
beyond the cult of Lebowski enthusiasts.

The upshot of this is that when you order a White Russian, you leave
it to the bartender to mix it, without any special instructions, beyond
whether or not to put it on the rocks. And, while the official Absolut
vodka website, for example, instructs the attentive tippler to "float"

the cream, the same website includes a variation, the unimaginatively named White Russian 2, in which all the components are mixed together. Now, it's difficult to imagine a bartender asking whether you want a White Russian or a White Russian 2, just as it's difficult to imagine asking for a White Russian floated, or a white Russian shaken or mixed or stirred.

And yet, the generous inclusiveness of the Absolut website aside and the wider cultural *nonchalance* about the way we go about ordering our White Russians notwithstanding, quietly, in chat forums and online recipe sites, and in the pages of novelty bartending guides and handbooks of gentlemen's etiquette, opposing positions on the question of how to assemble a White Russian are forming; and, since each method creates a distinctly different kind of drink from the others, the question of method impinges on questions of ontology: What, exactly, *is* a White Russian? I want to suggest that the Dude's approach to concocting and consuming this cocktail—casual, almost absent-minded—suggests a way around analogous ontological questions about late twentieth-century American urban masculinity, and the usual anxieties attendant thereupon.

Concerning the White Russian, there are, broadly, two factions: the floaters and the homogenizers.[1] Preferring the unmarked (and therefore more manly?) recipe featured on Absolut's website, the floaters hold that, having mixed the Kahlúa and the vodka—either on or strained through ice—we should, as Bob Emmons suggests, in his *Book of Gins and Vodkas,* "float cream" atop the vodka-cum-Kahlúa. In directions more fully elaborated upon, Salvatore Calabrese—author of *The Complete Home Bartender's Guide*—instructs us to "[f]loat the cream," which we have "lightly" whipped, "over the top of the drink" (135). Ian Wisniewski, in his book *Party Drinks,* explains this process somewhat more finely: "Gently 'float' the cream onto the flavored vodka so that

15.1. A couple of Caucasians: White Russians at Lebowski Fest 2006. Hillary Harrison, photographer.

they do not mix, by pouring it onto the front (the inward-curving side) of a spoon" (29).

This last set of directions, it seems, links the mixology of flotation to a somewhat precious and, I daresay, condescending notion of party etiquette. First of all, it requires a utensil beyond a glass and five fingers. And not just any utensil, but in fact one of the few utensils of which I am aware that has both a *front* and a *back,* either of which may occasionally

come in handy. Moreover, it's a bartending utensil used primarily for mixing, deployed in this special case for separation. So, we've got a little anatomy lesson built into a bartending lesson. Third, it is perhaps the only recipe for the White Russian that defines what it means to "float" the cream. It puts the word in quotation marks, thus alerting us that we are encountering not only a bartending lesson and an anatomy lesson, but a vocabulary lesson as well. While it is the nature of recipes and handbooks and guides of this kind to be didactic, this description engages in a kind of salacious hyper-didaxy: too much teaching, not enough drinking. Similarly picayune, Wikipedia, at last check, even insists on "fresh" cream. (The Dude, at least nominally, shares this insistence, as he is careful to smell the cream for freshness—or, perhaps, to ascertain that it is not yet *too* sour—before using it.)

On the other side of this mixological divide are the homogenizers, the most outspoken of whom may well be David Biggs, who directs us to "shake" the ingredients in order "to mix" them, in *The Cocktail Handbook.* In his follow-up volume *Legendary Cocktails,* published two years later (and thus giving the lie to his earlier book's title), Biggs imagines that the White Russian "probably reminded its inventor of the glistening snow of Siberia," before he instructs his readers to "shake the combination well and strain" (95). (Parenthetically, one might wonder whether this is not the recipe the Politburo applied for ensuring order in its Siberian work camps: "shake [. . .] and strain"; in any case, a twentieth-century inventor of such a drink might be forgiven for muddying the Stalinist snows of Siberia with a touch of Mexico's warmer, more sensual Kahlúa.) Whatever its origins, the homogenized White Russian is less refined in its mixology. Alan Axelrod, a *sturm-und-drang* mixologist with a shaker's torque built into his name, exhorts the intellectually disinclined in *The Complete Idiot's Guide to Mixing Drinks* to "shake vig-

15.2. Does half-and-half ever *not* need to be sniffed?

orously"—it's up to his idiotic readers to supply the grammatical object of this amusing directive (85).

Between these two extremes, however, is a middle way. It requires finding verbs neither as brutal and abrupt as "shaking" nor as subtle and effete as "floating." The Kahlúa website attempts to chart these straits. "Add milk or cream," it vaguely suggests, and "Pour over ice." "Home Bartender," a contributor to *Boston Cocktails,* a site devoted to the invention, dissemination, and discussion of cocktail recipes, suggests this middle way in his entry "Shaken or Stirred?" Explaining that milk- and cream-based cocktails require shaking in order to blend the ingredients evenly, Home Bartender adds, "I should note the exception of those [drinks] which are meant to be served not fully mixed, like the White Russian." This aside deftly parries the question of what to do with or to

the White Russian by making it an exception to the general rule. It also defers the question of authority and agency by employing the passive voice: White Russians "are meant to be served not fully mixed." To put it another way: the passive voice in this formulation does not so much *hide* agency as avoid it. It makes a claim without taking a position.

This apositionality is, I suggest, key to grasping the stakes of the Dude's mixing method. For the whole point of this middling mixology is not to worry too much about precise methodology. And, while Michael Flocker recommends the White Russian in *The Metrosexual Guide to Style: A Handbook for the Modern Man,* he indicates it is particularly suitable to those "who dig dairy" (31). That "dig"—the sly Dudism—belies the book's (and the drink's) appeal to metrosexuals who imagine themselves "spies and international gigolos" (31). It transposes us from Malibu or the Standard Lounge to the cluttered and overboozed sidewalks of Venice Beach.

The middle way, it appears, is the Dude's way, for it avoids the effort of shaking and straining, on the one hand, and the refinements of layering and floating, on the other. "Weathervane," a contributor to the online information forum "Everything2," calls attention to precisely this point in a post on "The White Russian" discussion board:

> Check out the way The Dude mixes his [White Russians] in *The Big Lebowski.* Seriously casual, barely even paying attention while he mixes it. None of this "half an oz. of *this* and *that*" nonsense. [. . .] Relax. Smoke a joint.

The "White Russian" page, despite its title, is not devoted solely to the drink. Since "Everything2" is a manifestly Ramist website, each topic is positioned as a "node," crisscrossed by lines of thought tangled at other nodes: the list of linked nodes at the bottom of the page suggests the variety of associations made possible by this rhizomatic organization;

15.3. The middling mixologist at work.

it includes "diphenhydramine," "Dostoyevsky," "Anal Sex," "Why you never see baby pigeons," and, inconspicuous among the others, "Leon Trotsky."

Trotsky, in fact, is doubly implicated in this drink. First, as Vladimir Lenin's lieutenant, he led the Red Army successfully against the anti-communist White Russian army during the Russian Civil War (1917–1921) to seal the communist *coup*. Second, after losing favor with the Soviet establishment under Stalin, he fled, finally, to Mexico, Kahlúa's country of origin.[2] Trotsky, as the insider/outsider and nationalist/exile, emerges, in this formulation, as a figure of permeability, a boundary crosser, a virgule (fr. L. *virgula,* little rod [not little virgin]; for the severing of which, see below). And, while he might have suffered some separation anxiety as he floated southward across the big water into balmy exile, perhaps a bottle of Russia's little water with

him, he also triangulates the mythical center of this otherwise de-centered drink, a triangle which, like the very one through which he would have passed, threatens to swallow up an otherwise linear cultural analysis.

And so, the place[3] the Dude occupies—or, more accurately, his placelessness—confers upon him a Trotskian positionality. For just as his careless mixology negotiates the poles of unity and stark separation, the Dude likewise manages to finesse, without flourish—employing, in a moment of supreme indifference, non-dairy creamer—the impasse of metrosexual masculinity, on the one hand, and of the nostalgic "man's man" masculinity, on the other: the former celebrating and enacting a kind of post-castration phallic masculinity, and the latter insisting on the masculinity's fundamental ontological and historical unity.

Such finesse appears remarkable, considering how prevalent fig-ures of separation and impotence are in *The Big Lebowski.* Throughout the film, U.S. president George H. W. Bush's insistence that Iraqi ag-gression "will not stand" serves as a leitmotif auguring both virile ag-gression and castration; Maude Lebowski refuses to interact with her father, stripping him of controlling interest in one of the family's corpo-rations; Walter Sobchak and his wife have divorced, leaving him with only his post-Vietnam frustrations and an adopted Orthodox Judaism that immobilizes him one day each week; Donny Kerabatsos is con-tinually excluded from Walter and the Dude's conversations; a severed toe serves as a kidnapper's threat; Mr. Lebowski, who has lost the use of his legs, seems unable to keep his wayward wife out of trouble. And, as if "aggression" that "will not stand," a daughter's antipathy, a cor-porate ouster, divorce, Sabbath-keeping, exile, amputation, flaccidity below the waist, and infidelity don't clearly enough suggest castration anxiety—a very special kind of separation anxiety—German nihilists unleash a feral "marmot" in the Dude's bath (!) as an explicit threat of

genital mutilation, while in a hallucinatory blackout, the Dude imagines those same nihilists, bearing giant scissors, chasing him. All of which, it's worth noting, started because of the loss of a rug, which "tied the room together," as the Dude repeatedly comments. Since, as Lisa Donald notes in her provocative essay "Bowling, Gender, and Emasculation in *The Big Lebowski*," "'rug' is a common, though unflattering, slang term for female genitalia," the Dude, it seems, is threatened with the loss of maternal unity, and thus with the anguish of castration.

In this regard, it's tempting to think of the Dude's milky mélange as somehow symbolic of an anxiously Oedipal over-attachment to the maternal. So understood, the White Russian becomes a means for the Dude to abate, for a few moments at least, a repressed longing for renewed unity with the forever forbidden, forever distant primal mother.

Such a longing would precisely symptomize castration anxiety, because the wish for maternal unity would serve as a powerful disavowal of the genital difference that, according to Freudian and post-Freudian psychoanalysis, is the anxiety's foundational trauma. Along the same lines, Maude's non-dairy creamer would thus announce her rejection of traditional maternity, while the Dude's frequently milk-soaked beard, surrounding his two lips, visually collapses the genital and mammary attributes of maternal femaleness.

It is the trope of femaleness coded as threat on which Donald dwells, arguing that the Dude embodies those anxieties about American masculinity that have emerged since women's liberation. I wish to make precisely the opposite claim: that the Dude's status as "a man for his time and place," according to the Stranger's introductory voice-over (rather than a man *of* his time and place)—that is, as an antidote for, rather than a symptom of his milieu—and the cult status of the film are results of the Dude's *immunity* to anxiety, and particularly castration anxiety. When Maude, for instance, begins her disquisition on her

> *... the Dude's frequently milk-soaked beard, surrounding his two lips, visually collapses the genital and mammary attributes of maternal femaleness.*

"vaginal" artworks and scoffs at the casual ease with which men talk about their own genitals, the Dude registers almost no reaction at all. Her approach to art and feminism—an all but manifest send-up of Eve Ensler's essentialist, facile notions of embodied womanhood in *The Vagina Monologues,* right down to her severe haircut—seems to have no effect on the Dude, so little do they provoke anxiety. Far from threatening castration, Maude succeeds in seducing the Dude, whom she has chosen as the sire of her offspring precisely because he does not suffer from modern masculine melancholia.

So, while the Dude's lactic predilections and Maude's milk substitute seem to put maternity in play, none of the (very infrequent) moments of anguish the Dude exhibits in waking life is gendered; indeed, when the Dude does seem to suffer something like anxiety (over the severed toe or his increasingly battered car), Walter's outbursts always rise above the Dude's angst, diminishing it by comparison. Only in his vivid and exaggerated dreamscapes does the Dude's anxiety get linked to castration, and then the scenarios are so stylized, so playful, so symbolically de trop that he seems to be merely going through the motions of castration anxiety, acting out a set of behaviors that, far from marking out some deep psychic traumatic space, rather show us, and the Dude himself, the very place that he never really occupies: the space of anxiety.

In this regard, then, castration, maternity, the femme fatale, and the usual trappings of film noir's signature embattled masculinity become feints, prestidigitations that continually lure the viewer or the analyst into dead ends. If these interpretive blind alleys[4] mark the investigatory spaces of modernist epistemologies, then *The Big Lebowski's* pastiche

of these figures invites us to imagine other, postmodern pathways and patterns of knowing, places and spaces that do not depend upon fixity and permanence to secure their ontologies. In fact, the film seems to celebrate a kind of unflappable, impenetrable identity, all play and surface, not just unmarked, but ungendered.[5] In short, the film seems to invite us to think Los Angeles, the city toward which every tumbleweed, separated from its stalk, blows. Like the drink to which the Dude is devoted, the city itself, according to Mike Davis's celebrated work of urban criticism, *City of Quartz: Excavating the Future in Los Angeles,* is "essentially deracinated": without center, without roots (18). Neither entirely homogenized, nor imperviously stratified, Los Angeles, like the Dude, seems to occupy a middle position between the mixed and the layered. All of which is to say that, as one of the legendary sites for *film noir* gender angst, the city here becomes the site for a postmodern *film blanc.*

The *film blanc,* in this formulation, emerges as a post-masculine negotiation of anxieties of all kinds, even mixological ones. As a pastiche of *noir*—or *blanc* parody, to borrow Fredric Jameson's formulation—it deflects plot and narrative, turning them into play, just as figures like "the Jesus" and as Donny, Walter, and the Dude's repartee in the bowling alley deflect and finally defer the doubly linear logic of bowling. And, apropos of this essay's own collusion in decentered cultural production, it is there, in the pit, that Walter drags the red—no pun intended—herring of V. I. Lenin through the wild (or grey?) goose chase on which the Dude, and we enthusiasts who try to pin him down, have been sent.

It seems somehow appropriate that the World Wide Web should emerge as the primary "place" in which discussions of *The Big Lebowski* and the White Russian should establish themselves and carry on, this volume's bookishness notwithstanding. After all, like Los Angeles, the decentered city in which the film is set, the sprawling history of the

sprawling nation after which the drink is named, and the tangled, metastasized plot of both *The Big Lebowski* and *The Big Sleep* (1946), to which its name alludes—the latter famously too tangled for its famously tangled screenwriter, William Faulkner, to follow—the Web offers the promise of anonymity, liquid liberation, and mixing without mixology.

Notes

1. Because floaters seem, by and large, unaware of any alternative to floating, and homogenizers to mixing, perhaps *faction* is not quite the right term here, as it suggests a self-consciousness of one's oppositional relationship to another faction.

2. Where he had an affair with Frida Kahló. Khaló/Kahlúa ... what might Walter say?

3. Or, perhaps, the places: an apartment on whose rent he is behind; the imaginary dreamscapes; Malibu, from which he is banned; the temporary, transitory spaces of the bowling alley, the car, the diner, and so forth. These all testify to an essentially divagatory impulse animating the Dude.

4. Perhaps bowling alleys, but also alleys of the sort down which Sam Spade's partner, Miles Archer, was lured to his death in Dashiell Hammett's *Maltese Falcon.*

5. Regarding the play of surfaces, it's instructive to note how much attention the camera lavishes upon the various smooth, reflective, retro-1950s surfaces that abound in this film, particularly in the bowling alley, including the finish on the floors, the buffed sheen of the balls, and the play of light on metal, vinyl, plastic, and wood.

Richard Gaughran

The Background

On the first day of classes in the fall of 2006, I walked into a James Madison University class of fifteen students, none of whom I'd met before. I had the usual plan for the first day: a short welcome and introductions, the distribution of a syllabus, followed by explanations and answering of questions. Before any of this, however, I planned to distribute a questionnaire to anyone who has seen the Coen brothers' film *The Big Lebowski.* But I had left the surveys in my office, so I placed my other books and papers on a table and mumbled something about having to return to my office to retrieve some forms I wanted the students to complete. When I returned about two minutes later, I asked, "How many of you have seen *The Big Lebowski*?" For some reason the room erupted in laughter. I didn't think much of that until some weeks later, when one of these students, in my office for a conference, told me what occurred when I was gone from the classroom. After I had dropped my belongings on the table and left for my office, she asked the rest of the students if they had seen *The Big Lebowski,* and didn't I remind them of the Dude? No wonder they thought my question to them, moments later, was funny.

I wasn't surprised to hear this student's explanation. For the past few years students in my classes have frequently asked me if I've seen the Coen brothers' *The Big Lebowski,* because I remind them of the Dude. I

16.1 and **16.2.** Professor Dude and the Achievers at James Madison University.

think I've finally figured out that I have some gestures or manners that they associate with the character, and I've stopped worrying that they've detected a lazy streak or have guessed—wrongly, of course—that I'm an enthusiast for illegal mind-altering substances. But in these exchanges with students I'm always struck by the fact that they seem very pleased to have what they imagine to be a version of the Dude for a college professor. So these reactions got me thinking: What is it that they see in the Dude that they find so desirable? Why did a student once email me for the sole purpose of saying that he appreciated the Lebowski routine and hoped I'd keep it up? I decided that an investigation into these students' attitudes would not only help us understand Dudeness more

clearly but also, and more importantly, reveal something about the current generation of students—their view of themselves and the world in which they live.

To get at these attitudes, I created the aforementioned questionnaire, which I handed out in my own classes and in colleagues' classes. Most of these classes, I should point out, were English

... these reactions got me thinking: What is it that they see in the Dude that they find so desirable?

classes, but not all the respondents were English majors, since James Madison University requires all students to take general education courses in literature. And colleagues in a couple of other departments also distributed my questionnaire. A total of about 180 students completed the questionnaire. I don't claim that my polling has been done scientifically, but the results are nevertheless revealing.

The Survey

I was interested in responses only from students who had seen the film, so before I distributed the survey to my own classes I asked for a show of hands. One of the first things I noticed, and some cooperating colleagues said the same, was the way classes split between those who have seen the film and those who haven't. In upper-level English classes most students have seen it; in lower-level general education courses most have not. And those who have seen it expressed indignation toward their classmates who haven't seen the film. "What? You haven't seen it? What's the matter with you?" Such would be an accurate paraphrase of their reactions.

The questionnaire asked some simple questions about how many times respondents have seen the film and how highly they regard it. Approximately 70 of the 180 claim to have seen it five times or more. Most of these say the film is either one of their favorites or that they like it a lot. Not surprisingly, there's a correlation between how many times a student has seen the film and a favorable opinion of it. It's almost true to say that only those who've seen the film once or twice rate it "so-so" or less favorably.

Mostly, however, I wanted the questionnaire to discover definitions and reveal opinions concerning "Dudeness" or Dude-like qualities. It came as no shock to see the list of synonyms, but I am surprised to learn that the English language has so many for this quality. Bear with this litany of over fifty words or phrases:

Laid-back	Chill	Calm
Carefree	Mellow	Apathetic
Comatose	Controlled	Worry-free
Natural	Suave	Spacey

Nonchalant	Affable	Difficult to upset
Stoned	Relaxed	Easy-going
Blasé	Abiding	Flexible
Complacent	At one with everything	Pacifist
Zen	Taoistic	Buddha-esque
Lackadaisical	Placid	Blissful
Adaptive	At peace	Hanging out
Unfazed	Self-assured	Level-headed
Unshaken	Indifferent	Stress-free
Content	Casual	Serene
Go with the flow	Resilient	Undaunted
Passive	Cool	Disinterested
Being yourself	Accepting	Open-minded
Awesome	Low-key	Non-reactive
Profound	Tranquil	Comfortable with self
Free-spirited	Good-time havin'	Grey

The students mentioned terms besides these, but for the most part they didn't suggest a trend. Some of these other terms I expected, such as "Friendly," "Witty," "Anti-establishment." Other responses don't convey much, such as "My idol," or "The Man." And a few negative terms appeared—and these did form a trend—mostly synonyms for "Lazy," "Worthless," or "Underachieving."

When I asked for more extended remarks, a sentence or two, about the Dude, the responses became more compelling, revealing an underlying tension or ambivalence concerning Dudeness.

There were, to be sure, a small number of respondents who had nothing good to say about the Dude. "A lazy, useless person," said one. Another wrote, "He's what any pothead could eventually become. It's as if he's lost all sense of his real adult self (which comes with responsibility)." This remark was echoed by another: "[He] ignores the societal

call for responsibility." But I must stress that the unqualified *negative* comments were very small in number.

A somewhat larger number of unequivocally *positive* remarks appeared. "He is my hero." And this one:

> Everyone should strive to be as much like "the Dude" as humanly possible. His outlook on life is something to be envied. . . . His attitude, charisma, opinions, etc., are advanced far beyond what many people believe they "should" be.

These unambiguously positive respondents outnumbered the negative ones by about two to one, but both groups were vastly outnumbered by those who expressed themselves ambivalently.

By far, most respondents appreciated the Dude for his Dudeness, but they expressed misgivings about how practical it is to be Dude-like, or else they voiced dismay about their own lives and their inability to express Dude-like qualities within their environment. A lot of these responses included qualifiers such as "However," or "If only." Here's a typical one, reflecting the opinion that the Dude is cool but impractical: "The epitome of a burned-out drifter, yet still very likeable." And here's a remark expressing something like envy for the Dude: "Basically he's one of those people you wish you could be."

Some of the ambivalent remarks expressed misgivings within the context of institutions such as marriage and family. "I'd hate to be married to him, but love to be friends with him," one wrote. In the same vein: "Someone I'd love to drink with. I'm glad, however, that I'm not his offspring."

Broadly speaking, the responses that show appreciation for Dudeness yet a desire to keep these traits at arm's length concern the issue of responsibility or lack thereof. And it's hard to miss the wishful thinking

in many remarks. "He's living the life I wish I could." Perhaps this comment sums up this "if only" ambivalence: "If I wouldn't be seen as a complete and total failure, or if I knew I had the financial security to do so, I would attempt to live my life in a similar way. Who wouldn't want to walk around in a bathrobe with a White Russian, bowling for the rest of his life?"

"Someone I'd love to drink with. I'm glad, however, that I'm not his offspring."

At this point in the process I was thinking that, in general, college students, or at least those whose attitudes I tapped, were living lives of quiet desperation. Their enthusiasm for the Dude, mitigated by frustration that contemporary pressures and responsibilities make Dudeness difficult to embrace fully, had me wondering whether young people weren't poised for a countercultural manifestation like the back-to-nature movement of the 1960s that found expression in various rural communes. Are students ready again to "tune-in, turn-on, drop-out"?

I then convened a focus group, drawn from respondents who said they've seen the film five or more times but on the questionnaire also expressed ambivalence about Dudeness. I invited ten of these students, five women and five men, striving for gender balance. As it turned out, only eight were able to attend the session, three women and five men. Nevertheless, something like a consensus emerged about the meaning of the Dude.

The Conversation

My desire to assemble a discussion group with women and men equally represented stemmed from my own notion that the Dude appeals more to men than to women. Therefore, I immediately raised this topic, but

the students gave the impression that they are weary of such concerns. A student named Kaitlin seemed to settle the issue for the group when she exclaimed, "Chicks can be Dudes too!"

After reciting the list of synonyms I had compiled from the questionnaires, I pressed the students further on the issue of the Dude as a role model. They dismissed the notion that the Dude was a role model in the sense that he should be imitated. After a student named Anthony remarked that students calling the Dude a role model are being hyperbolic, another, Andrew, admitted as much: "I called him a role model [on the questionnaire], but it was

"Chicks can be Dudes too!" half in jest, or maybe a quarter in jest."

The Dude, everyone agreed, provides vicarious release, but not exactly a paradigm for living. Students noted that Sam Elliot's character, almost in the first lines of the film, identifies him not as a hero but as just a man. And Kaitlin analyzed the Dude's function this way, in the context of societal pressure:

> We're exposed to all these images of media heroes, war heroes for instance, or people who do all these fifty million amazing things in one day and then go home and put dinner on the table. And it's really refreshing, and in a way he is kind of a modern hero for our generation, where he can still live a morally good life, and even with bowling and getting drunk all the time. He's not somebody we say, "Hey I wanna be like that." We can joke and say it. But we realize we're saying, "If I didn't have to be something it would be kind of nice."

Megan, also in the group, put it this way: "If you were presented with a choice by a genie: you can be the Dude or you can go the accepted society route, you'd have to really think about it. But it's a fun dream." And Alex summed up the issue this way:

There's so much expected of us right around this age. We realize we're in the last few stages before we walk out into the open world, and we're done with all the kid stuff, and seeing him being able to do that, you know, he's out there in the open world, and he makes us jealous, 'cause we're still working to get there. But we probably won't be able to get there, because there's so much expectation, and one thing always leads to something else.

The Dude, then, provides a kind of imaginative respite from everyday life. Yet, the Dude does exhibit traits students feel they can incorporate into their own lives while remaining responsible citizens. Perhaps foremost among these is the character's insistence on self-definition, the forging of his own identity, in spite of what others think or attempt to dictate. A student named Matt put it this way: "You don't necessarily want to *be* the Dude, but you want to have that freedom to be what you want to be." Alex concurred, reminding us that other characters in the film show the same independent spirit and style: "Like Sam Elliott's Stranger has his own style. 'I dig your style'. . . . 'I dig yours too, man.'" So, perhaps the Dude and the Stranger connect because they've both invented themselves while rejecting roles being dictated by the likes of the Big Lebowski. And Andrew added another example of this admirable autonomy, returning briefly to the issue of gender roles: "Maude is sort of a female version of the Dude in that she's living life the way she wants, no matter what the dominant culture thinks."

The focus group settled into admiration for the Dude for other traits. At first Megan expressed disappointment in the Dude for being too subservient to John Goodman's character, Walter, even calling this element in the Dude his "one fault." The group then attempted to explain this seemingly unlikely friendship. Finally, Matt introduced the idea that the Dude, Walter, and Donny have invented a kind of alternative family unit:

What strikes me is that the three of them . . . are like a family. We know nothing about their real families. All we know is that Walter has an ex-wife with a dog that has fucking papers. They're like an invented family, even though they're different. In a way, the setting with the first Gulf War, when people are at odds, makes this kind of arrangement the perfect thing for the times. That's the perfect family for that world. They may not agree on anything. We're in the middle of a foreign war. One of these guys was in the last war, one of these protested the last one, and they don't agree on these things, but for some reason they stuck together. It's really important for them to be a family.

Another discussion developed around the point that, though the Dude is undependable in one sense, he is quite reliable in another. When Anthony remarked, "You don't want to depend on him," Matt made a distinction: "Not for practical things, like paying the rent. But for emotional things, like supporting your landlord's Jack and the Beanstalk dance." Matt here was referring to a scene that takes place at the Dude's front door. The landlord invites the Dude to his dance recital, and he reminds him that the Dude's rent is late. I asked the group if they, like me, initially had the mistaken impression that the Dude would soon forget about attending the dance recital the same way he shrugs off thoughts of paying the rent. The students concurred, saying that they too were surprised to later see not only the Dude, but also Walter and Donny at the recital, as if in unconscious recognition that the landlord is "one of them."

When the group began talking about the unlikely bonds the Dude forms—with Walter especially, but Donny, his landlord, Maude—I read them a comment from the questionnaires, written by a foreign student from Germany: "[The Dude is] the ultimate American, in so far as he is independent and has his own style, taking his own freedoms . . . does not acknowledge class differences, crossing the borders easily."

The group agreed with this sentiment, and a student named Chris applied a label to this tendency, referring to the Dude's "Taoist qualities." When Sarah asked if Chris meant the Dude's being "able to take things as they come," Alex ran with the theme: "The Walter/Dude thing is Taoist. They're exact opposites. Yin and Yang. But they fit together." Matt agreed: "There is a Taoist reality there. You know, don't distort reality to fit what you think it is. You deal with it as it comes."

The Conclusion

To summarize, I think consensus emerged around three points. First, the Dude is not a hero or role model, but Dudeness does provide imaginative, vicarious respite in a chaotic, demanding world. Second, the Dude shows that self-definition, the forging of one's own identity, is possible, though the particulars can be problematic. Third, the Dude reminds us of important values, including friendship and the ability to cross boundaries to forge friendships. I then rather pedantically pointed out to the students that some of these conclusions placed the Dude in an American literary tradition, one that Henry David Thoreau expresses in *Walden* and elsewhere. The students dutifully nodded in agreement, but, Dudes all, they didn't seem eager to think of the Dude in such academic terms.

Matt eloquently summarized the discussion, and I'll give him the last word on the Dude:

> He's a man for the times. He lives in a disjointed society. And he's an anti-hero. He doesn't solve some big adventure case. He doesn't stand for what everybody thinks he should stand for, but he has his values. He just does it. He lives in a very disjointed society, but he's gonna take things as they come, he's gonna care about his friends, he's gonna go to somebody's recital, and that's it. That's how you respond.

Acknowledgment

Obviously, this investigation would have been impossible without the support of colleagues, especially Lucy Bednar, for her help with logistics and her detailed notes of the discussion group. I am thankful for the cheerful participation of students at James Madison University. In particular I want to thank Matt Arduini, Chris Ballard, Megan Bobrow, Anthony Carter, Kaitlin Connors, Alex Jones, Sarah LaPrade, and Andrew Williams. I dig your style, Dudes.

David Pagano

Non-human animals do not get much screen time in *The Big Lebowski*. We do see two domestic, misnamed mammals, one that Walter calls a Pomeranian and another that the Dude calls a marmot, but they are onscreen for only seconds. Other animals appear even less prominently, but before the film is over we hear the songs of humpback whales and the cries of seagulls, encounter a woman named Bunny, and apprehend references to bears, camels, walruses, steers, and pigs (in a blanket). It seems, then, that though they are not often visible in the film, animals manage to leave their tracks or traces in the possibilities of meaning that the movie generates. The question is, can we follow those tracks, master these traces, or do they constitute too many strands to keep in our heads? A little of both, I suggest: animals are an essential component of the Dude's journey or anti-journey, but because they speak insistently to the question of language in the film—more specifically, the question of how or whether language can cross boundaries and establish communication—they must to a certain extent escape our snares. In a word, in this film, animals *abide,* both with and within the Dude and his friends. Although I do not have time to address all of the species cited in the film, I show that *animality,* if there is such a thing, is a central concern for the Dude and for the human comedy he inhabits.

In her comprehensive book *The Brothers Grim: The Films of Ethan and Joel Coen,* Erica Rowell reads *The Big Lebowski* as "an antiwar polemic

*... animals **abide**, both with and within the Dude and his friends.*

disguised as a hilarious hippie boondoggle" (208). It is a masterful reading, exhaustively drawing together many of the film's elements into a central task of "spotlight[ing] corrupt power, ill-waged war, and phony rationale" (239). She does not make much of animals in the film particularly, but in an appendix to the book she mentions that throughout the Coens' work, animals are "often emblematic of a character's wild nature" (345). I follow this line in some detail, asking what it might mean to say that any of the characters in *The Big Lebowski* have a "wild nature." Certainly, Walter's ex-wife's dog seems to mirror in miniature his own bombastic, voluble self-assertion. And the *"small animal"* (as the published screenplay has it, 72) leashed by the nihilists echoes their sleek, comedic but troublingly unpredictable threats. However, Rowell's statement provides an entrée into the specifics of how animals are represented in *The Big Lebowski,* which, I believe, turn out to be quite complicated. But first we must detour through some recent writing and research about the place of animals in western culture more generally.

Erica Fudge's introduction to these current debates, *Animal,* puts it succinctly: "we always turn away from animals to look at ourselves" (107). What she means is that, traditionally, Western discourse about animals has strained to separate human from animal and to place the former over and above the latter and, moreover, has depended upon that distinction (consciously or not) to guarantee that contemplation or representation of animals serves primarily to investigate the human rather than the animals we putatively represent. We might say that when we follow the animals' tracks, we do so primarily for the purpose of marking our own territory. We trace our own outlines by determining humanity *in relation* to animality. In this autopoietic (or perhaps merely question-begging) procedure, we have largely structured "humanity"

by using animals as screens to reflect ourselves back to ourselves; the animals in themselves remain hidden or unseen. Fudge discusses some writers who, perhaps Kantian in spirit, are skeptical of ever "seeing" animals in themselves, and who argue that animals will always remain "'a blank paper'" (51) or that the best we can do is acknowledge the human tendency to think via metaphors and then find a more adequate metaphor for them than we have managed so far (11–12). She finds these attitudes unduly pessimistic, though she acknowledges that the challenges to seeing animals in themselves are large; she certainly argues that the dominant state of affairs for most of Western history, up to and including ape-language experiments, is unacceptable. Summarizing the critiques of such experiments by Hank Davis and Noam Chomsky (who, like Fudge, advocate for ethically studying animal communication systems based on what those systems do for the organisms who use them, not how closely they might approximate human language use), she writes, "What is revealed in ape language and many animal intelligence experiments, Davis and Chomsky argue, is not so much the animals' capacity, or incapacity, as our inability to look beyond our own frames of reference" (138).

The phrase "frames of reference" is an important one in the discussion below, but for now we should note the turn to the question of language in the previous paragraph. This is no accident, for among the most studied questions today concerning the relation between animal and human is whether any of the former possess the ability to use language. Much of the debate has to do with how one understands the word "language." There is no disagreement, of course, over whether animals can *communicate,* just over whether any of them naturally exhibit or can be taught language as humans understand it. For linguist Stephen R. Anderson, the answer, for now, is no: "There is no reason to believe that human language per se is accessible to other animals" (304). Anderson's

"per se" is composed of "at least" three essential elements: a lexicon, phonology, and syntax (294), elements, he argues, that science has not yet shown animals to be able to master. His position fits what Jacques Derrida claims has been the basic position on animal communication in the Western philosophical tradition, that animals can "react" but not "respond":

> All the philosophers we will investigate (from Aristotle to Lacan, and including Descartes, Kant, Heidegger, and Lévinas), all of them say the same thing: the animal is without language. Or more precisely unable to respond, to respond with a response that could be precisely and rigorously distinguished from a reaction, the animal is without the right and power to "respond" and hence without many other things that would be the property of man. (400)

In Cary Wolfe's gloss, this would be because "the capacity to 'respond' depends upon the ability to wield concepts or representations, which is in turn possible only on the basis of language" (133). Derrida poses a number of ethical questions to this traditional thesis, many of which turn on the assumption that (human) language should be considered a concept- or representation-delivery vehicle in the first place. That is, he asks whether it is clear that whatever we mean by animal communication does not inhabit language at its heart or its origin (we might say, whether the animal inhabits the habit or habitat of language [all from Latin *habēre*, to have or hold]). Western thought would then have taken it upon itself to exile the animal from the dwelling of language. Now, Derrida, Fudge, and Anderson all agree that we should hesitate before comparing human and animal communication, since such comparisons usually turn out invidiously to assume that the latter is merely a less elevated version of the former. It is just that Anderson's title and

conceptual frame—*Doctor Dolittle's Delusion*—suggests that the big mistake is thinking we can apply our own linguistic understanding to the communication systems of other species; Derrida, on the other hand, suggests that the big mistake is assuming a transparent intra-species understanding or communication in the first place.

Another way of approaching this question, though without the same insistence on language per se, can be found in Giorgio Agamben's *The Open: Man and Animal,* where he argues that the "anthropological machine" of the West (through Heidegger, if not beyond) has generated "the human" as the difference or conflict between "human" and "animal." The human is what must always separate itself from its own animality: "in our culture man has always been the result of a simultaneous division and articulation of the animal and the human, in which one of the two terms of the operation was also what was at stake in it" (92). To be human is to re-create perpetually one's humanity by separating it from one's animality. This is a tradition that has been intimately intertwined with various mind-body dualisms, so it is not surprising to find Descartes in his *Discourse on Method* suggesting that animals are something like autonomous machines, pure reactive bodies. They are animals because they do not bother disavowing their animality or their somatic nature. We must keep in mind these historical links between body/animality/reaction and mind/language/response as we proceed.

Agamben notes that the "anthropological machine of humanism is an ironic apparatus that verifies the absence of a nature proper to *Homo,* holding him suspended between a celestial and a terrestrial nature, between animal and human—and, thus, his being always less and more than himself" (29). The addition of "celestial" importantly highlights humanity's attempt to further articulate itself in relation to divinity,

for as Derrida and Fudge both observe, one of the originary moments in the Western tradition of differentiating human from animal is Genesis 2:19: "So out of the ground the LORD God [*Yahweh Elohim*] formed every beast of the field and every bird of the air, and brought them to the man to see what he would call them; and whatever the man [*ish*—not "Adam" until Genesis 3:17, so at this point a species name, which we must keep in mind when we consider "the Dude" below] called every living creature, that was its name." Fudge points out that this verse establishes an analogous relation between, on the one hand, God and animals and, on the other hand, man and animals. God may physically shape the animals, but it is up to man to complete their creation via semiotic identification or determination. She writes: "It is as if the animals had no identity, no presence without Adam, and their inherent powerlessness, perhaps most easily described as their inability to name themselves, has persisted in human relations with animals" (13). (She does not further mention that in these verses, God seems to create animals in the first place only because the lonely man has no helpmates, even as this implication may sit uneasily with animals' chronological priority in the "wet creation" story of Genesis 1.) Moreover, the West's inaugural scene of man meeting animal turns out to also be our inaugural scene of our own language use. Man's mastery ("dominion" in Genesis 1:26) of animals is simultaneously the reassurance that man has mastery of language, in that our words naturally, unambiguously, and correctly correspond to objects in the world. Here at the beginning, the essence of the difference between man and animal seems to be language mastery versus muteness. There seems to be no room for either animal language, on the one side, or linguistic confusion, on the other. Yet, although Agamben does not comment on Genesis, we might extrapolate his "suspension" comment above to suggest that *ish* may be read as the creature of God as well as the co-creator of the animals, both "terrestrial" and "celestial,"

thus not so much comfortably situated in a hierarchical architecture as riven from within by a process of self-definition through nomination of the other(s).

What does all this have to do with *The Big Lebowski*? First, everything in the film turns on language, or more precisely on the failure of language, or more precisely yet on the failure of language to act as a transparent medium through which objects can be clearly identified and ideas or affects can be transmitted from one self-knowing individual to another. The entire plot is set in motion by the ambiguities of a proper name, "Jeffrey Lebowski," which turns out to stand for two very different individuals, and its subsequent convolutions owe almost everything to misunderstandings and miscommunications. Moreover, much of the humor arises from linguistic misfirings and failures to communicate. Sometimes this occurs through "rambling" or "blathering" incoherence on the part of one character. More often, though, miscommunication happens through one character assuming a "frame of reference" that another character does not share. Walter sets up this basic mechanism of the film when he absurdly chastises Donny for the first of Donny's many questions in the film: "So you have no frame of reference here, Donny. You're like a child who wanders in in the middle of a movie and wants to know—" (here and elsewhere in the dialogue I cite, characters fail to complete their thoughts, due to both internal and external causes). Indeed, throughout the film Donny's questions reflect on the various competing frames of reference that impede communication and generate conflict and humor. Donny never assumes or appropriates frames of reference in order to assert; rather, he exists on the other side of the continuum, only ever questioning, remaining on the outside of any frame. For the Dude and Walter, on the other hand, frames of reference frequently collide. For example, there is this exchange when Walter arrives at the lanes with Cynthia's dog:

WALTER: Way to go, Dude. If you will it, it is no dream.

DUDE: You're fucking twenty minutes late. What the fuck is that?

WALTER: Theodore Herzl.

DUDE: Huh?

WALTER: State of Israel. If you will it, Dude, it is no dream.

DUDE: What the fuck're you talking about? The car-
rier. What's in the fucking carrier?

The demonstrative or deictic "that" in the Dude's question—a question posed between frames of bowling—is where the two frames of reference cross. Each man is a child wandering into the other's film. (Indeed, it could be argued that the Coens' entire filmmaking style consists in highlighting the productive absurdity that arises in transferring elements across cinematic frames of reference—for example, *The Big Sleep* crossed with the Western crossed with a satire or celebration of 1960s radicalism). "What the fuck are you talking about?" is a phrase which recurs, mutatis mutandis, throughout the film and could well be its motto.

Certainly it could be the motto of the scene that this exchange introduces, which also sets up the relation between animality and communication that the film explores. Its humor resides in part in the split between rules and interest, which we might be inclined to say is the split between human (rules, law, order) and animal (interest, instinct, passion). But this split occurs *inside* of a human character: "Walter, whose belief in rules shines through his knowledge of rodent ownership in city limits, has no qualms about letting his ex-wife's Pomeranian run around the lanes" (Rowell 350). Leaving aside for the moment the question of what species of dog it may be, clearly the animal does echo the way in which Walter perpetually agitates the Dude. But we should keep in mind that it is not so much the dog as such that bothers the Dude as the way in which the dog's animality is deployed by Walter. Moreover, the dog most emphatically acts in an apparently animalistic way (1) in

responding or reacting to *Walter's* violence when he draws a weapon on poor Smokey (a wildly non-rule-bound response to a perceived transgression of the rules); and (2) by barking and jumping up to Walter as if, precisely, to communicate. An ambiguous communication, to be sure, that could express either admonition or encouragement or—who knows—both. "What the fuck are you talking about?" is both what we might ask of it and what it seems to be asking of Walter. The animal here is both inside and outside of both human and non-human characters. For me, the funniest frame- or boundary-crossing aspect of the scene is Walter's response to the Dude's "You brought a fuck-

Indeed, dogs do not bowl, but clearly humans do not always follow the rules either.

ing Pomeranian bowling?" by which the Dude seem to mean to designate that the dog is out of its element. Walter's mismatched response turns on the ambiguities of "brought": "What do you mean brought it bowling? I didn't rent it shoes. I'm not buying it a fucking beer. He's not gonna take your fucking turn, Dude." Indeed, dogs do not bowl, but clearly humans do not always follow the rules either.

Walter's revision of "brought" is related to a particularly interesting species of this frame-of-reference genus in the film, namely, the Dude's habit of appropriating words and phrases he hears and awkwardly importing them into later conversations (for example, "this aggression will not stand," "you mean vagina?" "Where's the money, Lebowski?" and, with appropriate self-reflexivity, "to use the parlance of our times"). Again it is a question of translation across different frames of reference, a kind of bumbling creativity that repeats words with a difference in order to form them into something absolutely new.

I return to this question below, vis-à-vis the word "abide," but more generally we can say that its implication is that potentially every word

17.1. Has papers, but lacks a proper name.

spoken in the film, at least every word spoken by the Dude, should have quotation marks around it, cited as it may be from some previous context. That this is the case for language in general is not beside the point. To cite linguist Stephen Anderson again, "According to [Ray] Jackendoff, a significant step in the transition from [animals'] fixed calls to [humans'] protolanguage was the separation of meaningful cries from specific situations. [. . .] Think of an infant's first words [. . .]: 'kitty' can mean 'Look at the kitty,' 'Where's the kitty?' 'Come here, kitty,' "That looks like a kitty,' and so on" (315). But a point upon which both Derrida and the Coen brothers might insist is that innumerable possibilities of what we might call generative confusion spring up as soon as "kitty" can mean anything other than this particular kitty in front of me here and now. Indeed, I have been writing here of "animals" in the film, even if, as Derrida writes, this is a word we would do well "to keep within

quotation marks": "as if all non-human living things could be grouped without the common sense of this 'commonplace,' the Animal, whatever the abyssal differences and structural limits that separate, in the very essence of their being, all 'animals'" (402). Knowing that it cannot be a matter of simply giving up that word, or of giving up language, Derrida works though "animals" by coining *"animots,"* which, as Derrida's translator David Wills notes, is a "portmanteau neologism, combining 'animal' and 'word,' [and which in French] is pronounced, in the singular or the plural, the same way as the plural of 'animal'" (405). This new word does not wipe away the sense in which to talk of animals is to assume some *concept* of animality, to group together the absolutely different as if they were the same, but its self-reflexivity does, Derrida hopes, suggest a way to begin considering animals and our relation to animals in new ways. Any such new ways also would need to include the avowal that we who speak are no less "animals" than those of whom we speak, and thus would need to question any presumed mastery over them that would be based on difference and superiority—including especially the superiority implied in being first of all the masters of language.

Does *The Big Lebowski* offer such a new way of thinking? Human thought and human language necessarily entail violence to any singularity by encompassing it within some frame of reference, caging it within some concept. Perhaps, then, there is at least an ethics in multiplying those frames and continually rebuilding the cages, keeping them mobile and unsettled, and always being open to the surprise of confusion and laughter. As I mention above, the two most significant animals we see are misnamed, so we need to "keep [them] within quotation marks" also. As Rowell observes, "the ferret the nihilists throw in the Dude's bathtub is incorrectly referred to as a marmot" (350). The Dude himself makes this referential mistake ("Nice marmot"), but in this he follows Walter when he said of Cynthia's dog "I think it's a Pomeranian,"

> *Both Walter and the Dude are failed masters of language, fallen from their properly Adamic role as animal namers.*

even though the animal pretty clearly looks like a cairn terrier. Both Walter and the Dude are failed masters of language, fallen from their properly Adamic role as animal namers.

In one sense this "failure" nudges their humanity toward animality, inscribing an unmasterful, iterated naming process within their human mastery. However, the Dude also takes pains to insist on his *own* proper name. As he says to the Big Lebowski, "Look, let me explain something. I am not Mr. Lebowski; you're Mr. Lebowski. I'm the Dude. So that's what you call me. That, or his Dudeness. Or Duder. Or El Duderino, if you're not into the whole brevity thing." That the Dude is comfortable with these variations of his essential name may speak to the security resulting from his radical self-referentiality: as the Stranger says in his opening voice-over, "A way out west there was a fella, fella I want to tell you about, fella by the name of Jeff Lebowski. At least, that was the handle his lovin' parents gave him, but he never had much use for it himself. This Lebowski, he called himself the Dude." Seeking self-circumscription via self-naming, autonomy via autonomasia, the Dude grasps himself with his own handle. Indeed, he does so "manually," as he suggests to Jackie Treehorn, holding his own ground against the possibility of what we might call a post-human, virtual sexuality. And given the echo of the Latin *manus* (hand) in the Dude's comment, this may be the place to recall that for Heidegger, "[a]pes, too, have organs that can grasp, but they do not have hands" as humans do (*What Is Called Thinking?* 16).

Moreover, "the Dude," while proper to him, is, of course, precisely not a "proper name"—at least, not until it begins to circulate within the

Dude's frame of reference. Prior to his self-naming, the word would have come to the Dude as something more like a category or species or concept, that of "dudes" or "dudeness." Which itself is multiple, for "dude" in this film collects both the sense of a "city dweller unfamiliar with life on the range," as *Merriam-Webster's Collegiate* has it, and "fellow, guy," in the parlance of our times. The multiple species of "the dude" (the essence or idea of dudeness, as one might say of "the animal" when discussing "the question of the animal" in philosophy) has come to be *uniquely* specific to this one individual. All the more so in that most characters end up referring to him as "Dude" without the definite article, in the way that one might name one's cat "Kitty." The Dude, then, would be living up to his properly human status in deploying language such that each word, including whatever name *ish* may have given to each animal, necessarily gathers up *many* into an assumption or idea of *one*. In addition to the ability to trans-contextualize, Anderson writes, human language requires exactly this kind of gathering:

> Further, even at the earliest stage, babies have some words that refer to particular *individuals* ("mommy," names) and some that refer to *types* ("kitty," "car"). This distinguishing between proper and common noun references is another feature lacking in animal calls. Animals certainly recognize specific individuals as opposed to types, but the distinction is not reflected in their communication. It is, however, present in (and essential to) real language—even protolanguage. (315)

The Dude is always seeking an autonomy of ease, where "fuck it" or "take it easy" are indeed, in a way, his answers to everything. With "The Dude" he means to self-apply a mood or style of life, a genre or "type" of life, to use Anderson's word. This life would in one sense be preeminently human, rising above challenge and struggle in order to simply be.

But his challenge, and much of the humor in the film, comes from the world failing to recognize his humanistic self-assertion and micturating on his would-be relaxed lifestyle—beginning with actual micturation, which prompts the Dude to cry, "At least I'm housebroken!" to Jackie Treehorn's thugs. He is not an animal, at least not an undomesticated animal, he asserts (just as he asserted in his self-naming). Yet in other ways this is precisely what he would like to assert, and in general much of the Dude's struggle for mellowness ends up articulated through the difference (if there is one, as Derrida would say) between animal and human. At the same time as the Dude attempts to assert his human prerogative to self-name, his very quest for mellowness, his struggle to abide, is also a kind of quest toward becoming-animal. This would not exactly be the famous "becoming-animal" of Gilles Deleuze and Félix Guattari's *A Thousand Plateaus,* although it might bear some family resemblances, including an attempt to break free from "the square community." In fact, Donna Haraway has recently criticized Deleuze and Guattari's becoming-animal in a way that might resonate for us. Despite their appropriation of a certain idea of animality ("the pack," which to them connotes a contagion-based model of subjectivity to counter a Freudian one), she writes, their text is "a symptomatic morass for how not to take earthly animals—wild or domestic—seriously. [...] I am not sure I can find in philosophy a clearer display of misogyny, fear of aging, incuriosity about animals, and horror at the ordinariness of flesh, here covered by the alibi of an anti-Oedipal and anticapitalist project" (29, 30). These are absurdly harsh terms to yoke to the Dude's frame of reference, but there may also be a fine line between horror and humor, and if Deleuze and Guattari, according to Haraway, seek to escape much that they fear, so does the Dude. Through animality, precisely. (Haraway also has a fine and nuanced critique of Derrida's position, sympathetic but suggesting that he too does not sufficiently attend to the growing

body of positive knowledge about what might constitute certain animals' ways of being [19–23].)

We can see this when we look carefully at the scene in which the "marmot" arrives and at that scene's context in the film. As the Dude's anxiety increases over the course of the film, we see him taking steps to self-soothe, including listening to a tape of the 1987 Venice Beach league playoffs and performing *tai chi*. But the most laid-back we see him until the film's final moments is lounging in a candle-lit bath, smoking a jay, and listening to what the tape case identifies as "Song of the Whale: Ultimate Relaxation." This comes just after a double assault on his mellowness: another public rant by Walter, which follows the traumatic exposure to what he has every reason to believe is Bunny's toe. Note that the violence hidden in the image of a lucky rabbit's foot is revealed insofar as it gets displaced onto a human, even if that human turns out to be the "nihilist woman" rather than Bunny herself (and we can glimpse here that this entire problematic of the animal should be crossed with a discussion of gender in the film, which would need among other things to return to *ish* naming the animals alone, before *ishshah* is even created as "a helper fit for him," more adequate than the animals [Gen. 2:20]). Whether or not the Dude is pondering this linguistic play, he is certainly considering the violence of which the nihilists might be capable, because the scene begins with a point-of-view shot from his perspective, contemplating his own toes poking out of the water as he drifts (like the tumbling tumbleweeds) in the white noise of the whale songs and the gurgle of the tub's drain. The toes are visually severed from his body in this shot, decontextualized from him and morphed into signs of someone else's threat to him—as was, more literally and brutally, the toe which the Big Lebowski presented to the Dude earlier. Here, the body is translated into a message, animal(istic) violence uses a physical body as its tablet, and the toe is transformed into a perverse parody of a finger

pointing or pointing out. (We should not forget that Bunny's license plate reads LAPIN, as if to clarify that whenever the film articulates questions of the animal it also articulates questions of language, since the Coens highlight the arbitrary nature of two words for "rabbit" in two languages, English and French.)

The Dude's floating is an attempt to clarify the difference between language and the body or the animal, to abandon the former and abide in the latter. This floating is synecdochic of the Dude's entire life project of projectlessness, in which we can hear another version of the Western model of animal as reactive: we can imagine that animals Edenically dwell in the perpetual now of the moment's sensation, blissfully free of the human curses of self-consciousness, disappointment, and hypocrisy. Indeed, the mise-en-scène echoes the scene much earlier in the film when the Dude's face is violently submerged in his own toilet by Jackie Treehorn's thugs, its 180-degree difference in affect reflected in the cinematography, in the shift from the low-angle shot up toward the Dude's forcibly dunked face to the languid point-of-view shot described above. It is as if the Dude were transferring the image of his being submerged from one frame of reference to another. Suspended in the moment, unmoored from memory and anticipation, cocooned in a kind of undifferentiated ambiance, the Dude draws on the whale's song, just as he draws on his joint, to help relax himself into another state of being. That state would be without language as well (which, as we have seen, is the cause of all his problems)—except that it is precisely cetacean communication that the Dude appropriates here (much as he appropriates the human language traces I mention above). His frame of reference for these sonic patterns is wholly other than the (presumably humpback) whales', who, scientists think, probably use their songs primarily for sexual selection. This would be, for them, a matter of survival rather than escape or "ultimate relaxation." Even if this included an aesthetic

component for them (who could prove otherwise?), the Dude's use of the songs is a kind of figural "misnaming" of them, an attempted escape from communication that cannot overcome communication.

Another way to say this is to point out that needing to *seek* project-lessness is already to have fallen into "the whole durned human comedy," as the Stranger says; the human comedy in this film is, in fact, the relation of that comedy to animality. Here, it is predicated upon our inability to inhabit the Dude's fantasized animal Eden of consciousless-ness. In *The Big Lebowski,* that gap or distance is indeed the source of comedy; in other kinds of films, including many in the noir genre that the Cohen brothers play off of here and elsewhere, it is a source of horror or despair. In any case, to have to try to float in the whale's song is already to fail to reach the no-place the song represents. Moreover, the Stranger specifically links the human comedy to time and history: "I guess that's the way the whole durned human comedy keeps perpetu-atin' itself, down through the generations, westward the wagons, across the sands a time until—" (140). The human for the Stranger is continu-ity, temporality, process, and all this is what the Dude wants to be sus-pended outside of, as if in an eternal now or presence. Ironically, it is his perpetually agitated friend Walter who possesses this more disjointed or fragmented sense of time, such that he can, minutes after cocking his weapon and aiming it at Smokey's face, proclaim that "it's all water under the bridge." Walter does not need to try to achieve animality, he is merely there where animality is—where a certain idea of animality is—and he profoundly fails to partake of the emotional suspension the Dude seeks.

The Dude may be reminded of all this when the toilet scene is repeated with a difference as the nihilists and their "marmot" arrive. Again, the

Walter does not need to try to achieve animality, he is merely there where animality is …

nihilists are comedic, but they are also violent and cruel (Donny does die), and they appropriate animality in a much less benign way than the Dude. That the Dude is threatened by the "marmot" is a direct function of its own panicked distress. In particular, the dialogue and mise-en-scène remind us that it is his johnson (another play on the proper name) in particular which is threatened with decontextualization by the sleekly phallic ferret (compared to which marmots are less phallic and more rounded, phenotypically related as they are to squirrels, prairie dogs, and chipmunks). The brutality of the animal here is a function of the human; there would be no animal brutality if that animal were not being (mis)handled by humans (which recalls the "Pomeranian" in the lanes). Which leads one to wonder whether there is any drifting suspension, as in the Dude's fantasy of the whale, except from the point of view of the being that yearns for drifting suspension, the human. But as fast as the Dude is yanked out of his fantasized and virtual whale-Eden, he is returned to his own animality as his distress matches that of the "marmot." His body and the other's body both are "reduced" to reactivity, which does not stop them from communicating for and to those who have eyes to see or ears to hear. This, then, is the closest the scene gets to actual animality: bodies in terror, speaking mutely. Both the "marmot" and the Dude are out of their elements in this suspension, but they are speaking the same language.

As we know, the Dude abides. In the tub, naked as an animal, he would abide as animal, he would approach the status of the abiding animal, the merely living existent. But before the Dude abided, the Big Lebowski insisted that he would "not abide another toe." A hypocrisy and a dissimulation, no doubt, but this "abide," carrying the sense of "bear," "suffer through," or "withstand," agitated the Dude and precipitated his abiding in the bathtub with the whale songs. This other "abide," the sense the Dude invokes so famously at the end of the film, says its

17.2. "Less Phallic and More Rounded." Gustav Mützel [illustrator], "Steppenmurmeltier." From A. E. Brehm, *Thierleben [Allgemeine Kunde des Thierreichs]* (1883).

historically older meaning, which suggests an emptier passivity: to "wait," "continue," or "linger." It is this sense of pausing the temporality of human life, of entering a space beyond or outside of suffering, a space beyond or outside of time itself, that the Dude seeks in general and in the tub in particular. However, it is time and suffering that the nihilists return to him and that they show him to be thoroughly animalistic. To which we may add another frame of reference: "the Dude abides" cites *Night of the Hunter*'s (1955) conclusion, when Rachel Cooper says, after two children have gone through terrible trauma: "Children are man at

his strongest. They abide. . . . The wind blows, and the rains are cold. Yet they abide. . . . They abide and they endure." *Abide* as in "persist" but also as in "suffer," and just as the child may be seen as the human at its strongest, the Dude yearns for the strength of the animal. (That the West has often associated animals and children is not accidental either, imagining as it does that both may be free of the torment of fully articulated language.) All circulating around a Bunny's toe. As this point, the film may lead us to ask what exactly separates and links the human from the animal and whether thrashing for one's life can rigorously be distinguished from communication. The nihilists certainly mean to communicate something with the toe and with their animal; does the "marmot" communicate another unspoken message? Would it be anything like the Dude's when he says, "Walter, you're right, there is an unspoken message here. It's 'Leave me the fuck alone!'"

The different responses of the Dude and Walter to this incident are hilarious and telling. For Walter, it is a rule-free invocation of the rules. He can scarcely fathom the idea of believing in nothing, having no ground or law (except, presumably, self-interest, like an animal), and adds, "And let's not forget—let's not forget—keeping wildlife, uh—an amphibious rodent—for, you know, domestic—within the city—that ain't legal either." He can at least offer a coherent sentence of judgment on the question of what he takes to be a human ethos (even National Socialism), but when he turns to the relation between animal and human, both syntax and statute fail him. When the animal, or the idea of the animal, invades, the human finds its organizing structures becoming unstable. Mastery over both language and law collapse for Walter, and it becomes difficult to tell the difference between him, an animal, and one who might believe in nothing.

The Dude's reaction is his perpetual agitated failure to achieve whale-song mellowness: "What're you, a fucking park ranger now? [. . .]

Who gives a shit about the fucking marmot?" The Dude cannot help but reflect on Walter's humanity in relation to the animal; he disdainfully places him in the (absurd) role of park ranger and is dismayed that the focus is not squarely on him and his johnson. His "who gives a shit" certainly in

The Dude's reaction is his perpetual agitated failure to achieve whale-song mellowness: "What're you, a fucking park ranger now? [. . .] Who gives a shit about the fucking marmot?"

part refers to the "marmot" in itself (its fate, its life, whether it suffers), but given Walter's statement it also refers to however the animal might reflect on the nihilists and their legality. That is, it reflects on the Dude's strained appropriation of animality by expressing both his relative (and quite understandable) unconcern for the animal and his all-too-human inability to separate the animal from its position in the human economy. This inability to simply *be* the animal is what continually frustrates the Dude.

I began this chapter by suggesting that in *The Big Lebowski*, animals abide. We are now in a position to see that this is so in both senses of the word: first, they remain, rest, or continue and continue as they were, left alone, for we "know" nothing about any of the non-human animals in the film, not even or not especially what their names are; second, they endure or suffer through, without human help. But they abide in a third sense as well, in that they dwell or persist within and between the human characters. This may not be an ethics that by itself will help in addressing particular problems of specific animals in the world today, but it is the ground of a frame of reference toward both them and ourselves that suggests that the animal is integral to the whole durned human comedy.

18 Logjammin' and Gutterballs: Masculinities in **The Big Lebowski**

Dennis Allen

To be honest, I'll admit that I'm a bit embarrassed by the topic of this chapter—masculinity in *The Big Lebowski*—simply because it is so obviously thematized, so omnipresently *there* in the film. It's embedded in the film's generic allusions—most notably film noir but also the Western—those stories of heroic masculinity, which the film, of course, proceeds to rewrite and undo.[1] It plays directly across the surface of the text: for example, when the Big Lebowski, asking the Dude to help him find Bunny, wonders rhetorically, "What makes a man, Mr. Lebowski? Is it being prepared to do the right thing whatever the cost?" (to which the Dude replies, "That and a pair of testicles"). And if, following the Dude, we want to reduce the definition of masculinity to a more biological level, then the film certainly provides some moments in which to ponder the phallic, from Uli's performance as Karl Hungus in *Logjammin'* to the Dude's *Gutterballs* dream sequence, which may very well be the definitive statement of the link between bowling and sex.

This obvious attention to the topic of masculinity is underscored by the film's thematization of threats to the masculine, by a certain castration anxiety that recurs obsessively throughout the movie, evident, for example, in Maude Lebowski's discussion with the Dude, conducted in front of a painting of a giant pair of scissors, about the uneasiness some men feel when confronted by the word *vagina*, or in the nihilists'

insistence that if the Dude does not give them the money, then they will "come back and cut off [his] johnson," a threat that is rendered visually at the end of the Dude's second dream. All of which is not to mention the continual representation of an adjacent masculine anxiety, an anxiety about masculinity, that appears in a slightly different register. As we learn from Walter as he's destroying what he thinks is little Larry Sellers's Corvette, you do not fuck a stranger up the ass, which doesn't prevent both the nihilists and Jesus Quintana from threatening to do precisely that. In this context, I don't think it's entirely accidental that there are a number of effeminate characters who haunt the margins of the film, from Marty, the manager of the Dude's apartment complex, to Knox Harrington, Maude's video artist friend. In other words, although it's never presented directly, the film is shadowed by the specter of homosexuality, which seems to function here as the image of the ultimate catastrophe: a masculinity that is so completely failed that it collapses into femininity.

Obviously, then, one of the things this movie is about is masculinity, including anxiety about masculinity. Now, since this is an academic essay, what I should do is find something far less obvious to discuss, but I think I'll take my cue from the Dude, the laziest man in all of Los Angeles County. Rather than digging any deeper into the film, I'm simply going to belabor the obvious. What I am going to argue, then, is that the film investigates a variety of definitions of the masculine only to present all of them as failed or inadequate or lacking, although, as we shall see, there is one important and perhaps equally obvious exception to this principle. Your incentive to keep reading will be that this half-assed approach to the film will raise a question whose answer might not be readily apparent. If the film interrogates and undermines our ideas of masculinity, why do the Achievers, at least the male Achievers, like the

movie so much and identify with the characters? Why go to a convention dressed as Arthur Digby Sellers? Why is there a Lebowski Fest in the first place?

We Don't Need Another Hero

Actually, I suppose I should have said that the film interrogates "masculinities," since both contemporary gender theory and the movie itself make abundantly clear that there are a variety of more or less culturally acceptable versions of the masculine in any given culture at any given time.[2] Whatever version of masculinity we look at in the film, however, it never turns out to be particularly successful. It's almost as if the Coen brothers went through the standard academic literature on types of masculinity, working out a critique of each one.[3] So, the Big Lebowski, who is easily identifiable as a nineteenth-century masculine ideal based on actions and accomplishments, is mercilessly satirized throughout the film. The Big Lebowski's endless insistence on achievement is itself sufficiently over the top that we don't even really need Maude's revelation that the money has all come from her mother and that her father was a business failure in order to suspect that there's something fraudulent about all of this. And then there's Walter, who would be the central character if this were in fact a Western, the man of action in the "my buddies didn't die face down in the muck so that . . ." vein, who suggests that traditional violent masculinity isn't all that it's cracked up to be either. It's not just that most of what he does simply serves to escalate situations ("Mark it zero") or even that so much of it goes awry or backfires, usually with negative consequences for the Dude's car, as in the drop-off scene where Walter insists on trying to confront one of the kidnappers. Finally, when faced with the counter-violence that violence provokes, as with the actual owner of the Corvette, Walter cringes and backs away.

Like the film's heavies, the nihilists and Jackie Treehorn's thugs (who begin the plot by making a mistake), Walter's violent action turns out to be mostly talk. As the Stranger says, "What's a hero?"

The Stranger, of course, is actually speaking about the Dude, who is not a hero either, just the man for his time and place. Now, to begin to answer the question I started with: one reason that the Achievers like the film is that the Dude, despite being a throwback to the 1970s, perfectly incarnates a contemporary slacker masculinity that has become a focal point of recent work in men's studies and that is also targeted by advertisers, a masculinity that maintains a cynical distance from the achievement masculinity of the Big Lebowski and the violent masculinity of Walter and the film's various thugs (O'Barr). As one might expect, however, the slacker male is no more effective here than the Big Lebowski or Walter. Part of the brilliance of the film is to place the Dude in the traditional shamus role of film noir, which highlights the confusion and the passivity, the fact of being driven along by events, which was always the unheroic underside of the noir hero. So, the Dude spends most of the film being summoned here or there, or having people come into his apartment and threaten him, or, although new shit is always coming to light, not being any closer to figuring things out than Da Fino, the private dick hired by Bunny's parents, not to mention that his car is progressively destroyed until, finally, it's killed by the nihilists. Like Donny, like all the other male characters, the Dude seems to be out of his element most of the time. What's a hero?

If masculinity is thus so often flawed or ineffectual in the film, it's not surprising that, as I've already mentioned, a castration motif should be so overtly presented in the movie or that the

Like Donny, like all the other male characters, the Dude seems to be out of his element most of the time.

film also takes the underlying premise of the buddy picture to its logical conclusion and presents most of the male characters as partial or incomplete figures who appear as doubles or even triples of each other, as mutually completing supplements. Thus there are the passive, laid-back Dude and the aggressive Walter (although these positions reverse from time to time), the Big Lebowski and his assistant Brandt, three nihilists, and thugs who always come in pairs. Even the Dude and the Stranger are versions of each other, as their names suggest, the Dude being a modern incarnation of the Stranger, appropriate to a Los Angeles that is no longer the West. It's no accident, then—in fact, it would almost seem to be thematically necessary—that the action of the film begins with a confusion between two different Jeffrey Lebowskis.

I'll stop short of arguing that the film can be read as a sort of psychomachia of contemporary masculinities in which all the male characters are doubled and multiplied not only to suggest incompleteness and fragmentation, but also to represent various aspects of what a man might be in this time and place. Instead, as a summary of the film's representation of men, I'd like to look at one moment where that representation migrates to the level of the form of the film itself. Appropriately, this summary comes in a supplement, the introduction to the film by Mortimer Young in the opening sequence added to the Collector's Edition of the film. In what I will call Synecdochic Moment Number 1, the sequence contains two fairly obvious edits, the first after Mortimer's train of thought is derailed ("Where was I?"), the second after his discussion of the influx of foreign money into Hollywood. Now, within the diegesis, these edits are the signs of small failures, of moments during the putative filming process when something went wrong, gaps that disrupt the possibility of a whole. By the same token, on the formal level, as we know from D. A. Miller, these cuts are the filmic equivalent of castration, attempted sutures that reveal rather than conceal holes in

the text that are, precisely, the places where there is literally nothing for us to see (134–35). In this context, it's particularly apt that the central joke of the sequence is the film's critical and commercial failure, that Young's discussion focuses on restoring the film to its lost unity, and that the featured example of the restoration process is the diner scene about the toe, itself a severed member, so that failure and castration are simultaneously inscribed on all the levels of the filmic text.

And Then There's Maude

Okay, maybe that's going a bit too far. In any case, I know what you're thinking: masculinity doesn't always fail in the film. After all, the Dude does finally crack the case, and he does so at precisely the point that the film finds something on which to ground masculinity, some basis for asserting its validity. To begin discussing what that basis might be, I'll quote my favorite example of the principle, which comes when the Dude is at Jackie Treehorn's Hefner-like mansion:

JACKIE TREEHORN: People forget that the
 brain is the biggest erogenous zone.
THE DUDE: On you maybe.

As this exchange suggests, the Dude's encounter with Jackie begins a series of sequences that implicitly affirm the validity of masculinity by basing it on the most obvious biological level, on the phallic. With his career as a producer of porn films and his orgiastic beach parties, Treehorn serves as a model of this phallic masculinity—he might even be an example of what Maude calls "satyriasis in men"—and it doesn't seem entirely unrelated that he is probably the most conventionally successful male figure in the film. As the Chief of Police of Malibu says, Treehorn "draws a lot of water in this town."

Although the Police Chief goes on to say that the Dude is no Jackie Treehorn ("You don't draw shit, Lebowski"), the Dude's "on you maybe" implies that, if masculinity is defined in phallic terms, then the Dude might actually be more of a man than Jackie. We get some indirect confirmation of this when the Dude passes out from the Mickey Finn that Treehorn has given him and dreams his own personal porn film, *Gutterballs*, which contains enough phallic symbolism to make both Freud and Ron Jeremy blush. This is apparent even during the opening credits, where, as the screenplay puts it, "the title logo is a suggestively upright bowling pin flanked by a pair of bowling balls" (Robertson 160). Having begun with the bowling pin as phallus, the sequence then progresses through a number of forced perspective shots in which a *very* long, tapering, rectangular shape stretches into the far distance. So, Saddam Hussein hands the Dude his bowling shoes from an extremely vertical, almost endless shoe rack that seems to reach to the moon, a visual motif that is echoed by the stairs the Dude dances down. And, transposed from the extremely vertical to the extremely horizontal, this motif also reappears in the bowling lane that stretches behind Maude and the dancers in our first glimpse of them. Perhaps the best way to explain all this is to say that the entire sequence looks like the set was designed by a German Expressionist size queen.

Now, partially because the sequence also draws its inspiration from 1930s musicals and partially because conventional understandings of Freudian dream logic allow it and partially because of a certain, uh, complementarity in the anatomies of the genders, the symbolism of the sequence shifts at this point. So, the Dude gives Maude a choreographed bowling lesson

Perhaps the best way to explain all this is to say that the entire sequence looks like the set was designed by a German Expressionist size queen.

and then, as the screenplay puts it, "the lane is straddled by a line of chorines in spangly miniskirts, their arms akimbo, Busby Berkeley–style, their legs turning the lane into a tunnel leading to the pins at the end. But it is no longer a bowling ball rolling between their legs, it is the Dude himself" (Robertson 160). If the bowling lane has gone from a rather stylized phallic symbol to an equally, albeit somewhat differently, stylized vaginal symbol, the entire Dude has now become a phallus moving down that "tunnel." As such, it becomes almost impossible to miss what Maude has already figured out: the way in which the Dude salvages masculinity from failure and fragmentation. Thus, the Dude is able to demonstrate his masculinity—and the value of masculinity in general—through the phallic potency that allows him to conceive the Dalai Lebowski.

Now the only problem with grounding masculinity in this way is that if you base masculine identity on the biological and the anatomical, if you use that logic to make masculinity successful and whole, you end up enhancing rather than diminishing the threat of castration. To put it another way, if your masculinity is, finally, based on your johnson, what happens if you lose it? Thus, it's almost inevitable that the *Gutterballs* sequence, in which the Dude becomes a giant phallus, should end with him being chased by the nihilists, wielding giant scissors. Yet, if the film raises this problem, it also provides an answer for it. By implicitly moving from Freud to Lacan, from the literally phallic to the symbolically phallic, *The Big Lebowski* can outrun the nihilists, as it were, and affirm a phallic basis for masculinity. From this perspective, it's less important that the Dude literally demonstrates his phallic power by impregnating Maude than that, at the same time, he demonstrates it metaphorically.

In Lacanian terms, at the moment when the Dude becomes a father, he also assumes the paternal function, stepping into a position, however briefly, where he represents the Symbolic Order, the realm of

law, language, and culture. As Lacan would argue, this too is a moment when the Dude *becomes* the phallus, although, in this instance, that involves metaphorically occupying a symbolic site that represents the ideal of both wholeness and knowledge. It makes perfect sense, then, that immediately after the moment of conception, immediately after he learns from Maude that the whole purpose of the encounter *was* conception, the Dude has a flash of insight in which he suddenly understands everything and is able to unravel and solve the case. As Todd Comer puts it, "Hermeneutic progress is intimately connected to sexual prowess" (116n). Moreover, the Dude's assumption of the paternal function also allows him to reveal the film's other versions of masculinity as the frauds they are, from the Big Lebowski to the nihilists. In fact, although I wouldn't insist too much on it, one could argue that it's at this point that even Walter's violent masculinity becomes far more effective than it has been up until now, specifically in definitively defeating the nihilists.

This brings us to what I will call Synecdochic Moment Number 2, which requires that we return briefly to Jackie Treehorn's mansion. At one point during the Dude's conversation with Jackie, the phone rings; Jackie goes to answer it, scribbles a note on a memo pad while he's talking, and then, tearing the sheet from the pad, excuses himself and leaves the room. It's a classic moment from film noir, and the Dude does exactly what the noir gumshoe always does: he sneaks over to the pad and lightly rubs a pencil across it to bring out the imprint of the message on the next sheet. In the noir thriller, this is always the moment when an important clue—a name or an address or a phone number—is revealed that leads to the solution of the mystery. In this case, however, all the Dude gets is a drawing, a doodle of a stylized male figure with enormous genitals that is aptly reminiscent of the late work of Picasso. This is, of course, yet another of the seemingly innumerable moments in the Dude's investigation where what looks like an important clue

18.1. A moment of hermeneutic prowess.

turns out to be meaningless, and this one is certainly meaningless, at least on the literal level. On the figurative level, however, it is possible to read the drawing as *the* clue, both to the mystery and to the film's depiction of masculinity as problematic. Just as the name or the phone number points the noir detective to the next step in solving the mystery, Jackie's phallic image foreshadows, points the Dude to, the upcoming encounter with Maude, the moment of phallic and hermeneutic prowess that will allow him both to unravel the case and also affirm the validity of masculinity itself. In fact, I suppose one could even argue that, on the formal level, the technique of foreshadowing is itself a structural gesture toward the ideal of the phallic mastery of the Symbolic Father since it not only assumes that the text forms a coherent whole but also implies a position from which this whole can be seen omnisciently and completely known.

Okay, maybe that's going a bit too far, but all of this suggests another reason why the Achievers might like the movie, which suddenly reveals itself as yet another instance of Paul Smith's analysis of the narrative representation of masculinity in film, his recognition that if the hero is so often subjected to a chaotic period of failure and punishment in the diegetic middle, this is only so that he can emerge triumphant at the film's end, his masculine power not only confirmed but enhanced (94). And if the film just happens to begin already enmeshed in the period when the hero is abused and humiliated, one recalls that the same can be said of Clint Eastwood's *Unforgiven*. Achiever-wise, then, what the film suggests is that, appearances to the contrary, true masculinity, the Dude's masculinity, which is by association their own, may just be the only one that really counts, grounded as it is in the intersection of the biological and the Symbolic Order.

The Dude Fixes the Cable

So that would seem to be it, then. Except for Donny. Now I suppose that if you do want to see the film as a psychomachia about "The 90s Male," the death of Donny could be read as a sort of exorcism of what we can call, since the film does contain Bush Sr., the Wimp Factor. From this perspective, Donny's death represents an abjection of cluelessness and passivity that signals the triumph of the restored masculinity of the film's end. The only problem with this interpretation is that I don't think it's right. After all, there are problems with seeing the Dude as the triumphant masculine principle, even if we acknowledge that the principle in this case is less Clint Eastwood than Cheech and Chong. The difficulty is not just that, as Lacan would point out, the idea of phallic wholeness is always, finally, an illusion ("Signification" 288), and it's not just that the Dude's own moment of phallic triumph is actually precipitated by

Maude's actions rather than his own, so that once again he's merely a part of someone else's plan, passive even at the moment where he's most active. The very death of Donny marks the film's conclusion with a certain sense of loss. If this is masculine triumph, it seems a bit hollow and incomplete. All of which is not to mention that, although I hate to say it, at the end of the film the Dude still has not solved the problem that began the action for him: he still does not have a rug to tie the room together.

This would seem to take us back to our initial question then. Aside from the beverages, why would the Achievers want to identify with what we might call the Dude Imago, which seems incomplete even in its completeness? I mean, finally, you don't even get that much sex. The answer, I think, lies not in the fact that, like the noir hero, the Dude has a moment of knowledge, of realization, as I've been suggesting. Rather, unlike the noir hero, the important thing is, in fact, not the act of realization (the crime is solved) but exactly what it is that the Dude realizes. And what that is, is this: the Dude realizes that there was never any money: that the briefcase was empty. And from this come the ancillary realizations: that Bunny was never kidnapped, that the Big Lebowski did not want her back, that the nihilists are bluffing. And further: that the Big Lebowski hired him not in spite of the fact that the Dude is a fuckup but because of it, in the very plausible hope that the Dude would screw everything up, just as Maude selects the Dude to father her child precisely because she knows he isn't into the whole fatherhood thing, that he'll actually reject the paternal function. In short, what the Dude recognizes is the inevitability of lack, of castration—the no money/no Bunny principle that is at the center of this universe—and this includes the recognition that if he succeeds, it's only because he's a failure.

Walter doesn't get it, of course. In what may be one of the film's funniest sequences, the final confrontation with the Big Lebowski, Walter

wants his own moment of realization: that the wheelchair too is a fraud and that the Big Lebowski can actually walk. This turns out to be wrong, of course, precisely because its basic assumption is wrong. Walter wants for the film to be classic noir, for there to be a there there, some truth or presence, something behind everything that is actually something and not nothing. Insisting on the Big Lebowski's hidden capabilities, Walter refuses to believe in castration, in its inevitability, its always-already. The same is true with Walter's confrontation with the nihilists. Precisely because Walter is right—these men *are* cowards and they won't really cut off your johnson and maybe step on it and squoosh it a bit—he fails to realize that absence is the operant principle of this universe so that, even if you defeat the nihilists, Donny will die, pointlessly, of a heart attack and that none of it has anything to do with Vietnam.

*Precisely because Walter is right— these men **are** cowards and they won't really cut off your johnson and maybe step on it and squoosh it a bit—he fails to realize that absence is the operant principle of this universe so that, even if you defeat the nihilists, Donny will die, pointlessly, of a heart attack and that none of it has anything to do with Vietnam.*

The Dude does know this, but he knows even more than this. To begin with, on some level, he knows he's in a comedy. Thus, even if we narrow our attention to focus simply on the question of "what makes a man," what the Dude knows, I think, is that if castration is inevitable, then there is no castration. In other words, it's not quite right to say that the Dude accepts castration. Rather, this is about what D. A. Miller calls the negation of castration, the admission of the possibility that the complex that founds

both masculinity and male heterosexuality may itself be a myth (138). I could argue that this opens up a space beyond Oedipus, but I'll put it a simpler way. What the Dude finally realizes is that the very terms of the issue, which I'll confess are also the terms in which this paper's discussion of masculinity has itself been framed—phallic or castrated, whole or partial, success or failure—are fallacious.[4] You don't need to look at things that way. If you don't worry too much about what success is, if you never really ask the question "what makes a man" because it seems, finally, silly, then none of that really matters, which is why both the celebration of the phallic that begins the *Gutterballs* sequence and the threat of castration by nihilists running with scissors that ends it are finally presented in such cartoony, impossible terms. When you stop worrying about these things, what you get instead is the right approach for your time and place, which is the simple recognition that "sometimes you eat the bar" and "sometimes the bar eats you," and that that's pretty much it. To put it another way, it's not just that masculinity is not really the issue; asking "What makes a man" is not even the right question. What's actually important is that the Dude Abides.

My Buddy

The Achievers know this too, I think, and we can now get a more complete sense of the complex identifications and pleasures that have made *The Big Lebowski* a cult classic for a certain segment of the twenty-something population. Actually, it would be more accurate to say that the film is a cult classic for a certain segment of the twenty-something *male* population since the Achievers, and the attendees at Lebowski Fest, according to its founders, tend to be about 80 percent male. As such, perhaps the best place to begin in discussing the attractions of the film

is to consider the gendering of the film's audience. Why does the film appeal primarily to men? The obvious answer is that the film's implied audience is clearly male. This is less because it invokes genres (the Western and the detective film) that have been traditionally associated with male audiences or because the Coens wanted to center the film on a "male sport" and chose bowling (Robertson 44) than because the central relations in the film are all between men. Although the women in *The Big Lebowski* actually initiate most of the movie's action (Bunny incurring a debt to Jackie Treehorn or taking off for Palm Springs; Maude deciding that the Dude will father her child), they receive relatively little screen time. Instead, the film focuses on the male characters, on their actions and their interactions with each other, and on the close friendship of Walter, the Dude, and, yes, Donny, which is even more evident in their continual byplay and bickering than in their nominal status as a bowling "team." If the core of the film is, in a sense, watching Walter and the Dude argue for two hours, the appeal of the film to men derives, in large part, from this depiction of a very recognizable form of heterosexual male bonding. Simply put, men like *The Big Lebowski* because it's a buddy picture.

But the buddy picture is less a genre in its own right than a motif or structure that is compatible with any number of genres, from action/ adventure movies (the *Lethal Weapon* pictures) to the adolescent sex comedy (the *Porky's* and *American Pie* series) to the male melodrama (*Field of Dreams, Brian's Song*) (Donalson 8), which also means that it's a motif that is compatible with widely differing conceptions of masculinity. And that, in turn, means that no matter in what idea of masculinity you believe, there's probably a buddy film that illustrates it. In other words, if the appeal of the buddy pic is male bonding, you can find a film that reminds you, fairly specifically, of you and your buddies and how you interact. If the Achievers tend to be that version of contemporary

masculinity that I've identified as slacker males (smart, articulate and cynical, single, often underemployed, twenty-something men), then the film's central characters are, despite the age difference, fairly slacker-y themselves. Just as the Dude can function as something of an imago for the Achievers, so the film can be seen as a sort of celebration of the kind of male bonding they do (or would want to do).

The official story of the origins of Lebowski Fest confirms this aspect of the film's appeal. As the Lebowski Fest website explains in its FAQ, Will Russell and Scott Shuffitt, the Fest's Founding Dudes, used to entertain themselves by reciting lines from *The Big Lebowski* while vending items from Scott's store at weekend festivals and conventions. As the website puts it: "One fateful July in 2002, Scott and Will were vending the Derby City Tattoo Expo and were spouting off lines from *The Big Lebowski,* and the other vendors around them began to join in. This created a sense of bonding and camaraderie never before experienced between complete strangers." Since this turned out to be far more interesting than the tattoo convention, Will and Scott decided to hold their own *Lebowski* expo, the very first Fest. Now, as The Legend of Lebowski Fest indicates, the appeal of the movie is not just that it depicts male bonding but that it also enables it. Quoting lines from the film, Will and Scott and the complete strangers establish, through their mutual appreciation of the film, that they share a common perspective, a similar worldview, which provides the basis for that "sense of bonding and camaraderie." As Will has said in an interview about the Fest with Nikki Tranter of the online magazine *PopMatters, Lebowski* fans "are very much like me and I understand them." The Fest then simply brings together more like-minded people so that, as Tranter puts it, "everyone at Lebowski Fest is an instant friend." Discussing the continued growth of the event, Will confirms this point, "It's all been so amazing. The camaraderie of the fans is something that brings tears of joy at each event."

What Do You Do When You're Branded?

While the joyful bonding of the fans can explain the success of Lebowski Fest, this actually raises more questions than it answers: what makes people fans of the movie in the first place? And, even if we identify part of the film's appeal as coming from its depiction of a certain slacker-y male bonding, why do fans focus on this film and not, say, *Harold and Kumar Go to White Castle*? Why, for that matter, is quoting the film's lines an important mode of bonding around the film? Tranter attributes the film's cult status to the quality of the dialogue and to "the carefree ideal" represented by the characters, and certainly there is some truth to this explanation of the *Lebowski* phenomenon. One of the main attractions of the Fest is that it is suffused with the mellow spirit and party-readiness of the Dude. Yet, to understand the common worldview that unites the film's fans, we will need to take a closer look at the characteristics of the "slacker male" population, the demographic that constitutes the core of the Achievers. To do this, we can turn to advertising executive Doug Cameron's remarks during a roundtable discussion on "Advertising and the New Masculinities" that was held a couple of years ago as part of Advertising Week in New York. Cameron was the strategy director for an ad campaign promoting Fuse, the alternative music cable channel, which targets "late night slacker culture" as their niche market. As Cameron suggests, the defining characteristic of what he calls the "identity value for the brand" is "downwardly aspirational" younger men who invert mainstream ideology and tend to reject middle-class values, ideals, and institutions (qtd. in O'Barr). As Cameron goes on to note, this rejection very often takes the form of mockery or parody.

Cameron consistently tries to fit the slacker male into the familiar archetype of the youthful "rebel," implicitly situating him in that lineage

that stretches from James Dean to Sid Vicious and beyond, but I actually think something a bit more subtle is going on here, at least insofar as the Achiever segment of the slacker population is concerned. I would argue that much of the appeal of *The Big Lebowski* for the Achievers is that it depicts the universe as inherently ironic, which means that it doesn't take anything, including itself, too seriously. As such, the underlying worldview of the film perfectly parallels the slacker sensibility, which, contrary to what one might expect, is not nihilism but an ethos. If I noted earlier that the slacker male maintains a cynical distance from the other types of masculinity depicted in the film, I'll now go further and argue that this ethos involves a certain skepticism about nearly everything, what we might call "a willing suspension of belief."[5] Thus, the Achievers' fictional antecedent is not Marlon Brando in *The Wild One* but Dante and Randal, the cynical convenience store workers in the original *Clerks,* and the Dude finds his analogues in the hapless central characters of other relatively recent cult films such as *Office Space* (1999), in which Peter Gibbons gets a promotion because he hates his dreary IT job and stops going to work, succeeding precisely because success in the corporate world doesn't matter to him anymore.[6] If the universe is fundamentally ironic, actual rebellion doesn't really make a lot of sense.

It seems important to add that in the case of both the film and the Achievers, this sensibility is essentially a comic rather than a tragic one, and it would seem to be a fairly gentle and relatively non-judgmental sort of comedy at that.[7] I think this is precisely because, rather than a simple refusal or rejection of mainstream values and institutions, this ethos seems to operate through a process of *aufhebung* in which traditional ideals, images, and values are annulled by irony but not entirely discarded. In fact, I would even argue that this is a sensibility that is, in some sense, nostalgic, not so much for the ideals and values themselves but for the possibility of believing in them. It's the same sort of nostalgia

that underlies the Coen brothers' approach to genre in the film; indeed, it would seem to underlie their attraction to the retro in general: even as the movie explodes the conventions of the Western and film noir and parodies Busby Berkeley musical numbers and porn films (this is even clearer in the clip we see from *Logjammin'* than in *Gutterballs*), the ironic distance it places between itself and these genres can't conceal a certain affection for them. Given such a sensibility, it makes perfect sense that the commercial Cameron finally ended up making for Fuse was a parody of *Girls Gone Wild*, which allowed their targeted "identity value" crowd of slacker males all the pleasures of that genre and all the pleasures of laughing at it at the same time.

Now, Cameron's choice of parody is additionally important because it suggests a particular use of citation, a certain calculus of the quotation, that is closely allied to the ironic sensibility of the slacker male. If, by definition, quotation invokes the original thing but situates it in another context, this process subtly but inevitably distances the quote from its source and alters its meaning. This makes quotation susceptible to comic uses and ironic repurposing, the perfect vehicle for the process of *aufhebung* that I've been discussing. Within *The Big Lebowski*, the comedic possibilities of the citation are literally played out in the Dude's tendency to repeat phrases he's heard in other contexts, most famously when he tells the Big Lebowski that "This aggression will not stand, man," an adaptation of a sentence from television coverage he's seen of Bush Sr.'s response to the invasion of Kuwait. And, on a larger, structural level, quotation also provides the underlying logic of the film, its organization through the citation and reworking of various film genres. It's not entirely accidental, then, that the use of citation is also one of the Achievers' modes of bonding around *The Big Lebowski*.

If we return to the origin story of Lebowski Fest, we can now see that the ritual exchange of lines from the film functions a bit differently

18.2. Five Walters explore the "Calculus of the Quotation." Hillary Harrison, photographer.

than Tranter suggests. When one fan says to another, "I can get you a toe" or "It don't matter to Jesus," they do indeed establish a relation to each other through the film, but not really by celebrating the quality of the film's dialogue or identifying with the characters, with Walter or the Jesus. Instead, what is being invoked here is less a specific allusion to a literal part of the film than an appeal to the film's overall ironic sensibility, which is sometimes enhanced by a repositioning or reworking of the citation. Take, for example, the quote from Founding Dude Scott that provides one of the epigraphs for Tranter's interview: "*The Big Lebowski* is an important film to me because it reminds me that I am just a dude

trying to get my rug back." Now it's possible to see this as an articulation of some major significance the movie has, some important message that it conveys: about living in the moment and not getting caught up in the materialist rat race, for example, as Will says later in the interview. If you were determined to interpret the quote, I suppose you could even read it as an articulation of the existential dilemma of life in a world without meaning: we are all just dudes trying to get our rugs back. But, of course, the real point of the quote is that it's a joke. Scott's citation of the film ("I am just a dude") as an explanation of the movie's importance derails the process of explanation itself so that the quote doesn't take us deeper into the movie but back to the surface. It's actually a refusal to attribute any deep significance to the film at all or, if it does, to suggest that the real importance of the film is that it's not important, that nothing is *that* important, which may be the actual message the film conveys.

Okay, maybe that too is going a bit too far. Nonetheless, it would seem that, unlike most cult fan bases, Trekkies, say, or devotees of James Bond or Jane Austen, which do seem to depend on a relatively straight-forward identification with the characters or the author, the Achievers cohere instead around an ironic sensibility that, precisely because it is based on irony, can be an identity ("slacker male"), and an identification ("Achiever"), and a basis for bonding, and a simultaneous insistence on a little bit of difference from all those things. Thus, when Will says that the camaraderie of the fans brings "tears of joy at each event," he would seem to be demonstrating the double consciousness, the *aufhebung,* of the Achiever, expressing a genuine appreciation of that camaraderie and maintaining a certain ironic distance from it at the same time. And this double consciousness is why, finally, you don't really need to be a literal slacker or even male to like the film: it all has less to do with gender or even identity than with sharing a certain gently snarky view of the world.

This ironic sensibility not only helps explain the film's appeal to the Achievers but also allows us to answer the question with which we began: why do the Achievers like the film even though it interrogates various types of masculinity, including the Dude's? Like the film's quotation of various genres or Cameron's *Girls Gone Wild* parody, *The Big Lebowski*'s invocation of various masculinities is also a process of quotation that both gestures toward earlier incarnations of those ideas (Walter as the action/adventure hero; the Big Lebowski as General Sternwood from *The Big Sleep*) and reframes them to create a certain ironic distance from them. This establishes a liminal position that allows the Achievers to simultaneously appreciate and disavow those depictions of men, to both be and not be any or all of them, a ludic stance that is sometimes played out literally by coming to Lebowski Fest as Walter or Arthur Digby Sellers. In fact, given the ironic sensibility of the Achievers, it might be more accurate to say that they like the film not despite its satiric look at various types of masculinity but *because of that*. And that, finally, is just another way of saying that, like both the Dude and the film itself, the Achievers have also moved beyond castration, beyond masculinity as an issue.

Now, what you're left with when you distance yourself from that issue is another sort of masculinity, a masculinity that is precisely the opposite of *Branded*, where you have to roam the West proving that you're a man, perhaps because, like the Coens, the Achievers realize that sort of thing is impossible to prove. Instead, masculinity is understood in a much simpler way: it simply *is*. And, since it doesn't need to be proved, it doesn't even really require a lot of work. You don't have to get your picture taken with Nancy Reagan or run around threatening people with a "marmot." Moreover, if only for the sake of the pun, I would add that the final twist on this slacker masculinity is that it always maintains the possibility of self-irony, so that you can even refuse to be "branded"

in that other, late capitalist sense of the word, interrogating the "identity value of the brand," both the label of (and the products aimed at) "the slacker male." There's more that could be said about that, but instead I'd like to conclude by taking one last look at the Dude. Having been arrested after leaving Jackie Treehorn's mansion, a groggy Dude sings the theme song from *Branded* while he's in the back of the police car ("and they say he ran away. Branded!"). The Dude himself has, of course, just been picked up literally running from Treehorn's place, and he is about to be falsely accused by the Malibu Police Chief, albeit of disrupting Treehorn's party rather than of cowardice. When the Chief of Police is finished accusing and threatening, embodying the masculinity of the Law and implicitly invoking the laws of the traditional, Walter-esque sort of masculinity that informs *Branded,* the Dude's response is simple: "I'm sorry," he says, "I wasn't paying attention." If asked "What makes a man?" the Achievers, I suspect, would say pretty much the same thing.

Notes

1. For an analysis of *The Big Lebowski* as a revision of the Western, see Comentale in this volume. William Preston Robertson discusses the movie's indebtedness to film noir (98–99); see also Raczkowski in this volume.

2. The importance of this idea in contemporary gender theory is discussed by Gardiner.

3. For a succinct summary of this typology, see Clarkson, 238–40.

4. As such, Judith Roof seems right to argue in this volume that the threat of castration acts as a lure in the film, which is actually predicated on a "liquid economy" embodied in Maude.

5. There are any number of other relatively recent examples and incarnations of this slacker ethos, from the romantic pessimism of such early Fall Out Boy songs as "Grand Theft Autumn" to certain undertones in the character of Seth on *The OC,* especially in the first season. It's even raised to the level of an aesthetic principle in Richard Linklater's debut film, *Slacker* (1991), which eschews conventional narrative

development or plot complication and instead randomly tracks a series of twenty-somethings in Austin going about their lives.

6. In the second half of the film, when Peter and two other IT guys create a software program to siphon money from the company, the plan goes awry almost immediately due to their ineptitude. In the end, Peter finally quits his job to work construction with his Dude-like neighbor Lawrence, thus taking the only sensible course of action in a world where one succeeds by not trying and fails by trying to succeed. The film has a loyal following, and there are special screenings—at the Arlington Cinema outside of D.C., for example—with people dressed in costume and prizes for the best impersonations of the characters.

7. As far as the Coens are concerned, this ethos can also have a tragic dimension. Rather strikingly, the plot of *Fargo* (1996) closely parallels that of *The Big Lebowski* (a detective investigates a kidnapping that resolves the husband's financial difficulties) except that the events play out as tragedy.

19 *Size Matters*

Judith Roof

Preface: Bowling Another Frame

The Collector's Edition DVD of *The Big Lebowski* begins with an appended introduction to the film by Mortimer Young, president of Forever Young Film Preservation. His prologue, in the genre of the ceremonial film introduction, addresses both the casual viewer and the aesthete. Narrating the film's history and provenance, and preparing the audience for its delights, Young traces the journey of the version that follows, recounting its rediscovery in a dubbed Italian version that has been redubbed into English. What survives, he warns us, is not exactly the original, but close enough for a film that has been destroyed in a fire, multiply translated, lost and found, and restored to us under the title *The Grand Lebowski*.

The Measure of Things

> How you gonna keep them down on the farm
> once they've seen Karl Hungus?

In *The Big Lebowski*, a film with so many pins and balls, with so many penetrations, penetrating looks, and penetrated eye views, one would think there would be an ample supply of penetrations, all big, bulky, and vain. But there are not. Or there are too many soon-to-be disqualified

contestants. The only real man in the place seems to be "The" Jesus Quintana, a pastel-coordinated pederastic bowler with a penchant for threatening anal intercourse while waving the hard-on of his prosthetic finger stiffener. Bowling pins are relatively smaller than balls, if we wish at all to ascribe to what seems to be the obvious binary sex symbologies of the bowling alley. But the allegory is not as obvious as it seems, in fact, and it is at best fluidly shifting. Balls penetrate alleys and pins, and bowlers penetrate balls, three-fingering those bounding lasses that serve in turn as their rotund synecdoches, now big roly-polies frotting the standing ten, glancing the circle jerk where nine out of ten on the average come off. Then the benedictions of the great enfolding matrix, a giant set of holes descending on the hapless pins, sucking them up or brushing them off, cupping them in a caressingly careful (re)placement, and beneficently endowing the hungry balls with a ten-pack's impending generosity.

Bowling, that oh-so-homosocial sport (notwithstanding the occasional female figure guarding the mouth of the alley), enframes the film, its too-literal frames framing the film's other alleys of penetration, or flow perhaps, or in-mixture, other incidents where

... with so many penetrations, penetrating looks, and penetrated eye views, one would think there would be an ample supply of penetrations, all big, bulky, and vain.

the differences between pin and pin, pin and ball, ball and alley get all mixed up, lose their substance, dissolving all into a fluid wash that turns finally to ash, an ash, I might point out, that does not find its final liquid Pacific resting place, but, like most other liquids in the film, ends up coating the Dude's beard and moustache. What seems, at least according to the connotations of its title, to be a matter of solid, impressive size—a Big Lebowski—turns out to be a far less quantifiable scrabble,

indeed a mechanics of fluids in an economy of fluid exchange instead of a quest for solid salvation, Grand instead of Big, phonetic liquids and fading soft palatals instead of the labial plosives of the big word. The Big Lebowski is a fake. The Grande Lebowski is a woman.

Not a Dick in the House

The genre of *The Big Lebowski* has been variously discussed as a Western, a detective story, and a buddy film, but the film's generic alibis, though offering a glimmer of what turns out to be false expectation, are quickly undone.[1] The film's various generic frames—the "found art film introduction" performed by Mortimer Young, the Western-inspired *Tumbleweed* exposition starting the film, and the in medias res detective mystery—all turn out to have been based on false or minimal pretext, on what in retrospect turns out to have been exactly what it was all along—a generic gloss holding out the hope (as they all do) for aesthetic uplift, pioneer redemption, detective solution, or buddy salvation. The accruing of these frames is, however, one instance of the method of *The Big Lebowski,* which, it turns out, is neither an infinite nor even cleverly interactive intertextual cluing, but a generic wash, which, rather than informing expectations (the absent but omnipresent frame of the film's authors does that), mingles and dissolves genres as if they were waves on the shore in a backpedaling sea of retroactive resignification and generic reflux, an undertow of perpetual revision that operates as a mechanics of fluids instead of a cause/effect linear structure, a joyful flow and impregnating splash. *The Big Lebowski* is governed by an economy of fluid exchange or the exchange of fluids, which in the end is no exchange at all. This fluid economy moves in all directions simultaneously, producing layerings, erosions, vacuums, dissolutions, and flows that render structure and unidirectional cause/effect irrelevant, or, in contrast with

marked efforts at organization (such as genre), at least show their futility. Liquidity replaces the notion of exchange with ubiquity, expulsion with joinder, ejaculation with the oceanic, chronology with polydirectionality, and choice with indeterminacy. When deployed in oozing relation to the film's simultaneous efforts to plot, counter-plot, pierce plots, or avoid them, the result is a spectacular demonstration of both the egotistic investments and perils of attempts to order (on all levels) and the sloshing perennial co-presence of this fluid mechanic, not as a competitor in the binary arenas of structure, but as the exposed conspiration of all that frustrates the determinate.[2]

Fluid exchange, so less imposing and visible than what a Big Lebowski might convey, conjures up the nether aspects of any official missionary position, the side activities and foreplays that lubricate more solid transactions. There are no solid transactions in *The Big Lebowski,* save the supposed exchange of fluids between the Dude and Maude Lebowski, but even what we might understand of that as a transaction is spectacularly postponed, uncoordinated, and out of order as the Dude ejaculates post-coitally from the mouth. An economy of fluids is, as the film demonstrates, a very slippery affair, difficult to grasp, evanescent, suggested by the apparently random tumblings of the tumbleweed that begins the film, but not at all like the green-nailed, dismembered toe that, in all of its tiny castrating reminders, only faintly ghosts the flowing trail of the film's more liquid assets. *The Big Lebowski* plays through the clash and backwash of orders, in the end showing the aegis of the abiding flow.

The cooperative overlapping of a liquid economy with more traditional efforts at structure, chronology, and plotting makes itself most evident at two focal moments in the film, moments, which though emblemized, are focal only in the sense that their subject matters are either made completely meaningless by the concatenation of liquidity

and structure (castration) or actually provide a wormhole connection between them (coitus). Although *The Big Lebowski* seems rife with castration images, castrating acts, and castration symbols, the film's most emblematic moment of castration's threat occurs when the nihilists throw the marmot into the Dude's bath, producing a foam of threat in the empty spot where we assume the Dude's goodies reside. Both the threat of castration and the veiled phallus coexist, their intersection fronted by the roiling bathwater.

The coincidence of structure with liquidity in *The Big Lebowski* transforms any notion of a self-contained moment of "zesty" coitus between the Dude and Maude from an exchange in which two partners simultaneously exchange fluids and pleasures to a protracted flow in which processes and sensations circulate in almost random order. That the eventual intercourse between Maude Lebowski and the Dude almost occurs in the near-familiar trajectory of cause and effect—studio dirty talk, assault foreplay, a prophylactic visit to the doctor ("a good man and thorough"), an evening in bed, post-coital ejaculation—suggests simultaneously that coitus has been a progressively flowing project and yet it still has a trajectory. Coitus is a progressive and regressive affair, a hybrid of orders and the ordering, eventually, of gene-crossed hybrid offspring. Coitus clings to its causality, even if the order of things becomes irrelevant. What seems to be a problem of causality in the film generally—who did what to whom?—turns out to be a problem of temporality and epistemology produced by the floating casualness with which "facts" appear as if they can only be discerned through the laconic surfacings of advice in a magic 8-ball. Although transpiring through a series of events that would seem to offer themselves as the gradual unraveling of a mystery manqué, *The Big Lebowski* simultaneously exhibits the refreshing splash of a liquid ontology much harder to pin down.

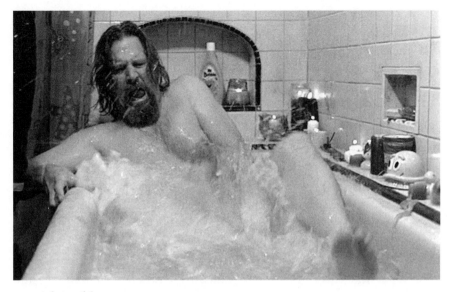

19.1. A foam of threat.

In fact, let's begin with the brooding omnipresence of castration, which seems to depend on some solidity somewhere. Castration is the feared and anticipated specter that backs all threats and ghosts all failures in the film. It is crassly literalized in the crisscross image of scissors, first sighted on Maude Lebowski's studio wall, then reiterated in the Dude's fantasy scenario, and suggested by the split, potentially scissoring legs of the alley girls, through whose aperture the Dude slides (a zoom with a view concluding in a pin head). Despite the scissors and the nautical marmot, whose thrashings are percussed by the nihilists' unsubtle taunts, castration does not really figure much in this film except perhaps in the past tense, for the simple reason that in order to figure castration, there must be something to castrate, even if that something is only the illusion of something to castrate (as always), and in

this film the castratable has already been dissolved into other, far less fragile things like rugs and broken tile and ringers and dirty underwear and little toes. What passes for a fairly obvious reminder of castration is actually a consistent reminder of what no one seems to have (except, of course, Maude and maybe Jackie Treehorn): the power to castrate, which is in Maude's case and maybe Jackie's, also the power to create.

The threat of castration, itself an empty threat since there is nothing but liquid at the site at which castration might occur, looms only in the imaginary as simultaneously immanent and accomplished. The fact of the matter, if ever a matter of fact can be, is that present threats refer to a past that constantly changes, a history under perpetual revision. Although history would seem to provide the pretext for action in the film—and many conflicting histories are offered: the Other Lebowski's, Maude's, Walter's—history itself is liquid, refracting, opalescent. Like water which distorts in its reflections, so the various histories in the film operate like the satyric palimpsest the Dude relieves from Jackie Treehorn's pad when Jackie leaves the room. Existing only in negative relief, floating as nothing in a sea of revealing rubbed-off graphite, the negative relief emblemizes the phallic possibilities of the entire film. The palimpsest presents the illusion that at some point in the past there was a solid presence that left the mark which the Dude has recovered by finding the traces of its presence/absence. A Big one exists in the past, torn off and removed, remaining as only a stain, a memory to be recovered in relief, a vision that habitually precedes the Dude's hallucinatory states in which the Big looms large. The legend of the Big, however, doesn't underwrite *The Big Lebowski* as a new version of *Totem and Taboo,* or even as a film demonstrating the confusions of post-paternality. There is nothing really so unusual about the film's lack of Big, if we believe Lacan's reading of the big P Phallus, which tells us that no little p is ever a big P at all, nor is the Big P really so Big (as the Big Lebowski himself

admirably illustrates).[3] We are all already castrated, the threat conveyed by the scissors is long past, and all we are dealing with now is a little pee. On the rug.

But before we wash the figuration of castration entirely, we should observe its flow, for even in its evaporations, castration winds through the text as a threat accompli, morphing liquidly, through surprisingly predetermined channels, themselves routed out by some liquid economy. The link between castration and liquidity in *The Big Lebowski*, figured centrally by the marmot in the bathtub, is like the association between a progenital tool and a raincoat: the tool keeps asserting and is doused by its own precipitations coming back on itself. Although prophylaxis in the film always comes too late, the connections between the threat of castration and liquidity as the film's terms of exchange constitute an economy that itself works backward, like a kind of reflux, in which delusively potent actions are always already prematurely evacuated of all possible efficacy. This suggests in turn that *The Big Lebowski* is finally about timing rather than order, or rather, the dissolution of chronology into the Stranger's omnipresent matrix of an eternal ever after. The film's series of mistaken identities are the effects not merely of bad timing but also of effect always coming before cause, the punishment before the crime. Or that the order of these things makes no difference at all in the end. But I get ahead of myself.

An economy of perpetual dissolutions is marked by the traces it leaves, just as waves leave their lines on the sand. We may want to see the Dude's gestures as all like the act of bowling—all like the pleasant aggressiveness of rolling that old ball down the lane. But even from the start no man in this film really acts alone, nor do balls roll true, nor do pins drop as they should. Actions other than bowling are like rolling the ball with no pins standing, going for a spare when there has already been a strike. The film is a series of frustrated gang bangs, of pale present

tracing mythical past exchanges which turn out not to be what we had thought, empty shadow motions like ricochets, like the wake of a boat, like waving goodbye when the plane has already taken off. And they are all empty.

The Dude, assailed by the pair of thugs who leave their watermark on his rug, heeds Walter's advice about the other Lebowski as a possible mode of recourse. This other Lebowski, though apparently solid, is a palimpsest Lebowski, an empty puppet offering a seemingly solid history of heroism and sacrifice to cover his other history as the disabled production of his wife. His wife had both real balls and fortune, the lines of the potent drawing that the others can only try to retrace. This "other" Lebowski is merely a front man, and as it turns out, a front man fronting nothing. This front man is in turn fronted by another front man, the obsequious Brandt, whose fronting has finally come to appear just as it is: a front. Infinite frontings do not recede infinitely, but instead give way to the nothingness the optical illusion of their fronting tries to refocus as something, disappeared through infinite recession, but looming as a fact of accrued frontings. The something the other Lebowski tries to wield as the instigation of a solid exchange already cannot be since it is premised neither on ownership nor the kidnapping of a something that was there but is now somewhere else (again the delaying economy of the palimpsest, which is never where it was).

Manfully visiting this other, "Big" Lebowski after his rug is damaged, the Dude finds the originary castrated character, the disabled war veteran sanctimoniously mouthing Walter's already empty war discourse. The Dude does not manage to contract a rug exchange with this past-tense mogul, who, unbeknownst to the Dude, has nothing to exchange anyway, but instead, slipping aside, effects the replacement with the Big Lebowski's obsequious partner Brandt, while being solicited for fellatio by the green-toenailed Bunny. Enjoying his new rug in the

place of the old, the Dude is brutally dispatched from the sweet reveries of his bowling tournament tape and induced into a magic carpet ride terminated when his hallucination suddenly acknowledges the weight of his ball. Solicited as the bag man to effect a monetary exchange to release the fictionally kidnapped Bunny, the Dude received a satchel full of nothing from Brandt to exchange for nothing, a nothing exchange representing a previous exchange in which the other Lebowski traded nothing for something, otherwise known as embezzlement. Walter, the man who is still puppy-whipped by his ex-wife, asserts himself into the trade-off with another nothing, or a past-tense metonymic almost something, in the form of dirty underwear to take the place of the nothing that is already there to be exchanged. Walter's substitution plan, of course, fails, which is nothing to worry about, although at this point in the film neither the Dude nor the film's audience knows there is a lot going on around nothing. Loose gun spraying bullets, Walter symbolically and belatedly lamed (the damage for him was deep in the past), the Dude's car collides with a guard-rail in a moment during which phallic symbols, like bowling pins, meet their inevitable fates. And if that is not enough of much too nothing too late, the Dude's already emasculated vehicle with its ringer case is stolen, and the Dude is dispatched to the deeply vaginal, dripping alley-like studio where he discusses vaginas with a cheery matter-of-fact Maude, a flying bestrapped dildo lustily spraying female figures, who, after retrieving the carpet the Dude stole, enlists the Dude to recover what was never there in the first place. As he is returning scathed from this latest encounter with the dentata, the Dude is hijacked again by the other Lebowski, who accuses the Dude of not making the exchange that couldn't be made, showing the Dude the severed toe, the, gosh, castrated guarantor of the exchange manqué, which is a real toe, but not the toe of the not-kidnapped real Bunny.

Then the Dude is assailed in his bath—where he is pleasurably awash—when three perverse nihilists fling a marmot into the tub, threatening a certain clawing and tearing unless the Dude turns over the money that was never there in the first place. Reminiscent of the recently beleathered Maude and the prosthetized Jesus, the bestrapped rodent frantically churns the water that stands in for, well, my point exactly, as the Germans unsubtly threaten to cut off the Dude's "johnson and squish it." Recovering his stolen car, the Dude finds a telltale school paper marked with a big red D, and with Walter, tracks this next empty malefactor down, demanding the return of the ersatz case, but failing again an exchange, failing even to elicit a word from the stony teen. Walter again shoots off into nothing, whacking off on a brand new red Corvette in pretend revenge: "this is what happens when you fuck a stranger in the ass, Larry," as he, of course, is in the process of fucking a stranger in the ass. The figuratively sodomized Corvette owner responds by beating the Dude's already-mangled car to a pulp.

As the Dude finally tries to take charge and secure his apartment, pounding a door stop into the floor on the wrong side of the door, he is again abducted, this time by the micturating henchmen who take him to Jackie Treehorn, pornographer. Pretending to enlist the Dude in an information exchange, Treehorn instead slips him a Mickey, an exchange which pretty much characterizes all previous non-exchanges in which an identifiable gift is not what it seems to be, producing the unconscious instead of a buzz, liquefying the Dude and sending him on a fantasy hallucination of bowling balls, pins, a welcoming Valkyrie for the courageous defender he has been, and ranks of dancing Medusas with heads of racked pins and gams funneling him unknowingly to a strike. He wakes up in the Malibu police department where he is dispatched by a mug shot. Returning home to find his apartment completely trashed, the Dude gets it together, we assume, to have sex with

Maude, who appears in the mess of the mess, to claim her part of the unknown exchange, where she, in fact, presumably does get something for nothing. During the (after) glow with the Dude sucking a roach and rendering a version of his life's claims to meaning, he suddenly has a new view of the entire affair, signaled by his spectacularly vivid and displaced oral ejaculation. He realizes that there was never a kidnapping nor an exchange nor an intended exchange in the first place. The only exchange that ever occurred was itself not even an exchange, but a theft, an embezzlement that left a trail of debt and delusion, producing waves of covering lies and alibis, a debt that, like a liquid economy (or economy suffering from a lack of liquidity), produces a perpetual, multifocal cascade of compensations, of vacuums water rushes to fill, leaving more vacuums until the entire pool roils as if there were a marmot in the bath.

Epiphany had, and survived; the Dude returns to bowling. The bowling team threesome, including the soon-to-be-forever silenced Donny, whose attempts at conversation constantly emblemize the bad timing of the rest of the film's events, exits the alley to come face-to-face with the three frothing nihilists who have started an auto bonfire and are now trying to shake them down for anything they can get. The massively ineffectual half-dozen go to it, promising to fuck each other, flailing in the air, Walter managing a Tysonian detachment of an ear, and Donny dying of a heart attack. The exchanges that were never made are capped off with the immolation of the fight's only casualties—Donny and the Dude's car. Fire is the analogue of a liquid economy, spreading, seeping, dissolving structure, ignoring centers and orders and plot. Donny, too, becomes ashes, which, released against the prevailing wind, are scattered the wrong way, coating his friends with a fuzzy patina of the guy who never knew the context. Only with the mysterious Stranger figure at the very end of the film do we find a tiny bit of a hint of an exchange that might actually have been made in the anticipation of a

"Little Lebowski" though we actually have no idea whose little Lebowski it might be. It might be Maude's or it could be Bunny's. It might be the Dude's or someone else's. Our assumption, like all other assumptions in this film, is a trick of our belief in the unitary character of cause and effect.

It is all, in short or optimistically long, emblemized by the complete identity of the satyrical palimpsest the Dude reveals in Treehorn's pad and the empty frothings of the marmot-stirred tub.

Got Milk?

And just as there is no exchange, there is no pay-off for this labor yet, for I have to go back again, to a point even before the point at which I started, and trace another set of exchanges which are not made: the repeated and proliferated images of liquids and foams which make it from glass to mouth, from body to rug, which in their constant comforting lapping presence evidence this liquid economy which both correlates with the constant impression of castration manqué and tracks another mode altogether, a liquid mode, this mechanics of fluids, which flow, dissolve, seep, foam, and saturate, making time, space, and size itself all irrelevant. *The Big Lebowski*'s economy of fluids operates not in relation to the Dude, Walter, the Big Lebowski, or even Jackie Treehorn, but the real stud of the piece, "The" Jesus Quintana, who understands that studliness is about pose rather than exchange, about appearance, about exhibiting oneself to an eight-year-old, who may be the only one upon whom such an exhibit might make an impression. The Jesus, who refers to himself in the third person, as, well, the Jesus, presents a meaningless limit on the bowling trio, strutting his pastel-pantsuited stuff on the alleys, asking, "Are you ready to be fucked, man?" threatening, "Nobody fucks with the Jesus," telling them that they "don't fool Jesus,"

and promising repeatedly to fuck them in the ass. The exchange Jesus effects is like all of the film's exchanges, an exchange of words, an empty exchange full of meaning, not of course the literal meaning of its signifiers, but meaning in its having been said at all. For Jesus and the Big P in general that is all the exchange that is needed—a display, the threat of an exchange to come if the Big P is not respected as it won't be, since the only evidence of Jesus' potency is his bowling stance, which the Dude reduces to merely his "opinion, man."

In the film's economy of fluids, Jesus constitutes a bobbing landmark in a foaming sea of trivial threat; he is the marmot of the bowling alley, snarling and promising to bite, all strapped for action like Maude. But these strap-ons are relevant only in a wet environment, the kind of pervasive humidity emblemized by the image of the milk moustache. The milk moustache occurs repeatedly throughout the film and it, too, marks a past exchange, the ingestion of liquid—a milky filmy liquid— the Dude constantly imbibes or is dunked in. The Lebowski portion of the film begins with the Dude shopping for milk, gulping it unseen in the store and arriving at the check-out with a milk moustache—more bad timing, a premature exchange, a liquid economy before a monetary one, out of order, out of joint. When the Dude returns home, he is attacked by two thugs, one of whom dunks both head and opened milk in a very mucusoid toilet so that the drippy Dude looks like he is veiled in some sort of ejaculate. The other thug urinates on his rug—the rug that tied the whole place and the whole film together. The economy is an economy of spillage, of running out and immersing in.

This liquid economy extends to include ingestion, as the Dude consumes his "Caucasians," which like the milk in the store, leave a milk moustache as the trace of their passage, of their

In the film's economy of fluids, Jesus … is the marmot of the bowling alley …

actual omnipresence, as this film is full of Caucasians, except possibly our Jesus. Ingestion and excretion are the models of activity in the film, established in the first scene. The bowling trio drinks Lite, Maude spurts liquid green paint, Mr. Treehorn "draws a lot of water in this town," Walter asserts first amendment rights over coffee, the Stranger sips sarsaparilla, and, like milk, Donny's ashes adorn the Dude's face. Images of liquid past, jostling images of castration manqué, pervade the film, presenting the specter of some recent and very messy fellatio.

But liquids also float a different story, in which exchange of any kind, past, present, or unaccomplished, is irrelevant because there has never been anything to exchange. Fluids engulf, sustain, fill in, protect, mark their own time which is another time. The Dude, who revises his view after sex with Maude, revises it because he ejaculates post-coitally, timing as usual too late, seeing after the fact, a timing that in harmonizing spectacularly with all of the bad timing in the film, is finally able to resonate with an economy of no timing, to see it for what it is. Almost. For the Dude's insight even here misses the point that there is no locatable point. He believes that insight and revision lie in penetrating layers of false facade, which implies that, for a moment at least, the Dude has an inkling of an answer which in the end is itself only the palimpsest of another past outline. The Dude is even capable of another view because he is already liquid, not because he presumably performed the joyous act of sex. He drinks and sucks and bathes, and although Walter drinks as well, and Walter demands the right to finish his coffee, Walter has not surrendered to milk itself—not milk as the trite figuration of maternity, but milk as a communion with mucous and seed, a seminal bath in an accumulating ocean where all but Donny end up. This liquid economy, so subtle, so in its own time and rhythm, is linked directly to how we see in the film. Liquidity is the model of the moving view, the framing that glides so smoothly through a range of perspectives, dollying in and out

of point of view, smoothly floating from one perspective to another. This liquidity is not analogous to the feeling of being on a boat—of experiencing the clash of structure and water, but of moving into the liquid itself. Though linked to a moving perspective, this liquid camera motion has the effect of disallowing the illusion of a single point of view in favor of a more oceanic, albeit localized, floating that flows toward and away from its subject, altering scale and blurring depth. The economy of these shots is liquid in so far as they take on and embody a multiplicity that flows, has no boundary, and is uncountable, if not unaccountable.

A similar play with scale occurs in the dream sequences. During the first sequence as the Dude is enjoying his magic carpet ride over the valley, he is grand in relation to the vista. His realization that he is holding a heavy bowling ball apparently stimulates the laws of gravity that pull him to the ground, but also produces a change in scale. The Dude becomes minute, small enough to fit into the hole of a bowling ball, through whose rolling aperture he sees the alley. A similar change of scale occurs in the dream he has after Jackie Treehorn slips him a Mickey. Entering the musical quasi-porn production number preceded by a very large shadow, the Dude again appears in miniature, changing scale against a set of changing scales—celestial bowling shoe storage manned by Saddam, endless steps, multiplying bowling pins worn as head-dresses by Busby Berkeley dancing girls. The transition from this dream into the scene of the Dude running down the middle of the street is filmed in slow motion, which perpetuates the dream-like quality of the previous sequence and produces a shift in scale—now temporal—of its own. And so what does this have to do with size? The Dude exists simultaneously in two economies that work differently, yet coordinate in their presentation of what we and the characters always miss, the production of the sense that simultaneously it all happened without us and it is all still happening, someone else drank and we are still in the

drink. This coordinates with the scalar shifts the Dude himself undergoes, becoming a phallus in a ball hole, to a whole vertiginous mode of seeing. Big means nothing, since the "Big" Lebowski in fact represents nothing, not even the fervid liquidity of the Dude and Walter. Size does not matter, since there is no way, in a liquid economy, to measure size in the first place, a size which shifts through a shifting view. Even measuring itself is irrelevant. Volume perhaps is more to the point, but even that only appears in connection to death. Sipping is what counts.

Liquidity, however, can understand the "grand," the translation offered by Mortimer Young in the film's preface. The Grand Lebowski is another matter altogether, liquid, obscenely fecund, vaginal when vaginality counts, full when all else is empty, not the reservoir of overhung nihilism figured in the Big Lebowski's swimming pool, but the fountainhead of endless Caucasians, of small drinks, da Vincic figures, spurting paint, roiling bath water, the Pacific ocean, and tinkling if annoyingly superficial laughter. If the Big Lebowski is an empty posture for a power that never was, the grand Lebowski—Maude—is full, beyond size and uncountable, not a dead ringer, but as the resounding gurgle of the fountain of sarsaparilla that leads finally to the calming flow of the Stranger's framing basso profundo, the voice that tumbles to the drink.

Notes

1. Most prior work on the film examines its presentation of the political or memories of the political. See, for example, Comer; Iuli.

2. The most famous humanities appeal to the "Mechanics of Fluids" occurs in Luce Irigaray's essay of that name in which she appeals to the analogy of the liquid as a way to contrast the possibility of apposite orders linked to gender.

3. Lacan famously suggested that no one has the Phallus, which in his system represents desire. See "Signification."

Brunswick = Fluxus **20**

Aaron Jaffe

The image of man is always intrinsically chronotopic.
Bakhtin

This chapter considers the cultural meaning of "wood" in *The Big Lebowski.*

There are unusual quantities of wood in the film: paneling, floors, bowling alley lanes, furniture, numerous props, and so on. From the opening sequence of exquisitely shot bowling balls casting down wooden runways to the final encounter between the Dude and the Stranger bellied up to the wooden bowling alley bar, *Lebowski* makes the uncanny "cultural power of wood" conspicuous, as Harvey Green puts it in his book on this subject (xxii).

In Coen films—and in *Lebowski* especially—design takes on a degree of agency that moves its significance from the background into the foreground. The role of wood, in particular, underscores a decisive concern in the plot and a cultural innovation the film makes concerning it: the role of genealogy—as in the genealogical tree. The Lebowski family tree (Jeffrey, Bunny, the Dude, Maude, the little Lebowski on the way) is decidedly not *arborescent* in the sense Gilles Deleuze and Félix Guattari criticize in *A Thousand Plateaus,* because it's hardly unidirectional, patrilinear, patrimonial, or branching ever vertically. Nor is it *rhizomatic,* the more famous alternative the pair propose to designate the

non-hierarchical, heterogeneous, and horizontal. The Lebowski family wood might be more adequately described as *lumberescent*—cultural wood that functions no longer as a signifier of vertical or horizontal growth but as a plasticized gift and plaything of design.

People treat wood, Green writes, "as organic and natural, and manufactured goods to be artificial and somehow tricked up [but] manipulated organic materials *are* artificial—the products of human art and artifice" (xxviii). Yet, large chasms separate the forest primeval and commodity wood products sold by linear measure in boards and sheets at the local home improvement super-center. The wooden manufactured goods that furnish our dwelling places, what's more, are a far cry from the days when wood was the omnipresent "jack-of-all-materials" used "for heat, shelter, food preparation, light, tools, weapons, toys, storage, land and sea vehicles, decoration and design" (xxii). Concerning these last two items especially—decoration and design—nostalgia for wood's organic and natural associations remains strong, even after mechanization and synthetic substances not only have made wood far less essential to our lives, but also have rendered its associations highly questionable. The appeal has in part to do with the very mutability and impermanence that new and improved materials have seemingly rendered a thing of the distant past. The fact that wood—formerly but only formerly living material—expands and contracts, weeps, warps, buckles, burns, leaks, swells, rots, and can be eaten by bugs helps lend things made from it something like Walter Benjamin's notion of aura.

In this way, we could link wood to the retro feel so crucial to the look of the film and the outlook of the Dude. Joel Coen gets at this when he explains in an interview the importance of bowling as a sport that has something to do with wood: "We like the design aspects of bowling. The sort of retro aspects of it seemed like the right fit for the characters" (Susman 84). It fits right in there. How does this association work? And,

how does it combine with the other prevalent material of both the film and the bowling: "plastic"? Perhaps, the Dude is not just another failed artistic character, the roadie with the band, but a kind of interior decorator manqué?

Among the many insights in William Preston Robertson's *The Big Lebowski: The Making of a Coen Brothers Film* is this lead about Coen brothers filmmaking technique: "Joel and Ethan are unique not only in the fact that they write it, direct it, and produce it, but that they are so very visually attuned. . . . To them, the look of a movie can be another character as well" (90–91). The lead provides a more general clue for my concern with material: the stylistic, chronotopic, and autopoetic potential carried by the stuff that things are made of. The Coens, it seems, are highly particular about material in their films. Whereas production design and art direction are matters of concern for all filmmakers to some degree or another, the conspicuous and deliberate attention to total visual design is one of the Coen signatures. Each of their films comes to be organized around a unifying aesthetic to such extent that the look of the movie becomes another character in its own right.

What does it mean to say that the look of a movie, its style, is another character? Consider *Barton Fink* (1991), the touchstone Robertson provides in this vein: production designer Rick Heinrich's "peeling" and "falling down" wallpaper at the Hotel Earle, discharging pus-like ooze, as if on psycho-dramatic cue (92). One reviewer who gets this drift describes the phenomenon as follows:

> There is the decidedly rank smell of brimstone in the air at the Earle. . . . It's so hot the wallpaper is peeling off [and] paste is running down the walls in gooey rivulets. . . . The Earle is . . . alive with the sounds of night: the creaking of ceilings and the protests of bed springs, grunts, thumps, screams, wails and wheezing doors. Decorated in ghastly . . .

maroon, olive drab and bloodstain brown—the Earle seems an organic being as crucial to this haunting tale as the spirit ship was to "The Flying Dutchman." A gurgling, heaving purgatory, it seems a most likely place to teach understanding and punish arrogance. (Kempley)

The sense of an organic being is revealing. The special evidence that the Coens are directors of first order—their auteur status as achievers of self-conscious film style—depends on the sense of a brush against some thing. Just as a piece of furniture acquires organic being when it is encountered in the dark, so too, their background detritus acquires personality. Perhaps *personality* isn't the right word here, for, if nothing else, the phenomenon shows personality to be less solidly "human" than it's cracked up to be. When Horkheimer and Adorno in *Dialectic of Enlightenment* describe the pre-animistic life forces that once inhered in primordial things, before they were "solidified [and] violently materialized by men," they call them "[u]nidentical, fluid *mana*" (15). "If the tree is addressed no longer as simply a tree," they write, "but as evidence of something else, a location of *mana,* language expresses the contradiction that it is at the same time itself and something other than itself, identical and not identical" (11).

> "If the tree is addressed no longer as simply a tree ... but as evidence of something else, a location of **mana,** language expresses the contradiction that it is at the same time itself and something other than itself, identical and not identical."

These atavistic, lumberescent feelings echo the sociology of interior design as described by Jean Baudrillard in *The System of Objects.* For Baudrillard, the import of modern interiors—couches, coffee tables, atmospheric color schemes, lighting, scented candles, and, above all,

what he calls natural and cultural wood (and here, it may profitable to think about the noir tradition as an interior design program)—the import of this stuff is its achieved dissonance of "externality, spatiality, and objective relationships." Exteriors expressed in a communicative equation between the "movements of emotions" and "the presence of things." Baudrillard writes:

> Today value resides neither in appropriation nor in intimacy [the purview of the dining room and the bedroom] but in information, in inventiveness, in control, in a continual openness to objective messages—in short, in the syntagmatic [associative] calculation which is, strictly speaking, the foundation of the discourse of the modern home-dweller. (24)

Baudrillard's new dweller thus inhabits a world without mirrors. The function of the mirror as a reflector of the expressive self into a domain of material inheritance and possession has been rendered obsolete by an equation of exteriorized style. He—for Baudrillard, it's a he—lives in an environment that has substituted the ubiquitous mirror above the bourgeois mantelpiece with the mirror which is not one, the reflection which ties his exterior dwelling space together.

The only true mirror in the film—the only time the Dude sees his own reflection—is in Big Lebowski's anachronistic trophy gallery, a mirror that inserts the Dude into a now entirely ironic domain of the exemplary liberal-bourgeois temporality and subjectivity, represented by the Man of the Year cover of *Time* magazine. Otherwise, the Dude's reflections occur in polished surfaces, first on the linoleum floor at Ralph's and paradigmatically and surrealistically in the bowling ball dream sequence.

"Neither an owner nor a . . . user" exactly, the character Baudrillard describes is "an active engineer of atmosphere." He is a temporary

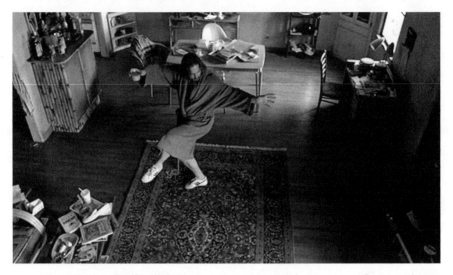

20.1. Space, at his disposal.

inhabitant, a renter, who insists, like an initiate into some kind of Eastern thing, a ten-minute *tai chi* in a *fang shun,* that the *art of placement* is an equivalent for the *art of flow.*

"Space is at his disposal," writes Baudrillard. It's his for abiding in: "he and the space in question [are necessarily] homogeneous if his messages of design are to leave him and return to him successfully" (25). No doubt you've seen the reflection of the carpet in the Dude's cheap sunglasses.

This is the relevant mirror. The sense of style as organic *Dasein* provides an equation, a sign of equivalence, that, in the words of the Dude, really ties the fictional reality together as an aesthetic event. Did it not? In practice, we find something that surpasses the mere organizing metaphor and approaches instead the conditions of the pathetic fallacy gone wild—style running nature amok, overflowing it.

T. S. Eliot develops the term *objective correlative* in his Hamlet essay to reject criticism focused on characters as interiorized psychological entities and thus to attend to the play as a total work of art in which both characters and things are objective—effects of the whole, in his phrase—dilatory, tumescent objects strewn across the stage like so many bowling pins. The Dudester as Hamletmachine: "Good night, Sweet prince," Walter reminds us of the allusion. And, Robertson tips us off to the centrality of this effect in the Coen experience when he describes Brunswick as the "unifying visual theme in a panoply of will-fully varying styles" (97). Yet, the point seems to be—to take a page from Quentin Tarantino—*just because style is a character doesn't mean that it has character.* Otherwise stated, when it comes to character or style, it's style that talks.

Even if this result isn't pre-ordained, it is crucial subtext in Coen filmmaking: again and again, the collaborative, osmotic effort of film production yields willy-nilly a unifying stylistic language for the film. And, above all, in *Lebowski* at any rate, two stylistic modes prevail: Brunswick and fluxus. In fact, Robertson identifies four modes—Bruns-wick, fluxus, Googie, noir—but I'm going to concentrate on Brunswick and fluxus because I think they organize the others. Brunswick is an ac-tual and still existing bowling company, and fluxus is an actual and still existing contemporary art tendency. We could, strictly speaking, find more fitting pairings for each (in the alley, AMF; in the gallery, Retro), but I like the decidedly asymmetrical pairing of a corporate aesthetic of leisure-time populism with an anti-art aesthetic of intermedia ob-scurantism. And, I'm going to use these names to convey their two sty-listic tendencies broadly and metonymically: specifically, natural and cultural wood; wood and plastic; placement and flow. In the pairing of Brunswick and fluxus, we arrive at the nexus of these two very different spatio-temporal material modalities—in other words, styles—when we

enter the bowling alley itself, with its anomalous, skeumorphic future pasts of plastic and wood. A *skeumorph* is an anachronistic design feature that has become vestigial: brass rivets on jeans, fake stitching on dashboards, imitation wood grain on countertops, and now simulated wooden bowling lanes.[1]

Let me start with color, turn to wood, and wrap back around to plastic. Here's a key conversation between Robertson and Rick Heinrich, the production designer, explaining the "Brunswick look":

> "People keep mentioning the 'Brunswick look,'" I say. "What is that look?"
>
> "Brunswick is a bowling company," says Rick, "And in the '50s, there was a certain color of orange and red that they used with a sort of beigey white that was fabulously reminiscent of the era that we were trying to invoke here. The ball returns and the projection scoring tables all had a very space-agey, streamlined look. (102)

The consistency of the color palette in the film—the dominant, complimentary, and accent hues of cream, burnt orange, salmon, green, yellow, purple—is a force of coherence through all the ins and out of different interiors, characters, objects, plot points, and citational tissue.

Now, wood isn't a color *per se,* yet it certainly plays a role in the film's color palette, akin to rust, in the Dude's description of his car's coloration. Indeed, Baudrillard describes how color, with the advent of the age of plastic, chemical dyes, pigments, latex paint, and so on, loses its stable destiny and becomes instead relational and functional. It becomes disassociated from solid materials and turns into "an abstract conceptual [veneer, a surface] calculation." Eventually, Baudrillard suggests material itself—wood, leather, stone, marble, horn, ivory, pearl, tortoiseshell—becomes little more than color by other means (37–38). This shift comprises an event horizon, and there is an obvious

time-space warp that happens in Heinrich's comments when he says *in the '50s there* [were these colors] *that were fabulously reminiscent of the era that we were trying to invoke.* What's curious here is the temporality: exactly what era is the film trying for? The film is set in 1990—and every kindergartener will tell you it has something to do with 1960s, hippies, Vietnam vets, resolving the cultural wars or something. Yet, the design pressure in the film comes from neither decade per se but from the remnants or ruins of one style in another, the sense of uneven spatio-temporal anachronism and drift, bowling as a run-down, un-renovated pastime filled with vestigial, half-forgotten things.

Brunswick, like many publicly traded companies, has sold a diverse array of products over the years (Brunswick Company). Sure enough, Brunswick began as a mill works, selling fancy wood-paneled bars to drinking establishments and eventually bowling systems as complimentary amusements. The concern was instrumental in establishing standard rules for ten-pin and setting up the American Bowling Congress around the beginning of the twentieth century (Brunswick Pro Bowling). In addition to its well-diversified bowling line—everything from lane decking and decorations to pinsetters and bowling balls—its main business today consists of pleasure boats and pool tables. The common denominator of these three leisure products—part of the business more or less since the nineteenth century—is precisely manufactured wood, wood in an age of high tolerance, mechanical production—in other words, wood in an age of its own material obsolescence. By the mid-twentieth century, with the coming of balls made of various plastics and the automatic pinsetter, a leisure-time imperium of sorts stretches its ten thousand alleys of beautifully machined pine and maple coast-to-coast (Berk and Simple).

Baudrillard writes:

Wood draws its substance from the earth, it lives and breathes and "labours". It has latent warmth; it does not merely reflect, like glass, but burns from within. Time is embedded in its very fibres, which make it the perfect container, because every content is something we want to rescue from time. Wood has its own odour, it ages, it . . . has parasites, and so on. In effect, it is a material that has *being.* Think of the notion of "solid oak"—a living idea for each of us, evoking as it does the succession of generations, massive furniture and ancestral family homes. (38)

The question Baudrillard poses is whether this idea of wood as living substance—a substance that represents so much latent fire—still retains any meaning? One also thinks of Gaston Bachelard's suggestive little book about fire in which he describes it as "the ultra-living element," the name that designates "all those tendencies which impel us *to know* as much as our fathers, more than our fathers as much as our teachers, more than our teachers" (7–11). He titles this book *The Psychoanalysis of Fire* because, he argues, convictions about fire are of a psychological nature. Baudrillard, borrowing from the comments about wood and plastic in Roland Barthes's *Mythologies,* states that wood is humanizing and timeless but wears out, burns, is prone to insect damage yet auratic, while plastic is disposable but permanent and polymorphic. Baudrillard takes Barthes one further—his distinction between natural and cultural wood indicates that once synthetics enter the picture, materials no longer carry subjectivizing depth—cultural wood becomes not a problem of individual psychology but economics and social-semiotics. It's no accident that one of the earliest commercial designators for plastic is the infinity symbol; the plastic crap you buy will likely be the most enduring record of your time in the universe.

There's a prodigious amount of wood in *The Big Lebowski*—all those tracking shots of wood floors and wood lanes. Not to mention *Logjammin'.* Any inventory of Lebowski wood, of course, must begin in the

bowling alley: the lanes, the paneled ceiling, the bowling alley bar. Yet, even before this, before even the credits, we've seen the finished hardwood floors in the Dude's bungalow, the hallway leading to the Dude's bathroom, the placement of his head in the bowl, in a way that prefigures the flow and placement of objects on wooden bowling surfaces. In addition to floors, with and without carpets and bowling balls, there's the Dude's cheap furniture—the wooden coffee table, the desk and hi-fi deck, the tiki bar and tiki-like couches, the star-like beams on the ceiling, and later the presence of two wood props: the Dude's 2×4 and the nihilist's cricket bat. In contrast, the Big Lebowski's ancestral mansion has older, more darkly stained and assuredly solid wood, aristocratic wood: parquet, plaques and trophies, antique furniture, molding, a massive wooden desk strewn with wood-handled office paraphernalia, the mantelpiece over the superfluous burning log in the fireplace.

Jackie Treehorn's bachelor pad, with all its shag carpeting, leather, concrete, and glass, does similar work: the wood paneling and the inevitable burning log in the fireplace underscores the conspicuously empty male privilege of gratuitous conflagration.[2] The masculine mastery of rarified natural materials is evoked by the name *Treehorn*. The satyr, the wood-god Pan, corrupts helpless forest creatures, nymphs such as Bunny Lebowski and Fawn Knutsen. And if Treehorn and his lair underscore wood's association with predatory male sexuality—satyriasis in men, as Maude says—the heavily wood-paneled funeral parlor, propped with another imposingly wooded desk, connects natural wood to its decrepitude, the sputtering flame of genealogy and moribund patronymic inheritance.

The exception to all this wood is Maude's studio with all its all concrete, leather, tubular

... Treehorn and his lair underscore wood's association with predatory male sexuality—satyriasis in men, as Maude says ...

metal, and plastic. What counts here is cultural wood—plastic benches, molded plastic chairs, and plastic bar stools all in mid-century modern. The reflective curves and Googie freeform echo the down-market models that adorn Lebowski's apartment and, where else, the bowling alley with its orange benches, chairs, and the ball returns reminiscent of the Korean War–vintage F-86 Sabre Fighters that the Coens found so beguiling (Robertson 61). Of particular note is the repeatedly cited Eames chair, one of the first objects to embrace the material aesthetic of plastic fully. The cardinal concern becomes fashioning chair molds that maximize the flux properties of fiberglass polyester.

Maude is roughly modeled on a specific fluxus painter and performance artist, Carolee Schneemann.[3] Some of Schneemann's works bear titles like *Vulva Morphia* and *Meat Joy*, one of her notable pieces involved painting nude in a tree surgeon's harnesses, and she coined the catchphrase, which I imagine Maude would also endorse, "I am the nude, but I also hold the paintbrush." Recall that *fluxus* means "flow." When we are introduced to Maude, she quite literally flows. Like the Dude, Maude is bowled the length of her dwelling, in her case by choice, in a sling on a ceiling track, carrying a paintbrush, the sound of which, as the Coens describe it in their screenplay, is "a rumble like that of an approaching bowling ball" (59). *Fluxus* is an expressive cognate of plastic, the Greek *plastikos*, meaning "fit for forming"—and consider the fondness of fluxus artists for paintings of flow-charts of art-historical diagrams rendered into endlessly flowing, convoluted art tendencies.[4] Plastic is uneventful and futureless, disposable yet perpetual. It fits right in there, placement and flow. This attention to plasticity, fluidity, and flux supports a certain feminist critical aesthetic and leads us toward Maude, the Grand Lebowski, as Judith Roof observes in this book. It also helps makes good on the film's allusion to Schneemann by re-diagramming

and in effect plasticizing the masculinist, genealogical substrate implicit in the prevailing conceptions of time and space.

Bahktin calls the material dynamics of literary space-time *chronotopes*. His neologism aims to convey the same kind of spatio-temporal co-dependency that the Stranger notes in the Dude's embodied *time 'n place*—he's the man for his time 'n place, he fits right in there. For Bahktin, time and space become, in an aesthetic practice, "fused into one carefully thought-out, concrete whole." In this whole, which functions for Bakhtin (as for the Coens) almost as a kind of character, time "thickens, takes on flesh," and space "becomes charged and responsive to the movements of time, plot and history" (84). In other words, the first tends toward wood, slow, thick, and fleshy; the second, toward plastic, quick, unstable, and charged. Thus, time-space presents us either with something that drips or pours; secretes or extrudes; grows or flows. Or, rather, the chronotope always occurs past tense: dripped or poured; secreted or extruded; grown or flowed. Is it an age of wood or an age of plastic? If nothing else, the man of his chronotope exposes the question as a false dilemma.

This chapter isn't the first to observe that the key to this film is the Dude's generic condition, his status as a person without papers on the frontiers of the territory called *noir*. If the original Phillip Marlow couldn't penetrate the case in *The Big Sleep,* what chance can an actual loser like the Dude have, right? But it's surely a novelty to describe the cross-section of this combinational agenda in terms of plastic-wood and to supply a diagram of the lumberescent genealogy as a bonus (see below). Charging a semi-catatonic pothead with sorting out a complex,

neo-noir kidnapping case is like overlaying medium-density fiberboard with hard resin laminate. He can't get to the heart of matter, because he is more or less like matter (i.e., a head stuffed with sawdust)—and less like an epistemologically competent hero—to begin with. Further, the matter that is the Dude is decidedly mana-like, in Horkheimer and Adorno's sense. The Dude represents precisely mana to all comers. From Treehorn's thugs to Lebowski Sr.'s fool errands; from Bunny's blowjob proposal to Uli's designs on *ze money;* Maude's donor seminal fluid; the Stranger's existential dilemma; all the way down to Marty's arrears and Fred Dynarski's grievance about Walter on behalf of the Southern Cal Bowling League—when you think about it, what the Dude is most consistently is not a person at all but a location for finding stuff *identical and not identical* to the Dude. The Dude is, like Horkheimer and Adorno's tree, the site where all this miscellaneous stuff can reliably if not always satisfactorily be tracked down or addressed.

Charging a semi-catatonic pothead with sorting out a complex, neo-noir kidnapping case is like overlaying medium-density fiberboard with hard resin laminate.

Those who would figure the Dude for a hero will protest here that he and his friend Walter, if not exactly penetrating, do seem to emerge at the end relatively unscathed: having proposed a plausible solution to Bunny's kidnapping, subdued the nihilists, given their departed friend Donny a communally coherent death, rolled their way into the semis, and so on. But we should also observe the extent to which the Dude suffers—abiding seemingly endless abuse and assorted loses: rugs, finders fees, Donny, finally his car. The Dude just wanted his rug back—did he even end up with one? Even the paternity of the "little" Lebowski on the way is always already lost to him.

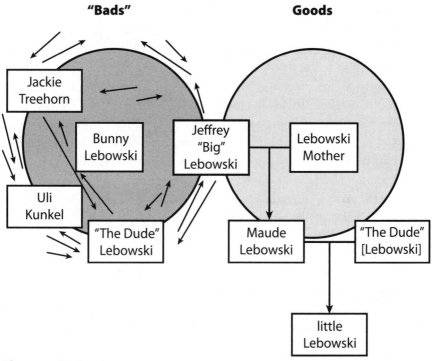

So, in the end, *que bono*? Who benefits?

One way to try to answer this—as Miss Marple and apparently Lenin know well—is to follow the money. Following the money in the *Lebowski* plot leads in a foreclosed and futile circuit of "bads," hazards premised on the Name-of-the-Father. The patronymic and arborescent genealogical tree proves to be a fraudulent phantasm all the way down to its roots. Above all, the film undermines the idea that the patronym must make good on all debts charged in its name. This dead-end plot

(represented by the circle of "bads" on the left in the diagram) is set in motion by the confusion of Lebowskis, not least the absent Lebowski at the center of this plot, Bunny, the trophy wife. And, strictly speaking, despite the red herrings and general confusion supplied by the missing Bunny, Jackie Treehorn, his thugs, the nihilists, Walter's whites, and even the Dude's trifles, the money goes nowhere. Jeffrey "the Big" Lebowski embezzles from one pocket to line the other—at least, according to the final solution that the Dude abides. In effect, from the opening encounter with the rug-peers, the Dude gets possessed by another man's patronym that is also his; he has a name which should be "good for it." Egged on by Walter, the Dude initially subscribes to this logic when he first goes to confront his namesake. The old wood should make good. The Big Lebowski should make good for damage made in the name he seems to solidly possess, for the name on wood of his young trophy wife . . . whose allowance is ample. This circuit is not only an epistemological dead-end for the Dude, but it also leads to much suffering and lost or damaged property, because it leads on a path to a non-existent genealogical tree that seems more like a tumbling tumbleweed than anything else.

The second, seemingly more promising way to answer the question is to follow the rug (represented by the circle of "goods" on the right in the diagram). In taking the replacement rug from the Big Lebowski, the Dude sets in motion a complex counter-plot, a magical gift refund of sorts, through which the spoils of the manor become un-spoiled. As if by sleight-of-hand, the Dude is removed from the flow of money, debt, and risk and placed in the countercurrents of proper names, objects, and interiors. The rug turns out to be a plastic inheritance of the best sort, trans-generation cultural wood that travels from Maude Lebowski to her now-deceased mother, uprooting all the seemingly unidirectional, arborescent certitudes of genealogy.

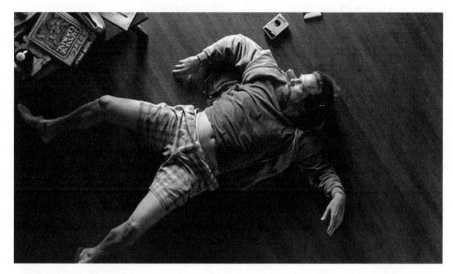

20.2. Exposed floors.

In effect, the Dude returns to the daughter a gift once given to the mother by the daughter, a gift which can't but remind us that it's the missing mother—like Bunny, another Lebowski by marriage—who's the bearer of a cultural, not "natural," patronym. She was the source of all that "Lebowski money" anyway, which was not the Big Lebowski's to give, was it not? He's the one on the allowance, remember. The final heightened effect of exposed wood floors in the Dude's bungalow right before coitus with Maude reminds us that all that remains here is this cultural wood, echoing the earlier shock of finding the rug at Maude's studio, which it quite pointedly did not tie together.

The Dude, who won't let anyone forget it, is not a Lebowski by choice; his is the proper name by design, the self-applied name. So, when the stranger tells us that a little Lebowski is on the way, it is even more Maude's name than the Dude's that really abides. Here it is: inheritance

itself has been rewired as a kind of cultural wood, lumberescent mana down through the generations, westward the wagons, and perhaps that way the little Lebowski on the way won't ever have to endure being called little Dude.

Notes

1. On skeumorphs, see Hayles, 13–17.

2. In real life, the house is a well-known gem of mid-century modern, the Sheats house, designed by architect John Lautner in 1963. See "The Twentieth Century: 100 Years of Design," *Architectural Digest,* April 1999, 266–67.

3. Special thanks to my colleague Susan Jarosi for first bringing this allusion to light.

4. My thinking here owes something to Ward Shelley's "Timeline Paintings," www.pierogi2000.com/flatfile/shelleywdrawings06.html.

Enduring and Abiding **21**

Jonathan Elmer

By the time I delivered the ideas in this chapter, in September 2006, in a dowdy wood-paneled "conference room" in a bowling alley in Louisville, Kentucky, during the annual Lebowski Fest held in the city and at those lanes, everything had been said. Mine was the final paper, and during the previous two days the film had been turned upside down and shaken, and then carefully situated with regard to fluctuations in the L.A. real estate market, the subgenre of bowling noir, the Brunswick color palette, nihilism and fluids, Paul de Man and Rip Van Winkle. Everything had been said, some things multiple times, and everyone was happy. Most people were happy. It became apparent to many of us that the film did not suffer from this critical vulturism, that the conversation could go on, potentially forever, without it being a problem that we were repeating ourselves and offering quite obviously contradictory views on many important aspects of the movie. The chatter did not exhaust the film, did not debase it or use it up, but it did not really exalt it either. The ability of the film to sustain such conversation was not due to its being a "classic," timeless or otherwise. It seemed, rather, that the film was not so much full of a complexity that needed endless "unpacking"—this despite the fact that *The Big Lebowski,* like all the Coen brothers' movies, lavishes loving, even obsessive, attention on all its details—than it was offering itself as genially *underdetermined,* available for any and all projections, investments, analyses, even mimicries.

The level of mimicry during the meetings was quite high—at moments, alarming. When one of the presenters donned a hat and began to deliver his paper in the voice of "The Stranger," I was seized with anxiety. But I shouldn't have been—it was a virtuoso performance, one of several, and even those of us who did not rise to such performative excellence were more and more immersed in an environment of mimicry as the meeting went on. Like Bartleby's office mates, who unconsciously respond to his infuriatingly underdetermined personality by imitating the sole unique aspect of his self-presentation—the word *prefer*—we all started to invoke the preferred nomenclature, we all entered each other's worlds of pain, and the general happy-go-lucky Walteresque profanity seems now, in hindsight, to have done a great job of tying the fucking room together. The film produced verbal and gestural mimicry, it elicited interpretive saturation, because of its ultimate underdetermination, its refusal to calcify into any one genre, any special place in an oeuvre, any commanding ideological emplotment. The film was less an object to take apart than a matrix for a strangely limitless refabrication, or reproduction. It morphed ceaselessly under the pressure of our gestures and our words and still remained, inviting all comers, disallowing no mutation, however strange. The film seemed strangely *generous*—something for which I was grateful as I began to deliver my superfluous final words. It forgave us all our trespasses.

In this essential underdetermination, *The Big Lebowski* takes on the aspect or identity of its central character, Jeff "The Dude" Lebowski, played by Jeff Bridges. I say "central character" with some hesitation, because I don't want to say "hero." It took me some time to realize it, but the title of the film does not refer to the character played by Bridges. Why this did not occur to me sooner is an unhappy reflection on my critical acumen, since the plot's entire motivating structure is the Dude's *refusal* to be known as "Mr. Lebowski.": "*I'm* not Mr. Lebowski," the Dude

explains to the wheelchaired Korean vet and tycoon with whom he has been confused. *"You're* Mr. Lebowski, man. I'm the *Dude."* Of course, when you have a title like *The Big Lebowski,* and not one but two characters named Lebowski, one of whom is clearly the main character, it's perhaps excusable to think that the title names the hero. But whatever Jeff "The Dude" Lebowski is, he's not any normal kind of hero, so I really should have known better than to think *he* was "The Big Lebowski."

I don't think the aggressive tycoon is the Big Lebowski either. *Mr.* Lebowski, sure, the Dude tells us that. And given their obviously disparate positions on the status hierarchy, one might conclude that the Dude is, logically speaking, the little Lebowski next to the bellowing, self-aggrandizing gasbag played by David Huddleston. But as we learn late in the film, there is already a "little Lebowski" on the way, the result presumably of the Dude's amorous night with Maude Lebowski, and her yogic cradling of his seed. So, if the Dude can't really be said to occupy the place of the little Lebowski, there's no reason to extend that exalted title to the Dude's millionaire namesake—*Mr.* Lebowski, fine, but not the Big Lebowski.

My first conclusion, then, in my effort to understand the meaning of the film's underdetermination is that the title is a feint. It sets us up for the expectation of eponymous heroism. Now, generally speaking, the relation between names and heroes is complex and profound:

> The hero fights and conquers. Where does this virility come from? From himself. But where does he himself come from? This is the beginning of the hero's difficulties. He has a name that is proper to him, one he has often even appropriated—a surname [*surnom*], just as we speak of a superego [*surmoi*]. He has a name, he is a name. (Blanchot 369)

Jeff "The Dude" Lebowski has a name, and this is indeed the beginning of his difficulties. But he does not "appropriate" this surname, as

one equips oneself with, accepts the burden of, a superego. He rejects that name and appropriates for himself the name "The Dude," an act we might rather call the creation of a subego. The Dude's essence, we might say, lies in his refusal to be Lebowskied. Where the title leads us to expect a hero, then, we find what I can only call a *condition*, a being-Lebowski. Looked at in this way, the title begins to seem like a weird homage, in a film with so many more overt homages, to Raymond Chandler and, specifically, *The Big Sleep*. Chandler's title, *The Big Sleep*, doesn't name a hero, either; it names the limit-condition with which the fiction and the film are obsessed—namely death. Chandler's plot is driven by everyone trying to avoid "the big sleep." The Dude also tries to avoid suffering the Big Lebowski: like the big sleep, to have the big Lebowski visited upon you, is not, perhaps, an experience from which one returns. The Dude comes perilously close to such a fate, but his refusal of the nomination constitutes his escape, or rather, his ability to *abide*.

The Dude refuses to be Lebowskied, then: this refusal, the assumption of a subego, constitutes a way of abiding that fundamentally revises the hero's role. "The hero fights and conquers," says Blanchot. "Where does this virility come from? From himself." Such words can't help seeming comical in the context of *The Big Lebowski*. The film as a whole asks us to see this negotiation between names and heroism as an extremely violent and comical affair. But the Coen brothers do not see "comical" and "serious" as mutually exclusive values: they are quite serious about the comicality of the stories they tell. This applies to the vexed question of the Dude's "virility." In the admittedly small-scale research I did on academic and crypto-academic treatments of the Coen brothers, and this movie in particular, I discovered that a number of people think this film is about patriarchy, or even that it constitutes an extremely clever critique of various kinds of violent male posturing, from Walter's

harping on Nam and constant invitation to enter his private "world of pain" to the patriarchalism seemingly implied by the whole Lebowski surname farrago. But whatever the film has to say about men and virility and patriarchy, however much the film exposes and deflates the virile pretensions underwriting pronouncements that "This aggression will not stand, man," it does so, I would suggest, from the side of the body, rather than the side of the name, idea, or value of manliness. The Dude is an exuberantly embodied character. One charming detail from William Preston Robertson's book on the making of the film is provided by costume designer Mary Zophres, who tells us that Jeff Bridges was so taken with the Munsingwear tighty-whities he was issued that he took a pair home to help him method-act his way to the Dude's level of grunge. In the scene in the bowling alley where the Dude performs some spaced-out stretching movements, canting over to one side, staring up at the ceiling, his Munsingwear peeps over the top of his stretch pants. It's a sweet moment, almost intimate. In general, Bridges plays the Dude as built for comfort, and Zophres understood this requirement of the character. In her account of costuming the movie, she offers fascinating information on how she fatigued the Dude's sweatshirts and shorts so that they could achieve the level of shapelessness that was deemed desirable. Whatever else the Dude's clothes may say about his economic situation, countercultural bona fides, or attitude toward personal hygiene, his baggy, bunchy clothes also keep before the mind's eye all that flesh that is being allowed to take up space unconstrained. In this way, too,

> *... the Dude performs some spaced-out stretch movements, canting over to one side, staring up at the ceiling, his Munsingwear peeps over the top of his stretch pants. It's a sweet moment, almost intimate.*

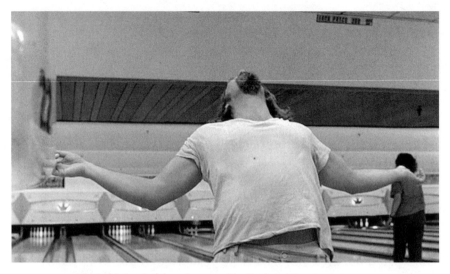

21.1. A desirable level of shapelessness: The Dude in Munsingwear.

the Dude's embodied presence is all the more powerful for seeming underdetermined, for having resisted the shaping, fixing, and molding imposed on it by what seamstresses would call clothes "with structure."

The Dude's middle-aged burliness, as played by Bridges and costumed by Zophres, has a comic quality, certainly. But the deflating power of embodied virility is, if anything, more marked in the screenplay. In the absurd second meeting with the millionaire Lebowski, the discussion turns to "what makes a man." The Dude genially listens to the fatuous musings of his namesake: "Is that what makes a man?" he is asked, rhetorically, to which the Dude answers: "That and a pair of testicles." The funniest riff on this theme comes in the scene with pornographer Jackie Treehorn, a scene which encrypts a reference to *North by Northwest*. The Dude, of course, shares with Roger O. Thornhill the discomfort of being mistaken for someone else. In Hitchcock's film,

Thornhill, desperate to get disentangled from his mess, jumps up at one point to get an address by rubbing the pad on which Eva Marie Saint had just written. The Dude performs the same clever maneuver at Treehorn's bachelor pad, which is itself so reminiscent, in its 1950s stylings, of James Mason's mountain retreat at the end of *North by Northwest*. Treehorn, a James Mason gone seriously to seed, has just scribbled on a pad while taking a call. When he leaves for a moment, the Dude leaps up and does the pencil-rubbing maneuver. But where Thornhill gleaned a clue, all the Dude gets is a traced version of Treehorn's pornographic graffito of a cock and balls. Slavoj Žižek has convincingly written of Roger Thornhill's struggles against the "symbolic mandate" imposed by the Big Other in Hitchcock's film. But when you substitute a Dude for a Roger Thornhill, a Jackie Treehorn for a Van Dam, a Big Lebowski for a Big Other, the mysteries of misrecognition collapse into cartoons (see Žižek 104).

The Dude refers to himself in the third person, which is weirder than it might seem. "Leave a message for the Dude," instructs the answering machine. What kind of person refers to himself in the third person? Let me leave aside "The Jesus": as the man in the purple jumpsuit sensibly advises, it is best "not to fuck with The Jesus." But there are others who refer to themselves this way. Bob Dole used to do so. So did Elmo from *Sesame Street*. Perhaps if we average these two characters, we get a sense of who the Dude may be—half political subject-function, half cartoon embodiment of the pronominal promiscuity of toddlerdom. I have just looked, albeit briefly, at the way the Dude's mode of virile embodiment seems to participate in both the elasticity and the comic violence of the cartoon character. But what about his Bob Dole side? The Stranger tells us in the beginning of the film that the Dude is the man for his time and place, that he "fits right in there." This description, like the title itself, functions as a lure, drawing commentators of all kinds to

spell out what makes for the Dude's exemplarity. But as I learned in Louisville, the Dude's ability to be plausibly exemplary of many mutually contradictory things is perhaps what is most unusual about him. If he "fits right in there," in other words, it's not because he is shaped right—like the perfect puzzle piece—but because he bends and stretches like Silly Putty. He is ideologically and socially interstitial. The Dude is like a socio-symbolic stem cell—pure potentiality in suspension, holding some special germ of exemplarity in him that turned one way can open out onto the abstractions of role, function, and ideological identity (his Bob Dole side), and turned another way remains essentially unformed, prior to the divisions and individuations that produce the identities we track with pronouns and proper names (his Elmo side).

In being so flexible, so unformed, the Dude is also what holds together the 1990s L.A. world in which he lives. Somehow we have to think together the fact that the Dude is the man for his time and place, and that he is over and over again in the wrong place at the wrong time: both central, the hub to which all the spokes are attached, and aberrant—the wheel is veering off the road. This double condition—central and adrift, exemplary and underdetermined—is what is at stake in the Dude's mode of being, namely abiding. It is possible, of course, to abide something, or not abide something, transitively. The millionaire Lebowski, for example, "will not abide another toe." In this sense, *abiding* is basically a synonym for "endure." But the differences between enduring and abiding are subtle and important. Consider the thumbnail sketches of his characters that Faulkner added to the end of *The Sound and the Fury* in 1946. After going through the cast—even Luster gets a sentence—Faulkner comes to Dilsey, the fictionalized version of his Mammy, Caroline Barr, she to whom he was to dedicate *Go Down, Moses,* "who gave to my family a fidelity without stint or calculation of recompense and to my childhood an immeasurable devotion and love." Alone among the

characters, Dilsey remains undescribed, Faulkner merely writing—and they are the book's final words—"DILSEY: They endured" (*Fury* 427). The "they" here, like the Dude's third person, invokes a trans-subjective identity, a rendering of Dilsey into an exemplarity "without stint," we might say. But Dilsey, in her summation of a capacity to endure on the part of her race, and her gender, still retains enough agency to qualify as a modulation of the heroic. If the classic hero is a vector of agency fulfilling his name's mandate, Dilsey as a "they enduring" is a kind of anti-hero, a figure whose mere lasting constitutes a baseline kind of agency. To endure is to maintain an identity, to withstand external assaults, while to abide is—according to the OED—"To remain in expectation, wait"; "To remain without going away, to stay"; "To remain in residence; to sojourn, reside, dwell."

In being so flexible, so unformed, the Dude is also what holds together the 1990s L.A. world in which he lives.

The idea that abiding is "to remain in residence," to "dwell," can remind us just how much of the action and conflict in *The Big Lebowski* concerns the Dude's dwelling. The Dude simply wants to dwell in peace, but it is his fate to have his most intimate spaces violated: his head is stuffed into his toilet, his bath is invaded by a ferret, his rug is pissed on. This rug may seem like a MacGuffin—the term given by Hitchcock to a wholly contingent object whose circulation generates a plot—but I think it is more than that. In "Building Dwelling Thinking," Martin Heidegger writes about the way buildings create the locations they might merely seem to occupy. His example is a bridge: "The location is not there before the bridge is. Before the bridge stands, there are of course many spots along the stream that can be occupied by something. One of them proves to be a location, and does so *because of the bridge*. Thus the bridge does not first come to a

*The Dude embodies **potentia,** he is always employable because he is never employed—merely abiding.*

location to stand in it; rather, a location comes into existence only by virtue of the bridge" (154). Heidegger calls this transformative power of the building/dwelling a power to *gather.* The Dude's rug gathered, in this sense, it tied the room together: it was essential to his dwelling, in Heidegger's sense. When we watch the Dude standing in the middle of his room, on the rug he has taken from the millionaire's house to replace his own, performing his idiosyncratic *tai chi*, we are witnessing his well-nigh priestly efforts to reconstruct his dwelling.

The rug is the central element of the plot because it ties the room together; it symbolizes, and more than symbolizes, the Dude's mode of dwelling, his abiding. "When we speak of dwelling we usually think of an activity that man performs alongside many other activities. We work here and dwell there. We do not merely dwell—that would be virtual inactivity—we practice a profession, we do business, we travel and lodge on the way, now here, now there" (Heidegger, "Building Dwelling Thinking" 147). But "virtual inactivity" summarizes quite precisely the Dude's mode of abiding. When asked whether he is employed, the Dude's incomprehension of the question is sublime: his slackerdom is metaphysical. The Dude embodies *potentia,* he is always employable because he is never employed—merely abiding. Or perhaps it would be more accurate to say that he embodies the virtuality that goes along with all our activity—the virtuality of its not having been undertaken in the first place. The Dude would very much like not to be so active, and he somehow is able to make present what almost always, for most of us (as Heidegger says), remains invisible and out of reach: our not-having-done, the virtual inactivity of merely abiding. I think this is why more even than Mammy Dilsey's enduring "devotion," the Dude's

sojourning, his standing by—as, for instance, when Walter scatters Donny's ashes—makes him a figure of immeasurable forgiveness. It's not impossible that Walter reads Heidegger, but whether he does or not, his decision to scatter Donny's ashes looks like an attempt to gather together what Heidegger calls the "fourfold" (earth, sky, mortals, and immortals), an attempt to dwell. The Dude stands by, he is sojourning at Walter's side, and it is he to whom the earthy dust of Donny's mortal remains sticks when the wind blows them into his face. The Dude is upset: if he's going to have stuff clinging to his beard, he'd prefer it to be white Russians. Walter is upset, too, and in the pain of his grief and his humiliation, he embraces the Dude, asking forgiveness. And the Dude grants the forgiveness, not by offering any fantasy bribe of a different world, but simply by standing by, making himself available for hugging. Like Whitman's other famous metaphysical loafer, the Dude conjoins virtuality and embodiment: he is "hankering, gross, mystical, nude" (45). And if he stands aside and waits, if he abides in expectation of our coming, it is not in the shape of some spirit or extraterrestrial creature, but precisely as the virtual inactivity of the earth itself, ashes in the beard, dirt under the bootsoles.

Endnote: The Goofy and the Profound:
A Non-Academic's Perspective on
the Lebowski Achievement

William Preston Robertson

As I write this, dressed in my "Achiever" T-shirt, the 2006 Lebowski Fest in Louisville, Kentucky, is but the stuff of dreams.

And what pizza with anchovies-spawned dreams they are: people packed (speaking of anchovies) into a bowling alley dressed as Brobdignagian Pomeranians and marmots; gangly cowboys with droopy handlebar moustaches and spear-brandishing, bowling ball-breasted Valkyries; purple jumpsuited-Hispanic pedophiles, and earless, red-spandexed Teutonic nihilists; knit sweater and plaid Bermuda shorts-wearing bearded, long-haired hippies, and flat-topped, goateed endomorphs in shaded glasses and duck hunting vests.

But of course, these are obvious and largely to be expected.

There are also the more obscure: a guy wearing a giant Folgers coffee can with shoulder straps; women dressed as Kahlúa bottles; two others dressed completely in white with scarlet lips, tight tops with hot pants and faux Russian sable hats, muffs and boots; a number of men dressed as urine-despoiled area rugs; a woman dressed as a tumbleweed; and a farm couple handing out leaflets for their missing daughter "Faun."

And then there's the really truly just plain abstruse: a quartet in donkey masks and uniform T-shirts that read: "Gold Brickin'"; a man wrapped in a blanket with happy porcine heads attached to it all around

like pustules in some exotic, *Merry Melodies*-themed pox; and most elaborately, on a plywood forestal diorama in the lobby, a man dressed as the Pope, sitting with his boxer shorts around his ankles, idly reading *The Vatican Times* newspaper and, um, well . . . *transubstantiating,* let's just say.

All of these figments happily swill beer and White Russians. And all, remember, are in a bowling alley.

Welcome to Lebowski Fest, the dreamscape that Joel and Ethan Coen built—or rather Joel and Ethan Coen as channeled by Will Russell and Scott Shuffit, the two youthful entrepreneurs who took a boredom-killing game of tossing quotes back and forth from the Coens' film *The Big Lebowski* (1998) and turned it into a quickly growing yet still delightfully low-rent annual fan event that is now six years running, with other events held, in addition to Russell and Shuffit's hometown of Louisville, Kentucky, in Los Angeles, Las Vegas, New York, Austin, Chicago, San Francisco, Seattle, and, now, London.

Thaaaaat's right, Dude: Lebowski Fest is goin' global!

The Big Lebowski is what I like to think of as the Coen brothers' "Tourette's movie." Coming as it did on the heels of *Fargo* (1996), a film lauded as a minimalist masterpiece of aesthetic precision and control, *Lebowski* is the obscenity-laced, arm-flailing explosion in the car ride home from the Academy Awards.

Referencing both the 1939 Raymond Chandler novel *The Big Sleep* and the director Robert Altman's 1973 *The Long Goodbye,* an eccentric reinterpretation of Chandler's 1953 novel of the same name, *Lebowski* follows the story of weed-addled amateur bowler and former 1960s college activist Jeffrey "The Dude" Lebowski as he pursues a mystery that lands on his doorstep one night and literally pees on his rug. Following the scent, so to speak, of the mystery, the Dude pitches headfirst into an

unsorted hamper of pop cultural styles, music, images, and intellectual references that put the film *The Big Lebowski* about as far from *Fargo* as, well, Fargo.

The Big Lebowski seems a curious film to generate a congregational cine-maniacal fan following. And yet Lebowski Fest is not like the midnight screenings of *The Rocky Horror Picture Show* (1975), in which audiences dress in drag, throw toast, rice, and toilet paper at the silver screen, shout dialogue in unison or re-enact the entire movie in silhouetted shadow play before the gargantuan projected visages of Tim Curry, Susan Sarandon, and Barry Bostwick.

Nor is it like the *Star Trek/Star Wars* mega-conventions, in which money tumbles like tribbles, vendors hawk insanely overpriced action figure "collectibles," and fans obsess competitively over the geeky minutiae of their futuristic haberdashery, weaponry, and alien rubber prostheses.

In short, Lebowski Fest is not about performance art, nor is it about merchandising.

No, the Lebowski Fest is . . . well, let's just say it's more laid-back than that. More contemplative. Sure, it's not a particularly productive contemplation—but it's contemplation nonetheless.

With no official endorsement from the filmmakers and no ancillary industry of insanely overpriced collectibles, there's really not a hell of a lot to do at Lebowski Fest other than bowl and drink and dress like a marmot. The movie is watched, once, on opening night. A variety of live bands play the next day, with a variety of games of chance offered between musical sets—the Marmot Toss, the Satchel Full of Underwear Toss, the Malibu Police Chief's Coffee Mug Hurled at the Dude's Forehead Toss. All of these games are shoddily constructed paper-and-plywood affairs, with no great effort shown to make them anything other than what they are: conceptual gags.

Indeed, the lazy, second-rate quality of Lebowski Fest is not merely willful: great care is taken to represent no care at all. If nothing else, organizers Russell and Shuffit are genuinely industrious lads—if not actual Achievers—with a global phenomenon on their hands and now their own book. And yet, each year, as the Lebowski Fests grow in number and geographic spread, the individual events themselves become smaller and even more trivial in their showmanship, with increasingly more obscure and insignificant celebrities connected to the movie being touted, whether it be extras with non-speaking roles or various inspirations for the Coens when writing the script—mocking in a way the shameless, capitalistic, bottom-of-the-barrel celebrity autograph circuit of the *Star Trek/Star Wars* fests.

This "verisimilitude of failure" is the Lebowski Fest paradigm. At its heart is what distinguishes Lebowski Fest from the other film-based fan phenomena. Whether all of the participants realize it or not (and I think a surprising number of them do), Lebowski Fest is really a celebration of concepts.

One can see it in the costumes, which don't just depict film characters but dialogue from the film: the Malibu police chief refers to the Dude's "gold brickin' ass" as he tosses his coffee mug at the Dude's forehead. A nihilist orders "pigs in a blanket" at a breakfast diner. And the previously mentioned pastorally loaf-pinching pontiff is a literal representation of a rhetorical question uttered by the Dude when asked if he'd like a refill on his White Russian, the line itself a confusion of the two smart-ass rhetorical comebacks "Does a bear shit in the woods?" and "Is the Pope Catholic?"

Concepts. Goofy, pointless, and insignificant. But concepts nonetheless.

It's no surprise, then, that the 2006 Lebowski Fest was preceded by The Lebowski Cult: An Academic Symposium in a back room at the

very same Louisville bowling alley. Organized by Aaron Jaffe, Assistant Professor of English, University of Louisville, and Ed Comentale, Associate Professor of English, Indiana University, the symposium featured papers with clearly ironic titles derived from sometimes profane lines of dialogue derived from the film separated by a colon from academic précis about postmodernism, deconstructionist theory, and . . . what-have-you.

To the distant clatter of alley pins and the stale smell of beer and onion rings soaked in oil were read such learned stuff as "*Logjammin'* and *Gutterballs*: Masculinities in *The Big Lebowski*" by Dennis Allen, West Virginia University; "Well, it's not a literal connection, Dude: History, Allegory and the Medieval Grail Quest in *The Big Lebowski*" by Andrew Rabin, University of Louisville; and one of my personal favorites, "New shit has come to light: The Information-seeking Behavior of The Dude" by librarians Emily Dill and Karen Janke, Indiana University-Purdue University Indianapolis.

As the only non-academic presenter at the symposium, frankly, I hadn't a clue what most of the presenters were talking about. However, one thing was clear: the presenters themselves did. They were discussing not just concepts, but concepts with which they were quite familiar, maybe even learned in . . . and as they discussed them, some seemed just a little drunk.

Two of the presenters, Judith Roof of Michigan State University and Tom Byers of University of Louisville, each delivered their papers in a *Lebowski* persona—a cowboy-hatted Byers offering his vernacular-laden text in a gravelly and laconic Sam Elliot drawl, and Roof, a feminist theorist, delivering her fascinating opus about the vaginal fluid iconography in *Lebowski* dressed with disturbing success like John Goodman's character, Walter Sobchak, complete with camouflage pants, head band, and graying brush cut.

Concepts—goofy, profound. Square dancing together until it's unclear who came to the dance with whom, and no one cares how good a dancer anyone is, just that a fun time is being had by all.

As I write this, dressed in my "Achiever" T-shirt (okay, I'm not really wearing one—that's just a literary device), and I once again recall Roof's engaging presentation, which again causes me to amiably push my testes from the sanctuary of my body cavity back down into the scrotal sac from which they have scampered up in screaming psychosexual panic (this part is true), it occurs to me how the two events, the 2006 Lebowski Fest, that drunkard's Oneiros, and its more scholarly lead-in, The Lebowski Cult: An Academic Symposium, were not actually all that dissimilar, give or take a year—or maybe ten—of postgraduate study. Both, in their own way, were really just playful, drunken celebrations of concepts. One focused a bit more on the drunken part, the other on the concepts, sure, but both undeniably meeting at the common point that was Joel and Ethan Coen's The Big Lebowski.

This was made most apparent during a roundtable discussion held in a small hotel ballroom across the street from the bowling alley on the last day of the symposium and the first day of Lebowski Fest. The room was surprisingly full for an academic conference of this sort, it seemed to me: a potent mixture of academics and Lebowski Fest participants that seemed rich with possibilities—possibilities that, to my mind, could have culminated in a chaotic scene of blustery titans, howling fat men, and vaudevillian German accents threatening emasculation while deriding any and all belief systems . . . maybe even some vomit as well.

As it happened, a similar worry was shared by Jaffe and Comentale, the symposium's organizers, once, of course, they got past the fear that anyone would show up at all. Such was not the case, however. Indeed, the opposite was true. The multitude of Lebowski Fest participants relished the opportunity to discuss the ideas behind their fascination with

the film. And the academics reveled in the opportunity to strut their stuff on such a hip proscenium.

A paper by James Madison University visiting professor Richard Gaughran (himself a dead ringer for Dude Lebowski, and without stagey augmentation) entitled "Professor Dude: An Inquiry into the Appeal of His Dudeness for Contemporary College Students" was discussed. Through the discussion, it became clear that part of *The Big Lebowski*'s appeal was that for a generation of students who have been pressured to excel since birth, and who then upon reaching adulthood were faced with the bait-and-switch of a service-based economy in which not only will they most certainly make less than their parents did salary-wise, but they also will be saddled with their parents' debt . . . where the ruler of the free world was C-student George W. Bush (assuming he didn't cheat to get that far) overseeing one of the biggest mediocracies in the history of U.S. government . . . given these things, a movie that presents as its protagonist a man who is weed-addled but educated, with no career ambitions beyond the bowling finals, but who is still somehow presented in a heroic light, as a loyal, nonjudgmental person, a good person, at peace with himself despite being, in the minds of harsher critics, a doofus loser . . . well . . . what's not to like?

In a sense, *The Big Lebowski*'s message is the ultimate liberal arts message: knowing things may not advance you very far in this world, but it certainly provides for fine entertainment.

Perhaps this, then, is the Coen brothers' lasting artistic impact on the culture, if not the box office: not just putting forth concepts for concepts' sake, but in encouraging a certain ease and comfort with concepts by using them as comic foils, by bringing well-honed, learned concepts before the lens only to have them do pratfalls and split the seat of their pants embarrassingly.

. . . Or in the case of *The Big Lebowski,* put the concepts of brilliant scholars into the mouths of stoned, angry doofus bowlers as fodder for their heated and inane debates—not to mock the doofusses so much (though doofusses they are), but to slap the concepts of brilliant scholars on the back, tousle their pomps, and offer to get them another drink.

Ultimately, this is the appeal the movie has to the Academy.

No, no. Not the one that awards the little naked man statues—I mean the real one.

Agamben, Giorgio. "Kommerell, or on Gesture." In *Potentialities: Collected Essays in Philosophy,* ed. and trans. Daniel Heller-Roazen. Stanford, Calif.: Stanford University Press, 1999.

———. *Means without End: Notes on Politics.* Trans. Vincenzo Binetti and Cesare Casarino. Minneapolis: University of Minnesota Press, 2000.

———. "Notes on Gesture." In *Means without End: Notes on Politics,* trans. Vincenzo Binetti and Cesare Casarino. Minneapolis: University of Minnesota Press, 2000.

———. *The Open: Man and Animal.* Trans. Kevin Attell. Stanford, Calif.: Stanford University Press, 2004.

Altman, Rick. *The American Film Musical.* Bloomington: Indiana University Press, 1987.

Anderson, Stephen R. *Doctor Dolittle's Delusion: Animals and the Uniqueness of Human Language.* New Haven, Conn.: Yale University Press, 2004.

Autry, Gene, with Mickey Herskowitz. *Back in the Saddle Again.* Garden City, N.Y.: Doubleday, 1978.

Axelrod, Alan. *The Complete Idiot's Guide to Mixing Drinks.* New York: Penguin-Alpha, 2003.

Bachelard, Gaston. *The Psychoanalysis of Fire.* Trans. Alan C. M. Ross. Boston: Beacon Press, 1964.

Badiou, Alain. *Ethics: An Essay on the Understanding of Evil.* Trans. Peter Hallward. New York: Verso, 2001.

Bakhtin, M. M. "Forms of Time and of the Chronotope in the Novel." In *The*

Dialogic Imagination: Four Essays, ed. Michael Holquist. Austin: University of Texas Press, 1981. 259–422.

Barber, Richard. *The Holy Grail: Imagination and Belief.* Cambridge, Mass.: Harvard University Press, 2004.

Barthes, Roland. *Mythologies.* New York: Hill and Wang, 1972.

Baudrillard, Jean. *Simulacra and Simulation.* Trans. Sheila Faria Glaser. Ann Arbor: University of Michigan Press, 2006.

———. "The System of Collecting." In *The Cultures of Collecting,* ed. John Elsner and Roger Cardinal. Cambridge, Mass.: Harvard University Press, 1994.

———. *The System of Objects.* London: Verso, 2005.

Beach, Christopher. *Class, Language, and American Film Comedy.* Cambridge: Cambridge University Press, 2002.

Beirne, Mike. "An Enchanted *Tiki* Ruse Gives the City of Sin a Grin." *Brandweek* 48 (2007):43. http://web.ebscohost.com/ehost/detail?vid.

Bennis, Phyllis, and Michel Moushabeck, eds. *Beyond the Storm: A Gulf Crisis Reader.* Edinburgh: Canongate, 1992.

Bergan, Ronald. *The Coen Brothers.* New York: Thunder's Mouth Press, 2000.

Bergson, Henri. *Laughter: An Essay on the Meaning of the Comic.* New York: Cosimo, 2005.

Berk, Scott, and Mark Simple. "An All-Too-Long History of Bowling." *X Magazine.* 6 (December 1990). http://cardhouse.com/x06/history.html.

Biggs, David. *The Cocktail Handbook.* London: New Holland, 2000.

———. *Legendary Cocktails.* London: New Holland, 2002.

Blanchot, Maurice. *The Infinite Conversation.* Trans. Susan Hanson. Minneapolis: University of Minnesota Press, 1993.

Böhm, Steffen, Campbell Jones, Chris Land, and Matthew Peterson, eds. Introduction to *Against Automobility.* Oxford: Blackwell/Sociological Review, 2006. 3–16.

Bosker, Gideon, and Bianca Lenček-Bosker. *Bowled Over: A Roll down Memory Lane.* San Francisco: Chronicle, 2002.

Box Office Mojo. http://boxofficemojo.com/.

Boym, Svetlana. *The Future of Nostalgia*. New York: Basic Books, 2001.

Bradford, Barbara Taylor. *Easy Steps to Successful Decorating*. New York: Simon and Schuster, 1971.

Brehm, Alfred Edmund. *Thierleben [Allgemeine Kunde des Thierreichs]*. Zweiter Band. Erste Abtheilung. Leipzig: Verlag des Bibliographischen Instituts, 1883.

Breu, Christopher. *Hard-Boiled Masculinities*. Minneapolis: University of Minnesota Press, 2005.

Brunswick Company. "History." http://www.brunswick.com/company/history/index.php.

Brunswick Pro Bowling. "The History of Brunswick: The Name That Built the Game." http://www.cravegames.com/games/Brunswick_Bowling/history.html.

Byers, Thomas B. "History Re-Membered: *Forrest Gump*, Postfeminist Masculinity, and the Burial of the Counterculture." *Modern Fiction Studies* 42 (1996): 419–44.

Calabrese, Salvatore. *The Complete Home Bartender's Guide*. New York: Sterling, 2002.

Carrera, Asia. *Filmography*. http://www.asiacarrera.com/mymovies.html.

Carroll, Nöel. *Interpreting the Moving Image*. Cambridge: Cambridge University Press, 1998.

Chadderdon, Lisa. "AMF Is on a Roll." *Fast Company* 17 (August 1998). http://www.fastcompany.com/magazine/17/amf.html.

Chadwell, Sean. "Inventing That 'Old-Timey' Style: Southern Authenticity in *O Brother, Where Art Thou?*" *Journal of Popular Film and Television* 32 (Spring 2004): 2–9.

Chandler, Raymond. *The Big Sleep*. New York: Vintage Crime, 1992.

———. "The Simple Art of Murder" In *The Art of the Mystery Story*, ed. Howard Haycroft. New York: Simon and Schuster, 1946.

Clarkson, Jay. "Contesting Masculinity's Makeover: *Queer Eye*, Consumer Masculinity, and 'Straight-Acting' Gays." *Journal of Communication Inquiry* 29.3 (2005): 235–55.

Clemens, Samuel Langhorne. *Adventures of Huckleberry Finn.* 2nd ed. Ed. Scully Bradley, Richmond Croom Beatty, E. Hudson Long, and Thomas Cooley. Norton Critical Edition. New York: Norton, 1977.

Clissold, Bradley D. "*Candid Camera* and the Origins of Reality TV." In *Understanding Reality Television*, ed. Su Holmes and Deborah Jermyn. New York: Routledge, 2004. 33–53.

Clowes, Daniel. "The Future." *Eightball* (4 October 1990).

Coen, Ethan, and Joel Coen. *The Big Lebowski.* [Screenplay]. London: Faber and Faber, 1998.

Comer, Todd. "'This Aggression Will Not Stand': Myth, War, and Ethics in *The Big Lebowski.*" *SubStance* 34.2 (2005): 98–117.

Commery, E. W., and C. Eugene Stephenson. *How to Decorate and Light Your Home.* New York: Coward-McCann, 1955.

Corrigan, Timothy. *A Cinema without Walls: Cinema after Vietnam.* London: Routledge, 1991.

Coughlin, Paul. "Language Aesthetics in Three Films by Joel and Ethan Coen." *Film Journal* 1.12 (Spring 2005). http://www.thefilmjournal.com/issue12/coens.html.

Curtis, Wayne. "Tiki: How Sex, Rum, World War II, and the Brand New State of Hawaii Ignited a Fad That Has Never Quite Ended." *American Heritage* 26.4 (August/September 2006): 38–46.

Daniele, Daniela. "The Hippie Hero in the Postmodern Landscape: Vineland and *The Big Lebowski.*" In *America Today: Highways and Labyrinths,* ed. Gigliola Nocera. Siracusa, Italy: Grafì, 2003. 639–47.

Davies, Philip John, and Paul Wells. Introduction to *American Film and Politics from Reagan to Bush Jr.* Manchester: Manchester University Press, 2002.

Davis, Mike. *City of Quartz: Excavating the Future in Los Angeles.* New York: Vintage Books, 1992.

DeKoven, Marianne. *Utopia Limited: The Sixties and the Emergence of the Postmodern.* Durham, N.C.: Duke University Press, 2004.

Deleuze, Gilles, and Félix Guattari. *A Thousand Plateaus.* Minneapolis: University of Minnesota Press, 1987.

De Looze, Lawrence. "A Story of Interpretations: The *Queste Del Saint Graal* as Metaliterature." In *The Grail: A Casebook,* ed. Dhira B. Mahoney. New York: Garland, 2000.

de Man, Paul. *Allegories of Reading: Figural Language in Nietzsche, Rilke, and Proust.* New Haven: Yale University Press, 1979.

———. *Blindness and Insight: Essays in the Rhetoric of Contemporary Criticism.* 2nd ed. Minneapolis: University of Minnesota Press, 1983.

———. "Confessions: Rousseau." In *Allegories of Reading: Figural Language in Nietzsche, Rilke, and Proust.* New Haven: Yale University Press, 1979. 278–301.

———. "The Rhetoric of Temporality." In *Blindness and Insight: Essays in the Rhetoric of Contemporary Criticism.* 2nd ed. Minneapolis: University of Minnesota Press, 198. 187–228.

Derrida, Jacques. "The Animal That Therefore I Am (More to Follow)." Trans. David Wills. *Critical Inquiry* 28 (2002): 369–418.

———. *Archive Fever: A Freudian Impression.* Trans. Eric Prenowitz. Chicago: University of Chicago Press, 1996.

Dery, Mark. "'Always Crashing in the Same Car': A Head-on Collision with the Technosphere." In *Against Automobility*, ed. Steffen Böhm, Campbell Jones, Chris Land, and Matthew Peterson. Oxford: Blackwell/Sociological Review, 2006. 223–39.

Doggett, Peter. *Are You Ready for the Country: Elvis, Dylan, Parsons and the Roots of Country Rock.* New York: Penguin, 2000.

Donald, Lisa. "Bowling, Gender and Emasculation in *The Big Lebowski*." http://lebowskitheory.com/frameset. [no longer available]

Donalson, Melvin. *Masculinity in the Interracial Buddy Film.* Jefferson, N.C.: McFarland, 2006.

Doty, Alexander. "There's Something Queer Here." In *Making Things Perfectly Queer: Interpreting Mass Culture.* Minneapolis: University of Minnesota Press, 1993. 1–16.

Eagleton, Terry. *The Illusions of Postmodernism.* Oxford: Blackwell, 1997.

Eliot, T. S. "Hamlet and His Problems." In *The Sacred Wood: Essays on Poetry and Criticism.* London: Methune, 1921.

Emmons, Bob. *The Book of Gins and Vodkas: A Complete Guide.* Chicago: Open Court, 1999.

Espinosa, Julio Garcia. "For an Imperfect Cinema." In *Film and Theory: An Anthology,* ed. Robert Stam and Toby Miller. Oxford: Blackwell, 2000. 287–97.

Ezrahi, Sidra DeKoven. "State and Real Estate: Territoriality and the Modern Jewish Imagination." In *Terms of Survival: The Jewish World since 1945,* ed. Robert Solomon Wistrich. London: Routledge, 1995.

Faludi, Susan. *Backlash: The Undeclared War against American Women.* New York: Crown, 1991.

Faulkner, William. *Go Down, Moses.* New York: Vintage Books, 1973.

———. *The Sound and the Fury.* New York: Vintage Books, 1956.

Faulkner, William, Leigh Brackett, and Jules Furthman. *The Big Sleep.* [Screenplay]. http://www.dailyscript.com/scripts/Big_Sleep.pdf.

Fiedler, Leslie. *Love and Death in the American Novel.* New York: Criterion Books, 1960.

Flocker, Michael. *The Metrosexual Guide to Style: A Handbook for the Modern Man.* Cambridge, Mass.: Da Capo Press, 2003.

Frappier, Jean. *Chretien De Troyes: The Man and His Work.* Trans. Raymond J. Cormier. Athens: Ohio University Press, 1982.

French, Philip. "Here's Looking Back at You." *Observer,* 6 August 2006, 10.

Freud, Sigmund. *The Joke and Its Relation to the Unconscious.* Trans. Joyce Crick. Intro. John Carey. New York: Penguin, 2003.

Frith, Simon. *Performing Rites: On the Value of Popular Music.* Cambridge, Mass.: Harvard University Press, 1996.

Fudge, Erica. *Animal.* London: Reaktion Books, 2002.

Fukuyama, Francis. *The End of History and the Last Man.* New York: Free Press, 2006.

Gabriel, Teshome H. *Third Cinema in the Third World: The Aesthetics of Liberation.* Ann Arbor, Mich.: UMI Research Press, 1982.

Gardiner, Judith Kegan. Introduction to *Masculinity Studies and Feminist*

Theory, ed. Judith Kegan Gardiner. New York: Columbia University Press, 2002. 1–29.

Garner, Ken. "'Would You Like to Hear Some Music?' Music In-and-Out-of-Control in the Films of Quentin Tarantino." In *Film Music: Critical Approaches,* ed. K. J. Donnelly. New York: Continuum, 2001. 188–205.

Gilroy, Paul. "Driving while Black." In *Car Cultures,* ed. Daniel Miller. New York: Berg, 2001. 81–104.

Gledhill, Christine. "Pleasurable Negotiations." In *Feminist Film Theory: A Reader,* ed. Sue Thornham. Edinburgh: Edinburgh University Press, 1988. 166–79.

Gold, Mick. "Life and Life Only: Bob Dylan at 60." *Rock's Backpages,* October 2001. http://www.rocksbackpages.com/article.html?ArticleID=3027.

Gorbman, Claudia. *Unheard Melodies: Narrative Film Music.* Bloomington: Indiana University Press, 1987.

Grafton, Donald. *Before Mickey: The Animated Film 1898–1928.* Chicago: University of Chicago Press, 1993.

Gramsci, Antonio. *Selections from the Prison Notebooks.* London: Lawrence and Wishart, 1971.

Green, Bill, Ben Peskoe, Will Russell, and Scott Shuffitt. *I'm a Lebowski, You're a Lebowski: Life,* The Big Lebowski, *and What Have You.* New York: Bloomsbury, 2007.

Green, Douglas B. *Singing in the Saddle: The History of the Singing Cowboy.* Nashville: Country Music Foundation Press and Vanderbilt University Press, 2002.

Green, Harvey. *Wood: Craft, Culture, History.* New York: Viking, 2006.

Grimm, Jacob, and Wilhelm Grimm. "The Story of a Boy Who Went Forth to Learn Fear." http://www.pitt.edu/~dash/grimm004.html.

Grossberg, Lawrence. "Is There a Fan in the House? The Affective Sensibility of Fandom." In *The Adoring Audience: Fan Culture and Popular Media,* ed. Lisa A. Lewis. London: Routledge, 1992.

Hall, Dennis R., and Susan Grove Hall, eds. *American Icons: An Encyclopedia*

of People, Places, and Things That Have Shaped Our Culture. 3 vols. Westport, Conn.: Greenwood, 2006.

Hammett, Dashiell. *The Glass Key.* New York: Vintage, 1989.

———. *The Maltese Falcon.* New York: Vintage, 1989.

———. *Red Harvest.* New York: Vintage, 1989.

———. "The Whosis Kid." In *The Continental Op.* New York: Vintage, 1989.

Hammond, Paul, ed. *The Shadow and Its Shadow: Surrealist Writings on Cinema.* London: British Film Institute, 1978.

Hansen, Miriam. "Mass Production of the Senses: Classical Cinema as Vernacular Modernism." *Modernism/Modernity* 6.2 (April 1999): 59–77.

Haraway, Donna J. *When Species Meet.* Minneapolis: University of Minnesota Press, 2008.

Harries, Dan. *Film Parody.* London: British Film Institute, 2000.

Harries, Martin. "In the Coen Brothers' New Film, the Dark, Utopian Music of the American South." *Chronicle of Higher Education,* 2 February 2001, B14–15.

Harty, Kevin J. "A Complete Arthurian Filmography and Selected Bibliography." In *King Arthur on Film: New Essays on Arthurian Cinema,* ed. Kevin J. Harty. London: McFarland, 1999.

Harvey, David. *The Condition of Postmodernity: An Inquiry into the Origins of Cultural Change.* Cambridge, UK: Blackwell, 1990.

Hassan, Ihab. *Radical Innocence: Studies in the Contemporary American Novel.* New York: Harper Colophon Books, 1966.

Hayden, Tom. *The Port Huron Statement: The Visionary Call of the 1960s Revolution.* New York: Thunder's Mouth Press, 2005.

Hayles, N. Katharine. *How We Became Posthuman: Virtual Bodies in Cybernetics, Literature and Informatics.* Chicago: University of Chicago Press, 1999.

Hecht, Alan. *Polio.* Deadly Diseases and Epidemics Series. Philadelphia: Chelsea House, 2003.

Heidegger, Martin. "Building Dwelling Thinking." In *Poetry, Language, Thought,* trans. Albert Hofstadter. New York: Harper and Row, 1971.

———. *What Is Called Thinking?* Trans. Fred D. Wieck and J. Glenn Gray. New York: Harper and Row, 1968.

Hersh, Seymour. "Last Stand: The Military's Problem with the President's Iran Policy." *New Yorker,* 10 and 17 July 2006, 42–49.

Hess, Alan. *Googie: Fifties Coffee Shop Architecture.* San Francisco: Chronicle Books, 1985.

Heyerdahl, Thor. *Kon-Tiki: Across the Pacific by Raft.* Chicago: Rand McNally, 1950.

Hip Wax. "The Barry Sisters." http://www.hipwax.com/music/barry.html.

The Holy Bible. Revised Standard Version. 2nd ed. Nashville: Thomas Nelson, 1971.Hollows, Joanne. "Mass Culture Theory and Political Economy." In *Approaches to Popular Film,* eds. Joanne Hollows and Mark Jancovich. Manchester: Manchester University Press, 1995. 16–36.

Home Bartender. "Shaken or Stirred?" *Boston Cocktails.* http://www .bostoncocktails.com/category/howto/. [no longer available]

Horkheimer, Max, and Theodor W. Adorno. *The Dialectic of Enlightenment.* Stanford, Calif.: Stanford University Press, 2002.

Internet Movie Database. "IMDb User Comments for *The Big Lebowski.* http:// www.imdb.com/title/tt0118715/usercomments.

Irigaray, Luce. "The Mechanics of Fluids." In *This Sex Which Is Not One,* trans. Catherine Porter. Ithaca, N.Y.: Cornell University Press, 1985. 106–18.

"The Iron Lung and Other Equipment." Smithsonian Institute. http:// americanhistory.si.edu/polio/howpolio/ironlung.htm.

Irving, Washington. "Rip Van Winkle." 1819. In *The Norton Anthology of American Literature,* 6th shorter ed., ed. Nina Baym. New York: Norton, 2003. 448–60.

Isacharoff, Michael. "Jakobson, Roman." In *The Johns Hopkins Guide to Literary Theory and Criticism.* Baltimore: Johns Hopkins University Press, 1993.

Iuli, Maria Cristina. "Memory and Time in *The Big Lebowski:* How Can the Political Return?" In *America Today: Highways and Labyrinths,* ed. Gigliolo Nocera. Siracusa: GrafiB, 2003. 649–56.

James, David E. *The Most Typical Avant-Garde: History and Geography of Minor Cinemas in Los Angeles.* Berkeley: University of California Press, 2005.

Jameson, Fredric. "On Raymond Chandler." In *The Poetics of Murder: Detective*

Fiction and Literary Theory, ed. Glenn W. Most and William W. Stowe. San Diego: Harcourt Brace Jovanovich, 1983. 122–48.

————. "Periodizing the Sixties." In *The Sixties without Apology,* ed. Sohnya Sayres, Anders Stephanson, Stanley Aronowitz, and Fredric Jameson. Minneapolis: University of Minnesota Press, 1984. 178–209.

————. *Postmodernism, or, The Cultural Logic of Late Capitalism.* Durham, N.C.: Duke University Press, 1991.

Jeffords, Susan. *The Remasculinization of America: Gender and the Vietnam War.* Bloomington: Indiana University Press, 1989.

Johnson, Lyndon B. "State of the Union Address." January 12, 1966. http://www .infoplease.com/t/hist/state-of-the-union/179.html.

Kael, Pauline. *Reeling.* New York: Warner, 1976.

————. *When the Lights Go Down.* New York: Holt, Rinehart and Winston, 1980.

"Kahlúa White Russian." Kahlua.com. Kahlúa Recipes. http://www .kahlua.com/main.aspx?language=en&country=usa&link=&recipe=.

Kassabian, Anahid. *Hearing Film: Tracking Identifications in Contemporary Hollywood Film Music.* New York: Routledge, 2001.

Keats, John. Letter to George and Thomas Keats. 22 December 1817. In *The Complete Poetical Works and Letters of John Keats,* ed. Horace E. Scudder. Boston: Houghton Mifflin, 1899. 276–77.

Kempley, Rita. Review of *Barton Fink* by Ethan and Joel Coen. *Washington Post,* 21 August 1991. http://www.washingtonpost.com/wp-srv/style/longterm/ movies/videos/bartonfinkrkempley_a0a172.htm.

Kermode, Mark. "Twisting the Knife." In *Celluloid Jukebox: Popular Music and the Movies since the 50s,* ed. Jonathan Romney and Adrian Wootton. London: British Film Institute, 1995. 8–20.

Kiernan, V. G. *America: The New Imperialism: From White Settlement to World Hegemony.* London: Zed Press, 1978.

Körte, Peter, and Georg Seesslen, eds. *Joel and Ethan Coen.* Trans. Rory Mulholland. New York: Limelight Editions, 2001.

Kunstler, James Howard. *The Geography of Nowhere: The Rise and Decline*

of America's Man-Made Landscape. New York: Simon and Schuster, 1993.

Lacan, Jacques. *The Ethics of Psychoanalysis, 1959–1960: The Seminar of Jacques Lacan, Book VII.* Trans. Dennis Porter. New York: Norton, 1992.

———. "The Signification of the Phallus." In *Écrits,* trans. Alan Sheridan. London: Tavistock, 1977. 281–91.

Lacayo, Richard. "80 Days That Changed the World—January 5, 1948: The Big Dripper's Opening." *Time Magazine.* http://www.time.com/time/80days/480105.html (accessed 8 July 2008).

Laclau, Ernesto. *On Populist Reason.* London: Verso, 2005.

Lapedis, Hilary. "Popping the Question: The Function and Effect of Popular Music in Cinema." *Popular Music* 18 (October 1999): 367–79.

Late Show with David Letterman. "Top Ten Things You Don't Want to Hear in a Bowling Alley." (aired 18 November 2003). http://www.cbs.com/latenight/lateshow/top_ten/archive/.

"Lebowski Fest." http://www.lebowskifest.com/.

Let's Go Bowling. Directed by Al Bradish. Bowling Proprietors Association of America. 1955. http://www.archive.org/details/LetsGoB01955.

Lindholm, Charles, and John A. Hall. "Frank Capra Meets John Doe: Anti-politics in American National Identity." In *Cinema and Nation,* ed. Mette Hjort and Scott MacKenzie. London: Routledge, 2000. 32–44.

Ling, Peter J. *America and the Automobile: Technology, Reform and Social Change.* Manchester: Manchester University Press, 1990.

Loyd, Sam. *Cyclopedia of 5000 Puzzles, Tricks, and Conundrums.* New York: Lamb, 1914.

Lutz, Tom. *Doing Nothing: A History of Loafers, Loungers, Slackers, and Bums in America.* New York: Farrar, Straus and Giroux, 2006.

Lyon, Janet. *Manifestoes: Provocations of the Modern.* Ithaca, N.Y.: Cornell University Press, 1999.

Lyotard, Jean-Francois. *The Postmodern Condition: A Report on Knowledge.*

Trans. Geoff Bennington and Brian Massumi. Minneapolis: University of
Minnesota Press, 1991.

Mahoney, Dhira B. "The Truest and Holiest Tale: Malory's Transformation
of *La Queste Del Saint Graal.*" In *Studies in Malory,* ed. James W. Spisak.
Kalamazoo, Mich.: Medieval Institute, 1985. 109–128.

"The Making of *The Big Lebowski.*" Directed by Richard Leyland. Polygram, 1998.

Malory, Sir Thomas. *Le Morte Darthur; or,The Hoole Book of Kyng Arthur and of
His Noble Knyghtes of the Rounde Table.* Norton Critical Edition. Ed. Stephen
H. A. Shepherd. New York: W. W. Norton, 2004.

Marling, William. *The American Roman Noir: Hammett, Cain and Chandler.*
Athens: University of Georgia Press, 1995.

Martin, Pete. "Pago Pago in Hollywood." *Saturday Evening Post* 22.44 (1 May
1948): 32, 71–81.

Marx, Karl, and Friedrich Engels. *The Communist Manifesto.* In *The Marx-Engels
Reader.* 2nd ed. Ed. Robert Tucker. Trans. Samuel Moore. New York: Norton,
1978.

Maslin, Janet. "*The Big Lebowski:* Comic Oddballs Hurling Bowling Balls."
New York Times, 6 March 1998. http://www.nytimes.com/library/
film/030698lebow-film-review.html/.

Mathis, Andrew E. *The King Arthur Myth in Modern American Literature.*
London: McFarland, 2002.

Miller, D. A. "Anal *Rope.*" In *Inside/Out: Lesbian Theories, Gay Theories,* ed.
Diana Fuss. New York: Routledge, 1991. 119–41.

Mills, C. Wright. "Letter to the New Left." *New Left Review* 5 (September/
October 1960): 18–23.

Moerer, Keith. "Sharps and Flats: Soundtrack from *The Big Lebowski.*" *Salon,* 5
March 1998. http://www.salon.com/music/sharps/1998/03/05sharps.html.

Morgan, David. *Knowing the Score: Film Composers Talk about the
Art, Craft, Blood, Sweat, and Tears of Writing for Cinema.* New York:
HarperEntertainment, 2000.

Mottram, James. *The Coen Brothers: The Life of the Mind.* Dulles, Va.: Brassey's,
2000.

Mouffe, Chantal. *On the Political.* London: Routledge, 2005.

Murray, Charles Shaar. "Local Jew Boy Makes Good: Bob Dylan's *New Morning.*" *Oz* (1970). Available from Rock's Backpages Library. http://www .rocksbackpages.com/article.html?ArticleID=2655.

Naremore, James. *More Than Night: Film Noir in Its Contexts.* Berkeley: University of California Press, 1998.

Nieland, Justus. *Feeling Modern: The Eccentricities of Public Life.* Urbana: University of Illinois Press, 2008.

Nietzsche, Friedrich. *Thus Spoke Zarathustra.* Ed. and trans. Walter Kaufmann. *The Portable Nietzsche.* New York: Viking, 1954. 103–439.

Novak, William. "Sex and Intimacy." In *High Culture: Marijuana in the Lives of Americans.* http://www.druglibrary.org/Special/novak/high_culture5.htm.

O'Barr, William M. "Roundtable on Advertising and the New Masculinities." *Advertising and Society Review* 5.4 (2004). http://muse.jhu.edu/login?uri=/ journals/advertising_and_society_review/v005/5.4roundtable.html.

Olton, Bert. *Arthurian Legends on Film and Television.* London: McFarland, 2000.

Onyett, Charles. "AMF Xtreme Bowling 2006 Review: Try Squirting Lemon Juice in Your Eye. It'd Be More Fun." IGN.com. (23 June 2006). http://ps2 .ign.com/articles/714/714477p1.html.

Oring, Elliot. *The Jokes of Sigmund Freud: A Study in Humor and Jewish Identity.* Philadelphia: University of Pennsylvania Press, 1984.

Palmer, R. Barton. *Joel and Ethan Coen.* Urbana: University of Illinois Press, 2004.

Pearson, Roberta E. *Eloquent Gestures: The Transformation of Performance Style in the Griffith Biograph Films.* Berkeley: University of California Press, 1992.

Pels, Dick. *The Intellectual as Stranger: Studies in Spokespersonship.* London: Routledge, 2000.

Peterson, Richard A. *Creating Country Music: Fabricating Authenticity.* Chicago: University of Chicago Press, 1997.

Pines, Jim, and Paul Willeman, eds. *Questions of Third Cinema.* London: British Film Institute, 1991.

Pope, Alexander. *The Rape of the Lock*. Ed. Cynthia Wall. Boston: Bedford Books, 1998.

Port Huron Statement of the Students for a Democratic Society, 1962. Michigan State University, East Lansing. http://coursesa.matrix.msu.edu/~hst306/documents/huron.html.

Putnam, Robert D. *Bowling Alone: The Collapse and Revival of American Community*. New York: Simon and Schuster, 2000.

The Quest of the Holy Grail. Trans. Pauline Matarasso. New York: Penguin Books, 1969.

Rajan, Sudir Chella. "Automobility and the Liberal Disposition." In *Against Automobility*, ed. Steffen Böhm et al. Oxford: Blackwell, 2005.

Riesman, David. *Abundance for What?* London: Chatto and Windus, 1964.

Robertson, William Preston. *The Big Lebowski: Making of a Coen Brothers Film*. New York: Norton, 1998.

Rogin, Michael. *Ronald Reagan, the Movie and Other Episodes in Political Demonology*. Berkeley: University of California Press, 1987.

Romney, Jonathan. "In Praise of Goofing Off." In *American Independent Cinema*, ed. Jim Hillier. London: British Film Institute, 2001. 258–59.

Ross, Alex. "Bogus Nights: The Immorality of Indie Film." Review of *The Big Lebowski. Slate*, 8 March 1998. http://www.Slate.com/id/3246.

Rowell, Erica. *The Brothers Grim: The Films of Ethan and Joel Coen*. Lanham, Md.: Scarecrow Press, 2007.

Royle, Nicholas. *How to Read Shakespeare*. London: Granta, 2005.

Russell, Carolyn R. *The Films of Joel and Ethan Coen*. Jefferson, N.C.: McFarland, 2001.

Sachs, Wolfgang. *For Love of the Automobile: Looking Back into the History of Our Desires*. Berkeley: University of California Press, 1984.

Salecl, Renata, and Slavoj Žižek. Introduction to *Gaze and Voice as Love Objects*, ed. Renata Salecl and Slavoj Žižek. Durham, N.C.: Duke University Press, 1996. 1–6.

Sex-Lexis.com. http://www.sex-lexis.com/.

Sheridan, Alan. "Translator's Note." In *Écrits,* by Jacques Lacan. Trans. Alan Sheridan. New York: Norton, 1977. vii–xii.

Shichtman, Martin B. "Hollywood's New Weston: The Grail Myth in Francis Ford Coppola's *Apocalypse Now* and John Boorman's *Excalibur.*" *Post-Script: Essays on Film and the Humanities* 4.1 (1984): 35–48.

Shumway, David. "Rock 'n' Roll Soundtracks and the Production of Nostalgia." *Cinema Journal* 38 (Winter 1999): 36–51.

Smith, Jeff. "Popular Songs and Comic Allusion in Contemporary Cinema." In *Soundtrack Available: Essays on Film and Popular Music,* ed. Pamela Robertson Wojcik and Arthur Knight. Durham, N.C.: Duke University Press, 2002. 407–30.

Smith, Paul. "Eastwood Bound." In *Constructing Masculinity,* ed. Maurice Berger, Brian Wallis, and Simon Watson. New York: Routledge, 1995. 77–97.

Solanas, Fernando, and Octavio Gettino. "Towards a Third Cinema." In *Movies and Methods,* ed. Bill Nichols. Berkeley: University of California Press, 1976. 44–64.

St. Clair, David J. *The Motorization of American Cities.* New York: Praeger, 1986.

Stanfield, Peter. *Horse Opera: The Strange History of the 1930s Singing Cowboy.* Urbana: University of Illinois Press, 2002.

Stoddart, Helen. "Auteurism and Film Authorship." In *Approaches to Popular Film,* ed. Joanne Hollows and Mark Jancovich. Manchester: Manchester University Press, 1995. 37–58.

Susman, Gary. "Making It Clear: The Coen Brothers." In *The Coen Brothers Interviews,* ed. William Rodney Allen. Jackson: University Press of Mississippi, 2006.

Tanner, Tony. *City of Words: American Fiction 1950–1970.* New York: Harper, 1971.

Tanzer, Michael. "Oil and the Gulf Crisis." In *Beyond the Storm: A Gulf Crisis Reader,* ed. Phyllis Bennis and Michel Moushabeck. Edinburgh: Canongate, 1992. 263–67.

Thomas, Rob. Interview by Whitney Matheson. *Pop Candy.* http://blogs .usatoday.com/popcandy/2006/09/podcast_for_big.html.

Time to Bowl (Booklet accompanying the DVD of *The Big Lebowski*). Polygram Video International, 1999.

Trader Vic [Bergeron, Victor Jules]. *Frankly Speaking: Trader Vic's Own Story.* Garden City, N.Y.: Doubleday, 1973.

Tranter, Nikki. "True Bliss: Celebrating *The Big Lebowski*." *PopMatters,* 31 August 2005. http://www.popmatters.com/film/features/050831-lebowskifest.shtml.

Umland, Rebecca A., and Samuel J. Umland. *The Use of Arthurian Legend in Hollywood Film: From Connecticut Yankees to Fisher Kings.* Westport, Conn.: Greenwood, 1996.

Van Boxsel, Matthijs. *The Encyclopedia of Stupidity.* London: Reaktion, 2004.

Walker, John. "City Jungles and Expressionist Reifications from Brecht to Hammett." *Twentieth Century Literature* 44 (Spring 1998): 119–33.

Wayne, Mike. *Political Film: The Dialectics of Third Cinema.* London: Pluto, 2001.

Weathervane. "The White Russian." Everything2.com. http://www.everything2.com/index.pl?node_id=136607.

"What's in a Name? Creedence Clearwater Revival." *ZigZag,* October 1969. Available at Rock's Backpages Library. http://www.rocksbackpages.com/article_with_login.html?ArticleID=2260.

White, Hayden. *Metahistory: The Historical Imagination in Nineteenth-Century Europe.* Baltimore: Johns Hopkins University Press, 1973.

"White Russian." Absolut.com. http://absolutdrinks.com/drink_recipe_white_russian_1816.html [no longer available]

"White Russian 2." Absolut.com. http://absolutdrinks.com/drink_recipe_white_russian_2_1817.html. [no longer available]

"White Russian." Wikipedia. http://en.wikipedia.org/wiki/White_Russian_(cocktail).

Whitman, Walt. "Song of Myself." In *Poetry and Prose,* ed. Justin Kaplan. New York: Library of America, 1982.

Wisniewski, Ian. *Party Drinks.* London: Octopus-Conran, 2000.

Wisse, Ruth R. *The Schlemiel as Modern Hero.* Chicago: University of Chicago Press, 1971.

Wolfe, Cary. "Thinking Other-Wise: Cognitive Science, Deconstruction, and the (Non)Speaking (Non)Human Subject." In *Animal Subjects: An Ethical Reader,* ed. Jody Castricano. Toronto: Wilfred Laurier University Press, 2008. 125–43.

Wolff, Robert Paul. *The Poverty of Liberalism.* Boston: Beacon, 1968.

Woods, Paul A., ed. *Joel and Ethan Coen: Blood Siblings.* London: Plexus, 2000.

Yurchak, Alexei. *Everything Was Forever, Until It Was No More: The Last Soviet Generation.* Princeton, N.J.: Princeton University Press, 2006.

Žižek, Slavoj. *Looking Awry: An Introduction of Jacques Lacan through Popular Culture.* Cambridge, Mass.: MIT Press, 1991.

Contributors

Dennis Allen is Professor of English at West Virginia University. He is author of *Sexuality in Victorian Fiction.*

Fred Ashe is Associate Professor of English at Birmingham-Southern College. Recent work has appeared in the *Hemingway Review.*

Matthew Biberman is Associate Professor of English at the University of Louisville. He is the author of *Masculinity, Anti-Semitism and Early Modern English Literature.*

Thomas B. Byers is Professor of English and Director of the Commonwealth Center for the Humanities and Society at the University of Louisville.

Bradley D. Clissold is Assistant Professor of Twentieth-Century British Literature, Film and Cultural Studies at Memorial University.

Jonathan Elmer is Associate Professor of English at Indiana University. His most recent book is *On Lingering and Being Last: Race and Sovereignty in the New World.*

Richard Gaughran is Assistant Professor of English at James Madison University, where he teaches American Literature and World Literature. He has published articles on baseball literature, popular film, and the literature of the American South.

Dennis Hall, Professor of English at the University of Louisville, studies popular culture. His recent work focuses on cultural icons such as the Little Black Dress and the Wrist Watch.

Susan Grove Hall is an independent scholar and co-editor of *American Icons: An Encyclopedia of the People, Places, and Things That Have Shaped Our Culture*. Her article on the icon Jell-O appeared in the 2008 *Studies in Popular Culture*.

Joshua Kates is Associate Professor of English at Indiana University and author of *Essential History: Jacques Derrida and the Development of Deconstruction*.

David Martin-Jones lectures in Film Studies at the University of St Andrews. He is the author/editor of *Deleuze, Cinema and National Identity* and *Deleuze Reframed*.

Justus Nieland is Assistant Professor of English at Michigan State University and author of *Feeling Modern: The Eccentricities of Modern Life*.

Craig N. Owens teaches literature and writing at Drake University. His research focuses on theater, film, and television.

David Pagano is Senior Lecturer of English at Old Dominion University.

Diane Pecknold is Visiting Assistant Professor in Humanities at the University of Louisville. She is the author of *The Selling Sound: The Rise of the Country Music Industry*.

Andrew Rabin is Assistant Professor of English at the University of Louisville. His work on medieval literature has appeared in *Viator*, *Modern Philology*, *JEGP*, *Mediaeval Studies*, and *Speculum*.

Christopher Raczkowski teaches twentieth-century American literature and culture at the University of South Alabama. His work on crime fiction has appeared in *Modern Fiction Studies.*

William Preston Robertson is an award-winning journalist and screenwriter based in California. He is author of *The Big Lebowski: The Making of a Coen Brothers Film* with Tricia Cooke, John Todd Anderson, and Rafael Sanudo.

Judith Roof is Professor of English at Rice University. She is also a filmmaker and Managing Director of SteinSemble Performance Group.

Allan Smithee is an independent scholar based in Chicago.

Stacy Thompson is Associate Professor of English at the University of Wisconsin–Eau Claire and author of *Punk Productions: Unfinished Business.*

Index

Edward P. Comentale is Associate Professor of English at Indiana University Bloomington. He is co-editor of *Ian Fleming and James Bond: The Cultural Politics of 007* (Indiana University Press, 2005) and author of *Modernism, Cultural Production, and the British Avant-Garde*.

Aaron Jaffe is Associate Professor of English at the University of Louisville. His publications include a contribution in *Ian Fleming and James Bond: The Cultural Politics of 007* (Indiana University Press, 2005) and his book *Modernism and the Culture of Celebrity*.

This book was designed by Jamison Cockerham and set in type by Tony Brewer at Indiana University Press and printed by Sheridan Books.

The text face is Arno Pro, designed by Robert Slimbach, and the display faces are Conga Brava, designed by Michael Harvey, and Wendy LP, designed by Garret Boge, all issued by Adobe Systems.